The Daybooks of Edward Weston

April 20 –

1923

Johan is here – has been here for over a week –
Days and nights of intensity – burning
discourses on many topics – of course
mostly photography!

Johan brought new work – fine industrial
things – nicely seen – but lacking in defi-
nition – and inexcusable fault when it
comes to photographing modern archi-
tecture and machinery – even the "mood"
could be better interpreted better with
sharp – clean lines – " – but if I see things
this way – Edward – I must render them
as I see them" – – "Nevertheless – Johan –
photography has certain inherent qualities
which are only possible with photography –
one being the delineation of detail –
So why not take advantage of this
attribute? Why limit yourself to what
your eyes see when you have

THE DAYBOOKS *of*

Edward Weston

Volume I. MEXICO

Edited by NANCY NEWHALL

AN APERTURE BOOK

Aperture is a non-profit, educational organization publishing
a quarterly of photography, books, and portfolios to communicate
with serious photographers and creative people everywhere.
Address: Elm Street, Millerton, New York 12546.

The Daybooks of Edward Weston, Volume II, California is
produced simultaneously.

This book is published primarily for the large public which
is familiar with Edward Weston's photographs and wishes to know
more of his life and thought. Those who wish to study his
photographs as presented with an excellence not attempted in this
book are referred to *Edward Weston: Fifty Years,* published by
Aperture in the Fall of 1973.

Library of Congress Catalog Number: 61-18484

ISBN Numbers: Clothbound 0-912334-43-46
 Paperbound 0-912334-45-2

Contents

Plates

Plates

Plates

Foreword

Seldom has an artist written about his life as vividly, as intimately and as sincerely as Edward Weston. Day after day, for more than fifteen years, this great photographer wrote his thoughts about life, outlined his hopes, catalogued his despairs, mercilessly criticised his photographs, and recorded every experience which was meaningful to him.

The result is an extraordinary document of the struggle of an artist to forge a style, to adjust himself to the world, to determine his position in society, and to appraise his contribution to it.

We know nothing comparable in the literature of photography. In many ways, the *Daybooks* bring to mind the *Journal* kept by another great artist, the French painter Eugène Delacroix as "a record of what is happening in my life and above all, in my mind." Like Delacroix, Weston wrote with no thought of publication. A few excerpts, however, appeared in *Creative Art*, August, 1928. Years after he had stopped writing the daybook, he reviewed what he had written and edited it. Portions were published in the *Alfred Stieglitz Memorial Portfolio*, and in his *My Camera on Point Lobos*. Shortly after his death in 1958, Nancy Newhall published portions in the special issue of *Aperture* dedicated to his memory and excerpts also appeared in the 1958 Summer issue of *Art in America*.

This is the first publication of the *Daybooks* in book form. The present volume comprises about half of the original manuscript — mainly the years when Weston was living in Mexico, from 1923–1926. A second volume, covering later years, will be subsequently published.

Weston arrived in Mexico at the height of that flowering of the arts which has been called the Mexican Renaissance. His contribution was immediately hailed by Diego Rivera and other leading artists. He shared their delight in discovering the spontaneity of folk art and the ancient pre-conquest relics. He became an aficionado of the bull ring. He learned the language well enough to communicate. Yet he was constantly swinging between love and hate of Mexico. The background of unrest made him uneasy. He never could identify himself with the country. The *Daybooks* contain not only the self analysis of an artist and a revealing commentary on photography; they illuminate Mexican society and culture in the 1920's.

Because of this documentary character, we have published the manuscript substantially as it was left by Weston. Cutting has been kept to a minimum, and is largely confined to the elimination of redundant passages and references of an obscure or highly personal nature. At his best, Weston wrote simply and well. But the value of the *Daybooks* would be impaired if the involved style which marks his moments of introspection and searching was to be "improved" by even the most judicious cutting.

When publication of the *Daybooks* was first planned, in 1950, Weston went through what remained of his Mexico negatives. From time to time he had destroyed many of them; those he could not pull a good print from, no matter how exciting the ideas and perceptions they embodied, were the first to go. Later, as his standards of technical and emotional realization grew higher, he discarded others; original platinum and palladium prints from a number of these still exist, in his own collection, now divided among his heirs, and in the collections of those who bought from him in the 1920's. From such of the surviving negatives as still pleased him, Weston had his second son, Brett, and his apprentice, Dody, make prints under his supervision. Many of those which appear here have never been reproduced before.

The selection is representative of the themes that then engrossed him, with the exception of the cloud series. Rushing up to the roof, adjusting his Graflex as he went, Weston could never quite materialize in a print the excitement he felt in these swiftly changing forms; Mexico City lies at an altitude of ten thousand feet, and no combination of film, filter, shutter, developer, paper then available — he tried them all — could give him the brilliance and sculptural luminosity of clouds in the dazzling light and dark, resplendent blue of those high skies; black and white silhouettes were not what he wanted. Yet at the same time, unknown to him, though they wrote each other now and then, Alfred Stieglitz was watching the gentle clouds about Lake George as if they were music, and forming from them his theory of the Equivalent.

No creator exists alone, however alone he may feel himself. "'Form follows function,' the phrase I love" — Weston was applying to both his subject matter and his technique, unaware that at the same time architects were evolving an esthetic based on that very phrase. He knew he shared with Charles Sheeler, whose photographs he felt had "dignity — a real reason for existence," his concern with the "very substance of the thing itself," and he knew what his work meant to the painters around him in Mexico — Rivera, Charlot, Siqueiros, Orozco. What he did not know until later was how close he was to Otto Dix and the "New Objectivity" movement, to Brancusi, Arp, Matisse; to Atget in France, Renger Patzsch and Peterhans in Germany, Paul Strand back in New York City. He did not know until toward the end of his life that some of his fleeting negatives of the market, street and village life of Mexico stimulated the photographer

Manuel Alvarez Bravo to a stark, wry, often beautiful expression of the strange contrasts of Mexican life — an expression whose linear and tonal qualities caught the imagination of the young Frenchman, Cartier-Bresson. In Mexico it seemed to Weston that he was being torn apart by two violently opposed directions, the "abstract" and the "real." Back once more in America, the two merged on his groundglass into one, and at this point his impact on young photographers in the United States became catalytic.

Before his death Edward Weston appointed Nancy Newhall as his biographer and turned over to her material which has been used in the introduction and which will appear in more expanded form in the biography now in preparation. We are indebted to Brett Weston and Cole Weston for their generous help. Professor D. Lincoln Canfield, of the University of Rochester, a specialist in Latin American linguistics, has most generously read the proofs and supplied the glossary.

BEAUMONT NEWHALL, *Director*
George Eastman House

Introduction

For Edward Weston, his *Daybook* was "my way of exploding... the safety valve I need in this day when pistols and poisons are taboo." To be alone, to focus on what was happening to him, he rose around 4 AM: "Peace again! — the exquisite hour before dawn, here at my old desk — seldom have I realized so keenly, appreciated so fully, these still, dark hours."

It is an utterly frank and intimate journal, so much so that when he reread it, he was revolted by all the "heartaches, headaches, bellyaches." Once, in 1925, he threw three years of it into the fire. When publication threatened, he went through the surviving eleven years of it with a razor and a very thick black pencil, crossing out names, cutting out "petty reactions, momentary moods" until much of the MS is full of holes or sliced to tatters. Even so, as he wrote me in 1948: "... it is too personal ... I usually wrote to let off steam so the diary gives a one-sided picture which I do not like."

Yet because he poured into the *Daybook* his resentment, bitterness, disgust, mercilessly exposing his own weaknesses, egotisms, evasions, he could turn to others with a gentleness, an insight and a sense of humor that made him deeply and staunchly loved. He seemed at first a quiet little man, rather professorial in appearance. His eyes, a hot brown, were slow and absorbent, as if he were always — as he doubtless was — searching to see and hold the deep inner image of every person, place or thing. Then you became aware of something inside him that was like a light; it warmed you, and suddenly you felt released. He never laughed out loud — his sister, Mary, recalled that as a boy, he would sit on the stoop of the Chicago house while the glittering Sunday parade of carriages went by, completely deadpan, while a large pet rat, heaving and twisting under his cap, caused astonished gasps from elegant ladies. He was a dancer, a wrestler, and a comic when the spirit moved. He achieved in his later years a simplicity in living that people kept comparing to Thoreau; he was not flattered. Thoreau, with only himself to look after, lived by a lake for two years; Edward, with four sons, two wives, and a legion of loves, had managed, in cities or out of them, to live and work with bare simplicity and a few basic tools for some thirty years. He knew what he had accomplished thereby: "My work has vitality because I have helped, done my part in revealing to others the living world about them..."

The *Daybook* is his Pilgrim's Progress. You can hear him grow, both as a man and as an artist. He began it, as he remembered, in 1917; from this period only the few pages which begin this volume remain.

The Mexican period exists now only in a typescript badly done sometime in the late 1930s or early 40s: "Yes, the MS was 'monkeyed with' by a German girl. It was supposedly just copied... In my original copy, which was longhand, the punctuation was dashes—('modern')—Since the first typewritten copy, each person has punctuated, paragraphed and spelled according to heart's desire." Edward burned the original MS; he had already cut from what the various typists received nearly all references to the agony he suffered over Tina Modotti's other lovers; nothing at all remains of his agony over his eldest son, Chandler, a thirteen-year caught first in the cross-fire between his mother and father, then in the crossfire between Tina and Edward. What remains of the *Daybook* in this period, battered and twisted as it is by the German girl's attempts to give it a romantic Goethean style, is still valid. I have cut only redundancies — the parties, the bullfights, the Mexican toys which in the original become monotonous, — and a few vulgarities and sentimentalities of the kind Edward could no longer stand: "Reading, for example, such lines as 'I drew close to her and kissed her' shivers me, makes me out a pretentious prig. I can't take it! Seeing it in a book would turn me into a hermit. Is there much of that stuff?..." Otherwise he thought it "not too bad — except when I try to write."

The years in Mexico were only the beginning. "Did I tell you that I have eight years of Day Book, post Mexico? Memory tells me it makes the Mexican period seem pallid." He was right, and here, though it has suffered heavily from his razor, we have the original MS in his massive scrawl. It is briefer, more incisive; his passion like fire eats at what in him was unessential to his purpose: "to present clearly my feeling for life with photographic beauty... without subterfuge or evasion in spirit or technique."

When the *Daybook* came to an end, on April 22, 1934, he had solved his crucial problems; his work had achieved the monumental simplicity of true greatness, and he was no longer alone. The last entry is concerned with the coming of his last intense love: "I must have peace, to enjoy, fulfill, this beauty."

Ten years later, he added a brief postscript, recounting main events; this ends like a premonition of what was to happen to himself: "Something almost worse than death came to my only sister Mary — a stroke which crippled her right side. She has come through in heroic fashion, learning to write with left hand, learning to walk, to talk." Edward, stricken with Parkinson's disease, a progressive disintegration of the nervous system, could not achieve such a comeback. Yet even in those last tragic years, when he could no longer see to photograph, when his hand shook too much to hold a pencil, he could remain, as Ansel Adams wrote, "a moving spirit, as always."

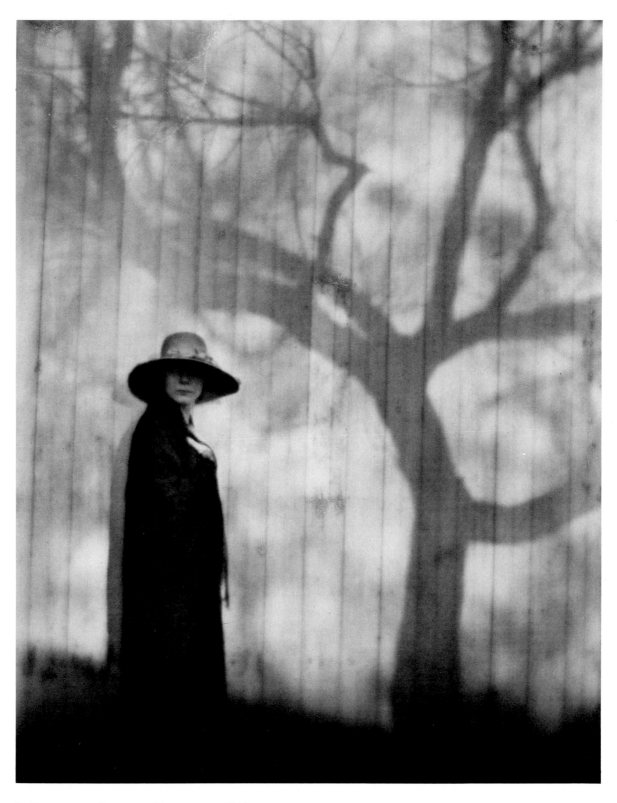

1. SHADOW ON A BARN AND MARGARETHE, 1920

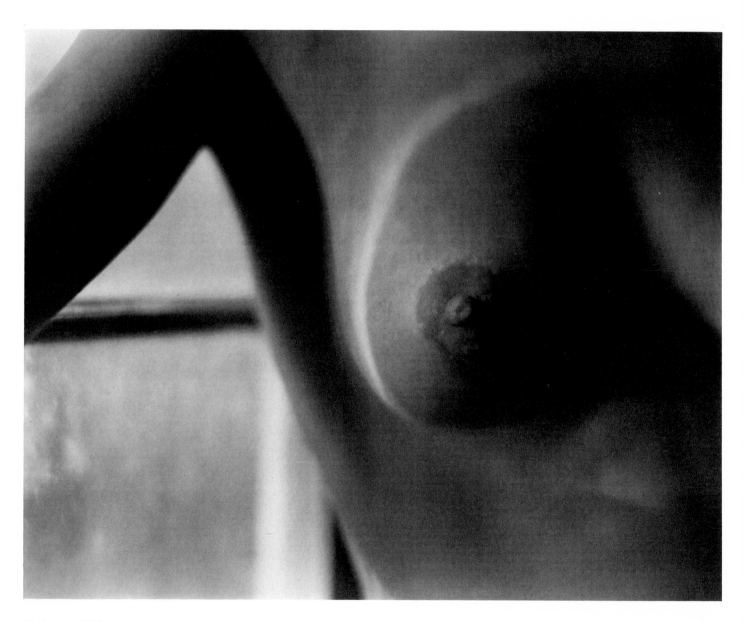

2. BREAST, 1920

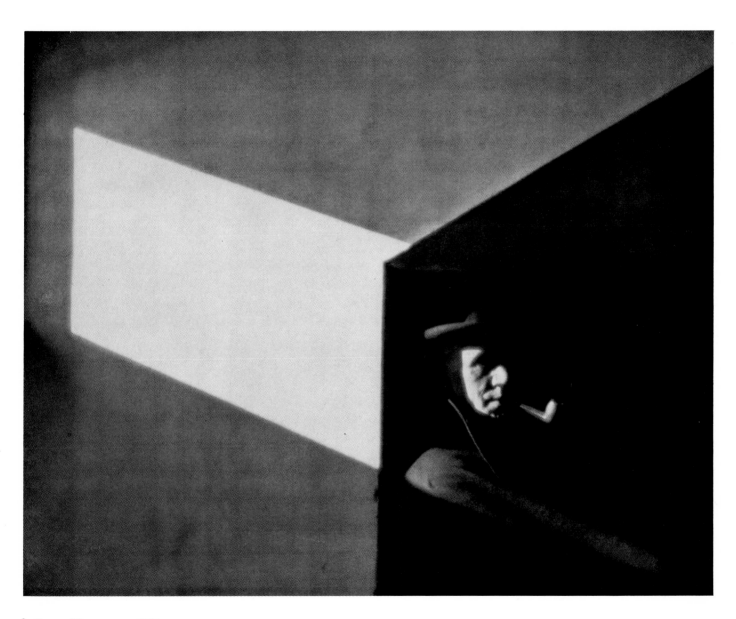

3. JOHAN HAGEMEYER, 1922

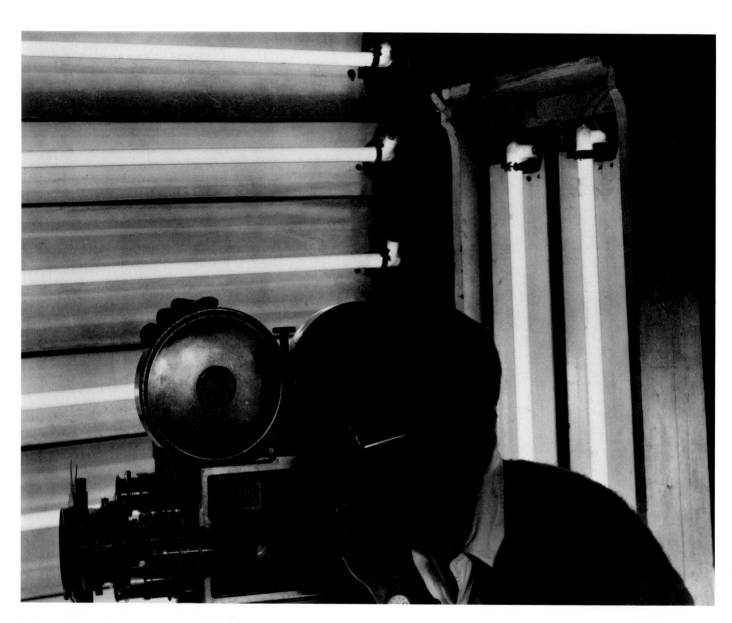

4. KARL STRUSS, CINEMATOGRAPHER, 1922

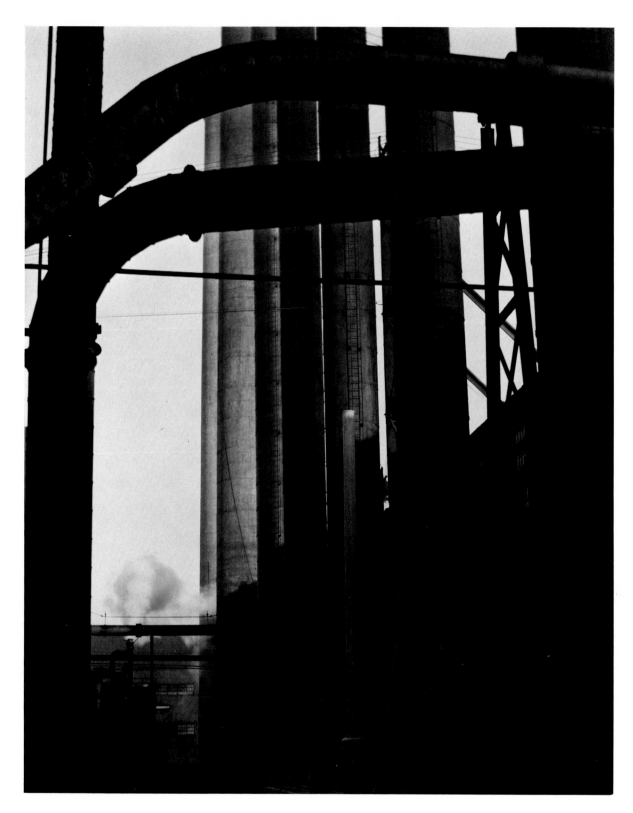

5. ARMCO, OHIO, 1922

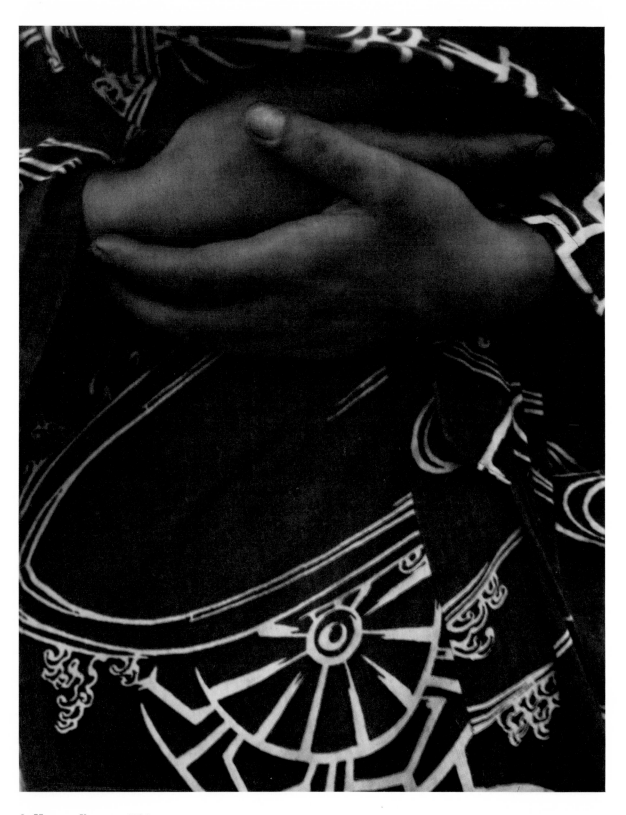

6. HANDS & KIMONO, 1924

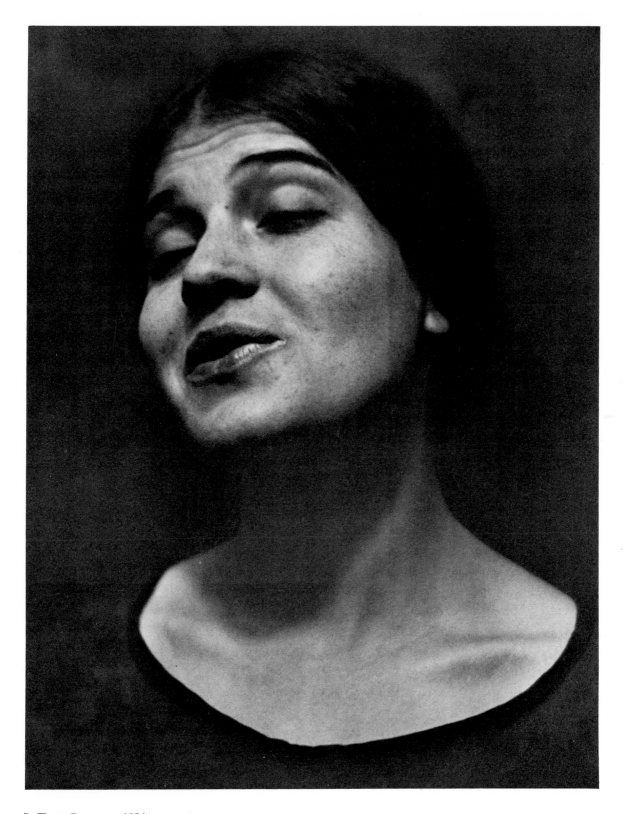

7. Tina, Reciting, 1924

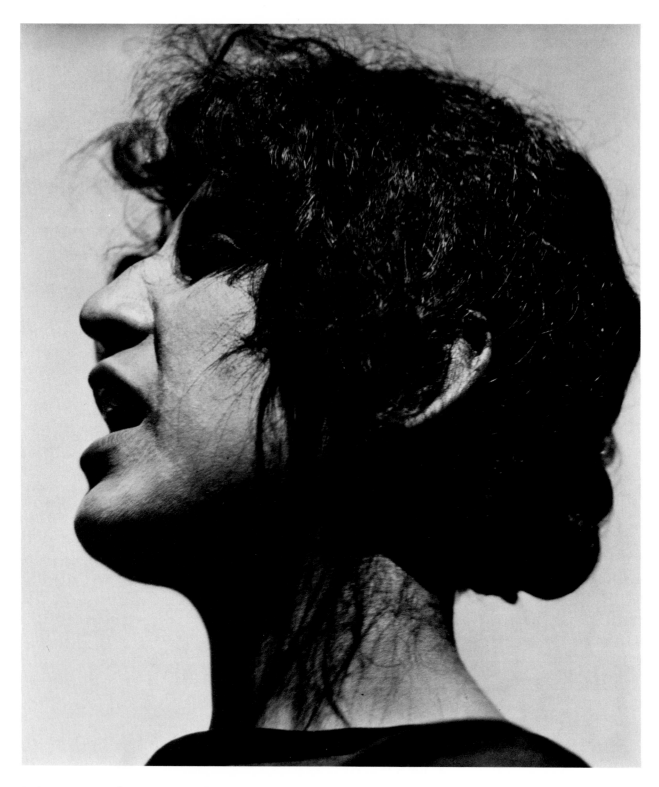

8. GUADALUPE MARÍN DE RIVERA, 1924

Without some sketch of the background, the Daybook is not always easy to comprehend. Briefly, then: Edward Henry Weston was born on March 24, 1886, in Highland Park, Illinois, of a long line of preachers, teachers, and doctors. He and his sister, Mary — "May" — nine years older, were the first children born outside of New England for more than two hundred years. His grandfather, a poet and a Black Republican, was the first to break the tradition: he left Bowdoin College, Maine, to found a female seminary in Illinois. His father, Dr. Edward Burbank Weston, found time during his general practice to teach obstetrics at a local college, introduce the ancient art of archery to the Midwest, and breed fine poultry. Edward, born late in his life, remembered him only as small, grey haired, stalwart, somewhat remote but very kind. The family moved to Chicago when Edward was a few months old. When he was five, his mother, Alice Jeanette Brett Weston, died; he remembered nothing of her except "a pair of burning eyes — perhaps they were burning with fever..." and her dying wish that he should break the family tradition and become a businessman.

He was frail as a child; during the usual mumps, measles, and so on, he instinctively fasted, and all his life, though he was never dogmatic about it, he preferred fruits and vegetables to meats, sunlight and cold water to any medicine. He was bored at school, except in painting class and at athletic events; made himself into a track star, took boxing lessons, and became, as his sons later admiringly observed, "a little strong man."

When his father married again, a widow with a teen-age son, both of whom Edward disliked, he and his sister were given the top floor of the Chicago house; May brought him up. Always they were very close; after she married John Seaman, an electrical engineer, and moved away, they wrote each other at least a postcard nearly every day.

In 1902 his father sent him a Bull's-Eye camera to play with during his summer vacation on a Michigan farm. Edward was excited; then he found he could not get skies or action, and began reading photographic magazines to find out why. Then he saw a view camera, with what seemed like a usable panoply of holders, tripod and an "Ideal Ray" filter, in a pawnshop window; he saved carfare and every other penny he could until at last he could buy it. From then on, he played hookey from school until it was obvious his academic career was at an end; he was always out with his camera photographing the southern parks, the prairies, the lakes. When, in 1903, a photographic magazine reproduced a little spring landscape, Edward was lost forever to photography.

His father, obeying his mother's last wish, sent him to Marshall Field and Co., Wholesale, where, under the eye of an uncle, he was to work his way up. He began as a "rabbit" — errand boy — and in three years worked up to general salesman at $10 a week. He hated it; he watched the clock for the moment he could go photographing again.

By 1906 he had saved enough from his salary to go on vacation to visit May, who was now living in Tropico, California. Tropico was then a few shacks in wonderful wild hills; Edward, fresh from the hot Chicago plain, found himself climbing up two thousand feet. He decided to stay, and got a job surveying for a railroad at $15 a week. Then he discovered the survey was a hoax, designed to sell real estate in the orange groves, and got a job with a real railroad, the old Salt Lake. But mathematics in the desert sun, the fifth day of a fast — "I didn't know how to break my fasts in those days —" caused him to faint. He quit, and went back to Tropico determined to be a professional photographer — "At least I would own the tools I needed." He bought an old postcard camera, and went from door to door, photographing brides, pets, everything from the newborn in its cradle to the corpse in its coffin.

Suddenly he found himself the owner of half a house; the idea was to build the other half later. He realized how deeply he wanted a home. He met Flora May Chandler, daughter of a well-to-do local family who owned considerable property here and there throughout booming Los Angeles county. He saw her at first only as "pretty and sentimental;" it was all he needed to fall in love. Obviously, itinerant photography could not support a family, so he went to learn the trade of portrait photography at the Illinois College of Photography. He accomplished the whole course in six months, was bilked of a diploma by a technicality, and went back to Los Angeles to work as a printer for local portraitists.

On January 30, 1909, he married Flora, who, as he gradually realized, was much more of a person than he had perceived: she was vivid, vital, generous — in his direst moments with her Edward recognized her stature — but she gave you her heart when all you wanted was a cup of coffee. Illness sent her into a paroxysm, jealousy into hysteria. A friend of both in those days, the photographer Imogen Cunningham, then married to the etcher, Roi Partridge, observed she was "like an electric fan you couldn't turn off." She bore Edward the four sons who were his deepest human relation: Edward Chandler, 1910; Theodore Brett, 1911; Laurence Neil, 1914; Cole, 1919. For Edward, his other loves might come and go like flowers in their seasons; Flora was the mother of his sons, and her generosity was total, even to selling land to help him after they had separated. He did not ask for a divorce until 1937.

In 1911, with the help of his in-laws, he built a rustic little studio in Tropico and set out a garden around it. The first week after he opened it, the total take was $1 for a dozen postcards. Soon he began making a success: he hid ungainly shapes in chiffon scarves, he vignetted down to the head alone, he became an expert retoucher. Customers were pleased, and enough wealthy clients, some of them stars from the burgeoning movie colony in nearby Hollywood, came up his daisy-bordered path to make his little business "'boil my pot', and support my other work, even then."

xvi

Trying to photograph his baby sons, he found himself tearing down the curtains from his skylight and other windows; he threw out a terrifying flashbag device, he got a 3¼ × 4¼ Graflex so he could follow motion, he worked more and more outdoors, and became absorbed by the problems and the beauty, subtle and forever changing, of natural light. His "spontaneous" portraits, especially of children and dancers, became famous.

When change came to Weston, it nearly always took the shape of a woman. In 1912 or 1913, he met Margrethe Mather, also a photographer. He did not see her at first; to the first casual glance she looked mousy. Then he happened to look at her direct, and was stricken—she was exquisite. It was his first experience of the power of understatement; he fell in love with art and with Margrethe Mather at the same time, and for some eight years could not separate them. It was a strange and troubling love. She was elusive, disappeared for days where he could not find her, then suddenly on his doorstep would appear a drift of daffodils, with, on paper the delicate grey-green of acacia leaves, a note of some fifteen words—her attempt at the ancient Japanese poem-form called *haiku*. He made her his partner; she was so unpunctual he called her "the late Miss Mather." He complained that she was often slovenly and dirty, slopping about in men's shoes. Yet he still loved her, trying to overcome his natural distaste and achieve a height where "morals" didn't matter. Yet Margrethe with her burning curiosity about what was happening in art, music, poetry, thought and life brought him what he had never known before; "art", to him, had been something enclosed in a gold frame on a museum wall or in magazines on the family's parlor table. He hadn't realized it was happening to him. Even at the end of his life, he still felt much as he did in the Mexico years — that Margrethe was "the first important person in my life."

By 1914, Weston was becoming nationally and internationally known for his "high-key" portraits, striking tonal arrangements, imaginative use of natural light seen in soft focus. He demonstrated his techniques before national conventions of professional photographers; received numerous medals and prizes; articles were written about him, and many small one-man shows demanded of him. In 1917, he was elected — along with the Earl of Carnavon — a member of the London Salon, then considered the highest honor Pictorialism could give. In the same year, he found himself involved in the reaction against Pictorialism. Stieglitz and Steichen, leading the attack against the decadence which was corrupting the movement they, more than all others, had been responsible for launching, threw out all but 55 of the 1,100 entries submitted to the Wanamaker Salon in Philadelphia. Weston received minor honors; Sheeler and Strand the main prizes.

Weston was becoming sick of shimmer and simper and the human ego, including his own. He sought bolder structure, deep space, sharper seeing, a more

humble and objective approach to life."... One does not suddenly change. I never lost my excitement over a sharp, exquisite photograph. What to do with it was a problem from which I was sidetracked... I think success in the 'salons' got the best of me. Then articles by Rosenfeld, Tennant, Seligmann, about Stieglitz began to appear. Later by or about Strand. These shoved me in the right direction... That whole soft focus period in retrospect seems like a staged act; I even dressed to suit the part: windsor tie, green velvet jacket — see, I was an artist!"

His memory was usually accurate, and he remembered that he began the *Daybook* in 1917. Yet in the first bonfire he records, in 1925, "... one brave moment in San Francisco, three years of writing went into the flames." Much later, in 1931, he came across a page he saved from this holocaust, and he was proud he had saved it. It is a savage indictment of his pretenses as he saw them in 1920: "... Well I know you, Edward Weston, and I say you have spent a year of writing in trying to build up a fine defence around yourself and your work, — excusing your weakness! and yet, knowing all this, you are not strong enough to destroy most of your work, nor these notebooks." Did he then actually begin his *Daybook* in 1919? Or did he burn the first three years in 1920, when he scraped the emulsion off old prizewinning negatives and used the glass to make a window?

He ceased to send to salons and magazines; little or nothing appears, except in Mexico, for the next ten years.

Tropico was becoming Glendale, Glendale was being absorbed by the huge sprawl of Los Angeles. Weston was horrified by what was happening, and in his naïveté, easily accepted the post World War I cynicism about America and democracy which led many of the most gifted writers and painters to consider themselves "the Lost Generation," and go abroad to live. Weston tried it himself: around 1921, he met Tina Modotti, Italian-born beauty whose family had moved from Venice to Los Angeles when she was a child. She had acted bit parts in the movies, served as model to friends such as Diego Rivera and other painters in the Mexican Renaissance. She hit Edward like a tempest, and she had about her a magnificence and a nobility no one who knew her could ever afterwards forget. In March, 1922, Tina went to Mexico City to attend her dying husband. She took with her Weston's personal work; exhibited at the Academia de Bellas Artes, it not only roused enthusiasm — for the first time, it actually sold. Edward dreamed neither for the first time nor the last time, of making a living, not out of the human ego, but, like any good painter, sculptor, writer, out of the great images he knew were in him. He decided to go with Tina to live in Mexico.

At this point, the *Daybook* begins.

NANCY NEWHALL

xviii

"By the way I have already written my introduction. Here it is: How young I was. That covers everything."

E. W.

PART I

Fragments from early Daybooks

1. *Boy and Camera*

(One page from a pre-1923 Daybook, undated)

. . . denying myself every luxury—indeed many comforts too—until with eleven dollars in my pocket I rushed to town—purchasing a second-hand 5 × 7 camera— with a ground-glass and tripod! And then what joy! I needed no friends now— I was always alone with my love. School was neglected—I played "hookey" whenever possible. Zero weather found me wandering through snow-drifts— seeking the elusive patterns in black and white—which covered the ground—or sunsets over the prairie wastes. Sundays my camera and I would take long car-rides into the country around Chicago—always alone—and nights we spent feverishly developing my plates in some makeshift dark-room, and then the first print I made from my first 5 × 7 negative—a snow scene—the tightening— choking sensation in my throat—the blinding tears in my eyes when I realized that a "picture" had really been conceived—and how I danced for joy into my father's office with this initial effort: I can see every line of the composition yet— and it was not half-bad—I can only wish I had kept the print at least for memory's sake—and not destroyed it with many others in some moment of dissatisfaction. Months of happiness followed—interest was sustained—yes—without many lapses —is with me yet—

Last year I talked before the University of California on photography and part of my paper it seems may well be added right here—"I come to you as a photo-grapher—a craftsman I hope. My education was not from the public schools where I dreamed my hours away—but from my camera. Before it came into my life—I had drifted along mechanically—passing from grade to grade—by fair or unfair means—watching the clock for recess or noonhours or vacation time— taking home books for study and returning them still unstrapped the next morning. But suddenly my whole life changed—because I because interested in something definite—concrete. Immediately my senses of sight and touch were developed—my imagination keyed up to a high pitch—because—at last after years wasted—accidentally enough—it is sad to relate—I became interested—

2. Notes from N.Y. Nov. 1922

(copied before destroying daybook 1942)

Near the "penny bridge", a few steps from my room (Columbia Heights). Morning coffee with Jo from the purple cup sister gave me.

The Hurdy Gurdy man who played to our window.

The lone man who wandered by playing a softly quavering flute; 30 years ago I must have heard the same man in Chicago. "God bless you Sir for the money. I surely need it."

Almost daily I haunted the bridges, Brooklyn or Manhattan. One Sunday I walked over Williamsburg Br. at sunset—then down among the tenements on Rivington Street—memorable night.

Two "specials" from Tina, each with 20.00 enclosed: "knowing that (I) would need money, that (I) must see Balieff's *Chauve Souris*."

Other evenings riding the busses, once alone in a drizzling rain.

Stieglitz: we finally met. I phoned him and he promised to see me as soon as his mother died. She was sinking rapidly.

My report of our contact: "A maximum of detail with a maximum of simplification"; with these words as a basis for his attitude toward photography Alfred Stieglitz talked with Jo and me four hours, or rather he talked *to* us, for we had no chance, nor desire, to say much. He spoke brilliantly, convincingly with the idealism of a visionary, enforcing his statements by an ever repeated "You see, you see."

I took my work to show Stieglitz. He laid it open to attack, and then discarded print after print, prints I loved. Yet I am happy, for I gained in strength, in fact strengthened my own opinion. I was ripe to change, was changing, yes changed, when I went to New York. I had shown my portfolio of photographs all over New York, had been showered with praise which meant very little to me, for all the time I knew that I was showing my past. I seemed to sense just what Stieglitz would say about each print, albeit I did not always agree. So I was not disillusioned. Quick as a flash he pounced upon the hands in "Mother & Daughter" (Tina & Mamacita), on irrelevant detail in the pillows of "Ramiel in his Attic" (frankly, I did not always know what he was talking about), bad texture in Sibyl's neck. "Nothing must be unconsidered, there must be a complete release" was an often used thought.

But I feel that I was well received by Stieglitz; I could sense his interest and he did give some praise. "You *feel*, I can see that, you have the beginning; will you go on? I do not know. You are going in your own direction, it is good, go ahead." Stieglitz has not changed my direction, only intensified it, stimulated me—and I am grateful.

Stieglitz said that he used an anastigmat lens of 13 in. focus on 8 × 10 plates, stopped down to f 45 or more, that he used a head rest to enable him to give exposures of 3 or 4 minutes.

In my enthusiasm I do not accept Stieglitz as an infallible master, nor would he want me to. He said: "Friends made me out a god, when all I asked was to be treated as a human being, then turned on me when I couldn't be all they asked—and 291 closed. But I have been thankful to every person who has hurt me. There has been one who has stood by me through it all—a girl from Texas. You see her paintings here stacked all around this room, this room that my brother allows me—and one for O'Keeffe downstairs. I have nothing left, deserted by friends and wife and child—yet in no period of my life have I been so enthusiastic and interested in photography and anxious to work. Yes, O'Keeffe has painted and I have photographed, I will show you." Then he showed us a few of his photographs, perhaps ten; most were in storage. The hands sewing, the breasts, a rather abstract nude. "Ah, you do feel deeply," Stieglitz said, "and that little girl over there trembles with emotion" (as much from the barrage of words as from the photographs!—E. W.) "You will go away and tell of this meeting and some will say 'Stieglitz has hypnotized you,' but I have only bared to the world a woman's life. Every woman has her virginal moments, even a prostitute. I have tried to grasp such moments too. The struggle is to live and express life untouched by the ideas of neighbors and friends. After all we only know what we feel, and I have been unafraid to say what I feel. You see that in my work. I have broken every photographic law, optics included. I have put my lens a foot from the sitter's face because I thought when talking intimately one doesn't stand ten feet away; and knowing that it takes time to get deep into the very innermost nature of matter, I have given exposures of several minutes stopped way down. You see my prints, the eye is able to wander all over them, finding satisfaction in every portion, the ear is given as much consideration as the nose, but it is a task, this desire to obtain detail and simplification at the same time. To make your subject forget a headrest during such long exposures is heartbreaking. If you had come to me four years ago I should not have been ripe to give you what I do now." Nor I ripe to receive it.

Returning to remarks on my work I quote Stieglitz: "I like the way you attack each picture as a fresh problem, you are not formulated. This is very interesting, and this the first complete failure you have shown. There must be an absolute release, nothing left unconsidered. But I will show you! I see you are not satisfied.

5

You do not think that you are great do you?" Then with a laugh, "I don't think that I am. This print has fine dignity. Treat anything you undertake with dignity, a portrait or a box of matches. If I were publishing *Camera Work* I would ask you for this breast, these torsoes and these smoke-stacks. My last message to you is work, seek, experiment." So ended our day with Stieglitz.

Several days later, and I am still reflecting over the very important day with Stieglitz. His work: solid, nothing neglected, nothing indefinite or wavering, "a complete release." But without minimizing the praise I have bestowed on his work, I think that Stieglitz exaggerates the importance of several portraits he showed. I feel that some of mine are just as important in their way. I have a problem to work out; to retain my own quality and values, but achieve greater depth of field.

––––––

My days in New York were nearing an end. My greatest desire was to see Stieglitz again. Then: "Rhinelander 8893 — Mr. Stieglitz? — yes, this is Weston. I would like to see you again but hesitate to ask for more time." — "I am glad you called, in fact expected you to. I told O'Keeffe about your work, please bring it with you."

A Mr. Seligmann was there when I arrived. O'Keeffe responded in much the same way that Stieglitz had, in fact made almost the same criticisms. "This is a fine head." "He is one of my closest friends: Johan Hagemeyer." "Yes, I remember him. This breast, is perhaps the most complete thing you have." (25 years later, I know that this photo was full of striving for effect, sensational, one of least important prints I showed). These stacks too are very fine, they remind me of the paintings of... (can't remember name) do you know them?" I did not.

My audience of three was pretty merciless, yet withal giving me due credit and sufficient praise. Seligmann, silent during the showing, turned and said "I want you to know that these pictures have meant something to me." And Stieglitz' final message, "Weston, I knew from your letters you were sincere. I have tried to give you freely. Your work and attitude reassures me. You have shown at least several prints which have given me a great deal of joy. And this I can seldom say of photographs. Goodbye and let me hear from you."

––––––

"Times Square at noon Jo. I have made a date with Sheeler." Stieglitz looking at my steel works photos had said "You should see Sheeler's work," and then in same breath "No, it is not necessary." But I concluded to go — and am very happy that I did. His photographs are a remarkable "portrait" of New York, the finest architectural photographs I have seen.

While with Sheeler, Paul Strand dropped in. We accepted an invitation to see his work. It was splendid, very much under the influence of Stieglitz, but a

worthy carrying on of the master's tradition. I shall have more to say in retrospect.

But it grew late and train time—we took our last bus ride from Washington Square to Grand Central. Good-bye New York, good-bye Jo. I shall not forget.

In 1942 Weston wrote: Evidently much writing of this period has already been destroyed. I can't find the account of the visit with Strand nor with Sheeler. I do recall that I found too much of Stieglitz in Strand at that time—quite understandable. And I remember that I was deeply impressed with Sheeler's photographs of New York, by far the best I had seen of that city. E. W.

Excerpt from Daybook, which Weston marked for omission:

Stieglitz said: "Weston, I asked Paul Strand if he knew of you. He said 'Yes, your work was no good.' Now Strand is very close to me, in fact no one is closer, but I took him severely to task for an unconsidered sweeping statement, and let him know how I felt having just seen it. He then admitted having seen only a few reproductions. Strand theorizes, does not work enough."

Chicago: Aunt Emma, Uncle Theodore, and the old home—mine too for a while—at 2213 Washington Blvd; it had gone to seed, a forlorn shadow of the past. I was still "Eddie" to the old folks, I must wear this or that, be in by 12, eat, drink, read as they do, vote Republican straight. But they had not lost their sharp tongues nor dry humor and they did everything in their own way to make me comfortable.

Aunt Em took me to the Chicago Opera Co. *Aida* was playing. I was bored; over all was a veneer of money; it was artificial, but not with the frank, gay artificiality of the *Chauve Souris*. A few voices being exploited, with the same old tunes. How can these people listen year after year! Once I got a slight thrill from a duet between Raisa and Marshall; but most of the time my thoughts went back to a haystack by Monet, sailboats by Manet, a landscape by Cézanne, and a drawing by Charles Sheeler of New York skyscrapers. These in the Chicago Art Institute. I regret to say—but only because of Aunt Em—that once I went to sleep.

Chicago was an anti-climax to New York except for a few fine contacts. Carl Sandburg took me to a tiresome party for which he apologized profusely; and I had a happy afternoon with Eugene Hutchinson and another with Mrs. Bertha Jacques via an introduction from Roi Partridge.

I went to Chicago Camera Club—and left without opening my portfolio. And here I had better wind up by telling the story of getting to New York, the why and how.

7

I had gone to visit sister May and John and family in Middletown, Ohio, prior to sailing for Mexico—a farewell visit for which John sent money. Well John and May got their heads together, decided to help me on to New York since I was already almost there, and might not have such a chance again.

The Middletown visit was something to remember with auto drives through the hills and dales of Miami Valley, all resplendent in autumn colors, and over the river into Kentucky, to Dayton and Cincinnati too. But most of all in importance was my photographing of "Armco", the great plant and giant stacks of the American Rolling Mill Co. That day I made great photographs, even Stieglitz thought they were important! And I only showed him unmounted proofs.

(Editorial comment: 20 years later they still look good—Edward Weston) The reunion with Sis and family was all and more than I had hoped for. John's interest in my work was outstanding and deeply appreciated by me. It was his desire to help me on to New York.

———————

Once more destruction enters in to cut short the visit with May in Ohio. Why, I can't remember.

3. Discussion on Definition

April 20, 1923—Glendale, California. Johan is here—has been here for over a week—Days and nights of intensity—burning discourses on many topics—of course mostly photography!

Johan brought new work—fine industrial things—nicely seen—but lacking in definition—an inexcusable fault when it comes to photographing modern architecture and machinery—even the "mood" could be better interpreted with sharp—clean lines—"-But if I see things this way—Edward—I must render them as I see them" — "Nevertheless—Johan — photography has certain inherent qualities which are only possible with photography—one being the delineation of detail—So why not take advantage of this attribute? Why limit yourself to what your eyes see when you have such an opportunity to extend your vision?—now this fine head of your sister—if it was focussed sharper you would have expressed your idea even more profoundly—Here is a proof (Bertha Wardell) which may explain what I mean" — "By God! I do see now—in this case at least—that a more clearly defined—searching definition would have unveiled and exposed the very suffering and strife I have tried to portray — but in some other prints I show you—it seems almost necessary that there should not be so much revealed—however in the portrait under consideration I realize that I skimmed over the surface and did not penetrate as I might have—I do not accept—swallow—what you say as a whole—but I have gotten something from the talk which makes me see more clearly and will make me surer of what I wish to do—Let me question again—if in a certain mood why should I not interpret that state through my picture and not merely photograph what is before me?—in such instances the use of diffusion would aid me —"

"Yes, it would aid you—to cloud and befog the real issue—and prevent you from telling the truth about the life towards which your lens is pointing—if you wish to 'interpret' why not use a medium better suited to interpretation or subjective expression—or—let some one else do it—Photography is an objective means to an end—and as such is unequaled—It comes finally to the question: For what purpose should the camera be used?—and I believe you have misused it—along with many others—including myself!" And so—on we went pro and con – – –

April 25 Quiet again—Johan beat his way north on Monday—I am glad to be alone—we love one another—but wear each other out — I really believe we would finally quarrel if thrown together too many succeeding days—I gave him

a print of my "Stacks"—"I have never before demanded a print from you Edward—but I must have a copy of that"—He would return again and again to it—"It is a thing I wish I had made—but I'm glad you did it for me to enjoy—for I feel I *could* have done it."

Together or with Tina or Margrethe — sometimes all four of us — we spent many vivid hours—at Stojana's—the Philharmonic—once an evening with Buhlig listening to his reading of that amazing poem *Waste Land* by T. S. Eliot—and looking over Billy Justema's drawings—listening too—to his reading—That night it rained—and returning to the studio still keyed to adventure—we donned old hats and walked into the rain—I took him to the river—winding our way among the dripping willows—around us the silence of hours past midnight — Bedraggled and drenched we reached home—but thrilled with the beauty we had had—

After the Philharmonic we desired a corner to sit and smoke and sip coffee—but to the shame of Los Angeles could think of barely a place but deadly respectable ice-cream parlors with smug people—sickening sweets—noisy clatter—commercial haste—and most likely bad music—

Margrethe ever curious had heard of a Greek coffee house near Los Angeles Street where sailors gathered—there had been a murder committed there and fights were a nightly occurrence—So we went—and though not favored with a murder or fight had a sufficiently exciting night—yes a fascinating night—

A room full of sailors with here and there a collarless nondescript—but mostly those not in uniform were that type of effiminate male who seek the husky sailor to complement their lacking vigour—One such fastidiously-dressed — unmistakable person—presented to us a most lascivious picture of impatient desire—his foot twitched continually—his whole body quivered—his lips fairly drooled—until finally with several others of his kind—a bunch of sailors were "dated up" and off they went in a limousine — Sailors danced together with biting of ears and open caresses—some sprawled over their tables down and out—every one had a bottle on the hip—while an officer of the law amiably overlooked his opportunity to enforce the 18th amendment—

A negro droned on the saxaphone—or "sexaphone" as Margrethe calls it—another picked the banjo—the four or five waitresses watched their chance to pocket tips or pick the pockets of drunken "gobs"—one sailor prize fighter reeled to our table loudly confiding his troubles—the quarrel he had "with that 'gold digger' over there"—had us feel his muscles and related his life history—

Margrethe was the only girl in the place besides the waitresses—But we were too differently dressed—too conspicuous and I wonder we did not land in the street —I should like to go again under different circumstances.

10

PART II

Mexico, August, 1923 — December, 1924

1. "Romantic Mexico"

August 2, 1923. Tina, Chandler and Edward on board the S. S. Colima, *four days out from Los Angeles.* At last we are Mexico bound, after months of preparation, after such endless delays that the proposed adventure seemed but a conceit of the imagination never actually to materialize. Each postponment became a joke to our friends and a source of mortification to us. But money had to be raised, and with rumors of my departure many last moment sittings came in, each one helping to secure our future.

Nor was it easy to uproot oneself and part with friends and family—there were farewells which hurt like knife thrusts.

But I adapt myself to change—already Los Angeles seems part of a distant past. The uneventful days—the balmy air has relaxed me—my overstrained nerves are eased. I begin to feel the actuality of this voyage.

The *Colima* flies a Mexican flag, she is small, not too clean and slow—yet I would not change to a more pretentious ship, noisy with passengers from whom there might be no escape. The crew, all Mexican, is colorful and inefficient according to our standards—but it is a relief to escape from that efficiency which makes for mechanized movements, unrelieved drabness.

On board is an Australian sea-captain, a coarse, loud fellow, who continually bellyaches over the dirt, food, service—he goes purple when a waiter's coat is unbuttoned, discounts the whole crew as ignorant, beneath contempt—yet he is the one who suffers by comparison. The Mexicans, at least, have an innate fineness, and they are good to look upon.

Yesterday the sea was rough, the *Colima* pitched and rolled—Tina sick, pobrecita! In contrast, the night before, our ship cut through silent, glassy waters domed by stars—toward what unknown horizons? A night of suspended action—of delayed but imminent climaxes—anything might happen—nothing did.

August 4. A half-moon half hidden by heavy clouds—sculptured rocks, black, rising from silvered waters—shriek of whistle and rasp of chain; 1:00 A. M. and we anchored in the harbor of Mazatlán, my first foreign port.

Morning—and we excitedly prepared for shore. Thanks to Tina—her beauty—though I might have wished it otherwise!—el Capitán has favored us in many ways: the use of his deck, refreshing drinks in his cabin, his launch to carry us ashore.

13

Did I visualize what I was to see in my first Mexican port? This is hard to say today—seeing, with stranger's eyes, a stageset: blocks of low houses—a continuous wall of alternate pastel blues, pinks, greens. Down narrow streets Indian boys drove heavy-laden burros; around corners appeared vendors of water or chickens—a half-dozen hanging head down, their legs crossed over a pole, all peeping dolorously.

Street stands sold tropical fruits—some new to me and delicious—for instance, the mango is truly nectar. Aguacates—avocados—sold for 5 centavos! There were vehicles for hire, two-wheeled carts and low-swung coaches. In one of these, drawn by a span of horses—decrepit ones I must admit—we drove along the coast at sunset.

Later, exploring the city streets at night, we found life both gay and sad—sharp clashes of contrasting extremes, but always life—vital, intense, black and white, never grey. Glendale, on the contrary, is drab, spiritless, a uniform grey—peopled by exploiters who have raped a fair land.

Often the barred windows framed lovely black-gowned señoritas—and some not so lovely.

Leisurely drinking ice-cold beer in the patio of Hotel Belmar was a fitting prologue to our first day in Mexico. Later we were introduced to Mexican hospitality when we met the captain at noon "for a cocktail". The party grew from four to a dozen—the drinks progressed from cocktails to tequila straight—Strange how one can understand a foreign tongue with tequila in one's belly.

August 6. Sailing again after two days in Mazatlán.
We did not go ashore again—too hot! Water has poured from my body in rivulets—never before have I perspired so profusely—nor so dishonestly loafed dreamy hours away (this thought reveals my New England background!)

I was tempted in Mazatlán to "go tourist" with my camera, making "snaps" of street scenes—even doing Tina in her grand coach backed by a ruin.

But yesterday I made the first negatives other than matter-of-fact records—negatives with intention. A quite marvellous cloud form tempted me—a sunlit cloud which rose from the bay to become a towering white column.

Mazatlán becomes more vivid in retrospect: I recall cool patios glimpsed from sun-baked streets which sheltered coconut palms, strange lilies, banana trees. I see the cathedral, with its crude Christ, horribly real—and the dramatic devotion of those who come to pray, some sprawled in abject penitence at the entrance before raising their eyes to the glories within.

In the cool twilight hour children danced in the streets—as our carriage approached, they stopped to see the extranjeros—foreigners.

August 8. Three days since leaving the boat. Before dawn we had anchored in the harbor of Manzanillo—by eleven, we had passed the customhouse officials,

14

though not without much palavering, suspicious glances at my battery of lenses, chemicals and personal effects, which Ramiel [McGhee, a close friend] had packed so well that I despaired of ever getting the trunks repacked before train departure.

But there was time to spare, so we wandered the streets escorted by el Capitán, ever attentive. As we sat with our beer looking out to the bluest of seas, a sailor from the *Colima* passed, hesitated, returned; saluting his captain he requested permission to order us drinks. A wandering trio of musicians passed—were hailed by "our" captain—played *Borrachita*—slightly tipsy. My Anglo-Saxon reserve was put to test—and lost. But it was more than the music—the hospitality—the blue sea—which broke my resistance: I knew that this day marked an end — and a beginning.

August 20. Avenida del Hipódromo 3, Colonia Nápoles, Tacubaya, México, D. F.— about 40 minutes by trolley from the city. We have leased an old and beautiful hacienda for six months; ten rooms, each opening onto a spacious patio, 85 × 100 ft., filled with vines, shrubs, trees. The house is of brick with high ceilings and tall arched windows, barred, heavily shuttered, seeming to suggest possible attack. The first night there further stimulated the imagination; I was awakened by gun fire under my very windows — then silence, not even audible foot-steps. Well, I did not come here for the ordered calm of a Glendale.

The brick walls of our casa are fifteen inches thick, and plastered in and out. The last occupant had papered the rooms with hideous results, and I, curses be, have been laboriously removing it, while the landlord stands by aghast.

Evidently the middle-class Mexican has no better taste than the middle-class American; the store-windows bear me out with a conglomeration of the most tawdry rubbish imaginable. When the Mexican apes the American he acquires his worst side; and, of course the reverse is true, recalling Mexican or "Spanish" type homes in California. Here, the new architecture is "Hollywood" burlesqued, incongruous beside the beauty of passing culture.

But the past still dominates; old churches stand like impregnable fortresses — quite apart from the new and superficial life which surrounds them. La Catedral is majestic, impressive when its great bells are tolled. "El Zócalo," the square in front, is out of keeping with its bad contemporary sculpture. Nearby two urchins played around a fountain graced by a vapid Venus; impulsively one turned, embraced her, kissed her stony lips, and laughed mischievously.

Beautiful women seem rare—maybe they do not walk the streets—and those of the upper-class dress in execrable taste. Maybe I expected shawls and mantillas! Of course, I except the Indian in native costume, both men and women. Often, they are very beautiful, have poise and dignity. Dregs of humanity are on all sides; maimed, diseased beggars pleading insistently.

15

The pulquerías — bars — in which the Indian finds solace for his lost glory are the most colorful notes of contemporary life in the city, and the following titles evidence the Indian's romance and imagination.

"Sin Estudio"	Without Thought
"La Primavera"	The Springtime
"Un Viejo Amor"	An Old Love
"El Gato Negro"	The Black Cat
"Las Flores"	The Flowers
"La Camelia"	The Camelia
"La Dama Blanca"	The White Lady
"La Esperanza en el Desierto"	Hope In The Wilderness
"Sobre las Olas"	On The Waves
"La Perla de la Piedad"	The Pearl Of Piety
"El Asalto"	The Assault
"La Muerte y la Resurrección"	Death and Resurection
"Las Primorosas"	The Beautiful Girls
"La Gloria de Juan Silveti"	(Juan Silveti being one of the popular toreros)

Imagine American saloons with such names! Perhaps, if they had had them, we should never have voted the 18th Amendment. That the Indian also has a sense of humor, I concluded from the following inscription noted on a mulepower truck — "Viva el Rápido" — Hail to the Swift One!

Getting established, starting life over from the ground up is not easy, especially lacking money, and with desires none too easy to please. Furniture has been a problem, that found in the average store expensive and hideous, fine examples of the best "Grand Rapids" style, highly varnished, crude and pretentious. Dishes and other details were equally hard to find until "El Volador," the thieves' market, was suggested. There we found every imaginable article to suit any extreme of taste; returning with Puebla ware for both food and flowers, imperfect pieces and modern, of course, but fine in form and color. We also purchased a couple of brass candle sticks at two pesos each, and an old inlaid chest which Gould's in Los Angeles might have sold to some three chinned dowager for a hundred dollars — this, after much bargaining on Tina's part, was ours for fifteen pesos. And, oh yes, the string of eighteen amber beads — lovely uncut ones, half-hidden in the clutter of an old Italian's stall — was purchased for two pesos!

August 23. Will we ever get established! Such confusion! Painters and plumbers at work trying to please the new arrivals. Such dolts!—Labor, too is the same everywhere—the workmen take their own time; one becomes impatient to no avail. "Bolshevism," remarked our landlord, "has spoiled labor in Mexico. We are a conservative people. We do not want it."

The painters, I am sure, think us "loco" preferring, as we do, the crude beam ceilings to the fake painted canvas which hid them. Our friends, too, think us slightly off for moving so far from the city and expecting our clientele to come

16

out. They are dubious as to the outcome of the venture. Well, surely now I have not come way to Mexico to open a commercial studio on "Main Street" — better have remained where I was! I hardly dare look ahead. Yet—I shall not worry; we may surprise our questioning friends.

A few days ago, Tina took me to see the work of Diego Rivera, murals for a public building. Later we met him. It was the work of a great artist which we viewed; and he was great in another way, tall and of generous girth — a striking figure! I regret not being able to converse with him for he has lived among the foremost contemporary artists in Paris, Picasso, Matisse, and others and he must know anecdotes.

After the inspiration of Rivera and his painting, I received a severe let-down. We went to Sanborn's. What was once a marvellous palace of blue tile has been redecorated, turned into a typical American restaurant.

The murals of Diego Rivera have raised a storm of protest from the conservatives, but the work continues on. I cannot imagine his having the opportunity to start such paintings in any American municipal building. Government "of the people, by the people, and for the people" does not foster great art. However, there are flagrant examples of municipal bad taste all over Mexico City. Statues to every sort of hero abound, line the Paseo de la Reforma, and dot the Alameda; gilded statues, some as vulgar as our own Goddess of Liberty. So, after all, middle class minds and apirations are the same everywhere.

Llewellyn [a pupil] is here, at last, with his police dog, Panurge.

Recounting his trip—brings back my own: The unforgettable train ride from Manzanillo to Mexico City, and those beautiful cities, Colima and Guadalajara. I should like to have lived a while in Colima, but we spent only one day in each place, just enough to excite our fancies. These cities were less spoiled than Mexico City, the natives more genuine.

From Manzanillo to Colima was a touch of the tropics, luxuriant vegetation with stretches of tangled vines, dense growth amounting to a jungle. The Indians sold strange and delicious fruits at every stop — the mango, fresh coconuts and bananas, aguacates, sugar cane. In these foods I indulged — they seemed safe enough — but, tempting as they looked, I hesitated over the tamales and other steaming dishes and sweets. Later I learned that the tamales were not chicken as advertised but iguana, the giant lizard — well, why not? A tender iguana might be more palatable than a tough old hen!

We wandered through the streets of Colima after a well-cooked savory repast. It was there we met little Carmen; she sat on the cement walk, leaning against a pillar under long corridors of arches, in front of her a tray of pumpkin seeds. She dozed, awakening now and then to dish out automatically a dozen seeds or so for un centavo. Again, her heavy lids would droop, once more her pale profile would assume its tenderly poignant outline in the flickering torch light. Tina wanted

her. "Will you come with me, Carmen, to Mexico? You shall be my little sister." Carmen's eyes dropped, this time with a shy, almost frightened hesitancy; we must ask her mamma who would soon return.

The mother had evidently been discussing the strange visit and request of the foreigners; she was belligerent, but softened when we gave presents to Carmen, a fan, a jar of jam, and other dainties. "She is all I have — and then she is sick — chills and fever — we cannot cure her — no — her father would never let her go." So we waved farewell to Carmen.

The plaza with its formal trees and arrangement might have been European; it was there the vendor of spikenard passed, an old Indian, barefooted, grey-bearded, carrying spikenard with yard-long stems. Tina should have one; it would complete her own loveliness, but we must bargain — everything is bargained for — even the romantic and beautiful. Finally, after prolonged arguing, the price was reduced from fifteen centavos to ten, but to pay him we found only an American dime! He looked at it suspiciously and another long palaver only half assured him that the dime was worth twenty centavos Mexican. He parted with the "nardo" and we with twenty centavos instead of ten! So ended fifteen minutes of bargaining with the laugh on us; but Tina had her spikenard.

Approaching Guadalajara, there was unfolded a breathtaking panorama — acres of water lilies along the tracks and stretching into the distance — pale lavender hyacinthine stalks — I called them "water hyacinths" for want of a better name.

August 27. We have been out but one evening since our arrival, that with [Roberto] Turnbull, a Mexican cinematographer, but very much Americanized. He took us to La Tapatía, a place famous for its cooking where "down and outs" rub elbows with Senators — Again a delicious meal.

I have yet to eat a poorly cooked dish in Mexico, and, too, they are reasonably priced, unless one wishes the privilege of gazing on the atrocious murals at Sanborn's. Then one pays, and doubly! The other day, for instance, a six course meal: soup, eggs, fish, two meats, pineapple and coffee, cost us $1.25 — less than 65¢ American.

So far, I have concluded that averaging up, living is less here than in Los Angeles, counting two pesos to the dollar; all will be well then if I can earn twice as many pesos as I did dollars.

The panchromatic films show deterioration; several negatives I discarded as hopeless, all show some fog and grain. However, most of them will be printable, and my one great hope, the towering white cloud at Matzatlán, though also deteriorated, will, I believe, admit of enlarging.

August 29. A month since we left California — and not once since the evening at La Tapatía have we had energy or opportunity to see the city after nightfall.

18

In fact, except for the train trip and what I can gather from this secluded retreat I do not know Mexico much better than when living in Los Angeles!

The tile roof to what once was a cowshed is a fine vantage point from which to view the country. Stone steps from the patio give easy access to the roof. Field after field of maize bounded by adobe walls stretch away towards distant mountains always banked by magnificent cloud forms. On clear days, I have seen snowclad Ixtaccíhuatl and Popocatépetl and usually the spires of la Catedral are visible. The castle of Chapultepec is near at hand, and, incongruously out of place, an occasional factory chimney blots the landscape.

Tina and I had a date with Rivera for Monday evening. He was unable to keep the appointment, so Guerrero and his lovely sister, Elisa, substituted for him. We dined at another typically Mexican place known for its good cooking and low prices—Monotes. The artist evidently haunts Monotes, the walls being decorated with humorous, grotesque, and Rabelaisian drawings.

Elisa is a fine Indian type; dressed in the costume of her native state she made a charming picture. Elisa spoke some English, more than I did Spanish. "Next time," I said to her, "I'll bring my dictionary." "When," she asked me, "will you bring the dictionary?" So now I have "una cita" for Thursday — my first "date" in Mexico!

Llewellyn's piano just came, he plays, trying it out. I have wanted music; I find it hurts. I feel singularly like an exile at times, as though I were here not altogether voluntarily...

After Monotes, we walked to *La Catedral*. Every inch of the facade of el Sagrario is elaborately carved, but held together—wrought into a perfect whole.

It pours! A deluge! Every day at 4:00, or so, the rain comes, and often in the night. I like the climate, it is cool, bracing. I sleep under three blankets but never shiver upon rising, nor wish to hover over a fire for a while as I did in Los Angeles. Neither do I back away from my morning cold bath, it is actually enjoyed.

If this, or equally agreeable weather, persists the year around, I cannot imagine a finer climate—and, because of the kaleidoscopic heavens, the play of light and shade over the landscape, monotony is precluded. I found the unvarying sky of Southern California more trying than the lack of decisive seasonal changes.

One attribute of the climate I have not enjoyed — *las pulgas*! The fleas have literally attacked me from all sides — and Chandler too — nothing seems to stop them. I believe they eat and fatten on the powder with which I sprinkle my bed. Guerrero laughs — tells Tina and I that we will become acclimated!

I am to have one of my dreams fulfilled — a whitewashed room; the furniture shall be black, the doors have been left as they were, a greenish blue, and then in a blue Puebla vase I'll keep red geraniums!

Hard work this reconstruction—we are all weary, and inclined to pessimism.

My hands are blistered, my back aches, my lungs are tortured with calcimine dust. The reaction comes when I contemplate that all this effort may come to naught.

August 31. Last evening, armed with my dictionary, I kept the appointment with Elisa. We dined at La Tapatía. I glanced at the menu, then shuttinmg y eyes, let fate decide the order. My finger pointed out pozole which with pollo — and tender chicken it was — provided a most delectable repast.

Elisa wishes to learn English, and I, Spanish, so discounting other desires, our mutual aim should provide many a pleasant evening. Just how the subject arose is difficult to recall, but Elisa taught me to say "Yo te amo" — and since she already knew the English "I love you," I taught her "Ich liebe Dich"! We parted early — "You have far to go and los ladrones – footpads – are bad" — "But I have a pistol!" — "No — no — for they are three — adiós — I give you un clavel blanco — a white carnation — have I satisfied you?"

September 1. The studio room finished at last. Walls light grey, doors and windows in their original green-blue, floor darker grey, on the walls a few prints — Picasso, Hokusai — and one of my own photographs — the "Smoke-Stacks" of course — in one corner a blue vase holding red flowers, for furniture two black colonial chairs, the new "old chest," and an inoffensive book case. Temporarily, my cot fills one corner — the room is so large, the furnishings so few — over it thrown an old piece of wool cloth, brilliant in color, flower patterned – probably it is Spanish. Tina acquired it for a song from Cesare, the old Italian in El Volador.

A deluge of rain swept over the building as I prepared for the first night in my completed room. The lighning dazzled, water gushed from the spouts, fell from the roof in sheets. Bare-foot, kimono-clad, Tina ran to me through the rain — but something has gone from between us. Curiosity, the excitement of conquest and adventure is missing. "Must desire forever defeat its end?"

September 13. We must move! — leave our beloved "El Buen Retiro". After two weeks of suspense and anxiety, we received the final verdict — "no telephone." Somehow, I had a presentiment that our efforts here were to be in vain, and so it has proved. A telephone is necessary. I am a "business man" and cannot stick thumb to nose in the direction of my public. How fortunate seems the writer with pencil and pad and any old corner for shelter — or the painter with a few brushes and tubes of paint!

Well, much money has been spent and time lost, the proposed date for my exhibit at "Aztec Land" is drawing near with work to be done and no place to work. Tina and I spent all day house-hunting, finding two possibilities but nothing so lovely as this hacienda which already seems like home — the most charming spot I have ever lived in.

20

Too, it has proven a wonderful place for work, indoors or out, with innumerable windows and doors and walls. I have photographed Tina — Chandler — Llewellyn and Elisa — two of Tina's I shall include in the exhibit — one of Chandler — three of Elisa. The pictures of Tina, excepting one sophisticated figure in black tailored suit, ebony cane, seen through a doorway against my high white walls, all but this one belong to a "romantic" school not altogether in keeping with my present frame of mind nor attitude towards my work.

I should be photographing more steel mills or paper factories, but here I am in romantic Mexico, and, willy-nilly, one is influenced by surroundings. I can, at least, be genuine. Life here is intense and dramatic, I do not need to photograph premeditated postures, and there are sunlit walls of fascinating surface textures, and there are clouds! They alone are sufficient to work with for many months and never tire.

September 15. Today, we found our future home — in a fashionable neighborhood this time, within walking distance from the heart of Mexico City, Lucerna 12, Colonia Juárez.

I dread the change, no place seems possible after "El Buen Retiro." The new house is a mansion by comparison: It has recently been re-decorated and re-papered with appalling results. It hardly seems possible that these people are not actually trying for ugliness. The only inoffensive rooms are the servants' quarters. How we all fight for them! If he knew, our landlord would be amazed, or amused.

The rent is an item which worries me — 260 pesos a month — a sum to make any craftsman ponder. To one who has never paid rent, this amount sounds impossible, but no such house could be obtained in Los Angeles for 130 dollars — nor anywhere near. Aside from business, I realize several advantages: we four shall not be isolated here night after night, thrown together continually to the point of irritation. We shall be able to see more of Mexico — the city — its life and activities, and meet our friends without such an effort.

This house-hunting has indicated a certain unconcern on the part of the Mexican people as to the personal relations of our unusual party. Not once have we been questioned as to why Tina Modotti and Edward Weston were living together, nor in the hotels has there been once an impertinent query. Viva México!

September 20. ... Sunday afternoon de la Peña came to renew his acquaintance with Tina. Last year he had purchased one of my prints of her at the exhibit in La Academia de Bellas Artas. Negatives of Tina have proved a profitable investment! He talked of his experience during the revolution; condemned to death by both sides, each thinking he spied on the other. He dyed his hair yellow and otherwise disguised himself, pretending to be a Belgian who spoke only French, and went abroad in the city for a year undiscovered, before escaping to America.

21

"Do you think there will be more outbreaks, or are troubles settled?" I asked —
"Next year at the presidential election there will be renewed fighting," he said.
"I hope so anyway — we miss the excitement — it was great fun." Then, with
another chuckle, "You know, only two Mexican presidents have lived through
their terms!"

We talked of Mexican music, which led to Spanish influence. "The Spaniards,"
said de la Peña, "were an uncultured race before the advent of the Moors; all
their civilization, arts, music, architecture, they owe to the Moors. Come, let
us walk to my home, I will play for you typical Moorish music, also a waltz
which might have been from Chopin, composed by a Mexican before Chopin
was born."

10:30, and the streets were already deserted. "There seems to be no night life
in Mexico. Where are all the people?" I asked. "They are busy inside," was the
laughing reply. We passed a little cafe. "I have not dined. Will you join me?"
queried de la Peña. "Frijoles refritos con queso y cerveza para cuatro – fried
beans with cheese and beer for four," he ordered. Into the bright night of a
Mexican moon we strolled once more. Only the inevitable dogs were abroad,
some skulking, some yapping, some friendly, a sorry lot — crippled and diseased
and starving like the beggars.

"What a night!" I invariably exclaim — for Mexican nights are bewitching.

De la Peña served us anise from Spain and black cinnamon coated cigarros. With
music and anecdotes the hours passed — a happy night indeed — except for the
fleas! — and, shall I confess? de la Pena's obvious infatuation for Tina! — Yet
should I be a "dog in the manger"? Next time I'll pick a mistress homely as
hell!

September 23. Fairly well established on Calle Lucerna. Best of all, the printing
room is ready for use thanks to Llewellyn. I have tried out the roll of W. & C.
Palladio [Willis and Clement Palladiotype — printing paper imported from Eng-
land. See appendix on technique] which I brought along and find it has not
deteriorated. Printed a negative of Chandler — little figure seated on the wall to
our "cow-shed" — against the sky of an approaching thunder storm — my first
print to be signed "Mexico, D. F." Also tried one of the Elisa negatives — Tehu-
ana costume. A fine, strong face is recorded, an Indian face. Will she like it, or
will she wish to be pretty?

Elisa is romantic — but I think unsophisticated. "Me gusta la música y las flores,
nada más." Are you sure, "nada más," Elisa? — for I recall one evening not
long ago, a perfumed evening, the wind fragrant from mosqueta bloom, the
moon with its halo of orange, when Elisa displayed desires other than those for
music and flowers.

We climbed to the roof that night, up the stone steps from our patio. Over the
distant city, blazing parachutes festooned the sky, bombs burst incessantly,

22

flaring rockets died with a shower of stars. From a nearby pulquería — music, laughter, festive noises, a nation celebrating its independence day, El diez y seis de Septiembre —

"I am going away soon," said Elisa. "Indeed! — why, Elisa — I shall weep." "Yes, Weston, I go to be married. I do not love him but I want experience — the experience of marriage. He is American and loves me very much. If I do not like, I go home to my mamma."

I ponder; if Elisa wants experience only, marriage seems a roundabout way. But should I become involved at this critical period? No — it must not be.

The next moment a soft hand, a sigh, an averted face — all is lost — our lips meet. Approaching footsteps, and the breathless instant is over.

Last week I wrote Margrethe to ship my old studio camera. I am dubious as to whether I can depend on her for even this important task. With no word from her since leaving Los Angeles despite urgent requests for certain negatives, I seem to have lost all contact with her, and am now in a mood of complete indifference.

From sister came a message of faith in my success — from Flora words of regret over the past — from the little boys dear tender scrawls — and from Ramiel the most beautiful letters of my life. He alone from out of the potpourri of friends and acquaintances has emerged a definite clear-cut figure from whom I cannot part — Ramiel! keenest of my critics, tenderest and most understanding of my confidants!

October 4–5. Have enlarged the great white cloud of Mazatlán. What a picture it might have been but for the film's deterioration! I have spent hours and many plates trying to improve its technical quality in the negative. Despite this loss in quality, it will be one of my finest and most significant photographs.

October 5. Night noises fascinate: in the still dark hours of wakefulness, a resulting intensification and magnification of one's hearing keys the imagination to an acceptance, an understanding or, at least, a conjuring with the impossible, the abnormal. So, with more prosaic daylight, with logic and common sense in authority, I question quite philosophically that which in the night brings free play to my most excessive fancies. Like an accompaniment to the half heard music of some eerie dream, faint, but clear and persistent above the raucous rooster and barking dog, quavers and trills a tiny whistle, from the distance another answers, and yet another, three notes, reed-like, flute-like, night after night. I listen and wonder. In the morning, I do not ask, afraid to destroy my mood.

Later in the week, I could not resist questioning. De la Peña told me that I heard the whistle of the Mexican police, a whistle retained from centuries back, when,

as in the days of Pepy's England, the night watchman, lantern in hand, made his round from street to street, calling out the hour, the weather, and "all's well."

October 6. Sunday, Xochimilco. The beginning to our day's adventure had its humourous side; Tina, Llewellyn, Chandler and I, loaded with cameras and lenses and tripods standing on Bucareli and Lucerna, awaiting the first Ford marked "Listo"—free for hire. It came, and in quick succession half a dozen others, the drivers of which having noted our apparent desire, drew up in long procession to take their turn at bargaining. One by one they left until the sixth capitulated, accepting Tina's offer of three pesos and no more.

The ride to Xochilmico was one to remember. The Mexican sky, always dramatic, presented a surpassing spectacle. Gathering rain clouds, gold rimmed, massed against intense blue; straight ahead rose Ixtaccihuatl, "The White Woman," higher than the highest cloud, dazzling and splendid in the sunlight. Impossible to believe this October! — the springlike green of grass and cottonwoods, the freshness of air.

We raced! The Mexican drivers are the most reckless and most brilliant I have seen. They have to be or perish, for apparently there are no traffic laws. We passed and were passed on either side, turned around or crossed to the left at will, and as for speed, I clenched my fists and held my breath!

We approached the outskirts of Xochimilco. "It reminds me of Italy," said Tina. "Only more beautiful," added Llewellyn. Walls, walls brick or stone or adobe; Mexicans do not parade front lawns. Instead, potted geraniums sprawl over wrought iron gratings, brilliant on the faded pinks and blues of the sun-baked casitas. Now the architecture changed definitely; thatched huts appeared, a bunch of pansies from nowhere dropped into Tina's lap, followed by a breathless Indian boy who jumped into the car to claim his five centavos — then Xochimilco! These once floating islands which comprise Xochimilco were long ago rafts. Upon them the Indians raised vegetables, planted flowers; gradually, the vegetation took root in the bed of the lake and the rafts became islands, flower-covered islands, divided by canals not unlike Venice. Sunday is a gala day in Xochimilco. The water was dotted with canoes or larger canvas-covered boats all bedecked with flowers and filled with festive people, gay people who sang and thrummed guitars and were "borrachito" with pulque or wine.

Soon, we too were gliding down the water ways, past quaint thatched huts, past sad willows, and gardens of pansies, lilies, forget-me-nots, violets. We too laughed and sang and became "borrachito," for across the canal darted a swift canoe to serve us pulque curado. Later, another canoe drew up to our side, this time with elote asado — roast corn — hot from a charcoal stove in the centre of the canoe. The same Indian cooked us delicious enchiladas, so savory that an unmentionable number were consumed.

24

Then came the flower girl, her boat piled high with pansies, forget-me-nots, carnations — "Señorita, Señorita! Cinco centavos!" waving toward us a bouquet of pansies, almost an armful—We did not resist!

I called the willows of Xochimilco sad. They are poignantly so. They are tall, straight, and slender as an Italian cypress, but more lissome and yielding. With each passing breeze, they sway unresistingly, bending their tops in mournful submission; a bed of river rushes is not more graceful.

Our canoe was "manned" by one Indian who stood in the prow with his one long oar, but some canoes, (or "barge" would be a better name for these larger square-nosed, awning-covered boats) held twenty people, with an Indian at the stern and prow. These were the gay parties with singing and drinking and señoritas, "Wine, Women, and Song." They brought their cocineras—cooks—too, who served hot food from charcoal fires, while other criadas—servant girls— watched that no glass remained empty, or kept the long table from stern to prow laden with viands.

By now, it was raining but it mattered not, the boat was covered. "Parada!"— Stop!—I cried to the Indian and we stopped by a canal on which floated those same lovely lilies of pale lavender I had seen in Guadalajara. From somewhere, far away, came the strains of *Mi Viejo Amor*—My Old Love—, nearer a girl sang *Chaparrita*—Little One—; our gay canoe glided to its landing.

October 30. First Exhibit at "Aztec Land." The exhibit has been open for over a week; it is a success. I have done what I expected to do, created a sensation in Mexico City. Roubicek, the owner of "Aztec Land," told me he has never had such an attendance to any previous exhibition.

I have never before had such an intense and understanding appreciation. Among the visitors have been many of the most important men in Mexico, and it is the men who come, men, men, men, ten of them to each woman; the reverse was always the case in the U.S. The men form the cultural background here, and it is a relief after the average "clubwoman" of America who keeps our culture alive. The intensity of this appreciation and the emotional way in which the Latins express it has keyed me to a high pitch, yet, viewing my work day after day on the walls has depressed me greatly, for I know how few of them are in any degree satisfying to me, how little of what is within me has been released.

Of the future, I hardly dare think, for all I can see ahead is day after day of professional portraiture, trying to please someone other than myself. Eight prints have been sold to date, the first one to Lic. Ramón Mena, archaeologist, who bought *Tehuana Costume* of Elisa. Best came [Alberto Best-Maugard] and has been of much help.

The second day, Robelo [Ricardo Gómez Robelo] came, so unexpectedly after this long silence, it was a shock. We embraced long and with emotion, it was so

good to see him. Robelo has been very sick, that was apparent. How sick, he would not admit,—confined to his home, nevertheless writing, in spite of his illness, a book on the Pyramids of Mexico.

An interesting and also interested visitor was Dr. Atl, who came with Nahui Olin, apparently his mistress, a quite fascinating Mexican girl who has spent most of her life in Paris. Tina and I dined with them, then went to Nahui's home — more later concerning the work of Dr. Atl and Nahui Olín — their books and paintings. As I walked down Avenida Madera with Atl, it seemed that he was greeted by every other person. On foot or in machines, they bowed or called to him.

Last evening, Diego Rivera visited the exhibit. Nothing has pleased me more than Rivera's enthusiasm. Not voluble emotion, but a quiet, keen enjoyment, pausing long before several of my prints, the ones which I know are my best. Looking at the sand in one of my beach nudes, a torso of Margrethe, he said, "This is what some of us 'moderns' were trying to do when we sprinkled real sand on our paintings or stuck on pieces of lace or paper or other bits of realism."

With Rivera came his wife, Guadalupe, tall, proud of bearing, almost haughty; her walk was like a panther's, her complexion almost green, with eyes to match — grey-green, dark circled, eyes and skin such as I have never seen but on some Mexican señoritas.

Just now an American girl came in for an appointment. "Do you know," she said, "that you are the talk of Mexico City? No matter where I go — to afternoon tea, to card parties — your exhibit seems to be the principal topic for discussion. You have started out with a bang! — already famous in Mexico!"

Incidentally we are popular — Tina and I have been dined and wined and feted to repletion, yet we have refused more invitations than we have accepted.

Sunday night — depressed and lonesome, I stole silently away from our casa and walked for hours alone; sat in the Alameda and watched the little dramas staged on every bench; strolled along where the "puestos"—booths were preparing for Christmas trade — much utter rubbish made for the tourist, but some lovely things. To assuage my "blues," I did my first bargaining alone, purchasing two lovely dishes of Jalisco ware. I should not have spent a cent, but I needed to, and did!

Then I found a merry-go-round I watched and listened for an hour. In one seat a sophisticated senorita, legs crossed to better show their beauty, nonchalantly lit a cigarette. In front of her, on a rose-bedecked horse, rode an Indian, a flaming flower in his mouth, a green feather in his wide sombrero. There were bare-footed Indian girls with hair to their knees and dandified men with canes, and, of course, children, all swirling around and around and around on this merry-go-round — which being gayer than ours, was sadder.

26

November 1. To the puestos again last evening, strolling by booths filled with both atrocities and work of the finest craftsmanship; it is evident that the Indian's work is becoming corrupt, and with another generation of overproduction and commercialization will be quite valueless. It was all very gay, festive, colorful — with food as important a display as art. Opposite the puestos, a continuous line of charcoal fires over which, in sizzling pans, cooked enchiladas and other tempting foods. Quite as frequent were the vendors of candies and cakes — the Mexicans consume quantities of sweetmeats prepared with imagination.

Sittings ahead, many dates pending, but oh how tired I am of professional portraiture!

Sunday, November 4. Plaza de Toros. Tina, Llewellyn, Chandler, and Edward. The exhibit is over — the lights turned out last night. Roughly, I estimate that between 800 and 1,000 people visited the "Aztec Land" balcony during the fourteen days — about 250 registered in the guest book, which will be a treasured souvenir. I have made quite a definite break into the consciousness of the Mexican public — especially among the painters and poets and lovers of the arts — many of whom returned again and again, and many of whom would have bought but for their purses.

Of the eight prints sold, six were nudes of Margarethe made that last terrific week with her, before leaving for Mexico. Rivera liked one of the beach fragments of her the best of anything in my collection.

A day of blazing sun tempered by shifting clouds. We had been warned that the Sección del Sol—the bleachers—was no place for a lady, that one could expect a rough, tough crowd, but Tina was game, and besides the condition of my purse precluded the comfort and refinements offered by the shade.

We arrived at the plaza an hour early to choose the best vantage point for comfort and "respectability." Already crowds were streaming in. Outside were vendors of food, frozen dainties or frying meats—the charcoal stove turns any street corner into a kitchen. Banderillas were for sale, supposed to have once waved from the back of some luckless bull. Gaona, el Matador, and the people's idol, was to fight. His picture was being sold in buttonhole bouquets, a leaflet published for bullfight "fans" was named after him.

We entered the the gate to "el Sol." A soldier stepped suddenly forward, threw his arms around me grabbing at my hip pockets — fire-arms and knives are barred from the bullring! At our baseball games, a pop bottle is occasionally tossed by way of protest, but the Mexican thinks a gun more efficacious.

It was soon evident the sunny side *was* tough: to relieve monotony, apples and other handy articles began whizzing, until the fun waxed furious and a man was lifted bodily from his seat and handed kicking and struggling over the audience. A protest would have been futile—even the victim pretended mirth.

27

At the stroke of 3:00, a door of the Arena swung open. The announcer of cere-
monies in flowing cape and plumed hat, astride a horse in gorgeous trappings,
crossed to La Autoridad. Saluting, he reared the horse to a stand and with a dig
of spurs dashed back to lead in the toreros. They paraded across the arena, proud,
nonchalant, vain as peacocks and as beautiful in brilliant silks and satins. The
band crashed, the audience wildly cheered and the fight was on.

A tense, breathless, expectant moment—another door swung open to admit the
onrushing bull — in the centre of the arena he paused, tail arched, head aloft,
pawing the sand and snorting defiance. But in this game of life and death in el
Toreo, the bull alone is foredoomed; he is to die, there is no hope. He paused but
an instant and then charged the first flirting cape; how easily, how carelessly,
how gracefully, did the toreros avoid those mad rushes! Until the bull, bewildered
and panting, spied a new enemy — a picador had edged the blinded side of his
decrepit old nag close to the bull. Pica in hand, he was braced for the attack — a
sudden impact of horse and lance and bull — a momentary swaying from the
shock — the long lance in the bull's side — the bull's horns in the horse's bowels
— then, as the picador jumped for his life, the horse streamed pink guts onto the
sand and dropped to his death. This was the ugliest and saddest part of the fight,
though upon reflection one must admit that the horse died a glorious and honored
death! — less sordid than that which otherwise would have awaited him, pulling
his creaking cab at the bite of a lash.

The most spectacular, dramatic and beautiful moment of the afternoon was the
placing of banderillos by Gaona. Green-ribboned banderillas high in his up-
stretched arms, he waited; such brains and daring to match the charge of a
fighting mad brute. Squarely he met the bull, perfectly he placed the banderillas
back of the lowered horns, miraculously he stepped aside, while the bull careened
away, tossing, bellowing and the audience exploded with a roar of applause.

All moments were not so exciting; at times, the action dragged, especially at the
final killing when the bull, already tired, faced Gaona's red-cloaked sword.
Playing for the death-stroke allowed for much technique — beautiful posturing —
and daring too. It made one creep to see Gaona deliberately turn his back and
with never a backward glance walk away from the still dangerous bull. But the
bull was tough and would not die. And the audience was fickle, alternately hissing
and cheering their idol, until finally the sword sank to the hilt and the animal
into the dust. Three mules dragged him out.

Another expectant pause, the bugle and the next contestant. This bull was
afraid, refused to fight and was soundly hissed for his cowardice. I suppose
peacefully grazing on a daisy-covered meadow would have better suited his
desires! The naïveté of the audience in hissing or acclaiming the bulls, as they
did the toreros, was amusing. It was thumbs up or thumbs down as in the days
of the ancient gladiators. Finally, the banderillas were placed and this time we,

28

as the uninitiate, had a surprise, for they exploded with a bang and poured forth smoke and more bangs which sent the bull bucking all over the arena. But even then the bull turned tail, ran away, and the killing was slow and tiresome. By now, the audience was getting peeved. And when the next bull appeared, a small unworthy beast, they arose en masse and loudly denounced the management for poor bulls, verbally fining the promotors 1,000 pesos and remaining unappeased till the fine had been confirmed —? The bull was chased from the ring and his substitute provided a gallant fight.

And my reactions? Was it a cruel spectacle? Yes, undoubtedly, though perhaps not so bad a way for a nation to release its sadistic emotions. . . can it be denied that we go to an auto race secretly hoping for some thrilling accident? Of course, not death, but —! Our prize fights? It is only the few who care for a fine display of scientific boxing, it is always the bloodiest slugging match between longshore brawlers which gains applause. While in the Mexican bull ring, it is grace and daring which the audience cheers. Unnecessary cruelty is frowned upon — for example, a picador was recently fined for remounting a wounded horse.

The Mexicans are not hypocrites in their pastime. They grandly stage a mighty pageant with death proclaimed upon their banners. The blood and suffering are but means to an end — like the music — the color — the hot sun — the bellowing bull — that of aesthetic gratification. Yes, I shall go again.

2. "Heroic Heads"

November 9. Have been very sick, fainted away at the opening of Sala's exhibition, and spent the next day in bed — fasted and am better now. I have not mentioned Rafael and Mona Sala, both fine individuals, Spanish, he a painter. We have seen quite a bit of them.

I have been working some with my camera, made nudes of Tina, work not unworthy — what shall I say? — of my lens? — also the best portraits I have done in Mexico — of Nahui Olín.

Last night it rained. In Los Angeles, the real-estate mongers would call the weather "unusual," for the rains are supposed to have been over for a month or more. Llewellyn had a bright idea and we all "fell for it." The four of us, Tina, Llewellyn, Chandler, and myself stripped naked and played tag on the roof in the rain!

Afterwards, a brisk rub-down and we were in a fine glow and ready to read *Moby Dick.* This book has been one of the literary adventures of my life, a great book, full of profound philosophy, prose poetry, thrilling adventure, but I can't stomach his attempts at humour. His jokes are bum; his puns forced!

Just caught a flea — what grim satisfaction — fiendish delight — in contemplating its execrable, nauseous, accursed remains squashed and bloody between one's finger nails! — But they are not nearly so bad as when we first came; in fact, they had almost quit operations until this rain once more drove them in.

Saturday to Sr. Tomas Braniff with Tina. It was one of those futile attempts to bring the artist, musician, poet, intellectual together for the serious discussion of "philosophical and artistic" problems, doomed to failure — for the artist wishes to play, to live, not talk shop on every occasion. Braniff, a Mexican millionare, has opened his palatial home and gardens for this serious purpose, probably with desire to shine in the reflected light of the artist. Robelo was there, and Best-Maugard, and Guadalupe Rivera, also Dr. Atl and Nahui Olin.

Lupe was easily the most striking figure in the crowd, her dark hair like a tousled mane, her strong voice, almost coarse, dominating.

There was brilliant repartee at the dinner table set under the garden trees, the conversation veering, as usual among intellectuals, to sex. Lupe, discussing the homosexuals in Guadalajara, "A group of men there," she said, "actually wore high-heel shoes and lace frills." "Every other man in Mexico is homosexual," added Nahui Olín.

30

When the "regular program" started, the fun was over, everyone tried to be interested or was frankly bored. But we had been well served and Braniff was generous with Cognac and Chartreuse — so, listening to dull theories was the price to pay — and we paid. I shall not forget Lupe's singing of Mexican popular airs.

Last eve was Diego Rivera's birthday. We were invited to six o'clock chocolate. Rivera arrived late from his work of painting frescoes. He was beaming and of ample proportions. I took him one of my prints for a birthday gift, and he gave me a drawing made for one of his murals in return. I had my choice from his portfolio of sketches, but found it almost impossible to choose. Seldom, if ever, have I so thoroughly enjoyed a portfolio. Diego is a master.

Lupe was stunning as usual. She has much of the Indian, so much a child, never a hypocrite: everything she feels is immediately acted out and we were witness to a burst of emotion unpremeditated and unlooked for. Diego had invited Tina and me to see his drawings, so we escaped from the party, dull, as most parties are, to a side room. Soon Lupe appeared, choking, sneering, raging, head tossing, eyes streaming. "Ha! I invited her to see how you two would act together. I did not want her here—you don't think I wanted her!" — and so on, and on about some woman supposed to have been Diego's love. "Estás loca—completamente loca,—You are crazy—completely crazy," was Diego's placid, unruffled defence. Lupe left, still storming, only to return, and this time denounce us for having deserted the party, broken it up, cornering Diego. She was right, but Diego's drawings were more important than the party! We felt uncomfortable — worse, guilty, so prepared to leave. Penitent, Lupe came to Tina with a present — two gourds, fantastically painted, a peace offering. I am to photograph her soon.

Today the first order from a sitting in Mexico, 3 prints — 110 pesos. No platinum paper yet—ordered a month ago from England.

November 19, Evening. Diego and Lupe Rivera were just in, this time cooing like turtle-doves. It was "niño" this and "niña" that, and she wore a new coral necklace. "In Guadalajara, they thought Diego was my father," laughed Lupe, "and when I told them he was my husband, they said, 'How could you marry such an elephant?'"

Diego looked at my Picasso etching — "I saw Picasso etch that, it was done in December 1908 — I don't know why he dated it 1905 — at a time when he was in his cubist period. Many said he had forgotten how to draw, so he did that, among others, to disprove them. Picasso had a failing, he was always falling in love with the sweethearts of his friends, — hence, continually in trouble."

I showed Rivera some of Chandler's stencil designs and he seemed greatly interested. Chandler has done some very fine things, and out of a clear sky,—at least, I can't figure where the influence, if any. Chandler's photographs have

been interesting too — one I would have been happy to have made myself. I can see my influence in these, yet they were made entirely unaided. Chandler has had to shift for himself, and having no playmates for baseball or marbles has amused himself by creating.

El Convento de Churubusco is a gem. I think it is the loveliest of the churches I have yet seen, though they should hardly be compared — each having its own special charm. Churubusco is intimate, I wanted to linger and rest in its tiny patio, to caress its mellow tiles, to worship before its lovely golden virgin.

The rest of the party made photographs, one man being a wealthy amateur. I did not, for the churches in Mexico are an end in themselves, needing no further interpretation. I stand before them mute — nothing that I might record could add to their beauty.

Previous to visiting Churubusco, we went to el Convento de la Merced. We met Dr. Atl, who lives there. "I should like to photograph you here, Doctor." "All right." Dr. Atl's "all right" is part of him. His real name is Gerardo Murillo, "Atl" being Indian for water; and "Nahui Olin" is also Indian, standing for the "four movements of the sun." Nahui's real name is Carmen Mondragón. Nahui's books may be interesting, but written in French and Spanish I can make no comment. But neither her paintings nor Atl's have great value, indeed some of his murals I thought very bad, full of half-baked metaphysical striving. But Diego Rivera is so outstanding a figure in Mexican art that much of the rest seem trifling by comparison.

A tiny chapel stands in the centre of a busy market place on Callejón de Manzanares, near the convent. It is quite unpretentious, no carved facade, nor blue and yellow tiles, only bare walls of pastel pink and swirling streams of Indians flowing around it.

November 21. The second order in, this time from Americans here from Tampico, it amounted to 280 pesos, 8 prints from six negatives, a task ahead — six enlarged negatives! So far I have made all my sittings with the Graflex out-of-doors. We eat for another month!

At Churubusco, I picked a daisy to send to Margarethe.

November 24. A few more names noted on the pulquerías:

Charros no Fifis	Cowboys not Dandies
Los Hombres Sabios sin Estudio	Men Wise Without Study
La Hermosa Ester	The Beautiful Esther
Mis Illusiones	My Illusions
Las Fieras	The Fierce Ones
El Gallo de Oro	The Cock of Gold
Alegria del Amor	The Ecstacy of Love

Llewellyn left this morning. I watched the train pull out with much sadness. He has been a delightful and lovable friend. Though his piano, at times, was sorely distracting and his dog a damned nuisance.

Llewellyn has been of much help to us, but, for his own sake, he should have just been coming instead of leaving. I am afraid he has not learned much photography with all the confusion of getting established and the exhibit.

Lupe de Rivera sat to me yesterday — fascinating girl, quite the most interesting I have met here. Results — at least one or two good heads and one figure, but I wish to work with her again.

Thursday last to San Juan Teotihuacán and the Pyramids of the Sun and Moon with Rafael and Monna, Felipe, Llewellyn, Tina, Chandler and Edward, also three cameras, good food, and plenty of wine. I made a few negatives, the best one not of the ruins, but the surrounding country — a typical Mexican landscape made from the summit of the Pyramid of the Sun. We shall go again, for night came on too soon. Next time the stay must be for several days; it is far too much to absorb in a few hours.

Coming home on the train, Rafael bought for Monna and Tina gardenias cradled in a hollowed banana stalk — how tenderly the Indians do things, with what imagination — a stalk eighteen inches long overflowing with gardenias!

November 27. Today a new servant. Aurora could no longer leave her children, and we did not want them. Now Elisa has come, whom we are to room and board and pay fifteen pesos a month, $7.50 American for a month's work! And this is much compared to what they used to get. No wonder then, the revolutions. Elisa can neither read nor write. Aurora could, but Elisa is quick and intelligent, while Aurora was slow and stupid — so much for education.

November 28. To six o'clock chocolate with Diego and Lupe Rivera. Mexican chocolate is generally famous, Lupe's the best I have had. She has it shipped freshly ground from Guadalajara and prepares it with much art.

I took the proofs of Lupe to show — the best heads I have made in Mexico. Everyone was enthusiastic. Diego turned to Tina remarking, "It bothers the painter to see such photographs."
I like him immensely—Lupe too. They are both so genuine and outspoken — too much so for some people. The other evening, Lupe told us, she had broken up a party by appearing, quite accidentally, when it was expressly understood that she would *not* be invited. The party was in honor of the Chilean poetess, Gabriela Mistral, who started to leave upon Lupe's arrival... Now I have no desire to meet the famous poetess. I find myself withdrawing from people who are too nice.

Rivera told us that a group of the Mexican artists had formed a syndicate, that they considered and called themselves "workingmen" and nothing more. I like this attitude and proclamation. A real artist is nothing if not a workingman, and a damn hard working one.

Rafael and Monna told Diego of New York. "If I went there," he said, "I believe I should turn to painting bill-boards and posters." He spoke of the machine, "There is so much beauty in the steel door to a safe vault. Perhaps future generations will recognize the machine as the art of our day." I think so too.

There was much talk of Tehuantepec, the most southerly state on the Isthumus, of the beautiful women and their costumes. The women handle the commerce of the state; the men do the physical labor. Free love is common practice in spite of Catholicism, which is taken seriously only as a festival. The natives speak a language of their own supposed by some scholars to be the tongue of the ancient Atlantians.

The evening furnished much repartee too swift for me to understand. Especially did Lupe and Rivera banter, keeping the whole group convulsed. He is tall and fat, she, tall and slender. "He has breasts like a women," said Lupe, "and I have none — so we make a perfect union." "Diego tries to bind his down," — from Lupe. "Lupe stuffs her front with cotton," — from Diego, and so on, and so on —.

Today again to the Braniff mansion of gold leaf and alabaster; the whole "Painters' Union" was there, some of them, most likely, to get a square meal and a drink. Rivera an animated cartoon, with his two chins, two bellies, and inevitable smile. Lupe with her "Por Dios" and "Caramba." Jean Charlot, a French boy, whom I like immensely, and who gave me one of his excellent wood cuts. Robelo very frail.

We talked on the pyramids. I learned that they are now thought to antedate the Egyptian pyramids. That now, some archaeologists consider that from here went the Chinese to populate Asia, from here went the Egyptians, and also the Semitic tribes. Not the reverse, as heretofore believed, that this country was part of the lost continent of Atlantis. A book recently published in France, after twenty years of research — deciphering of documents in the Vatican, stolen from here by Cortez,—shows actual maps of Atlantis with ports and named cities. Finally, in San Angel, a half hour ride from here, has been uncovered from beneath lava rock a city dating at least ten thousand years B.C. All quite fascinating, nay, thrilling conversation.

Amusing talk from Robelo too. It seems there is a man here so bewildered by Rivera's work that he has decided to give a talk "on the pathological case of Diego Rivera"! Robelo wants to be there and answer him.

In the United States, without art traditions except borrowed ones, we are apt to accept anything new and labeled "modern" without discrimination. Here, in Mexico, they are so hidebound with convention that the work of their greatest painters is ridiculed. Yet they do appreciate and are proud of their pyramids and ruins of the past...

34

The Mexicans still refuse to accept me as an American. I have secret delight in assuring them that I am a type of the real American now already extinct — that our aristocracy is dead. How uncomfortable my neighbors and relatives of the charming and chemically pure city of Glendale would be to think that one of my "loose morals" and disrepute should be posing in Mexico as a true American type!

The Mexicans have such contempt for Americans as they know them that I have begun to think that God Almighty sent me here to bring about more amicable relations between the two nations!

December 2. The article on Diego Rivera in "The Freeman," is re his work in the Preparatory School. His later painting in the Ministry of Public Education is much finer, and now he tells us he is more pleased with his murals at Chapingo than any he has done. The article goes on about the "Union of Technical Workers, Painters and Sculptors" which adheres to the Moscow International, with Rivera as the leader. It speaks of painting on canvas as painting degenerated, and further — "While feeling that he belongs to the future one is glad that he lives today. Rivera is humble with the humility that comes to those who, having confidence in their own worth, recognize the worth in others, who out of disillusion create beauty, out of human suffering the future —"

Rivera is a vegetarian. He appeared at the Braniff banquet carrying his own dinner of grapes and apples tied up in a red bandana handkerchief... I rather envied him his meal and remembered my own days of intestinal purity. I may return to them again. I have a feeling that eventually I shall. This country with its abundance of tropical fruits should be paradise for the vegetarian.

December 7. To Monna's and Rafael's for chocolate. In Mexico it is 6:00 o'clock chocolate, instead of 5:00 o'clock tea. A Mexican Senator was there, he and his guitar, a tall handsome charro. He had fought in the revolution, two years with Villa; everyone here seems to have been in the fight. "Villa was the best loved man in Mexico," said the Senator. "He was an outstanding personality and made a gallant fight for the oppressed." And we in the United States, thanks to our controlled press, think only of "the bandit Villa." Lupe and the Senator sang Mexican popular songs all evening — some were in memory and love of Pancho Villa.

Diego was there. I watched him closely. His six shooter and cartridge belt, ready for service, contrasted strangely to his amiable smile. He is called the Lenin of Mexico. The artists here are closely allied with the Communist Movement; it is no parlor politics with them. Rivera has small sensitive hands, those of a craftsman, his hair recedes from his forehead leaving an expanse which occupies half his face, an immense dome, broad and high. Chandler gets quite a "kick" from Diego — his ponderous proportion — his infectious laugh — his mighty gun. "Does he use that to defend his paintings with?" he asked.

My days pass monotonously enough, trying to make an ancient American woman, dressed in a black mantilla, look like a Spanish señorita, retouching hours at a time — bah! for professional portraiture! This jotting down of impressions helps to relax and prevents mental stagnation. I write a few words, then retouch a few wrinkles. My writing does not help me physically, however, my eyes suffer and my body is cramped. My only salvation has been fifteen minutes, hard exercise and my morning cold bath.

Aguacates are out of season. I miss the noon meal of hot tortillas and aguacates, but now we have the chirimoya. And for me to dine on chirimoya is to become intoxicated — it is like eating perfume. Also, we have chico zapote, sugar cane, granada de China, and soon the mango will be in again. Northern fruits pale beside these sun-drenched, nectar-filled fruit of the tropics.

December 8. At last the revolution is upon us. Long hinted as a possibility, it is now a reality. Wires are cut between here and Vera Cruz, Tampico and Western points; trains are halted, except those to El Paso which are filled with fleeing Americans. De la Huerta has 15,000 men against the government, several states have gone over to him, artillery is being rushed to defend Chapultepec Castle. Obregón arrived on a special train last night. Soldiers are marching with beating of drums and blowing of bugles. Food prices are soaring — and this is our only concern — for if we tend to our business, danger is unlikely. Opinions vary as to the duration of this outbreak; from three to six months is the average answer.

We have spent a little ready cash on staples, beans, rice, and charcoal. This early morning, before dawn, distant cannons boomed incessant, probably only practise before actuality. —

For the first time in Mexico, that old melody of my aunt's music box has returned — my childhood again —

Jalisco has gone over to the de la Huertistas. Federal troops are preparing to attack Guadalajara. Most of those with whom I have talked opine that the revolutionaries will win, and quickly. Something must happen soon or we shall be stranded.

December 9. My second bull fight. After El Toreo — Matadores "Nacional Segundo" y "Valencia" — altogether the most stupendous, electrifying pageant of my life — I feel for new adjectives to interpret my emotions — my synonyms fail me. . . They grasp the cape together. The bull charges. Up goes the cape; under and between them the bull, not once, but time after time. And then, with a climax of applause, they kneel together before the bull, each grasping a horn, and salute. But the killing of the last bull was the daring feat of the day — a fitting finale. He was a powerful brute. The six banderillas had been placed – three times had he charged the picadores and as many horses were strewn upon the arena. Blood streamed over his black hide — yet he was fighting and dangerous. With his red-cloaked

36

sword, Nacional played him for a while, then baring the sword, awaited the bull's attack. To attempt the death stroke on a charging bull is almost suicide, a miscalculation possible death. It is seldom done. Three times Nacional met the charge. The audience on tip-toe, the band hushed. The third clash was successful. The sword sank to the hilt. Nacional walked away without looking back.

December 10. De la Pena and Turnbull, old "fight fans," tell me they have never seen a more thrilling fight.

And a "letter" from Margarethe — "To write you tonight — am sending a telegram" — that was all!

And this from Margarethe to Ramiel: "She (Flora) wept around here one A. M. after Edward's first Stieglitz letter (from N. Y.) — blaming herself for holding Edward back — I told her — in front of Tina — that she was responsible for Edward's success — without the balance of her and the children — the forced responsibility — Edward would have been like the rest of us — dreaming — living in attics — living a free life (O God!) etc. etc. not growing and producing *as he had.* Opinions to the contrary Edward as gregarious as anyone I know — Flora seemed grateful for my words but soon forgot them..."

December 14. Definite news of the revolution is difficult to obtain. The newspapers are censored. One paper daring to print the truth was put out of business, its press utterly demolished by "burglars." Mexicans practise "direct action." Politics are as rotten here as in the United States or anywhere. 30,000 men have been fighting around Guadalajara, and there have been skirmishes at Tacubaya, where we once lived.

The Eleventh — to La Festivadid de Nuestra Señora de Guadalupe with Monna, Rafael, Felipe, Lupe, Chandler and Tina. It was not the day of important dancing, but we did see one dance — and in church! Pagan dancing in a Catholic Church: the Indians accepted Catholicism but introduced their own rituals. We met the parade of Indians coming down a narrow walled street, all gaily attired, carrying large half-wreaths of streaming tissue paper, and followed them into the church. There they dropped on their knees and, still chanting, crawled toward the altar. Arising, they danced, simple, rhythmical, monotonous steps, using the wreaths overhead, passing through and under them. An impressive sight, the church with its vaulted roof, its towering columns, with Indians kneeling on the floor, or seated in row after row of wooden benches, many holding lighted candles, hundreds of flickering candles lighting passionately devout faces — such faith! And the priests above intoning their formulae.

Some of the tribes had come great distances, many had made the pilgrimage on their knees. Miraculous cures were reported; evidently the Virgen de la Guadalupe is as potent as Mary Baker Eddy and certainly more picturesque.

37

All around the church the pilgrims had camped. They were cooking their tortillas and frijoles over the charcoal fires. Some were beautifully costumed; Lupe tried to buy their sashes—she did not succeed. Either they were too proud — one was quite angry — or else they did not understand Spanish. Magnificent specimens in one group—a girl I remember with breasts like cannons and legs like tree trunks, of regal bearing she was. One felt ashamed in scrutinizing her. She could have annihilated me with one arm!

These were the simple, saint-like worshippers, but there were others, for Tina had her pocket picked twice! Across the street from the church, a merry-go-round wheezed out "Yes, we have no bananas" — "Si no tenemos plátanos" — a touch of today clashing with ceremonials from antiquity.

We purchased "modern art" for 65 centavos, brilliant designs on glass which might be object lessons to some "modern painters." The "modernist" cannot merely go back to the primitive, for he cannot compete at all!

As a side-show to the main event of the fiesta, the celebration of the Virgen's appearance, posters announced a special bull fight.!

Elisa, our new servant, is a continual source of merriment. She is quite concerned with my welfare — intensely curious too. I am sure she thinks we are all un poco loco! Especially do our cold baths amaze her. I have had a bad cold in the head; tonight she watched me wash my face, she shook her head disapprovingly, "Señor, cold water is very bad for your 'catarro.'" She has requested a picture of me. So I still have an admirer.

Sunday morning — Beethoven this morning or the bull-fight this afternoon? That is the question. Bulls and bravos versus Beethoven. I can hear Beethoven in New York or Kalamazoo. I can see El Toreo only in Mexico. Why question? Viva los toros!

Next day. His name is Juan Silveti. He is called Juan sin miedo—Juan without fear—and not without reason! I saw him tossed in the air by the bull, I saw the bull mauling his sprawled figure, yet he rose to attack with a daring and brilliance which electrified the audience. One moment to escape death by a miracle, the next to arise, walk straight to the bull, knell before it, kiss its nose, and walk away, back turned, as unconcerned as if he were coming out of church. Facing the bull again with bared sword, he delivered the estocada with the first attempt. The bull dropped and the audience roared in a wild furore for ten minutes.

Silveti wore a scarlet cosume, black trimmed, and salmon colored stockings; Gaona was dressed in gold and blue with salmon stockings, both beautiful. Indeed, it is impossible to over-exaggerate the beauty of the whole pageant, even the mules which drag the dead bull out, with their blue and red trappings. There is a saying in Spanish, "When there are bulls there are no bullfighters.

When there are bull-fighters, there are no bulls." There must be both elements for a good fight.

The bulls were very poor yesterday. Gaona, especially, had no luck. He is said to be the best banderillero, indeed more, he is acclaimed the greatest matador in the world. My naturally superficial observation would be that Gaona is a cold, scientific fighter, one who takes no chances, but is absolutely sure of himself — an artist, nevertheless, whom I have seen in postures which would make an Isadora Duncan envious, and done with the bull's horns grazing his belly. To return, Gaona's placing of the banderillas was superb — each set with such precision that the completed group was arranged on the bull's back as a perfect star — a star of red, blue and yellow, clear brilliant primary colors too — nothing dilute for the Mexican taste.

December 21. I can't go on this way. I must acquire a formula for my portraits. I compromise anyway — and give far too much of myself to an unappreciative audience.

Yesterday, I quit — put down my prints on which I had spotted all morning. Poor technique? Yes, but not my fault — finger-prints and scratches and bad retouching done by others — retouching necessary to make an American of questionable age look like a vivacious señorita. I quit, I say, and paced the floor the afternoon — the worst reaction to professional portraiture I ever had. It made no difference to me that rent was due and the work had to go on.

As I walked back and forth in my two by four room with its ugly wall paper, its cold cheerless aspect, I pondered much, and a new philosophy of life was presented to me — probably by the devil — that of the Indians who lie in the sun all day and pawn their blankets for the price of a bull fight. They, at least, must be happy, no thought beyond the day, no desires, no ambitions. I became obsessed — overwhelmed by the desire to quit, realizing the futility of effort.

Yet here I am this morning at my desk, working harder than ever, attacking this negative almost with ferocity, as though it were one of the tasks of Hercules. The outward and superficial reason that if it is not done by tomorrow I cannot go to El Toreo Sunday! — and five foot letters announce Silveti y Nacional!

Strange humor, living from week to week in anticipation of the Sunday bull-fight, acknowledging its cruelty, shuddering when a mortally gored horse careens across the arena with its guts wrapped around its legs, but watching the pageant or orgy, nevertheless, in fascinated horror. The Latins have evolved a sport which symbolizes life, its glorious moments and its sordid ones, its dreams and deliriums — and futility, and they can return from such an afternoon to tenderly pet their birds and water their geraniums —

December 28. 5:30 A. M., early as in my old Glendale days. In Mexico I rise late—between 7:30 and 9:00—the latter hour almost never! Christmas

passed rather uneventfully. La Noche Buena was the occasion for quite a display of fireworks and much shooting. The Mexicans never miss a chance to use fireworks and La Natividad is no exception.

The moon was full. I walked our white roof alone. My thoughts were with the little boys in California, — hoping they had some joy, a tree with lighted candles and candies. Christmas is children's day.

Christmas day we went to El Toreo, Tina and I, but not for los toros this time; we heard the Mexican National Orchestra render Debussy and Beethoven, indifferently, and Bertha Singermann recite. I felt like cuffing her hands, they were so calculated. Her whole performance got on my nerves. She received an ovation.

After, we walked to the Salas taking them a couple of my prints of La Pirámide del Sol. Rafael had been painting, two large canvases, color and design from the masks purchased at the puestos. He gave me the one I liked. He is blue, discouraged, does not like Mexico City, wishes to return to New York...

December 31, 1923. I reiterate: for a change I enjoy my morning coffee alone. Today, however, "Pancho Villa" is by my side. At him I can curse, to him relate my woes, yet his only response is to show his teeth in a fierce grin. He has an enormous revolver, and an ample sombrero in which I have placed a flaming geranium, also one in his horse's bridle. From his saddle hangs a note, "Para Eduardo — el Niño." He and his horse are made of reed by the Indians. I liked those sent to Cole and Neil so much that Tina gave me Pancho for Christmas. Flora writes: "Neil said, 'Mama, I thought we would get just a little iron horse and man.' They were certainly responsive to that toy, more so than I have ever seen them."

The puestos are thinning out. Chandler and I walked there Friday... I should like to have had a Piñata, one of the life-size figurines which the Mexicans fill with toys and candies for their Christmas festivals, — then break in a blindfold attack. They hung in rows from beams of the booths, fantastic, beautiful, or screamingly funny: marvellous sail boats, brides in flowing veils, charros, a suicide—gun in mouth, streaming realistic blood, and many Charlie Chaplins, clever, clever cartoons.

After my last bullfight, I left with a bad taste in my mouth, a decided reaction against El Toreo. It was not a reaction to the fight itself, which I insist is a glorious affray, but to the audience — the fickle, contemptible audience. I went, hoping to see Gaona for once at his best. He fought brilliantly for a while, but with a gored hand could hardly finish the first bull and did not appear again.

This left Nacional to fight the remaining five, which he did superbly as usual, keeping the crowd in a continual uproar of applause. The sixth bull was a poor one and difficult to fight. It found the body of one of its victims and mounting

40

the dead horse danced a dance of victory — though a rather hollow one since he was dying too. From this vantage point the bull refused to go and it was almost impossible for Nacional to deliver the estocada attempted several times.

Then they started, the audience, whistling, hooting, hissing, a disgusting exhibition of unsportsman-like conduct towards a brave matador exhausted from his fight against five bulls. The bull was backed up to the barricade which separated the arena from the audience, they were yelling almost in Nacional's face. He raised his hand in vain protest, attempting once more to drive the sword home, but they continued the uproar. Nacional was furious, his pride was hurt. He almost climbed the bull's back, driving the sword to its hilt. He threw science to the winds in a suicidal attempt to please the audience and the next moment was tossed in the air — only the animal's death saved Nacional. He arose a hero who had just been hissed! But he stood unheeding the cheers. Torn, disheveled, bloody, he made straight for those whose jeers nearly brought his death and with anger-distorted face screamed at them. Once around the arena he went, acknowledging the plaudits, tossing back the canes and hats,—then fainted.

January 1, 1924. New Year's Party. The party was a success! Lupe Rivera and friends planned it. They came early in the morning to cook and prepare typical Mexican dishes all day — "ponche" too, made with rum and served hot. About thirty came, among those I knew, the Salas, Lupe and Diego, Jean Charlot, Galván, several quite beautiful señoritas with one of whom I had a slight flirtation — armed and aided with my dictionary!

Several Germans came; they had been in Mexico only two days. One of them, an author, I liked, responded to, and he enjoyed my photographs, or rather the only one I showed him, "Pipes and Stacks," made in Ohio a year ago but just printed in platinum. The Salas like it the best of all my work and so does Charlot, — it is a fine print.

The Germans eyed Lupe as though she were some wild animal, and looked hesitatingly at the strange food. They must have been a bit scorched with chile, for after the first dish they refused even olives! Well they might have gazed on Lupe, she was barbarically splendid in red and gold with heavy festoons of gold chain and earrings,—she dominated the evening.

At the stroke of 12 there was much embracing — greetings of "Feliz Anno Nuevo" — and 1924 was here.

January 6. Hace mucho frio — quite the coldest yet, at 7:00 A. M. the thermometer in my window registered 39° F. Last night coming home from la ciudad— the city—I shivered as the wind swirled down calle de Balderas. We had sat in a saloon drinking hot Tom and Jerry, discussing the revolution. "Don't be too sure the government is going to win," said an American here twenty years. "The United States has always picked the losing side and they are helping

Obregón. And don't think that times are abnormal. Four hundred years' history shows that fighting of some kind is a normal condition here."

A contrary opinion came from Salomon de la Selva, poet and politician, who dropped in the other night, "There is only one possible answer re the revolution —Obregón will win, Calles will be elected." Salomon talked long and interestingly on early Mexican history.

No sittings ahead, food prices double, matters appear very bad.

January 7. Our New Year's party was such a success that a weekly gathering at Lucerna 12 has been decided on. The Braniff reunions have been discontinued "because of grave conditions resulting from the revolution." Ours will be inaugurated for the same reason. Unlike the Braniff parties, any discussion of art or philosophy shall be incidental to singing, dancing, food and drink.

Last night was the second party. Galván and Lupe sang again. The same crowd met. Before dancing the men removed their pistols which brought some realization that times are grave.

The sages predict the end of Mexico City January 11th by the eruption of Popocatépetl. Too bad it cannot be postponed till the 12th, the day of our next party. We might dance to our doom.

It remains cold, "unusual" weather say the Mexicans. I believe them — they are not all real estate dealers as in Los Angeles. I smoke my pipe to warm my hands while retouching.

I am finishing the portrait of Lupe. It is a heroic head, the best I have done in Mexico; with the Graflex, in direct sunlight I caught her, mouth open, talking, and what could be more characteristic of Lupe! Singing or talking I must always remember her.

January 12. Popo did not erupt. We are still alive and the party was held as usual ... a young artist danced la rumba Cubana, a very "wicked" dance indeed, the origin of the quite dilute American "shimmy."

I witnessed a new side of Diego. Declining the proffered glass, he drained a part bottle of Cognac. Consequently becoming joyously belligerent, further dancing became impossible, he desired singing and more singing from Lupe and Galván almost wrecked the phonograph when a foxtrot was started. He treated Lupe roughly and I can well believe the reports that sometimes he beats her. What a magnificent melee it must be when those two clash! Lupe calls Diego "Chaparrito" — the little one!

January 18. And no money for rent. The dueña—landlady—is not at all sympathetic with the condition of our pocket books. One sitting ahead but the situation is bad. I started to town with one of my lenses to sell or raise money on, but no luck. Met García Cabral on the way and we had café con leche together.

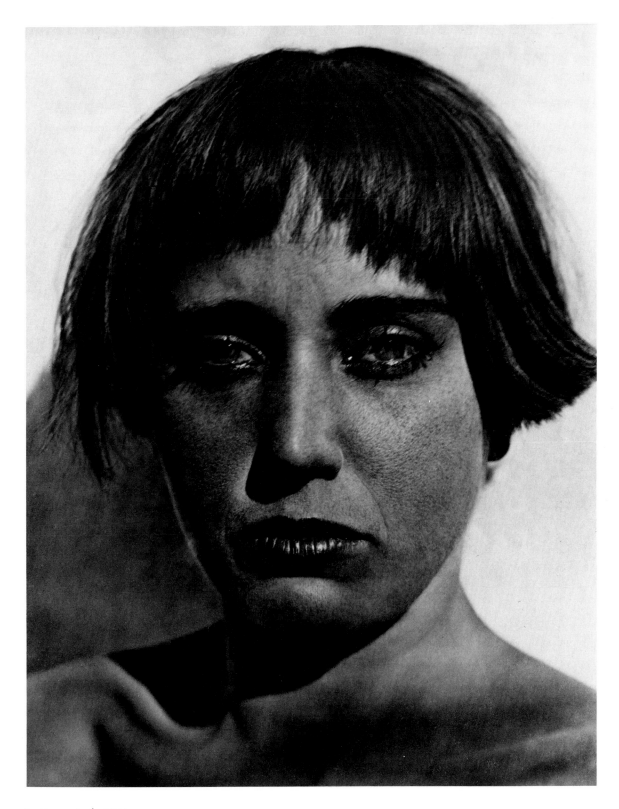

9. Nahui Olín, 1924

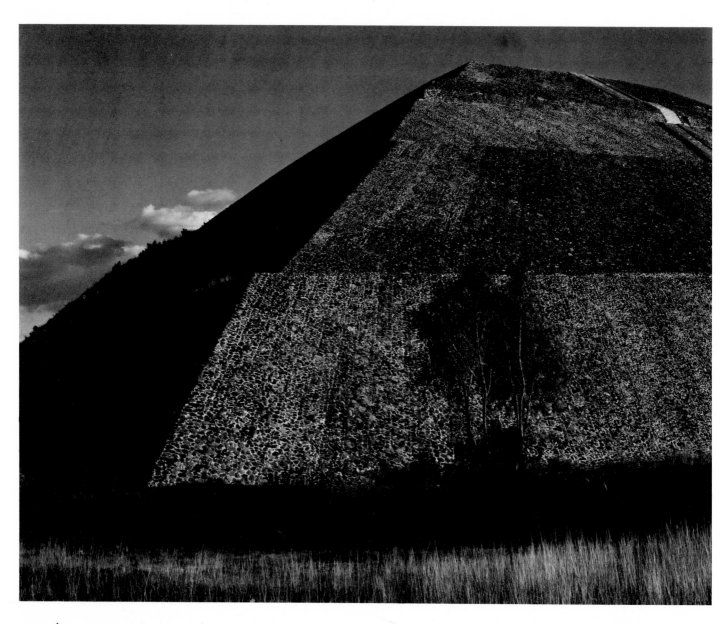

10. Pirámide del Sol, 1923

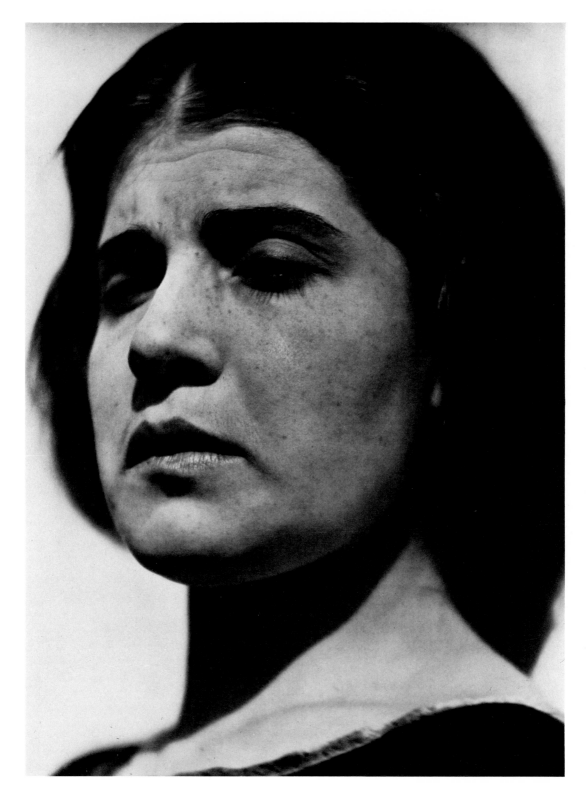

11. Tina Modotti with tear, 1924

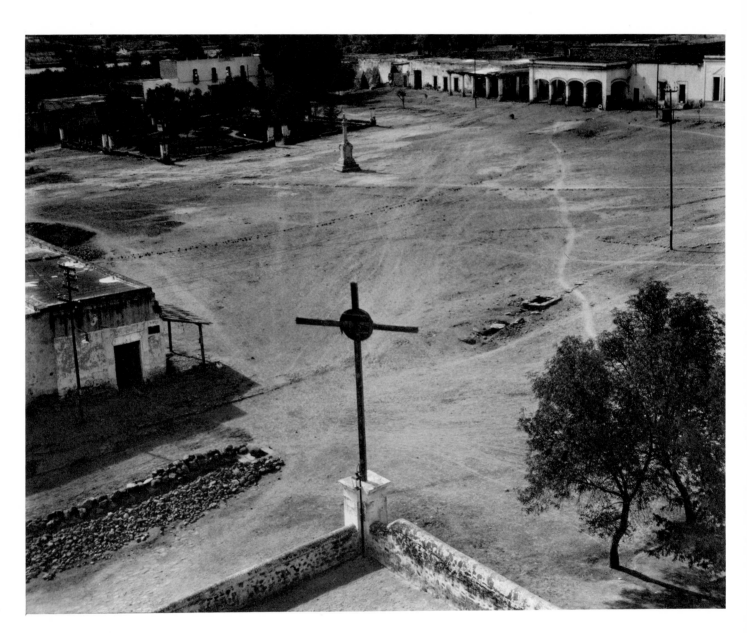

12. Cross, Tepotzotlan, 1924

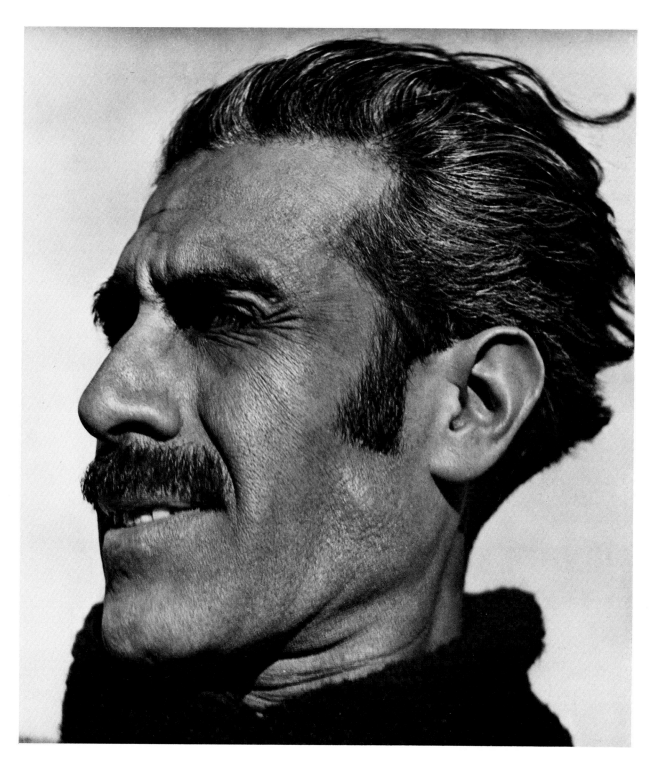

13. Manuel Hernández Galván, shooting, 1924

14. DESDE LA AZOTEA, 1924

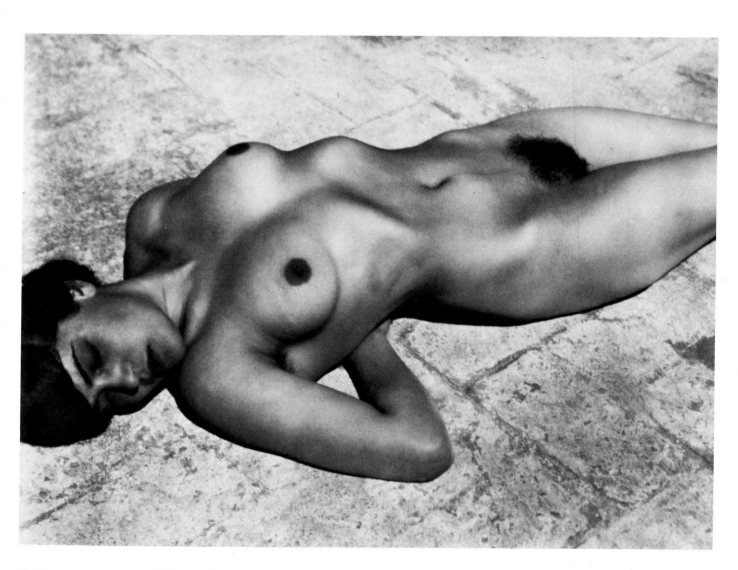

15. Tina on the Azotea, 1924, 5, or 6

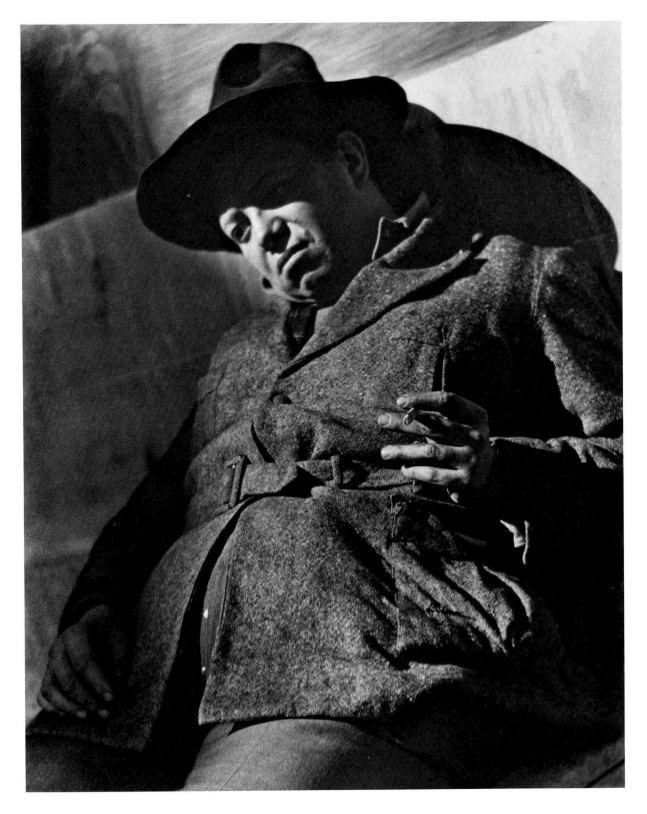

16. Diego Rivera, 1924

I am saving his Monday morning sketches from *El Toreo*, they are very fine. "You are not American," said Cabral, "a Russian or Czecho-Slovakian type, but not American." "Soy Americano," I answered.

Last night to visit Señor y Señora Cueto, – chocolate as usual. On the walls were many paintings — her older work. They were — well, not very good, but her present work — how much more vital and important! Brilliantly executed rugs, painted gourds, experiments in other crafts, all very Mexican, very personal. One carpet of an intense green and red vibrated so violently as to actually dizzy me. I could hardly look at it.

Their collection of Aztec antiquities, small but fine, increased my ever growing respect for the civilization destroyed by the Spaniards.

Charlot too had several fine things, notably one piece, a conventionalized sculptured head of a duck, as simple as a Brancusi. "They were greater than the Egyptians," was Charlot's comment.

A horrible night of dreams. I saw my father put a gun to his head and shoot himself — he was holding Cole in his lap at the time.

Just now a letter from Bertha Wardell — "We are finding life interesting in the midst of a Righteous Crusade against the Wicked Dance. It has so far deprived us of the use of our studio but not of our legs so we have nothing really to complain of." Christ! Is this possible! O how sickening! My disgust for that impossible village, Los Angeles, grows daily. To think that Mexico had to abandon the fair country of California to such a fate. I ask every Mexican, "Do you wish like conditions here? If not, then fight American influence in Mexico!" But being an American I like to believe that only in Los Angeles could such a situation exist. Give me Mexico, revolutions, small-pox, poverty, anything but the plague spot of America — Los Angeles. All sensitive, self-respecting persons should leave there. Abandon the city of the uplifters.

Sunday morning — the third of our informal evenings last night. New faces, García Cabral, Revueltas, members of the Cabinet, generals, etc. — absent faces, Agueda and Lila — my tears. — Internal dissensions already — the Mexicans are quick to love and quick to hate. The Germans are amongst the gayest who come. Cabral sang well songs from Argentine.

"When we first came here," said Charlot, "we attempted to have open house as you are doing, but we gave it up. Some of the guests were sure to end the party by shooting out our light bulbs."

Already I sense an end to these gatherings under the present plan. It is too much of a mixture; it may be an amusing contrast, the refined Madame Charlot along with Mexican generals comparing bullet holes in their respective anatomies, but it is sure to end disastrously. As Diego put it — rearranged in my own phraseo-

logy — "I want either one thing or the other, a party where I go with the avowed intention of getting drunk, or one with a more subtle prospectus."

January 22. Manuel Martínez Pintao, — we found him, Charlot, Rafael, Tina and I, at Iturbide 27, in an ugly little room, in which his wood carvings mingled strangely with modern chromo calendars and a cheap brass bed. In fact, the carvings, work of many months of love and craftsmanship, were hung directly above his bed, this product of a factory from which one hundred identical beds might have been turned out in a day.

What a personality too! I did not need to understand each word he uttered to feel the import of his prophetic gestures. One knew the man must be as great as his work — or greater. Pintao is Spanish, but he has lived most of his life in Mexico. His motives are usually religious, but never sentimental. Too bad he has not the opportunity to apply his art, for instance in the carving of some impressive door. Diego made a vain attempt to get him a commission with the government. One application of his work is in the carving of bastones — canes — a row of them hung on the wall, beautiful things. How I wanted one! Much of his work was in ebony. "Ebony is so common in Mexico that it is used even as fire wood," said Pintao.

Tonight a full moon, brilliant, almost dazzling — around it a delicate green light and, still further encircling, a halo of orange.

Sunday. Tina, Chandler, and Edward: Galván invited us to join him for an outing. In a high powered car, sixty miles an hour, we climbed the road to Toluca. Up, we roared past plodding Indians and their burros, through old towns, then into pineclad mountains. Once we were stopped by soldiers, ready for action, and significantly reminded of the revolution. But a flourish of Galván's pass, and recognition of a general amongst us, changed the surly attitude to a salute.

Lunch under the pines — tortillas, hot from the ashes of a bonfire, frijoles y carne — beans and meat — and plenty to drink — tequila y cerveza — beer. The Mexicans had with them, naturally, their guns. "Let us shoot, but save a few rounds, we may need them on our return!" said Galván. He placed a ping-pong ball forty feet away and pierced it the first shot from his pistola. The Mexicans broke beer bottles with much cracking of guns and threw knives with accuracy, but I bested them in jumping.

We climbed higher into the mountains. Tina wore tight skirts, not expecting to walk; they were revealing. "You have pretty legs, Tina," I suggested, being slightly borracho. Pablo, our driver, walking with us, roared with laughter. Por Dios! One never knows when to speak in English with safety, least of all, did I think Pablo would understand!

We viewed the simple and solitary monuments to Mexican Independence; would that all monuments were as fine. Dusk was on us before we left for El Desierto de

44

Los Leones. "Desierto" is not to be translated "desert" as we know the word, but "wilderness," for we were still among pine-covered mountains. Night in the wilderness, the straight black pines, the stately cloister on the hill, — and then the moon rose, la luna sobre el convento. O Mexico, you touch one deeply, poignantly. We loitered along, spellbound, even the ride home was slow, hesitant, reluctant. It grew cold. "I should enjoy a half hour battle to warm me up." said General G.

Chandler plays "El Gato Montés" — The Wildcat — and I remember los toros once more, the opening yell, that wild call for blood from 30,000 frenzied barbarians, — I include myself, — but barbarians who appreciate beauty as well as blood. Black bulls once more charge flirting capes, horses crumble into still heaps of blood and guts, picadores land on their necks, and Nacional saves a life.

January 26. After four cloudy days, gentle rain is falling, much like a January day in California. A sitting was postponed because the young lady could not wash her hair. I wore a smiling mask and changed the date; a cloudy day and a pretty girl's unwashed hair might change another's life, — tomorrow's tortillas depended on that sitting.

The gods always save me at some crucial moment, this time through Flora, who wired me $200. I hope she sold no land at a loss.

Strange not to hear from Ramiel — over a month since he wrote me of his accident, and six weeks since Margarethe wrote "God help me to write you tonight." From both I should have heard, and for not merely sentimental reasons. May's appendix in the slop pail! Dearest sis, when shall I see you again! Johan may be alive or dead, for aught I know; not a line since I have been in Mexico.

Senator Galván in last night to say hasta luego — see you soon. He leaves for the front this morning. His talk of the Indians was refreshing, especially after the depressing opinions from other Mexicans related the last few days, — one felt not only hope, but desire to help. For today, at least, I am a "Callista."

We sat in Monotes talking. "We are going to make Diego Rivera a deputy," said Galván (deputy is similar to congressman in the U.S.). "But you will spoil a great artist," said Tina. "No, he can still go on painting," replied Galván. "Anyhow, Diego is even greater as a statesman."

Interesting faces at Monotes, the derelicts, the dreamers, the useless riff-raff of the world, artists, poets, etc. Always good food there, tamales de pollo y atole, tostadas sabrosas.

Then we went to El Teatro Lírico — Lupe Rivas Cacho y Compañía. I had heard much of her and was not disappointed. The last scene was spectacular, backgrounds, costumes entirely made from sarapes, a dazzling prismatic effect. Everything, it seems, is right in the proper place or at the proper time. Before,

I had not cared for the crude colors of the *modern* sarape, but here the ensemble was stunning.

January 30. The night before we had been alone — so seldom it happens now. She called me to her room and our lips met for the first time since New Year's Eve. Then the door bell rang, Chandler and a friend, — our mood was gone.

Morning came clear and brilliant. "I will do some heads of you today, Zinnia." The Mexican sun, I thought, will reveal everything. Some of the tragedy of our present life may be captured, nothing can be hidden under this cloudless cruel sky. She leaned against a whitewashed wall. I drew close... and kissed her. A tear rolled down her cheek — and then I captured forever the moment...

Let me see, f. 8 — $^1/_{10}$ sec. K I filter, panchromatic film — how mechanical and calculated it sounds, yet really how spontaneous and genuine, for I have so overcome the mechanics of my camera that it functions responsive to my desires. My shutter coordinating with my brain is released in a way as natural as I might move my arm. I am beginning to approach an actual attainment in photography that in my ego of two or three years ago I had thought to have already reached.

January 31. To San Angel, the guests of Sra. Oscar Braniff – Beatriz. A grey, still morning, occasional rain drops. We walked through the crooked cobbled streets, winding up and down and around – it recalled Mazatlán, the houses in pastel shades, the barred windows on street level, the walls — such walls! — three feet thick, with blossoming pear trees just rising above them. Pear trees everywhere in San Angel, planted by the Carmelite monks over 300 years ago, gnarled old trees but still hardy. The monastery of Nuestra Señora del Carmen — what a thrill its massive walls of weathered pink crowned by domes of yellow and blue tile.

We went inside the Church. At the door a Christ so life-like in bloodstreaming agony as to shiver even me. What then must be the anguish of those devout Indians who kneel before this tortured figure!

The walls of the chapel were richly and intricately carved and covered with gold-leaf from top to bottom. The ensemble was unusually complete and harmonious, though two or three modern paintings in perhaps unfinished or destroyed portions caused discord.

On the floor, directly under a glass-cased Christ in black satin robes, was a metal spittoon.

Homeward bound at dusk, still raining a gentle drizzle. El Paseo de la Reforma glistened, wet and fresh. Even the gilded Angel of Peace loomed lovely in the transforming mist.

February 3. Galván — Tina — Edward — Chandler — Pepe to El Desierto de los Leones again. We went prepared for emergencies, three automatics and a rifle, much am-

46

munition. Precautions proved not mere unnecessary readiness against fanciful possibilities. For, arriving at the Convent, we found it barricaded and awaiting an expected raid. Two days before the de la Huertistas had attacked and taken away some thirty horses. Now, on the roof, behind sandbags, soldiers leaned on their rifles.

The wilderness around held a grim portentousness. The sky was leaden. The wind whistled through a sea of pines. "Wear this," said Galván significantly, handing me a Colt automatic. I laughed to myself as I strapped it on. I might shoot straight with my camera, but this!

If the sky was heavy and gloom-laden, the earth was not. Scarlet snapdragons flamed. We climbed through purple lupin taller than our heads. And all the time the gale swept through the pines. We climbed up and up, stumbling forward, slipping back. I was the rear guard. My camera slowed me down. It is always so. I pay the price of my love, — perhaps my only love.

At last, the summit, the gale fiercer than ever. Our eyes lied, for the racing clouds seemed to bring down upon us the mountain side, and our ears lied, for the roar of the wind seemed the booming sea.

A sheltered spot for lunch down by the convent. Indian women served us hot tortillas and mole, hot with pimienta; arroz, frijoles y cerveza completed our happiness. The afternoon sheltered by the cloister walls. No storm could disturb the calm of the cloister, the old monks built impregnable fortresses. They were protected not only from the elements and beasts of the wilds, but from prying people, meddlesome outsiders who might probe too deeply into their well-ordered lives, who might discover rust on their instruments for self-torture. They must have been artists in life as well as master builders. We left early – it might be that danger lurked in the dark.

I wanted to catch Galván's expression while shooting. We stopped by an old wall, the trigger to his Colt fell, and I released my shutter. Thirty paces away a peso dropped to the ground — "Un recuerdo—a keepsake," said Galván, handing it to Tina.

February 6. No money for days—we live on Elisa's savings left in our care. The draft from Flora has not arrived, no mail comes through. Persistent thoughts that I must try to leave here, return to Los Angeles,—not to stay there, of course,—merely to use that place as a start towards new fields.

At last, I have heard from Ramiel, such interesting news too — that concerning the children: "I arrived at your house towards evening —Brett was in the yard chopping wood —Neil was playing. I called. They both ran to me screaming at the very top of their voices. Brett threw his arms around me embracing me with great real affection and Neil clung to me for dear life. We all went in together. Flora was joyous over my coming. Cole came in for his share of affection. It was all very beautiful, Edward, and touched me deeply. What a dear child Brett is.

He has grown so fast and is going to be a fine looking fellow. His freckles are disappearing—a milk white skin, heavy, brilliantly gold hair and the bluest eyes, and the most naive manner. There's a lot of the bucaneer in him, a real swashbuckler. Later on, he should go in for exploration, archaeology. Neil is growing tall and weedy, the same pensive, wistful face and manner. Flora will never understand him. I wish you had him with you. Cole so much like you, Edward, the image of you in face. I love his voice — something very original in his accent and speech — and what a fine shaped head and your eyes — so like yours."

And then this about Flora: "How strange it all is — her great respect for me now. She fairly clings to my sleeve, but really, Edward, she is the same — a touch of madness in her, but generous, after all".

Yes, Flora, you *are* generous, and you mean so well, and you have written me so beautifully. But when I think of living in the same house with you or near you, my reactions are definite. It cannot be. Yet—I wish to be near my children,—the desire is strong.

And this about Neil: "The car drove up. We got in. Neil was in the yard, your wistful dreamchild, Neil. I shall never forget the sad pathetic look on his little face as I kissed him goodbye. I shall never forget how he looked up into my face, the tears in his eyes, and asked so wistfully when I was coming back. As we drove away, he stood there a figure of utter loneliness."

And then this to me, always to be treasured: "But you, Edward, stand alone on your pinnacle, the one person really close to me, you are one of the few men I have known, as I have journeyed through life, who understands the privileges and obligations of friendship, and expresses them with a great generosity. You have comprehended and practised it, in the deepest meaning of the word. You have been reliable, sympathetic. Your tenderness and sympathy which began so long ago have continued unabated.

"I have tried to repay them with just as enduring and affectionate gratitude. Your love has been altogether a free gift. How much it has enriched my life, I shall hardly attempt to say. I miss you more and more as the days pass — no one can take your place in my heart."

February 7. A sitting this morning, another tomorrow morning, and this afternoon an order for 315 pesos from an American here, a Mrs. Moats, portraits of her daughter. On top of all this good fortune, a registered letter just came from Flora with the 200 dollars, so we are safe financially for a while. What a mental relief!

Names of pulquerías noted at San Angel: "El Vacilón de la Morena" — The Jag of the Brunette, "El Gran Mareo" — The Great Seasickness, "Las Buenas Amistades" — The Good Friendships, "La Atrevida" — The Daring One, "Al Vuelo" — In Flight.

48

Pintao visited us the other morning. I took advantage of his presence and photographed him as he conversed with Tina. Some of the heads are rather intense characterizations.

He waxed enthusiastic over my photographs, which pleased me. The approach to his own work is entirely intuitive — hence its great vitality, profundity. He is impatient with geometrically calculated work. With his knife and a block of wood he starts, his mind free from formulae. As he cuts away, the vision — if you will — comes naturally, the form grows unstudied.

I told him that my photographs were entirely free from premeditation, that what I was to do was never presented to me until seen on the groundglass, and that the final print was usually an unchanged, untrimmed reproduction of what I had felt at the time of exposure. "You work in the grand manner," he said...

February 14. The new head of Tina is printed. Along with Lupe's head it is the best I have done in Mexico, perhaps the best I have done at all. But while Lupe's is heroic, this head of Tina is noble, majestic, exalted; the face of a woman who has suffered, known death and disillusion, who has sold herself to rich men and given herself to poor, whose childhood knew privation and hard work, whose maturity will bring together the bitter-sweet experience of one who has lived life fully, deeply, and unafraid.

February 20. The order from Mrs. Moats delivered and received in return 315 silver pesos. I will need a cargaodr — porter — to carry it to the bank. Four more sittings recently, — considering these revolutionary days with everyone "broke" and my work so comparatively expensive I am rather gratified at the response.

Now for the first gossip, scandal re Tina and I living together in Mexico. It naturally came from an American who "thought it was disgraceful and wouldn't send her daughter to me — to such a house to be photographed."...

I accept the loss of a sitting. I can draw in my belt, use one sheet less of toilet-paper per day, eat one less tortilla, and buy one spike of nardos instead of two. Poor woman, I would not hurt your daughter. I am far less dangerous than the sexually unemployed. Do you ask of your butcher his moral attitude before buying a slice of ham? Do you question how many women Caruso has slept with before purchasing tickets to the opera? Do you come to me for a portrait by a craftsman, or to see a marriage certificate garnished with angels?

I am doubting more and more the sincerity of these daily or semi-weekly notes as they concern me personally — my real viewpoint and feelings uncolored by petty reactions, momentary moods. With the passing of time, perhaps the greater part of what I write would not be thought worth writing, either forgotten entirely, or realized as untrue.

I am sure, nevertheless, that my diary is a safety valve for releasing corked-up passions which might otherwise explode — though I sometimes think storm

clouds would sooner break with a thunder of words, — but a perspective of months must bring a saner, less hysterical, more genuine outlook.

Certain it is I blush with shame, growing unutterarbly miserable when I remember or reread opinions I have indulged in regarding Tina; especially does this happen after such a night as came to us last Saturday. The pendulum must swing back and forth, the mercury rise and fall when two people live in too close contact, — but the retrospect of years will return to me overwhelmingly only the fineness of our association. I am sure of this.

Six letters all told within the past week from Ramiel, and one to Tina too. How excited we have been, how truly thrilled and stimulated. I have both laughed and wept — the keenest mind you have, Ramiel — of anyone who has been very close to me...

Chandler is in school now, a technical school offering a course in shorthand, typewriting, grammar: Spanish is spoken...

February 21. A hell of a day yesterday. Bitter disappointment awaits the worker in photography.

After risking my neck to get the 8×10 camera on la azotea—flat roof—over Tina's room, the highest vantage point of Lucerna 12, and after straining my back and stripping my nerves to capture a sweep of scurrying cloud forms, developement revealed fog — ruinous fog — unmistakably from extraneous light, — and a beautiful negative it was, or might have been!

The demon fog can play such uncanny tricks—always I am confounded, disconcerted, mystified until the trouble has been located. All morning I squinted and poked and probed, finally patching with felt the supposed leak due to a warped back, but I lost my negative, as fine a one as any of clouds I have done.

In a blue funk, I was ready to quit, and when Galván called, accepted his suggestion that we ride into the country and then walk for a while.

North, and out of el distrito federal, he took us, to a barranca—gorge—close by — in fact, hardly twenty minutes drive away, yet, from the desolation of this cactus covered gulch we seemed a hundred miles from any city street. Cactus and rock and the tortuous curves of el arroyo seco—the dry gulch—a bleakness to the spot intensified by a lowering sky, black wrathful clouds, angrily unable to spill their burden of rain. We climbed, we shot, we lay on the dead grass and watched the sunset edge the clouds with rose, and all around stiff cacti in spreading silhouette. Tea with Galván, his three old aunts and Don Pepe, — cajeta de Celaya, te, pasas, — jelly from Celaya, tea, raisins, and sweet bread.
I feel better, to hell with photography, art, women and all.

Yet—I wished for my camera today. Those serrated stalks of the maguey their bold uncompromising leaves cutting the horizon, they would make a fine jagged base to a typical Mexican sky.

February 24. Another outing — Galván's idea. He is certainly a good sport. At his own expense — it cost him at least 70 pesos — he hired a camión for the day and took some twenty-five of us to Toluca. The occasion was the staging of un Jaripeo, lassooing of wild horses and cattle, riding them, — all of which brought back early memories of "round-ups" in California. Never, though, have I seen such beautiful and expert use of the rope. The uncalculated postures of the charros, their foot-work, the use of their hands are as graceful as any dance could be and more genuine than most.

The phrase I love — "form follows function" — is as applicable to these charros as it is to the smoke stacks and grain elevators of industrialism. I could watch with more enthusiasm such exploits than the staged entertainments of our best interpretive or "classic" dancers. Perhaps a thousand years hence our successors will "revive" the lost "art" of the charros or cowboys, with like results, anaemic and colorless.

An exciting moment was that when a charro astride a swiftly running horse placed banderillas in a bull's back. Another charro jumped through his lasso and the next instant his rope coiled over and captured a pony racing by at full speed. Much enthusiasm was shown by the audience, dianas —fanfares—from the band, and amongst other symbols of excitement and appreciation Tina's hat sailed into the ring.

The drive to Toluca was through a fair and fertile country, especially el valle de Toluca. At noon we stopped at an old Indian roadhouse. A meal was served fit for hungry bellies, mole de guajolote, tortillas, y pulque, plenty of pulque, so we were all very jolly after. Galván sang as we jounced along over the rough road, and we interspersed with many a "¡Viva México! ¡Viva Zapata! ¡Viva Pancho Villa!" Burros packed high with produce, crated chickens, pulque in bursting pigskins, charcoal, pottery, scurried out of our way, and to help the excited Indian drivers, we shouted "¡Arre! ¡arre!" — giddap — as we passed.

I had Galván's head printed in time to show at the Saturday night party. It was the cause of much interest and applause all around, but especially from Galván himself who was almost boyishly pleased. I place it along with the recent heads of Lupe and Tina, as one of my very best.

February 26. The revolution? Except for high prices on food, charcoal, and other staples, deserted stores, vacant houses, the war might as well be in Europe for all that we feel. Some shock, death among our friends may bring a realization that thousands are being killed all around us. This is a possibility, for Galván is to head an expedition to the front, some of our closest friends will go with him, familiar faces will be missed from our Saturday nights. Lupe and Diego are leaving too, for Chapingo—political reasons. It is all very sad, this losing of new-found friends, — and some perhaps forever.

Tina and I have been writing joint letters tonight. Smoking our respective pipes, we penned lines to Johan and Ito.

Best-Maugard in today with a stunning Mexican girl, Dolores del Rio, a real beauty. Suggested I photograph her, think I shall.

Best carried bad news of Robelo; he has been very sick. I should not be surprised to hear of his death.

February 28. First to hear Gabriela Mistral, Chilean poetess, give a paper on books for children. We left soon, unable to hear. She had an interesting head. From there to el Anfiteatro de la Escuela Nacional Preparatoria where we heard a very fine rendering of César Franck by el Cuarteto Clásico Nacional, the first good music in Mexico — of course, I mean of its kind, for after all I enjoy and respond deeply to the folk songs of a people.

Then to Monotes for supper, finding there the musicians we had just heard. It has atmosphere, Monotes, a real Bohemian "joint."

At the preparatory school we had opportunity to view Diego's murals at leisure. I like his later work much better. I now recognized many familiar faces he had used as models, Lupe, of course, Nahui Olín, Lupe Rivas Cacho, Sra. Crespo, Palma Guillén.

March 2. "Club" night last night. Some thirty of us went en masse to a circus on Bucareli — Gran Circo Ruso it was announced. Russian refugees, some of them, from the Bolshevist government, and a most unpleasant picture they naturally painted of the Bolshevists. Others from the earthquake in Japan with stories of hair-raising adventure. The circus as always was poignantly sad with little children swirling through space, with sorry clowns, and contorting gymnasts, with all its oppressing glitter. Home to dance and tea, but I left the party and went to bed, slightly weary, and rather sad.

March 3. It so happened, Neil, that last night I dreamed of you. I held you on my lap, kissed your broad forehead, and you cuddled close, and asked for stories. We talked long together, of fierce fanged Aztec Gods, of white rabbits in clover fields, — and we recalled days of long ago. How it used to be at bed time you would climb upon my back for a good night ride out under the tall black trees, waving farewell to Lady Moon, listening to the little pines whisper, or maybe, picking loquat blossoms fragrant in the night fog. Now you are there, and I am here, and perhaps you are so big a boy I could no longer ride you so. Well, it came to pass that in my dream you dreamed too... All quiet now, only a distant mocking. I watched your sleeping face, as I looked down upon you, you became not only Neil, but the symbol for all in life of tender hopefulness. They will flout you, insult you, lynch you, but I will protect you, for I have masks that you shall wear, a horned and grinning devil, a sharp beaked bird, a ram in solemn mummery. I have them, I shall keep them for that hour when it must be you shall

52

need them to hide behind and keep inviolate, untouched, the spark within which is yourself. They shall be my only legacy to you, cardboard, painted masks, thicker than your thin skin...

Brett Boy! Hot Dogs! Hot Soup! When are you coming to Mexico? You'll have to learn new slang here, ¡Caramba! or ¡Sangre Santo! or ¡Por Dios! You golden haired, blue eyed son of a sea pirate! — for to see you, who would guess your parentage!... Come through with a letter will you? How's the cheesehound? And do the butterflies still flit before your stumblings? I'll bet you're a handsome devil by now, a real heartbreaker with the ladies, but watch out for them... You'll be the butterfly, and maybe break your wings. Then you can't fly to foreign lands after gold and lost Gods. But if you don't get trapped, you may in your search for gold and conquest, land on some cannibal island to become the Fair White God of a swarthy race. Wear a plumed hat and a jewelled sword, ride an elephant and have a hundred coal black wives to wash your socks and tickle your toes! Quien sabe? Hot Soup! Sizzling Hot Dogs! Dad —

Baby Cole —

Six months since I have seen you! Do you even remember how I look? I wonder, because my mother died when I was five and all that returns to me of her, are a pair of black and piercing eyes—burning eyes—perhaps they were burning with fever. But Mr. Gehee says you are the image of me, so all you have to do is look in the mirror and see Daddy and yourself all in one! Say, my greatest desire is for a ten minute romp at hide-and-seek with you, to hear your shrieks of joy, to see your eyes snap and sparkle, or to have you jump from the terrific heights of some table — jump with a shiver across the yawning chasm below into the sure safety of my arms. So let's plan this prodigious exploit, you and I,—anticipation is good tonic for the blues. We'll pretend hard, shall we?—Daddy.

A recent morning I took my Graflex to the circus, made negatives which please me of the graceful folds, the poles and ropes of the tent. One, "shooting" straight up, recalls a giant butterfly. At least two of them are interesting as experiments in abstract design. Tina too made several good things of the circus...

3. *The Thing Itself*

March 6. Incredible that I should have been in Mexico six months without visiting the Nacional Museum! But the right day nor time did not come until yesterday, when Tina and I decided to go there. No use in my attempting descriptive matter, I shall only put down my personal feelings.

I had expected much, but what I saw was far beyond my expectations. Besides the gigantic sculptured pieces hewn from rock, more or less familiar through reproductions—things overwhelming in their grandeur, their imaginative attributes, their fineness of conception and execution —there were exposed exquisite jewellery of the most delicate craftsmanship, gold, silver, jade; sculptured heads in obsidian, alabaster, of a simplicity and economy of approach quite a revelation. Even pieces in that perishable medium, wood, remained, a few examples only, to exemplify the supreme art and civilization of the early races who once glorified Mexico!

We were fortunate in having Jorge Enciso, supervisor of public buildings, as our guide, and through him were admitted to the phallic room. This was intensely interesting... There was no note of frivolity in them, they had a religious austerity.

From the fact that no remains of prehistoric man have yet been found in Mexico, Enciso disagrees with Robelo, inclining to the theory that the orientals, Egyptians, and other races came here, but he told us that four distinct epochs lie buried and are now being excavated under Mexico City!

Dr. M. came just before we left for the theatre to take "us" to a merry-go-round he had discovered on Orizaba. I told Tina I well knew he only asked me through politeness, for the Dr. M. is most attentive to her. "Three's a crowd, dear. I would feel quite uncomfortable." "But Edward, I have no desire to become involved with Dr. M." So much for my doubts and jealousy.

The theatre party wound up with tostadas at Monotes. Too much for one day, I am wan and worn this morning and must rest, for tomorrow is our belated Mardi Gras party, everyone to mask, everyone to become borrachito, or plain borracho.

March 9. The Mardi Gras party went off with a bang! Many funny and some quite beautiful costumes. Masking, costuming, and drink loosens up the most sedate. Tina and I exchanged clothes, to the veriest detail. I even squeezed into

54

a pair of mannish shoes which she had just bought. She smoked my pipe and bound down her breasts, while I wore a pair of cotton ones with pink pointed buttons for nipples. We waited for the crowd to gather and then appeared from the street, she carrying my Graflex and I hanging on her arm. The Ku Klux Klan surrounded us and I very properly fainted away. We imitated each other's gestures. She led me in dancing, and for the first few moments everyone was baffled. After awhile I indulged in exaggerations, flaunted my breasts and exposed my pink gartered legs most indecently. Lupe was enraged by my breasts, punched at them, tried to tear them loose, told me I was sin vergüenza—without shame. I treated Tina shamefully in my "take-off"—even beauty can be made ridiculous. I hope I have not "cramped her style!"

Lupe Marin came dressed as Diego, padded, ponderous, lumbering. Chandler in his Indian suit was a real success, he is liked by everyone.

I drank freely of tequila but became only slightly borracho, enough to be a little vulgar, and I think shocked the good Frau Goldschmidt when Nahui Olín, Dr. Matthias and I danced together.

Best-Maugard came in late to bid farewell. He and Ciro Mendez left on the 3:00 a. m. train for New York.

March 10. Visiting the museum last week focussed my thoughts once more on the issue of photography. For what end is the camera best used aside from its purely scientific and commercial uses?

The answer comes always more clearly after seeing great work of the sculptor or painter, past or present, work based on conventionalized nature, superb forms, decorative motives. That the approach to photography must be through another avenue, that the camera should be used for a recording of *life*, for rendering the very substance and quintessence of the *thing itself*, whether it be polished steel or palpitating flesh.

I see in my recent negatives of the circus tent and of the glass roof and stairway at San Pablo—pleasant and beautiful abstractions, intellectual juggleries which presented no profound problem. But in the several new heads of Lupe, Galván, and Tina, I have caught fractions of seconds of emotional intensity which a worker in no other medium could have done as well.

I shall let no chance pass to record interesting abstractions, but I feel definite in my belief that the approach to photography is through realism—and its most difficult approach.

March 12. From the negatives made of Tina lying nude on the azotea, one very excellent result which I have printed: it is among the best nudes I have done. I also printed the arrangement of glass roof and stairway made at San Pablo—a fine print, I like it. Reprinted nudes of Margarethe sold at exhibit and a portrait

of Montenegro done last week. Charlot, as planned, sat to me yesterday: I photographed him while he sketched Tina.

I have always had the desire to frequent the pulquerías, to sit down with the Indians, drink with them, make common cause with them. Two things have held me back. First, most of them are dirty! I don't mind a *little* dirt! But even stronger is my second reason for hesitating; I feel my presence would be resented, even to the point of my landing in the street. Imagine sauntering into the pulquería named Charros No Fifís, wearing my knickers and carrying my cane!

However, Tina and I came across a pulquería on Insurgentes: it was quite clean and almost empty. We went in and enjoyed not only the idea of drinking together in a pulquería but the delicious pulque as well, which this time was cured with pineapple.

Another place we went together lately was to a "cine." Nothing unusual to record "going to a movie," except this time we saw Tina herself on the screen, a small part she did some years ago in Los Angeles. We had a good laugh over the villainous character she portrayed. The brains and imaginations of our movie directors cannot picture an Italian girl except with a knife in her teeth and blood in her eye.

This morning I was awakened by running water, just water from the faucet, but never was the sound of water so sweet before. For two days we have had no water, or rather only that which was conserved in advance, and it was running low.

A city of a million people without water, cut off for repairs! A water famine must be fearful—the very thought is terrifying. I splashed extra long in my cold bath though I only missed it twice.

Oh! but those morning baths at Tacubaya—standing naked in the sunlit patio, with the musk-rose, the twittering birds, pouring buckets of ice-cold well water over me, then basking in the early morning sun. I miss the beautiful old house at Tacubaya too, and my whitewashed room. I still dream of having a high-walled whitewashed room opening onto a patio.

But for the wallpaper, my present room has much charm, and could, with a pot of paint and a day's work be greatly improved. But I begrudge the money and time on a place uncertain as a permanent abode. My present effort to make the room livable consists in the placing and use of various native crafts: a sarape over my bed, a petate for my floor, a lovely old flower-decorated chest to hold treasures, the caja de orinar for more treasures—old love letters. The bastones de Apizaco brighten one corner, and my chair is an "episcopal."

March 16. 5:30 this morning and despite the late hour we retired after the party. A bad head: it was considerably jarred last night, boxing with Charlot. He was once an amateur champion in France and certainly knocked me around rather roughly!

56

Some criticized my latest nude of Tina reclining on the azotea because of "incorrect drawing," but Charlot did not mind it: he tells me that Picasso got his "inspiration" to use false perspective from amateur photographs.

Diego had another interesting note on Picasso, that he was never influenced or went to nature for inspiration, always to other "schools" of art.

Another nude of Tina's hands and breasts was well liked: it has a fine flow of line, and despite a loss of texture through movement, —the exposure was forty-five seconds, —it retains solidity and pleasing quality.

I danced many times and furiously, —it was distraction I needed. I am most assuredly not mentally calm. The ghosts of my children haunt, their voices, their very accents ring in my ears. Cole's merry laugh, Neil's wistful smile, and blue-eyed Brett's generous gestures. Some solution must come; I need them, they need me.

The best dance of the evening was with Elisa, yes, our servant Elisa. I dragged her to the floor, despite her protesting cry, "No, no, Sr. Don Eduardo," and we whirled around at a great rate while the crowd applauded.

The mail brought me Paul Jordan's new book of essays, *On Strange Altars*. Glancing through it I note passages which recall and reveal the charm and lovable qualities of P. J. himself, and his delicious humour too. The dedication that is the personal one to me reads, "Whom we call friend we treat with discourtesy." Just once have I had a letter from P. J., that one from London after his meeting with Havelock Ellis, only a short note. I should enjoy one of the all night sessions at "Erewhon," the blazing grate fire, the library lined with books and thick with smoke, and P. J.'s tales of his adventures in England, with Arthur Machen, Thomas Hardy, Havelock Ellis, for there are few who tell tales so delightfully as P. J., nor relate naughty stories with such gusto and with less offense. I still see his twinkling eyes, hear his chuckle, and "Cousin Sarah" stretched on a nearby lounge, listening with smiling tolerance.

March 21. Not yet 5:00 a. m. I awaken early as in my California days, my mind refuses the sleep my body craves. Last night I wrote a love note to Margrethe and received one from Flora: poor Flora, she has had a dirty deal from life. I must try to be tender to her, it is not easy to thrust aside such a great love as she offers me, —that is, when it comes from a distance!

Brett sent me a screamingly funny letter: part of it read—"I have a sweet new girl, she sure is a peach—Old Orville tried to kiss her but I knocked him in the jaw ha, ha."

March 23, Sunday. Three servants this morning! Elisa's sister and aunt descended upon us from Guadalajara and immediately went to work as though they had always been here. I am wondering if they have adopted us! They awakened me too early this morning with their industry and I feel quite spleeny from so short

a sleep after the party—quite a crowd last night. I did not enjoy it, excepting the food which Lupe prepared. Her turn always brings something good; count on Lupe to use imagination and not hand out sherbet and stale cookies as did Margarita, the fresh and blooming German girl. We had pozole and pulque curado, and plenty of it.

We went last Friday to the weekly gathering of another group, mostly Americans, the first time in Mexico to a party where "American" was spoken! It sounded almost weird. I didn't particularly enjoy it. When Spanish is spoken one can't understand all the vacuity of the conversation. Carlton Beals, author of a new book on Mexico, was the most interesting person there.

Tomorrow is my birthday. A year ago today—and sometimes it seems but a few weeks past and again distant ages—Margarethe planned a surprise on me, and I sat down to a festive table at Richard Buhlig's,—Ramiel, Henry Cowell, Buhlig, Margarethe and I. Now Henry and Richard are in Germany and I am here.

This being Sunday morning Elisa brought me flowers fresh from the market, clavel sencillo, "simple pink," and pinned one to my buttonhole.

Sunday evening,—After a day of loafing and napping, it is well to let the world slip by occasionally in indolent indifference. The twilight was spent in Tina's room and in her arms, for she had sent me a note by Elisa. "Eduardo: ¿Por qué no viene aquí arriba? Es tan bella la luz a esta hora y yo estoy un poco triste." — Why not come up here? The light is beautiful at this hour and I am a little sad.

There is a certain inevitable sadness in the life of a much-sought-for, beautiful woman, one like Tina especially, who, not caring sufficiently for associates among her own sex, craves camaraderie and friendship from men as well as sex love. How well she indicates this desire and the difficulty of attaining it, when, during a discussion last night over a certain woman, homely, repressed, and probably not able to get a lover, but withal popular with both sexes, she exclaimed, I thought pathetically, "At least she has good friends." So we were just friends for that twilight hour and later Chandler brought us naranjas y chirimoyas y pulque still fresh from the party. When I returned to my room for bed, there on my pillow was a new design by Chandler done for my birthday, a beautiful thing, one of the best he has made.

March 24, 1924. "Thirty-eight" today! My Birthday morning. Elisa is playing music so I shall not be "triste." Chandler came in before I was dressed and beat me up quite roundly. Then Tina appeared with the coffee pot. "Hurry up. Wash your face. We'll have coffee." Returning, my table was present laden. Elisa had bought me one of the naive, realistic figurines in clay, a group, a brave charro in grey and gold, his novia in Mexican pink, holding, we decided, a bottle of tequila. From dear sister a letter enclosing a U. S. "greenback" which will be

58

promptly transposed into ten pesos plus. From Tina a pair of silk pajamas with geraniums in the buttonhole, a little pito—whistle—too,—a crowing cock in clay to replace the one mourned as lost, and, most loved of all by me, a letter, a note of two words and three purple hyacinth buds which conveyed more in simple emotion than pages could have done. The words were only "Edward, Edward!"

March 25. The 24th was also Turnbull's natal day, so Tina supervised a delicious dinner for us with emphasis on Italian spaghetti and red wine. After dinner Roberto and I went to view the private archaeological collection of William Niven. The exhibit represents the five successive civilizations of Mexico covering a period of over 10,000 years! It also represents the unaided labor of Niven who has made important discoveries and has many pieces not duplicated in the National Museum. Niven is Scotch, entertaining, witty and very much in love with his work.

I came away with three examples from the Tlachichique civilization, "the makers of all things," dating 2000 years before Christ, two fine heads and an exquisite hand in terra cotta—they cost me fifty centavos each. If I had only fifty pesos to spend, what a collection I might have! These pieces he excavated at Atzcapotzalco, buried some two and a half meters below the surface. This civilization was pre-Aztec. The Aztec period lies buried at a depth of one and a half meters and dates much later,—1200 A. D.

March 26. And I have been to see Niven again. A crowd of us had dined with the Wolfs in a vegetarian restaurant they frequent only a few blocks from his museum. So we went there together, spending a full and stimulating hour. Niven is so willing, anxious to talk, to explain. He is 74 years old but vigorous and enthusiastic. He invited me out to dig with him on some Sunday. This appealed to me indeed. I accepted.

March 28, Early morning. The tent of El Gran Circo Ruso is now enlarged and printed. I could wish for a more searching, critical definition in parts: the use of camera without tripod is not conducive to accurate focussing in a dim light which precludes the use of a small stop. Nevertheless, if it is not microscopically sharp, it is visually satisfactory, and I pulled a good print from the negative.

March 29. Without water again. None since yesterday noon, when, without warning, it was turned off during my platinum printing. Surely there is something fearful about a water famine.

March 30. French, Spanish, German, Italian, Mexican, Hindu, American, these nationalities were represented at last night's party. At times there have been more; most always Chandler and I have been the only Americans present. Spanish, of course, is the common tongue though French and German are also heard.

59

It was Tina's turn to serve, and she gave us, like a true Italian, spaghetti and red wine.

The evenings are taking on a different aspect as new faces come and old ones go. Galván and the fair Margarita are still missing and Lupe is sick in bed, enceinte it is hinted, but that word is too sophisticated for use with Lupe—plain pregnant is better. I genuinely regret the absence of Galván, his guitar, his singing and spontaneity.

Then the advent of the few Americans brings a new note, fortunately acceptable. The Wolfs are both teaching in the public schools; which fact I note that I may mention the waggish humour Mr. Wolf has introduced into his teaching. Wolf once served his day as an I. W. W. soapbox orator and is now helping to perpetuate the delightful songs of that political party by imparting them to the Mexican school children!

For the evening I had enlarged and printed a head of Neil, and hung it over the black table. "What a beautiful boy," was the general comment. I easily agreed. At eleven o'clock Sr. Oscar Braniff will sit to me, the first real sitting in several weeks. I shall pray to the Virgin for cash results!

April 2. Is it possible this is April! The rains must be about over in California, and here they will soon start. This is the most disagreeable time of the year in Mexico City, so very dry, with much dust in the air and frequent high winds. It has been warm too, but not unbearably so. I am told it never becomes warmer than the weather just experienced. Then it is nothing to what Los Angeles can occasionally offer in the way of heat. And when I think of Eastern U. S. with its prostrating summer days and unrelieved nights, this country must be quite a paradise in comparison. This weather has been perfect for printing Palladiotype, so dry and cloudless.

We called on Lupe last evening. She is not pregnant as rumored. I was shocked at her appearance, so pale and haggard. Two months in bed was the physicians' instructions; it seems to be a general collapse. Jacoby, brother to Frau Goldschmidt, bought two of my prints for her birthday. They were "Hands against Kimono," which, by the way, I like as well as anything I have done in Mexico, and "Profile" one of the old nudes of R. W. But everyone working for the government is broke so I got only promise of pay, and this is not well for us, being almost penniless too!

A letter from B. from "her desert": "Now spring is on the desert once more and I spend days gazing at the smoke tree in bloom, a grey exquisite little tree with indigo purple blossoms and they remind me of you as everything lovely which I ever see or touch will do." And more: "Do you think you shall be in Mexico City this summer? I may come up for a few weeks. Let me know. Be well and be sure of my love ever."

60

It is late, after midnight, but I am wakeful, and the fleas bite. It seems I shall never become acclimated to las pulgas.

We have just walked home from the Salas, a warm balmy night. The evening was spent discussing our proposed trip to Tepotzotlán during Holy Week. We are all quite enthusiastic over the venture, just we six, the Salas, Felipe, Chandler, Tina and I, and, oh yes, Elisa to keep house for us.

A good supper tonight, the Salas have a most excellent cook, spaghetti rivaling Tina's and codfish Spanish style which I could not but compare to the simple creamed codfish or codfish "balls" (what a name) of my New England ancestors: the codfish a la española, a racy, piquant dish, and colourful to the eye: that of New England a staunch, wholesome, unimaginative food, cooked to be consumed.

Upon our return we found that "I" had had a visitor. Elisa told us that Dr. M. had waited a long time for "me." It seems likely Elisa is mistaken in the intent of the call, for a fresh pineapple had been left with greetings for Tina!

I wish I could assume the attitude of Charlot and Féderico, who had great fun at the Goldschmidts, showering Tina with mock attention in the style of the Doctor whose infatuation is so profound he cannot disguise it, or else does not care to.

Sunday morning. The party was a frost, due mostly to the poor food the Frau Goldschmidt served — and not half enough at that. I hinted to several hungry-looking friends where to locate the pot of cold frijoles and they disappeared one by one into the cocina.

Aside from the food, the parties are no longer what they were. The ones who added so much life have gone: Lupe, Galván, and some of the señoritas, who if nothing else were pretty and gay. A German captain came, a striking figure with his military bearing, shaved head, sword cuts, and spats; an exact drawing of him might have been a cartoon, but he was agreeable, entertaining, brainy, and warmed to my work. He is supposed to be, we were told, the best dancer in Germany, but there was no dancing last night. The insatiable Dr. M. was absent and Tina spent her evening enthroned like a queen in an equipal, unable even to walk on her sprained foot.

The roses are blossoming now in California. The "ragged robins" must cover my old studio and the orange trees are fragrant, the loquats too; the fresh spring rains have transformed the landscape. These months are the loveliest in California.

April 9. On top of other troubles, I have had more fog, negatives absolutely ruined. I have found my trouble, or troubles, for my camera leaks light in half a dozen places. Evidently the protracted dry weather of this season has caused

shrinkage of the wood. No sooner have I found one leak than another would appear, keeping me in a state of continued consternation.

Experimenting yesterday with Tina as a target, we were interrupted by Charlot and Federico, and, shortly after, Rafael wandered in and then Monna. So we sent Elisa after pulque and idled an hour. The Mexicans have a habit of calling unannounced. Fortunately, we have not, as yet, been greatly bothered. Though, sometimes, it has been necessary to refuse an audience, especially to the frequent calls of Dr. M. whose visits, however, can not be blamed on Mexican habits! Charlot adorned a wall on our azotea with a cartoon of Dr. M. kissing Tina's hand while her head is turned over her shoulder to kiss someone else. It brought much laughter from all including Tina. One way to kill a person is to ridicule.

Much work and experimenting with my leaky camera, mostly using "Panchito" for a model. I believe every hole is now found and stopped and I am ready for the trip to Tepotzotlán. We may go alone, since Monna Sala cannot leave her work.

Tomorrow I am sending with Federico Marín, Lupe's brother, forty prints for a "one man" exhibit in Guadalajara during Holy Week. With what backwardness do I part with forty of my best photographs! Weeks of work and much money they represent. Federico and Charlot have begged us to come along, promising a royal time at very little expense, but it does not seem possible. We can go to no expense, nor spend the time in being entertained.

Lupe called today. After all, she is pregnant, and, though very sick in appearance, much better mentally.

Almost two months since hearing from Ramiel.

April 12. The clouds hang heavy, forecasting rain, also interfering with the progress of photography, particularly in the printing of Palladio. It sprinkled a drop or two at Santa Anita yesterday, not enough to be noticed by the festive throng, gay in their celebration of La Fiesta de Dolores.

On the Viga canal, from bank to bank, floated flower-covered barges filled with the merry-makers, all poppy-garlanded and singing, or strumming guitars, or making love, or drinking pulque. Not only the women and children wore wreaths of flowers upon their heads, the men, too, were crowned with flaming poppies or snowy daisies.

We sauntered down the Paseo de la Viga, Tina and I . . .

Everyone was either eating, selling, buying, or carrying celery. Of course, we conjectured, celery must have some religious significance, maybe blood purification. But no, we were told, it was only a custom comparable to our "raisin day" in California, or "apple day," or "eat-a-pie day," celery being the especial crop of this community.

Once we ventured into a crowded cross-street and found it difficult to get out.

62

A swirling, shoving, confetti covered crowd, borrachito with pulque, surrounded us. I held my breath for fear of harm to the girl's sprained ankle, or a worse calamity. We fought our way out ... Again, we essayed into a tempting patio lured by the sound of music. It was jazz, but very languid jazz and there pulque flowed freely. White geraniums lined the walk; we plucked a spray and left.

The church at Santa Anita was simple, but exquisite; the color pink, weather-worn to expose the coat of blue underneath. A church, large or small, simple or elaborate, I exclaim, "This surely is the most beautiful of all!" Then, remember-ing, or seeing again an old one, I must again exclaim, "Ah, no! How could I have forgotten, this is the loveliest."

Today, in El Café de Nadie, Avenida Jalisco, I am showing six photographs under the auspices of Movimiento Estridentista. It is the same cafe where months ago de la Peña took Llewellyn, Tina, and myself to dine and I watched the pale prostitute with the scarlet mouth. That night I am sure Llewellyn and I were excess baggage! The exhibit is in charge of Maples Arce, editor of *Irradiador*. Others showing are Jean Charlot, Rafael Sala, and masks by Cueto.

The Salas are, after all, able to join us Semana Santa for the vacation in Te-potzotlán, so we are in the throes of preparation, planning to leave Tuesday. A letter from Jorge Enciso gives us the "key" to Tepotzotlán and permission to sleep and live in the convent. Chandler does not care to go and I am not en-couraging him, for after a day he would be restless, want to return, and drive us all quite mad.

Ciro Méndez and Best have been seeing Ruth Wilton in New York. I intro-duced them and today a letter from her tells of their times together. I sent Ruth a little jícara and an Aztec head. She writes, "How I appreciate the fact that you chose these things and sent them to me. It makes me happy! Somehow it typifies what your friendship has been to me."

April, Semana Santa, 1924, Tepotzotlán, Estado de Mexico. Tina, Monna, Rafael, Felipe, Dominga, Elisa, and E. W ... To begin first with the last day:

"If you awaken before I do, call me at 4:00," Tina had said. It was after five when the swallows began circling in and out through the mirador where she and I slept. At my right, a full moon was setting back of the tower of Tepotzot-lán; to the left, over a green fertile valley, the sun was rising through morning mist. The air was delicious after the season's first rain. Birds everywhere over-flowed with song and I thought to myself this is one of the never-to-be-forgotten moments of my life! "Tina! Tina! Awaken! It is time for coffee. We must start early this last day."

There was no lingering over coffee. We, with our cameras, were soon on our way. For a peso an Indian boy would carry the cameras all morning; fortunate, for an 8×10 outfit with an f. 3.8 lens is no small item in weight. Looking back

toward the church, Rafael and Monna appeared on the horizon and soon joined us for "buenos días." But we separated, Tina and the Salas in the direction of a little white chapel, I into the region of cacti, maguey, and crumbling walls.

Fascinating material to work with, the maguey, the organ cactus in their stark severity; not easy to isolate however, and so, after two hours wrestling with my problem, the boy suggested fresh pulque which idea appealed. Five centavos worth each and we were refreshed with this agreeable mild intoxicant. So I once more attacked the maguey to honor the plant from which is fermented pulque, the plant and beverage so typical of this plateau.

Sharper and sharper I stopped down my lens, the limit of my diaphragm, f. 32, was not enough so I cut a smaller hole from black paper. How ridiculous a "soft focus" lens in this country of brilliant light, of clean cut lines and outlines, —of course, I should add, how ridiculous the "diffused" lens in any country!

This morning's examination of my negatives—for though I returned quite worn last night I could not sleep before developing—revealed a number of satisfying results, things which express well my reactions to Mexico. Technically speaking, I had several disappointments, bitter ones, fog again utterly ruining three negatives despite all my preliminary precautions; but those which were clean were brilliant and chemically fine.

I exposed no film on the church, except a few records with the Graflex for "recuerdos." Many times I pointed my camera towards it—almost longingly—towards this building of such great beauty, but always the lens was finally pivoted away and off into the region of cacti and maguey, or of walled streets and open sky. Of the walls and cacti I had much to say—they, at least, have not been exploited, but the most casual, superficial of tourists would exclaim in rapture over the church, "snap" it with their Kodaks, and then rush back to the hotel lobby.

A group of such tourists we observed awaiting the return train for Mexico. They furnished us much amusement, this family of Americans! How they edged away, nay, shrank away from every sarape-wrapped figure who brushed too close. One imagined a bottle of "Lysol" in each of their pockets and smelling salts ready for use. We soon parted company for they rode "first class" while we piled into "second."

It is evening; already I have printed and mounted one of my Tepotzotlán photographs. Two reasons prompted such celerity: first, intense desire to see finished prints, to gloat over the results; second, to forget, by plunging hard into work, our present precarious condition, for I have just eight centavos left, with rent past due.

The print I made is a lovely thing of the plaza. It has luminous shadows and delightful detail. A huge cross cuts almost the centre of the print. A stickler on

"composition" might complain, but rules, like laws, were made to be broken by those who can. This negative was made from aloft, in the tower.

However, it is not my very best one, which is an excellent thing of organ cactus against a crumbling old wall, but with a technical defect, a new and sickening trouble, a round spot of fog, apparently lens flare, appears in the center of half of my negatives. Why I should be thus afflicted I cannot guess, for I have used the "Variable" stopped way down before without trouble and none of these negatives were made against the light for, generally, I avoid back-light as the plague. Well, being a good printer, I can print down those spots, but I don't like the idea, nor fancy the extra work, and it takes some of the joy away that I get from making a straight print from a perfect negative. But for the flare spot, some of the negatives needed not even the work of spotting one dust speck.

La Iglesia de Tepotzotlán, in the churrigueresque style, or at least the facade is (but I must avoid the use of terms and periods, not knowing them), is a church dating back to the 17th Century. Over-elaborate, for me, are the tower, facade, and interiors, yet one marvels at the cohesion of such elaboration. Inside is gold, gold, gold over intricate and beautiful woodcarving; the ensemble fairly made one dizzy. Only a virgin land of untold wealth plus the fanaticism and faith of the Indians, could have made this possible. And these Indians were not merely influenced by the Spanish conquerors in their work. "We have nothing comparable to this in Spain," exclaimed Rafael.

One small room in the dome of which floated a beautiful golden "bird" was anything but Spanish; strange figures holding up fruited baskets, swarthy tropical figures and fruits which had nothing to do with Catholicism. Here the color scheme was a departure from the monotony of so much gold; vermilion and blue combined with the gold to give an aspect of almost oriental splendor. My "bird" which flew in the dome has become a standing joke. "Don't you know that's the Holy Ghost?" said Monna.

Another negative with the pissing Indian: he came out so opportunely just as I was to expose, and stood there serenely, as one is wont to do; I uncapped the lens and have him, stream and all, a touch of life quite unexpected. It might be called, remembering Rosenfeld, an "affirmation of the majesty of the moment."

Living was none too comfortable in the convent, for water was scarce and a daily bath is my one confirmed iniquity. But we ate well on pollo and tender little pigeons. They, at 35 centavos each, were cheaper than meat. So much fun at meal-time gatherings with Felipe's attempts at English, with jokes over our improvised candlestick, a candle inserted in a roll of toilet paper and adorning the tripod top to light the supper table. And so it went—a vivid week to remember.

April 23. I am still in a daze over the result of my exhibit in Guadalajara. Charlot and Federico returned bringing us 280 pesos for eight prints! The ones that sold

were as big a surprise as the number—among them several of my very best things. The complete list follows: "Steel," 40. pesos, "Pipes and stacks," 40., "Pirámide del Sol," 30., "Grey Attic," 35., "Breast," 35., "Refracted sunlight and Torso," 30., "Pirámide del Sol," (another view) 30., and "Karl Struss, Cinematographer," 40. Yes, I am amazed!

And then to actually spend money for them! To not only admire them, but to desire to possess them! Los Angelenos would have said, perhaps some few of them, "Yes, they are nice, but so expensive and I need a new tire for the auto; otherwise, we cannot go to the beach Sunday," or, "I must have a new hat for Easter." The Mexicans, impoverished from the revolution, complained of the prices, yet they bought.

I wonder if a trip to Guadalajara would not pay well? I should much prefer living in one of the smaller, less spoiled cities, but never considered the idea as practical. Federico says that living there is half what it is here.

This city has never appealed to me as a whole, not forgetting the charm of certain spots unspoiled as yet, and its delightful climate. But there is Chandler to consider, he is interested and working hard in his school and insists we must go without him!

April 24. Printed more negatives from Tepotzotlán: a subtle, delicate print of a weather worn wall, quite different from the vigorous work I have been doing, pleases me; a couple of the organ cactus and walls also please, but I had a hell of a time printing down the flare spots and find some almost impossible.

Today I received fifty dollars from Flora and an order for 120 pesos. Money seems to be flowing in by way of contrast to the past few weeks.

Evening. Just waiting here by my window for the Salas, who are coming to chocolate at 6:00. It is raining gently, the sky is so soft and grey, the air so clean.

With the brief morning sun, I printed my order and then one more negative from Tepotzotlán, an arch with organ cactus underneath; it might be a stage setting and is dangerously near being just picturesque. I might call my work in Mexico a fight to avoid its natural picturesqueness. I had this premonition about working in Mexico before leaving Los Angeles and used to be almost angry with those who would remark, "O, you will have such a wonderful opportunity to make pictures in Mexico."

From the twenty or so negatives I exposed in Tepotzotlán, I have at least ten worthy of printing in Platinum.

A friend, Dr. Mayorga, an optometrist, also an amateur photographer who has himself made several lenses, came this morning to look for my lens trouble. He opines that I cannot avoid trouble using an anastigmat lens of f. 3. 8 with such

a surface of glass exposed to the dazzling [light] of Mexico. A lens shade does no apparent good. Of course, wider open, the flare disappears, but that does not help me. I want depth of focus. This leaves me no lens for outside work. I shall try to pick up a cheap rectilinear of about 15 inch focus, one that will stop down to U. S. 256!

April 26. Chandler's Birthday. I peeked into his room, next mine, and I am sure he lay there pretending sleep to postpone the proposed beating: he is fourteen today.

Our roomer, the engineer, owes now over 200 pesos and tells us he can pay nothing for two months more, wishes to give us a note. He may be honest but we cannot assume this rent burden any longer. We must move and are now in the midst of house hunting and fighting with our dueña.

Ella Wolf served us Borscht, a Russian soup, black bread, and Russian candy this party night: altogether it was a successful gathering. I am no longer under illusions that the *people* of Guadalajara have better taste than those of other communities, for Charlot told me that the Governor of Jalisco purchased five of my prints for the State museum; however, this was satisfying news.

Charlot in looking over my prints laughed outright, then flushed confusedly. "I laugh so at times when I am emotionally stirred," he said.

Federico brought bad news, that another and probably worse revolution was fomenting under General Flores: if I were sure this were so, I should return at once.

Charlot's burst of emotional laughter recalls how in the old days, I, for the same reason, used to laugh at Tina and she would look at me surprised and wondering.

April 28. Sold six prints last eve to an American here from Cincinnati. Needing money so badly, I let them go for much less than I should have, the six for 150 pesos. Mr. Hawley bought: "Head of an Italian girl," "Romantic Mexico," "Portrait of Robelo," "Valle de San Juan Teotihuacán," "White Iris," and one of the new prints from Tepotzotlán.

If only I could make a decent living selling prints instead of doing portraits I should be happy. With the Guadalajara sale and that of last night I have received 430 pesos for fourteen prints within the ten days past.

April 27, Sunday. "El Toro," "La Corrida de la Primavera," the "last" fight of the season, so advertised, yet almost two months ago they said the same thing. However, that insatiable "fan," Turnbull, assured me it would be the last big one. We went together. The day was obscure, the wind high, making fine cape work difficult, and also exceedingly dangerous, for a gust of wind swirling the cape might cause the bull to charge in the wrong direction with even death as

a result. Despite the day, Gaona was superb and I can now well understand why he is crowned king of them all.

I find myself watching the fight with less emotional excitement and more intellectual curiosity than heretofore, and caught myself humming a popular air with the crowd, even as the bull drove his horns into a horse's belly. One becomes hardened to anything, used to all sensations; blood and death grow eventually commonplace, love and romance too. It is only my work that I return to with never diminishing enthusiasm, with untiring energy.

Music, jesting, laughter, "rough-house," color, blood, death! What a wildly tense two hours. And walking home alone down Oaxaca, what hideous humans begged alms, what loathsome dogs yapped, what beautiful señoritas leaned from flower-covered balconies. What a land of extremes! And what can be its destiny?

April 29. Reprinted several of the prints recently sold, also one new one, that of the pissing Indian. It is a fine print technically from a fine technical negative. The photograph reproduces and conveys all the solidity of the house and walls I felt as I viewed my ground glass. Also it has humour!

Tina just called up, "I have gained a real triumph, Elisa is brushing her teeth! I don't know whether she is using your brush, or my brush, or a new one of her own, but she is actually brushing them!" When we first got Elisa, Tina encouraged her to brush her teeth, but she would always say, "O, that is only for rich people!"

Elisa's sister, Dominga, is still here; apparently she has adopted us. We say nothing for she helps Elisa and she has all too much work in this enormous house.

Visiting Roubisec today; he has a copy of *Ulysses* we should like to buy, or borrow. Tina remarked, "A friend told us that soon there would be another revolution." "He lies," answered Roubisec, "there will be not one, but forty!"

April 30. "Elisa! Elisa!— Oiga! Tráigame cafe, pronto, pronto!" Listen, hurry!— Bring coffee, fast, fast! for today I must move. I am the only one who must change The engineer wants my room at 30 pesos per, and we have rented the garage for fifteen, so we have decided to stay here and try to re-rent the front rooms for around one hundred pesos. If we can do this, we might much better stay where we are than try to re-establish, fit up new workrooms, and pay the landlord an extra month or two for breaking our contract.

Despite the ugly wallpaper, I have become attached to this little ladder-reached room in which I have been able to isolate myself to my benefit as well as others...

May Day, 1924. Awakened by loud, furious, and prolonged explosions, "The new revolution is upon us," I thought, "or the forty of them"—but then, after collecting my sleep-dazed senses, I remembered this was May Day and being celebrated Mexican way.

68

I awakened this morning in my new room. My first words were profane and directed toward the wallpaper. It is covered with persistently irritating spots, little spots, big spots, spiteful spots, quite maddening to the eye. My next words, also profane, were for the leaded glass windows and doors which cover one whole end of the room, more spots, red circles of glass, green triangles of glass, blue oblongs of glass; for relief, my eye wandered to the ceiling. My swearing found a complete release, a moulded tin border enclosing lines, and more lines, and then scroll work flourishing around flowers so real one could smell them. A pretty penny the landlady spent to create this luxurious atmosphere, I contemplated, small wonder she refused to come down on the rent arguing the house had "just been redecorated at much expense." Either I shall become used to this room, hardened, or it will "get" me.

But there is always the azotea for retreat, and last twilight found us there full length on a petate, faces skyward, watching the grey, gold-tipped storm-clouds shift; Tina recalling memories of Venice which Dreiser's *A Traveler at Forty*, had brought back, or discussing that subtle and fascinating book by Wasserman, *The World's Illusion*, which we are reading aloud, or just gazing skyward and silently dreaming.

May 2. May Day in Mexico, unlike the United States, is Labor Day, and the proletariat made the most of their occasion. Not a camión nor a streetcar in service, no newspaper published, bread and even tortillas were unobtainable, and in this city of over a million people telephone service was cut off. We passed the day uneventfully, or rather we did not celebrate.

I printed again, to complete my collection, all work of the past. Pulled a fine print of Robelo, which still remains one of my best portraits.

Tina printed her most interesting abstraction done in the tower of Tepotzotlán. She is very happy over it and well she may be. I, myself, would be pleased to have done it. She printed from the enlarged positive, so she has a negative print and shows it upside down. All of which sounds "fakey," and, in truth, may not be the best usage of photography, but it really is very genuine and one feels no striving, no sweat as in the Man Ray experiments.

Still printing! I wish to have everything saleable ready for possibilities. One new thing, Panchito Villa, he halts, saluting, before a mountainous basket; it is humourous, has good technique.

In the afternoon, house-hunting: one place we would take in a minute but for the price of 150 pesos. The house is built on a triangular lot and every room has outside exposure, also a fine azotea from which one looks down on two streets with parkways. It is a cheerful house and many of the Mexican homes are dark and gloomy as tombs, besides being impossibly arranged. One could have no privacy, no isolation in them, each room opening into the next in the most

sociable way. Actually, I found one house in which the toilet and bath could only be reached by walking through some half dozen other rooms! I laughed to Tina, "Our temperamental family would separate after one week, or less, of such intimacy."

These are the older homes which from their architectural beauty we are drawn to; the new houses, built American style, may be more comfortable, "up to date," but are so ugly as to be blots on the beautiful landscape. I am not complaining over the arrangement of all the old Mexican homes; in fact, my ideal is such a place as we had in Tacubaya, with every room having its private door like so many little houses opening onto a patio.

May 5, "El Cinco de Mayo," Monday. Sunday, we went with the Salas to San Agustín Acolman, off in the direction of San Juan Teotihuacán. From the roof of the church, we viewed the pyramids at no great distance. The church, built by the Franciscans, in the 16th Century, is a simple massive structure with none of the pompous show and glitter of Tepotzotlán. The murals which covered the patio walls were tremendously interesting, in fact, the whole church important. We decided, then and there, to ask permission of Jorge Enciso to live in there for a week as we did at Tepotzotlán.

Being Sunday, services were held, and though simpler than those of Semana Santa in Tepotzotlán, perhaps even more impressive. The small group of kneeling Indians, the gorgeous trappings of the priest, the Indian at the organ who played and sang Tosti with a voice which moved one to deep emotion. "I felt like applauding in appreciation, Tina." "You took the words out of my mouth, Edward." And as he sang, birds joined him from the vaulted ceiling above. The surrounding country was as fertile and beautiful a valley as we have seen. Red wine, bread, cheese, and crisp lettuce in the shadow of the church...

Gupta cooked for our Saturday night "salon;" curry and sweet rice he gave us; along with Lupe's pozole and Tina's spaghetti, the best supper we have had.

For the first time in weeks, Diego came, wandered smilingly in, paintcovered from head to foot. Regular faces are now Jorge Enciso and Julio Torri,—the latter, Lupe insists, is the best writer in Mexico. Gupta brought a Hindu friend especially to see my work; he was impressed.

"Why don't you dance," I said to Dr. M., who sat forlornly alone. "Tina does not want to dance tonight." "But there are other girls!" "I am a monogamist," he smiled. "For me there is only Tina!" I admired his frankness. Of Chandler's photograph done in the zaguán—entry—at Tacubaya, he said, "I like it as well as the best of yours." So Chandler made him a print.

May 14, Wednesday, at sun up. Some time before the 17th, we are to move, the house on the triangular lot our destination. Tina bargained the man down to

70

125 a month. We have to pay our present landlord 250 cash before we leave here and 100 a month after till we pay two months in advance for breaking our contract! Wealthy people are usually the closest, stingiest, most unsympathetic. "We, too, have suffered from the revolution," he said, "we must share our losses."

May 16, 1924. Avenida Vera Cruz 42, Esquina Durango. Five-thirty yesterday morning found us through coffee, packing with feverish haste, and in great agitation to move before our dueño discovered us; for we decided to leave Lucerna 12 without paying the 250 pesos demanded. Extortion it seemed, and worth a gamble to avoid payment. Before 9:00 our belongings were waiting at the door of Vera Cruz 42 and soon Tina appeared with the discomforting news that our landlord would bring suit if the money were not paid within two days.

First impression of our new "home." It is much noisier than the other two places we have lived in. A continuous stream of those stinking, irritating, rattling, "busy" assemblages of tin called "Fords" in the form of "camiones" or "listos" tear by. We are close to fashionable apartments frequented by Americans...

[Under my] window is a palatial and pretentious home. It is not quite human, I would prefer a pulquería. The streets which radiate in all directions are parked with trees, fresh, green, well kept. My room is small, but sunny and agreeable. Thank the Gods, it lacks wallpaper and the neutral paint will admit the use of decorations.

On account of its shape we have called this place, "El Barco," the boat: the studio room, a triangle coming to a sharp point, is the prow of our ship; indeed, with two round windows in this room like portholes, we think the place well named. One reason for being attracted to this house was its airy and sunlit rooms, each with outside exposure; but, in gaining light and air, we have acquired noise, and lost some privacy, for though one floor up, we are, nevertheless, "on the street."

May 19. Flies and "Fords" prevent morning dozing, no matter how much desired or needed. The flies enjoy a sunny cheerful room and swarm in each morning as they never did at Lucerna. Like a naughty boy wishing to register protest, if handy in some newspaper headline, I would literally spit on the name of Henry Ford for having created such evil, noisome contraptions. One might write an essay on their "symbolism;" a conventionalized Ford should be printed on the paper banners of democracy. "Time" and "labor" savers? Yes, depending on what one means. But if Henry Ford had lived contemporary with the Pyramids, and had served that age with his efficiency, there would have been no time nor labor for the building of them. Emancipated labor would have spent its time under "Fords," correcting poor craftsmanship, or in them, rattling and jolting along, excitedly and importantly, on errands to nowhere.

May 24. If dreams have any symbolic significance, the one I had last night must be of great import. I only have a thread to go on, I cannot recall nor reconstruct the whole dream. It was this, someone, and it is impossible to remember who, said to me, or rather I understood them to say, "Alfred Stieglitz is dead." "Alfred Stieglitz dead!" I exclaimed. "No," said the person, referring to a newspaper, "not dead but dying."

The obvious way to interpret the dream, if dreams are to be interpreted, would be in the forecast of a radical change in my photographic viewpoint, a gradual "dying" of my present attitude, for Stieglitz has most assuredly been a symbol for an ideal in photography towards which I have worked in recent years. I do remember the pain and shock of this news.

Tina and I were reading *The World's Illusion* last evening and with continued interest. The door bell rang; it was Dr. M., or perhaps his ghost, for Charlot and Federico had assured us they had killed him! I am sure Charlot's sarcastic wit, his subtle ridicule, did kill something, for he did not seem quite the same hand-kissing enraptured admirer as before, or it may be he has changed his method of attack, or it may be that I have changed and am indifferent as to the turn of the tide.

Dr. M. did not speak well of Wasserman's writing in German, said that he was facile and influenced by the greater German authors. I told him how much we were enjoying the translation.

The doctor was overflowing with enthusiasm following his visit to San Juan Teotihuacán. Las Pirámides are the greatest structures in the world he thinks.

We discussed too the proposed exhibit of my work in Berlin which he is anxious to undertake and drank "rompope" to its success. I should want it to be a complete and comprehensive showing and I hesitate over the time and expense in producing the work. If I could feel assured of financial reward, I then might go ahead, but I cannot use the energy nor money to further my glory.

Dr. M. suggested a plan to revolutionize Mexico politically, socially, economically, within twenty-four hours; he would prohibit absolutely the owning or carrying of guns. I am sure the plan enforced would bring immediate and definite results, for the carrying of pistolas is a universal and terribly abused privilege, resulting in a continued performance of tragedy and death, turning each individual, as it were, into an arbiter of law according of his own personal viewpoint and desire. Senators and governors carry guns to their assemblages; Indians to their pulquerías; and little boys flourish them on the streets: the last remark is, to be sure, some exaggeration, but actually I have seen, and more than once, boys of twelve or fifteen with automatics and cartridge belts. This condition would be bad enough in a northern country among people of better poise and self control, but here, in a land where life is cheap and death unfeared, where individuals are quick and hot tempered, the result is appalling.

72

The same disregard of life is shown in the use, or rather abuse, of the automobile in Mexico. The pedestrian has little enough right to exist in the U. S. at present, here, seemingly, none at all. Fast, furious driving, unmuffled and uncontrolled, is universal, and the wreckage of cars and camiones strewn along the streets and highways becomes a casually noted part of the landscape. One steps into a camión as into the hands of fate, perhaps to arrive at one's destination, but quite as likely to awaken in a hospital, or maybe, according to God's will, in heaven or hell.

The Fords marked "listo" are just as bad. Tina and I had a wild ride in one some days ago. One need not hunt a "Coney Island" in Mexico for thrills; hail a Ford, announce that you must reach a certain point at a certain time, then rest assured that if you get there you will have had your money's worth of excitement, that any thrills overlooked by the driver of your own car will be afforded by numberless others.

We were to meet Charlot at the train for Chapingo; we waited too long on the wrong corner for a camión, there were five minutes left to reach the station through busy crowded streets. "Can you meet the train at two, or no pay?" we asked the Ford driver. He could, and started off with no intention of losing his pay! Pedestrians dodged our car in laughable haste but I well know how they were cursing us! One's psychology is quite different depending on whether one is in a machine or in front of it! Pedestrians were missed by inches, dogs scampared yelping out of our way, we escaped crashing into other Fords miraculously, and, having been jolted and bounced into a state of limp jellification, arrived on time—but no Charlot! Some misunderstanding: disappointed, we made the best of matters and decided to walk for awhile.

It was an old and beautiful part of the city, as yet unspoiled. We came upon "La Santísima." Once before I had seen this church at night. It is a marvel with its fine towers and exceedingly rich churrigueresque facade, my favourite of all the churches I know in this style. We paused long in mute contemplation, then, wandering on, found ourselves in front of that lovely Virgin to whom the prostitutes offer prayer, Nuestra Señora de la Soledad—more exclamations and enraptured meditation.

Then we came upon several examples of contemporary decoration which excited our aesthetic senses quite as profoundly, if differently; they were pulquerías. Assuredly there must be a "school" of pulquería painting, for though diverse, they have the same general trend in color, effect, and design.

If Picasso had been in Mexico, I should feel that he must have studied the pulquería paintings, for some are covered with geometrical shapes in brilliant primary colors to excite the envy of an European modernist. These paintings which include every possible subject, beautiful women, charros, toreadors, "Popo" and Ixtaccíhuatl, engines and boats, are the last word in direct naive

realism. With the titles emblazoned over the doors, imaginative, tender, or humorous, one has in the pulquería the most fascinating, interesting, popular art in modern Mexico City.

"After all," I said to Tina, "We have had an enjoyable afternoon and the exciting ride was well worth a peso!"

May 28. It is 4:30 but I cannot sleep.

Yesterday, Sta. Bichette Amor sat to me, a re-sitting, the first in Mexico: small satisfaction in knowing her first sitting was good from my viewpoint. The two sisters, Paulette and Lidia, were pleased and their order of three prints each is already delivered. For once, we were glad to have an excuse for rushing out work; they were anxious to get them for a birthday and we to deliver them for reasons too obvious to state.

With no workroom as yet, finishing has been a problem: hanging blankets over doors and windows, we have developed in my "ropero"—closet—a hot, sweaty, suffocating job; reminding me of boyhood days in photography, the improvised workrooms, toilets, closets, kitchen sinks, bath tubs pressed into service.

How well I recall one brilliant idea for a darkroom, a hoop around which was sewn a long black bag; this bag, open at the bottom, closed at the top, could be lowered by pulley and cord from the ceiling to cover a table below. In this "darkroom" many a now forgotten masterpiece was developed. But that was fun, pure joy, while developing "business" sittings in my ropero, and in my "declining years," is not!

A gentle knock at my door, "¿Quién es?" "Sr. Don Eduardo, ya me voy." I opened, and Dominga stood there weeping, such a forlorn little figure in black. She was leaving for Guadalajara, her home. No work here in the big city of her dreams. Her grief was touching. I took her in my arms and petted her; she sobbed and turned away. "Adiós, Dominga, hasta pronto," but, of course, I shall never see her again. They are so tender, these Indians. We are fortunate in having Elisa and Pedro; she works hard, is appreciative, and ever remembers us with flowers or little gifts. Ella Wolf asked of her if she liked to work for us. "We thank God every day for having such a fine home with Sta. Tina and Sr. Don Eduardo," she answered. Yet all we have done is to treat them as human beings and pay her fifteen pesos a month!

June 3. By moving we have cut our rent in half; but groceries, staples, fruit are so expensive in this neighborhood that if Elisa did not hie herself to the now distant market places, our living expenses would be double. We did not anticipate this condition, neither did we realize how noisy this corner would be.

I do not let the rest of the family know my inner distress and rebellion over the noise. Sunday is especially bad, and as I sat retouching in C.'s room, every camión that roared by made direct and telling attack on my nerves. The "Ford"

74

has become a fixed symbol in my mind for all that is noisy, vulgar, mediocre, noxious. To the doctor's suggested reformation of Mexico through the abolition of promiscuous gun-carrying, I would add a law forbidding open mufflers.

I should like, for a while, a room overlooking one of the market-places, to be able to sit all day long and watch the never ending, ever changing, kaleidoscope of life below. Saturday we went to shop in El Mercado de la Merced, the largest of the many markets—such an amazing sight! Quite every edible thing known to mankind seems on display, and many which only the imaginative Mexican could have discovered as edible.

The fruit astounds one: here are mountains of oranges, carloads of bananas, rooms piled with watermelons, acres of pineapples, mangoes, aquacates. One could describe in a like way the display of vegetables, fresh from their trip down the Viga canal,—not to forget the poultry: blocks of chickens, turkeys, geese, legs tied to prevent escape before doom, all adding to the general confusion with peeps and squawks of discomfiture. Purchases were made, a pineapple for 35 centavos, aguacates two for 5 cents, mangoes 7 cents each, and bananas—I don't know how many, but a basket full for 35 cents.

So we had much to carry, and from somewhere, just at the right moment, a cab appeared; they always miraculously emerge into view exactly when and where one needs them, as though the driver scented his prey from afar. I do enjoy the cabs, creaking, swaying things though they are; one always feels sure they must fall to pieces before the trip is finished, either that, or the horses will drop and gasp their last.

We have had two breakdowns, both ludicrous rather than dangerous. Once, coming from work at Montenegro's, we piled a cab full of tripods, cameras, and gifts, and ourselves. Wes wayed along—not quite two blocks—then the wheels started to wobble in alarming fashion—finally, coming to a dead stop, our driver announced that the wheels were about to come off! We piled out into the street, cameras and all, hailing the first "Ford."

But the funniest experience, with the laugh on Tina, was that which took place in front of the Hotel Princess our first day in Mexico City. To see the city from a leisurely moving cab was a mutual and instinctive desire of both Tina and myself, so, coincident with our wishes, as if we were Aladins with a magic lamp, a cab drew up "listo." A moment of preliminary bargaining in which the driver discovered that though we were tourists we knew "the ropes," and Tina stepped up into the cab, happy over the anticipated ride. Now Tina is not thin—neither is she fat—but as she stepped in, she also went down, for the cab floor gave way and there she straddled, one leg on the step, the other passing through a hole in the cab floor! Pedestrians and loungers had a good laugh, covert or open; they also had a good look, for Tina's legs are well worth an extra stretch of the neck to see. As gracefully as possible, we regained our lost dignity and bravely

75

hailed another cab, while the first driver, mumbling oaths and apologies, stood contemplating his wreck.

Somehow, this recalls another episode, not humorous though, even a bit dramatic, this time in a camión. We lived in Tacubaya, we had hunted furniture all day; night had come and rain was threatening. Halfway home it started, it poured, the heavens opened, cloudburst and sheets of water fell; the camión skidded through streets turned into rivers and when our stop was reached, we stepped into water to the knees. Home was still a good half mile away, impossible to reach in such a storm, neither could we stand there undecided in the rain.

We made toward a distant light. It proved to be a saloon; it might have been reasonably respectable, or very tough; behind those translucent glass doors who could guess what scene would be disclosed. Not that Tina is squeamish, she is invariably ready for any adventure, but I, as her "Protector," with slight knowledge of Spanish, momentarily hesitated. We pushed in: a crowd of drinking, singing chaffing men stood at the bar; we joined them, put our feet on the brass rail, and, as they eyed us in curious amazement, this evident "gringo" and this Latin girl who spoke Spanish with an English accent, ordered drinks for the crowd. "¡Salud!" At least, they saw we were friendly and "good sports." Then with the usual gallant attention to women that the Mexican man never fails to show, a machine was placed at our disposal. Another short dash through the still-driving rain and river-like streets, and we landed drenched but laughing at "El Buen Retiro."

June 7. La Ciudad de Mexico is clean these days. She is rain-drenched; she glitters in the early sun. The mornings are quiet, serene; nature awakens calm after her bursts of temperament indulged in the afternoons. The sky is the bluest blue ever conceived; the clouds which gather and drift, the whitest white ever imagined; and the shadows cast by an uncomprising sun are not those loved by the poet of anaemic moods.

All morning, clouds float across the sky, great white-sailed boats, pleasure boats on a joyous sea. Then the afternoon: the changing clouds, now grey, now black, a stirring and swaying of trees, a scurrying of humans below, a mumbling of heavens above, an apprehension of tropical discontent. As prelude to the storm, a few drops fall, patterning the street like big polka dots on calico: no intermission, no delay, a crash, pyrotechnics and artillery; first rain, then hail, the wind slanting it this way and that, throwing it up again to the sky from whence it came. The mad frenzy dies from its own passion. The furor is too great to endure. The climax comes with a last violent deluge and suddenly nature lies still, quiet, exhausted.

The reunion is over. Anita [Anita Brenner, writer and editor] served chango, cinnamon toast, and tea. It was delicious. This will be the last time that food

plays a part in our reunions. We have found that several of those we like best stay away, not having a peso for the collection hat. Conditions are no better, in fact worse. The government has cancelled eighty days of back pay. Everyone is gloomy, broke, trying to leave, but unable to get away. The Salas, the Goldschmidts, Gupta, Matthias, and others all anxious to get out.

Garduño has loaned me an old R. R. [Rapid Rectilinear—see appendix.] lens which I can stop down to a pinhole. I was happy with fresh prospects until traces of fog on new negatives brought madness to my brain. The trouble was soon disclosed. My bellows have sprung a dozen tiny leaks. Mexico is rough on cameras, but damn American craftsmanship.

My one happiness today is a new yellow table against my grey walls. On it I have arranged my brilliant gourds and painted fruit and jicaras.

Sunday morning came a note from Tina via Elisa: "What do you say to going somewhere this morning? We might happen to find Diego at the Secretaria." He was not there, but we viewed his work again.

One of my favorite panels is of two figures dancing a jota—superb! There were many fine things to exclaim over, but I might offer criticism too. Diego has become formulated, is repeating certain figures and attitudes; but remembering that he is painting day after day at so much a square foot, I rather wonder at the variety of his imagination.

From the Secretaría to el Convento de la Merced: Dr. Atl was not home. We made Graflex negatives looking down on the market, then wandered through its streets, purchasing gourds, baskets, and flowers for a few trifling centavos.

We saw a bit of incongruity over which I am still chuckling; it was in a public toilet. Now Mexicans are never hesitant about using the side of a wall, or any other convenient spot, when called by nature, but in the market so to relieve oneself would be impossible without spattering fruit, vegetables, poultry, or one's neighbors. So here was this public toilet of wooden stalls marked three and five centavos according to the luxury afforded. Well, I have seen shrines to the Virgin in a butcher shop over piles of porkchops, in bakeries illuminating buns and bread, in pulquerías, among hardware, in fact, everywhere, but I never hoped to find one in a toilet! But, there it was and quite resplendent with flowers and many lighted candles! It was the pinnacle to our morning of sight-seeing. We took a cab for home.

June 10, 1924. From somewhere comes the thought, it may be my own or another's, that it is no test of bravery to face unflinchingly danger or death in public; that cowards may rise to an heroic posture given an audience. But to be fearless and intrepid when quite alone is real proof of courageousness. This thought I carried home with me from El Toreo Sunday evening. For otherwise, would that young novillero—novice bullfighter—have risen three times to face

his bull knowing as he must have, that less than an even chance with death was all he held?

He was frightened from the start — that was evident. He lost his head time and again, that was fatal. He could have quit with good excuse the last time they picked him up dazed and hurt and horrified, for the audience rose and screamed "No! No! No!" as he once more staggered toward the bull.

Perhaps it was the thought of his ladylove to whom he had so gallantly bowed and tossed his velvet cap before the fight; or, perhaps, it was an assumption of bravery, a desperate false pride, a mask to the hooting, taunting public, for it must be a brave man who dares admit to terror; or it may have been economic determinism, the knowing that this, his first introduction as a "future ace," could make or finish his whole career, which impelled him to fight on so hopelessly.

Of course, he became worse, and more frantic, with each succeeding failure to deliver the estocada, and when one attempt passed through and out of the bull's shoulder, the groans and whistling from the crowd grew to an uproar.

Then the bugle blew, first warning that his time limit was nearly up, then the second blast which was his finish and disgrace. The arena doors opened and in trotted three tame steers to coax the bull away. The bedraggled brute followed willingly enough; he had fought his fight and was the victor; he was glad to return to green pastures.

But the bull was tired. He had charged the bewildering capes. He had gored his horses and received the return shock of three picas. For just an instant, at the gate to freedom, he paused with lowered head and heaving sides, the brilliant banderillas drooped from his shoulders to the ground, the no less brilliant blood streamed over his flanks. It was a fatal pause. From the center of the arena, the shamed and agonized novillero saw one last chance! Crazily running, he reached the bull, poised for a moment, concentrating, gathering together his scattered wits, he placed all hope, despair, defiance, into this last frantic attempt. He once more gambled with death, but he won. The sword went straight and clean to the hilt; the bull sank with no preliminary stagger; the audience rose en masse at this unexpected climax.

The matador walked with dragging steps and bowed head across the arena, heedless of their ovation. To the encircling fence he went, leaned his head into his arms and wept. But they would not let him stay there. They pulled him resisting into the arena again, and with still bowed head, he received the deserved applause. For though he had fought a poor fight, he had returned unhesitatingly to possible death; he had been an object of ridicule and, worse, of pity; but he had been sublime. I have seen better bull-fights; I have not seen a more dramatic one.

June 12. "¿Cómo, Señorita?" I said, prepared to bargain over a bouquet of mosquetas, seductively fresh and fragrant. "Quince centavos, Señor, muy frescas, muy barata — cheap." Yes, they were cheap, I was ashamed to bargain, and took them with no further palaver. It was the market of San Juan, I had gone there hoping to find some little things for the children, but I found mostly food and flowers. The flower market lined both sides of the street for a block, to walk there is to be transplanted into fairyland. Flowers might be had for any mood, all the old fashioned flowers of one's childhood, stock, pinks, forget-me-nots, daisies, gladioli in profusion, and more strange tropical bloom, gorgeous, aloof, at least to an Anglo-Saxon. The display of fruit almost equaled that in la Merced. A mango de Manila for cinco centavos completed my expenditures and I made haste for the bank and more sordid aspects.

Two months rent in advance is our contract with the new dueño; not easy to pay, for my recent sittings have not been profitable. Prospects become less possible to reckon with; I only hope to stay in Mexico long enough to work and create more comprehensively. Then? Well, I ponder much over New York these days. It seems the logical place for my return. Rafael and Monna are to write the Dudensing Gallery about my work, send a few prints, and try to arrange an exhibit for the coming autumn season.

It is a shame to leave Mexico so soon, with much yet to do and see, and with C. interested in his school work as he never was in the States, — at the head of his class he told me last night. But I cannot go on in this uncertainty, this pacing of floors and wondering what will happen next. If I cannot work in peace here, I might better try elsewhere.

It is the instability of Mexico which is maddening: a land so rich, so beautiful; a race, the Indians, so tender, lovable; but all smeared over with a slime of political intrigue and treachery in which my own country has played its shameful part.

I walked to the Salas' last evening. Through a stretch of open landscape on the way, the snowy summits of Ixtaccíhuatl and Popocatépetl floated like white clouds above a grey mist; detached from any earthly base, they rose into the heavens, and in supernal majesty remained there, for they are inhuman mountains. Ajusco was in the distance too, crowned with black storm clouds. He is a dark, gruff, and mighty pile of rock, a friend of the wind, recipient of lightning, resounder of thunder, but he is of the earth — and human.

Sunday morning. As time passes and one gradually eliminates and unconsciously classifies people, the number is reduced to a small group of acquaintances and a still smaller handful of friends. Among these, Jean Charlot remains as the one whom I am most strongly drawn towards, and this despite a slight separation through difference in tongue, albeit his English is usually sufficient. Because of

his devout Catholicism, a superficial barrier is presented; though this barrier is not impassible as it might be if he were devoted to Christian Science or Methodism, for at least I can admire the beauty of his religion. Charlot is a refined, sensitive boy, and an artist.

Of course, in mentioning close friends I do not overlook the Salas. I have seen more of them than any other "person," but it is collectively that I always think and speak of Monna, Rafael, Felipe, and their unavoidable dogs.

June 18. A letter from Imogen and Roi Partridge [Imogen Cunningham, photographer, married at that time to Roi Partridge, etcher, both long time friends]: "We want very much to possess a print of your Mexican stuff, whatever you think would interest us most. We can only have one at present. Roi is enclosing your old time price for that."

Besides being happy to hear from them, I was pleased indeed to know that two struggling artists like my work well enough to pay out real money for it, and, at that, without even having a choice.

June 21. For 25 pesos I purchased a Rapid-Rectilinear lens in a cheaply made shutter. Now I start a new phase of my photographic career with practically the same objective that I began with some twenty years ago. My expensive anastigmat and my several diffused lenses seem destined to contemptuous neglect, though it may be I shall dust them off for an occasional portrait head. The shutter stops down to 256; this should satisfy my craving for more depth of focus. Now if I can patch the leaky bellows and straighten my warped holders, I shall be ready to face life afresh, free from fog and flare.

Sunday morning. As usual, last evening, the "reunión." At midnight, Frances said to the few lingering ones, "Let us go dance at the Salón Azteca. It's a tough joint; we'll have fun." There were Anita, Frances, Tina, and there were Charlot, Federico, a couple of Americans, and myself who went to the "Gran Salón Azteca."

It was as tough as promised. Logically then it was colorful. Since no restraints of style and method were placed upon the dancers, one saw an unrestricted exhibition of individual expression, desires, passions, lusts, mostly crude unvarnished lusts—though that French cocotte was subtle indeed and beautiful too. One could not but wonder why she was in such a place among cheap and obvious whores. On her arm was tatooed "Pas de chance." Jazz took a popular place in the music, but the danzón best revealed the temperament of the Spanish-Indian mixture. It is a dance from tierra caliente—tropic earth,—a slow, langorous, sensuous dance of hip movements, the feet scarcely leaving one spot.

As unmistakable foreigners we were eyed, but with more curiosity than hostility. Frances however committed an indiscretion when she asked the orchestra for a waltz. It was received with hoots and whistles, until the leader arose and called

80

out, "'Familia,' remember where you are, this is not the bull-ring." The protesting hoots were silenced and the waltz went on.

Sunday, I took Olga to her first bull fight. Though I knew she would be shocked, I could not forsee the utter horror with which she viewed the spectacle. It was a bad beginning. The first bull charged a picador at once and it was a gory affray. Olga sat with her head sunk into her hands, moaning and trembling convulsively. I pitied her more than the dying horse. I seemed to see momentarily the fight with her eyes and then became introspective. She said, looking at me in amazement, "O, how can you call this beautiful. How can you return week after week to see this awful sight. I don't understand you!" And I wondered about myself; is my reaction to the beautiful and dramatic so intense as to paralyze any other emotion? Or, in my present condition of disillusionment, am I drawn to this debauch of death for its symbolism? Or—is it indulgence in heretofore unreleased sadistic attributes? Or—do I watch with the eyes of a detached spectator of life who sees in El Toreo only another phase of that cruelty and indifference which surrounds and permeates and tinges nature crimson?

The fourth bull brought death to a novillero: he had killed the first bull in fine style, received acclaim and the band's diana. But they try so hard, these novilleros, to please, to show their skill and daring, to win their spurs. He met the bull's charge on his knees. He was caught and gored. He lay so quiet in the sand as the bull rushed over him towards the frantic capes which could not save him now. They carried him from the arena—his head stretched back.

June 27. Tina returned from the city with a pie, the first we have had in Mexico. "Guastaroba bought it for me," she said. "I wanted some pastries from a street vendor, but he said, 'No, they are dirty. Instead we'll go into this bakery and I'll buy you one of those round things the Americans make.'"

I have been assured from many sources that a new revolution coincident with election time is inevitable. I have decided to get out, if for no other reason than that I cannot afford to stay through another such outbreak. But there is another reason, the war between my heart and brain.

For example, yesterday, Rafael, Tina, Felipe, and I went to Churubusco. I did a lot of setting up and focussing, but not an exposure. From there we went to San Angel and el Carmen with the same result.

Both places were quite too beautiful, the element of possible discovery was lacking, that thrill which comes from finding beauty in the commonplace.

All the splendour of Mexico, aside, of course, from nature, lies in its past; the present here is an imposed artificiality, lacking the crude and chaotic but vital and naturally functioning growth of the big American cities.

To be sure, within a few hours ride from Mexico City one may find towns which are as they were two hundred years or more ago. In them I am sure life would be simple, unconstrained and colorful. But questioning myself the answer comes

"No," I could not for any length of time live such a life. It is inevitable that I shall once more be drawn into the maelstrom and complexity of today.

Sunday morning. At Prof. Goldschmidt's last eve, a new Communist group was formed. I shook my head when he asked for my name; I can afford no more complications in my life just now.

The Goldschmidts' house is rather well appointed for that of a "red" leader, and they serve elaborately, buy lovely Mexican things which make me envious – all the time complaining over hard times, and owing me money for a sitting. But the professor is not to blame, rather his dowdy little wife who is a climber and a bore.

After the meeting a crowd decided for "Salón Azteca" again, but I was too weak and dizzy to attempt dancing. For several days a bad head and an uncomfortable stomach have sickened me. Perhaps Elisa's delicious enchiladas started my troubles, or it may be eye-strain, or it may be nerves from varying complications; at all events I have been wretched.

Nevertheless I have tried to work and yesterday attempted to register cloud forms from the top of our azotea work-room. The sky was magnificent but shifted so fast that working with a stand camera proved difficult. My "arrangement" would not wait even the short time required to slip in a holder and squeeze the bulb. Upon developing, I found my subject had moved too fast for a two second exposure: I had stopped down to 256 with a Kl filter. The best negative was one looking down on our boat-like azotea, its "prow" pointing out into the intersecting streets.

July 2. My plans are taking now a definite shape and, unless something quite unforseen happens, I leave before the end of this month, for I have passes to the border which expire then. Tina got them for me. And now, "Elisa is crying over the dishpan. Chandler told her you were going away. She wants to go with you," said Tina.

Just because it seems that I am really going, many sittings are dated ahead; "business" is good! I shall need every penny, for I must raise at least 350 pesos to carry us from the border to Los Angeles. Chandler wants to stay and keep on with his school and Spanish. Tina has offered to care for him—but Flora?

Sunday July 6. Election Day! "Better stay at home today" has been the oft repeated warning. Revolution? Or no revolution? That is the question!

The bull fight needs sunshine, brilliant and hot. I have felt the lack on cloudy days. Without sun the action appears slowed, undoubtedly is. The crowd, too, is less gay and responsive. Even the band seems hoarse and wheezy, while color— the sparkle and glitter of bespangled costumes, all the dazzle of gorgeous trappings—is dulled to drabness. Yesterday's fight was a weary, dreary affair. The

fifth bull was killed in a drizzling rain, and there was no protest when a sign was hung from the "Autoridad" which gave notice: "Se suspende la corrida." I watched the wet dejected crowd file out—felt their grey gloom, and was one with it for I knew that probably I had seen my last fight in El Toreo.

July 9. Clouds have been tempting me again. Next to the recording of a fugitive expression, or revealing the pathology of some human being, is there anything more elusive to capture than cloud forms! And the Mexican clouds are so swift and ephemeral, one can hardly allow the thought, "Is this worth doing?" or, "Is this placed well?"—for an instant of delay and what was, is not! The Graflex seems the only possible way of working. Yesterday's results gave me one negative worth considering: to be sure I made but three, but time and patience were spent in waiting and studying.

My eyes and thoughts were heavenward indeed—until, glancing down, I saw Tina lying naked on the azotea taking a sun-bath. My cloud "sitting" was ended, my camera turned down toward a more earthly theme, and a series of interesting negatives was obtained. Having just examined them again I am enthusiastic and feel that this is the best series of nudes I have done of Tina.

Such a day at San Cristóbal with the Salas! Really a wonderful day. We met at the station "Buena Vista" early and had reached our destination before 9:00. The air was fresh and cool, the sky dotted with round little clouds so peculiar to Mexico, the landscape—green stretches of meadow pointed with cottonwoods and maguey—backed on the horizon with hills. I carried my Graflex and before noon had made two dozen exposures, indicating well my response to the surrounding country.

Then came lunch hour: always the noontime lunch and siesta has been an unforgettable part of our excursions. Yesterday was no exception, with Tina's salad carrying off the honors. Before we had finished, the little round clouds had massed into a threatening overcast sky, and when a few rain drops spattered down we made for the nearby historical house in which Morelos was prisoner before being shot. From the upper windows we watched the rain sweep over the landscape, a soft tender rain, soon spent.

Sauntering back the two miles or so to the station, we crossed plowed ground on which was strewn broken bits of pottery. A search was indicated. I made the first find of value, a small idol,—a head— probably Aztec. It was a thrill to find one of those fascinating fragments. And then I found another, and another—four in all. My day, indeed! Monna discovered a head of the Mongoloid period in much better condition than mine which were weather worn and almost effaced. The day ended with a dash for the station to escape another shower. Evening came, and we, homeward bound in a wet train passing through the fields...

July 14. How "fast" the light here in Mexico! Most of my open landscapes of Sunday were on the verge of overtiming, yet they were stopped down to $f/32$ and had $1/10$ sec. exposure on panchromatic film using a K 1 filter. The Graflex is a spontaneous camera but lacks the precision of a view box planted firmly on a sturdy tripod. Careful as I am in focusing and releasing, many of my negatives — speaking critically — were slightly off in definition, were not as accurately seen as they might have been with my view box. But it is indeed difficult to be accurate on a $3^1/_4 \times 4^1/_4$ plate with the lens down to $f/32$ and a filter over it; and when the result is to be enlarged to 8×10, slight defects are also enlarged. Then, too, the chemical quality is never so smooth — be the care ever so great, and the loss ever so little — in an enlarged negative, as in one made direct. But I say this at the same time defying most anyone to say which are my prints from direct 8×10 negatives and which are those from enlarged negatives.

Of the exposures made at San Cristóbal I have enlarged one, a typical Mexican landscape with a fine and characteristic sky. At the same time I enlarged one of the recent nudes of Tina.

July 18. Sittings and hard work these days; trying to leave the 31st. It recalls the final days in my California studio — tense, hectic, hours. But then, at least, I had some assurance that I was leaving, eventually. Here everything is vague. Even today, less than two weeks from the date set, I am uncertain about two important items: will I acquire enough money for the trip? and — do I really want to go?

July 19. It was 7:00 o'clock of the evening. The storm had passed over but lingered on the horizon — mountainous white clouds illuminated from within by lightning. Sky rockets showered stars and bombs burst to honor Juárez' death. The Mexicans have plenty of national heroes to give them reason for celebration. If they had none, they would invent them! Holidays there must be, and often! I viewed the spectacle from our azotea. Below, from the street, the organ man ground out *Chaparrita* in competition with yelps and snarls from a dog fight. As the clouds sank from sight, a great moon rose — round — cold — metallic — a piece of polished brass. In its brilliant light the white azotea seemed snow-covered, and the chill night air completed the illusion. It might have been a frosty winter evening, instead of July. So many nights I have walked the azotea waiting for my films to wash...

The Salas gave me a farewell supper with Gupta as chef — Hindu cooking of course, and delicious indeed. Only a few were there: Charlot and his mother, Carleton Beals, Khan Khoje (how very much I like him), Olga Wolf, and Federico.

July 24. On a day when a lull or intermission came during the hurry of finishing, we dropped all work, and, cameras in hand, took the train for Amecameca y los Volcanes. It was a late afternoon train. The sun cast long shadows over a very

Mexican landscape—typical of this mesa at least: great stretches of level green, interspersed with pools of water, or sheets of water, on which floated lavendar hyacinths. On the horizon, always hills or mountains, green or grim, and above them, always clouds of infinite form. Then the train would wind through nearby hills and with every few miles, high up on some well-chosen prominence, a little chapel or larger church was patterned against the sky.

Dark! when we pulled into the village of Amecameca. A hotel was sought. There were but two, so we chose the "Hotel Sacro Monte." With tact and respect for my lady's wishes, but with certain desires and anticipations, I let Tina make arrangements for the night. If we would use one bed the price was but un peso cincuenta centavos, the dueña told us, and Tina thought we should save the extra money—to which I agreed!

With stock and white geranium from the patio we covered our pillows, a preliminary preparation to enhance the night. Well—the bed was hard, the pillows harder, and worse, lumpy. Also it was cold! The snowy breath from Ixtaccíhuatl descended upon us, and all the covers from nearby beds did not quite suffice, though snuggling close to each other did help some.

Morning came clear. From the cobbled street we looked up to the "White Woman," so silent, so aloof, above. And Popocatépetl, to the right, belching forth sculptured smoke, a majestic sight. Café con leche, we had been told, would be ready at 5:30. It was nearly 7:00 before we were served a pitcher of steaming milk and extract. But what does an hour or so matter in Mexico—except that for long we wandered chilled and hungry through the cobbled streets of Amecameca. Appeased and warmed by a breakfast simple but satisfying, we hired an Indian boy to carry the cameras, and ascended el Sacro Monte. It was a wonderland we viewed, with green valleys rising up to the snowy volcanos. El Sacro Monte was a dream place too; its church, its chapel, the flower-covered graveyard. Far back to where the graves were few and scattered we sauntered, to where the poor were resting under simple but often beautifully carved slabs.

July 30. A year ago yesterday we sailed from Los Angeles on the *Colima*. Until five o'clock last night I was undecided whether to leave Mexico tomorrow (on which day the passes were to expire), or not. After a terrific inner struggle, both emotional and intellectual, I finally realized, and decided I must stay. From this decision, today, I am having violent reactions, but I still know that I have made the only possible and logical resolve.

I have had many presents—farewell gifts. From Charlot, a watercolor—a serape-wrapped Indian—one of his best; from Pintao, un bastón—his own carving of course—something I had long coveted; from Laura and Negrete, an idol—he himself had unearthed it from his hacienda in Jalisco—a clay figure fifteen inches high, elongated forehead, exaggerated nose, stump-like arms—from which I get a tremendous thrill; and from Olga, a book for Chandler.

85

... thought of seeing the boys: that was a force which almost broke down my better judgment. Mexico seems my only hope, I have nothing else. So I had to say to myself: "Wait. Do not act too hastily. Time—even a month or two—may change everything." And conditions here? No revolution yet. Many sittings, and more in prospect...

Aug. 2. I am feeling the anti-climax of my changed plans: I hate to face my friends though they seem quite happy to find me still on deck. Somehow I remember the boy who was forever threatening suicide, until his friends, weary of talk, waited upon him in a body, requesting him to either "shut up or make good!"

Well, by remaining I can more completely realize Mexico in my work. Time is required for a new land to sink deep into one's consciousness. Also I can go on with my collecting of Indian craft work. An occasional small expenditure, and now and then a gift, has already brought me many lovely objects and recuerdos. I must make the best of my time while in exile!

4. *Landscapes and Still Life*

August 4. For months — until it had become a standing joke — I had been promising an "American breakfast" to Tina and Chandler. Sunday morning, after a long walk to insure hearty appetites, the event took place. We went to a "Lonchería Rapida" — one of those places into which drift unassimilated 100% citizens of the U.S., looking for a little "home atmosphere" and "substantial" American cooking. I don't know whether hot cakes and corn syrup are more substantial than tortillas and frijoles, but they tasted good for a change, and so did the ham & eggs, and coffee American style. The atmosphere was American enough, being that of our great institution for prospective dyspeptics — the "Quick Lunch Counter."

From this nourishing repast Tina and I went on another lark; we had our pictures taken! This too had been talked over and the idea flirted with, for if ever I have seen ludicrously funny "portraiture" it has been in Mexico City in the show cases of the cheap photographers. After much hesitating and speculation over the various displays, we climbed the steep stairs to a comical little studio and were waited on by the "artist" in person — himself a cartoon.

"We have been married just a year today," said Tina coyly. "We wish a photo to commemorate our anniversary. El Señor is very religious, perhaps you can put a church in the background; and I should like to hold these lovely flowers," pointing to a dusty, dirty bunch of roses. "But you will have better ideas than we — your pictures are so artistic!"

The photographer beamed with satisfaction from the compliment and bustled around in excited preparation. I was seated; Tina stood with her hand on my shoulder; to one side a plaster Christ; the background a vaulted church interior. Purposely I sat as stiff as possible: feet together, hands outspread on knees. But alas, I couldn't get away with it. The artist insisted I cross my feet, and, in desperation over my hands, placed a book in them.

It was all over before we knew it. "Your light is very good," said Tina. "Yes," said the photographer, "I study the latest lighting effects from the U. S.," pointing to a pile of *Studio Light* magazines!...

Presto! and the church behind us changed to a spring landscape, the Christ to a beflowered pedestal, and we held hands while the artist snapped his shutter. The last, in which the romantic temperament of the Mexican reached a climax: in

front of the same leafy landscape, on a rustic "something," Tina sat reading a book. (As I leaned over her shoulder I noted it was tables of U. S. Railway statistics!) My hands were on her shoulder and at the critical moment she was told to turn and gaze up into my eyes — click-click — and "exhibit A" for a future divorce case was made. "Funny if he should put this in his show case, Tina!"

"You wish a deposit?" "Any amount you wish to leave." "And the proofs?" "They will be ready Tuesday." Out on the street again?: I thought I must explode with laughter," said Tina. "How did we keep a straight face?"

To complete a full day, and to celebrate my remaining in Mexico, I went to El Toreo in the afternoon. Until the fifth bull I cursed my luck and came near to leaving, for the bulls were but heifers which ran away so fast that neither man nor horse could approach them — it was a game of catch-the-bull rather than dodge it, and I was thoroughly disgusted. But the fifth bull brought a sensation. I had seen advertised that "Armillita Chico" would fight, which — since I did not know of him, meant nothing to me.

This is what I saw. A thirteen-year-old boy, dressed in a black conventional suit, wearing a school boy's cap, stepped into the arena, faced his bull — which though small was a spirited animal — and fought not only bravely, but with such finesse that he was awarded that great honor, the bull's tail! Diana after diana was played for him during the fight; the audience was in a bedlam of uproarious joy; a future hero had appeared on the horizon; they stayed on their feet shouting appreciation, and I was one of them!

His cape work was fine; he kneeled to the bull, among other tricks of the trade; he placed the banderillas and executed the estocada like a veteran. It was a perfect fight. The boy was modest too. He looked around almost bashfully, smiling appreciation as he held up his trophy — the tail — to the thundering applause above. Not only hats, canes, overcoats, but money too, showered down upon him, and with the fight's finish, a crowd of excited little boys broke into the arena, hoisted him to their shoulders, and marched triumphantly away.

August 8. Ricardo Robelo is dead . . . and though this has been expected for long the news is saddening. I have seen nothing of Robelo since my exhibit last autumn; in his sickness he preferred to remain away. Our actual contacts — even in LA — were few, but always intense, and he will ever be recalled as a vivid personality and fine friend.

Have finished one of the San Cristóbal landscapes, and also printed a cloud negative, photographed last month. Both please. The cloud print is a subtle, delicate and emotional thing.

Yesterday, from a Prof. Millard Rosenberg who came to be photographed, I had one of the sincerest appreciations of my work that I have received in Mexico.

Sunday evening. We sprung a surprise, that of our late photographic adventure, on the Saturday night crowd. The one holding hands, and the other group with the plaster Christ, were finished and placed conspicuously in the studio room. They brought shrieks of laughter, and they were worthy! To Jean and the Salas we presented copies.

August 13. After several hours — spread over a couple of days — of nerve-wracking effort, I at last pulled a good print from the negative of the "Valle de San Juan Teotihuacán." I did not waste so much paper as the foregoing may indicate, but made endless tests for time and contrast. I wanted the maximum of brilliancy in the clouds while yet retaining detail. The addition of Bichromate to the developer — to the point where my clouds were satisfactorily brilliant — rendered the sky dark, apparently over-corrected. Yet, I would ponder to myself, those brilliant clouds against the deep blue sky can only be shown as very white against a background contrastingly dark. But the dark sky of the print — correct in monochrome — was to the eye a most resplendent blue.

The final achievement, and I am pleased with the print which is *straight*, shows the trees as the darkest note; then the sky at the top of the print next in tone, which becomes lighter and lighter as it blends to the horizon, quite as though I had used a graduated filter; then the distant hills which are darker than the valley itself, and finally the white and static clouds which hang over the landscape as though permanent, unchangeable. For actual visual correction the use of even a K2 — 3-time filter with panchromatic film, is dangerous here in Mexico, and a K3 filter (for "absolute correction") would often produce a quite incorrect result.

The most pleasing compliment that a Mexican can give me is to say that I have really *felt* Mexico deeply and sincerely. This compliment I have had on numerous occasions.

August 14. Another landscape from San Cristóbal now printed. It rings rather novel for me to be writing of my "landscapes," practically the first I have done since I began photography as a boy some twenty years ago. The reason, lack of time and opportunity — though, after all, mainly lack of desire. But I do respond to nature as she is presented here in Mexico. This view is a beauty, a real joy to me: silhouetted trees against low hills for a narrow base line, and a sky expanse showing cloud forms quite at variance — a long line of cumulous clouds forming another base, and above, a reach of delicate fleecy clouds — a combination of contrasts quite typical.

An evening with Pintao — smoking his cheap but good cigars, eating his medley of sweets, and sharing his wine. It is all but incomprehensible to me how a man who does such really great wood carving can display such poor taste in other things. He showed us a head of Christ which some friends had painted and presented to

him, which was not even an interesting abomination — it was simply inane — and he showed it with pride. But one does note such anomalies amongst simple naive peoples who produce unconsciously craft work of great beauty, but are completely lost outside of their own narrow circle of comprehension — are utterly lacking in discrimination.

August 15. Photographed Marguerite Agniel, an American dancer here on vacation. Made nudes: except for two negatives of legs, failed. Was too worn out; must rest. Expect to go to Cuernavaca, Monday, for several days vacation.

Sunday, August 24. Back home after five days in Cuernavaca, where we had the use of Mrs. Moats' lovely house for the week. The place was a surprise to us — a pleasant one, for the country home of a wealthy American was pictured in advance as something quite different from the delightful place we found, with rooms high up overlooking and surrounding a sunken patio. From the patio, steps led to the balcony and rooms above.

Cuernavaca is built among hills, in a country luxuriantly tropical; the houses with sloping roofs of tile, the streets cobbled and well kept — in fact Cuernavaca had an air of well-being that few Mexican towns have. There are many things to remember...

(The Borda Gardens)

Here was a synthesis of Mexico's tragedy and decay, though the Gardens, being of Italian design, took one somewhat out of Mexican or Spanish atmosphere. One evening we swam the great lagoon lined with banana and coffee and mango trees. Impossible to work photographically in the Borda Gardens, quite too picturesque.

But in the garden of Fred Davis I responded to a towering palm which, seen through my short focus lens with the camera tilted almost straight up, seemed to touch the sky. I have already printed from the negative and those who have seen it respond with exclamations of delight. It's a great cylindrical, almost white trunk, brilliant in the sun, topped by a circle of dark but sungleaming leaves; it cuts the plate diagonally from a base of white clouds. Then one day I photographed details of a small but most interesting pyramid near the city, a structure contemporary with those of San Juan Teotihuacán. From four of these negatives I have printed; fine technical negatives, revealing well the massive solidity of the masonry which has stood the weathering of centuries.

The town itself was again too picturesque to photograph. It was so theatrical, so dramatic, that unless one became used and hardened to it, living there would be as mentally exhausting as spending all week in an art gallery or sitting all day in a theater.

Jean Charlot, Federico Marín, Anita and Dorothea Brenner spent two of the days with us.

90

August 26. I have returned, after several years use of Metol Hydroquinone open-tank developer, to a three-solution Pyro developer, and I develop one at a time in a tray instead of a dozen in a tank! I am quite pleased with my new negatives, and with the flexibility of my pyro developer, nor do I bewail the extra hours in the "cuarto obscuro," though now I shall be more than ever careful not to expose on an ill-considered subject. My professional portraits I shall continue to run through a tank in the old way. More and more I realize I must conserve my strength for the work that I love.

Another conserver of strength and saver of time has been the retouching of all my professional sittings by a paid retoucher. The work seldom means anything to me beyond money, the public does not appreciate any difference in results, so why should I ruin my eyes and tax my nerves! My one regret is that I must sign these prints; may they soon fade into obscurity!

The purchase of that cheap Rectilinear lens was of the utmost importance to me: gone are all my flare spots, internal reflections — yet unknowing ones remark on what a fine lens I must have! I have, but it is relegated and forgotten.

The print from the new palm negative is chemically and emotionally beautiful. It is the result of only two attempts, the first one — but for a defect in the paper — would have been as good. Most of the prints from negatives made with direct creative intent are also the result of but little experimenting; usually two or three prints suffice. Or rather I should say that because of the cost I can afford to make but few prints, sometimes but one — and of course I am not always entirely happy. "If I could only use one more sheet of paper," I say to myself, and then stoically, though regretfully, seal the can of palladiotype, promising myself to someday reprint all my favorite negatives. By that time, perhaps far distant, all my present favorites may be in the discard!

August 31. Monna said to me last night, seeing my new photograph of the palm. "Ah, Edward, that is one of the finest things you have ever done. Aesthetically it has the same value as your smoke stacks." Monna's opinion is always of interest to me.

Just the trunk of a palm towering up into the sky; not even a real one — a palm on a piece of paper, a reproduction of nature: I wonder why it should affect one emotionally — and I wonder what prompted me to record it. Many photographs might have been done of this palm, and they would be just a photograph of a palm — Yet this picture *is* but a photograph of a palm, plus something — something — and I cannot quite say what that something is — and who is there to tell me?

Sunday, September 7. ...today I am so weary, so very, very tired; and the bull fight was a poor one...

September 11. Rain and an overcast sky for over a week. Unable to print palladio. Sittings though, four of them; if I don't watch out I may make money. That would be funny. Remembering my inspired manifesto — "To work, Edward Weston" — I'll state that I have been working hard enough, but not in the intended sense of my proclamation, when I had a vision of glorious new achievements. My work has been drudgery. I should be glad of these sittings — as a means to an end; that end, money for more films, more paper, for other work that I want to do.

There is definite talk of Brett coming here, if someone is found to bring him. Flora wants him with me. Better with me, to be sure; no woman is fit to bring up a boy. How can they possibly understand them!...

September 16. I am desperate over this continued cloudy weather, yet I used to love grey days: it must be that now it prevents my working. After having lived in California and more especially Mexico, I feel that never again would it be possible to remain long in a land of rain and mist. I am not even provoked to make negatives these drab days.

One should do something just as significant while the rain falls and clouds hang low, but I at least am not aroused; perhaps because I am not visually excited as by the definite form which the sun invests. Today I am going to expose at least one negative on anything or person that passes my lens, if it be no more than to again open and close my shutter—

September 17. I kept my vow and exposed several negatives on Felipe. Today is Tina's big day: she appears in the initial performance of the Mexican *Chauve Souris* — el *Teatro Mexicano del Murciélago* — Mexican Theater of the Bat.

September 20. That tinkling tune from my Aunt's old music-box returns again to recall my childhood, and her earthenware crock of fresh doughnuts and white sugar cookies.

The *Chauve-Souris?* Well done for an initial attempt though somewhat reminiscent of the original production and lacking its finish. Tina? A difficult part, which might easily have become melodramatic, done with restraint and understanding. The native dancers brought from tierra caliente in the acts "Juego de los Viejitos" and "Danza de los Moros" were excellent — the latter indeed superb. The act "Camiones" was a side-splitting burlesque, but of local interest only. Those who had never seen Mexico City would not appreciate it.

Sun at last! Orders printed and new negatives made, which show a return to life! I worked from the azotea, pointing my camera searchingly in every possible direction. The best negatives, those looking down on nearby roofs and houses: an attempt to amalgamate widely diverse objects, to unify them, to present them as a complex but coherent whole.

92

Sunday. Today [at Azcopotzalco] we, the Salas and Westons, had agua miel—honey water—for the first time, freshly drawn for us from the maguey. ¡Qué dulce! ¡Qué fresca! ¡Qué sabrosa—delicious!

The patio of the most important church there captivated me. The only vegetation was a superb banana tree in the exact center, offering as interesting an object for the attack of my camera as did the palm at Cuernavaca. I shall return there, for with my Graflex I could not register definitely what I felt might be done with the 8 × 10 view camera.

September 22. Over the roughest road yet encountered in Mexico — and that is damning it sufficiently — Turnbull, Chandler, and I . . . to the Santuario de Nuestra Señora de los Remedios. The sight there was not the church, but the old aqueduct with its curious towers like those of Babel, built by the Spaniards in 1620. The span of the aqueduct is of simple and elegant lines. It drew me to expose two negatives, looking up from almost directly underneath.

Difficult to work when one is guest, and the rest are waiting, even though good-naturedly. But these free trips to remote points are not to be overlooked, rather considered as scouting expeditions, for one can always return if sufficiently interested.

The evening I spent alone among the ever-fascinating puestos, purchasing for ridiculously small amounts more animals of clay — a bull, a horse, a pig — executed with fine feeling for essential peculiarities of form, or as in the pig, painted with a keen sense of decoration. Then the tiny figures in metal: the charro a-horse with raised banderillas — what grace! what elegance! what understanding of anatomy! These Indians never went to "Art School." And again the sense of humor shown: the long-legged, pink-legged, lamb, with its silliest of faces . . .

Always when I go to the puestos I think of my little boys, and picture their wide-eyed wonderment and their sure cries of delight — "O buy this, daddy!" Then, arm-laden, we would walk joyfully home together.

September 30. A big day of printing — the first day possible for palladio printing in three weeks: results, fourteen prints from as many negatives. Perhaps I attempted too much. I view the results rather pessimistically tonight, but "the morning is wiser than the evening," recalling a saying from the Russian Folk Tales which I used to read the boys.

Today I feel is the first day of winter, not by the calendar, to be sure but because not all day long did one cloud appear—¡qué milagro—how micraculous! Too, there was a crispness to the air not of the balmy rains.

Several negatives printed are new, made during this last cloudy week when I turned to my camera for diversion and consolation. Still-lifes they are, and pleasing ones: two fishes and a bird on a silver screen; head of a horse against my petate; chayotes in a painted wooden bowl. The animals of course are from

the puestos. The bird is a beauty indeed — a blue heron, bill and feet red, neck turned over its back to almost a completed circle — a lovely thing in line, but done by nature (albeit nature improved by man) for the bird is a painted gourd. However the horse and leopard owe nothing to nature but inspiration. The horse is Chinese in feeling — a 7th century porcelain perhaps! Charlot, seeing it, hied himself at once to the puestos to find another; disappointed, he playfully attempts to steal mine on every occasion.

These still-lifes, strange to say, are the first I have ever done; and feeling quite sure they number among my best things, I would comment on how little subject matter counts.

Other new prints which please are the complicated "arrangements" of our neighbor's azotea and nearby houses. My technique and understanding of photography improves. A torso of the dancer Agniel is as fine a nude as I have ever done — a simple and very sensitive rendering of line. Unfortunately, due to careless use of an old developing hanger, the negative has stained edges and I was forced to use lamp-black on the print — very little — and not one person in a hundred would know — but I do — and it spoils my joy!

A block of houses, though rather ugly new ones, crowned by a pyramid of fine clouds gives me a real kick. Again technique and understanding of photography.

One of my favorite new negatives I despair of getting a good platinum print of: it is a sky with delicate white cloud forms. After repeated attempts I must admit that my original print on Azo, made to study, pleases me more than the platinum. The *Gaslight* print is more nebulous, more subtle, and its colder color more suitable. I shall try once more. The portrait of Sala is a good likeness, and a satisfactory print.

October 2. After trying again to improve my printing of the new cloud negative, I have given up until some future day, to try it on white-stock platinum. My print of yesterday is an improvement, but not yet what I visualize! The trouble is this: the slight tone of the stock is just enough to destroy the more subtle gradations in the clouds, their delicate brilliancy, and with the addition of bichromate to gain the brilliancy of the Azo print, I cut the clouds out against the sky in a way that makes them look pasted on. Admitted, indeed, that one peculiarity of the summer clouds here is this very way in which they are "cut out" against the sky — great white everchanging, swiftly shifting forms, against a ground of the deepest blue — still there is an exaggeration in my print that is not satisfactory. I shall bide my time. I cannot afford to keep white stock on hand — I seldom need it, the buff being better for my professional work. But I did pull a print yesterday to compensate for my other failure: a new printing of my palm. It is dazzling in its brilliance, and the improvement shows what might be done by repeated experiments.

I mounted and had ready the new prints to show at a supper Tina and Federico prepared Wednesday night — she cooking spaghetti, he furnishing the wine. An agreeable and congenial crowd: the Salas, Felipe, Federico, Gupta, Khan Koji, Anita, Charlot, Tina, Chandler, and myself; how many nationalities! Catalonian, Spanish, Mexican, Italian, Jewish, French, Hindu, and Gringo! I had sufficient interest and enthusiasm shown in my new work to repay my efforts — such opinions as: (from Felipe) "The best you have done in Mexico..."

Now I have set me a new task — that of making ten enlarged negatives from Graflex films selected from my work of the last eight months. I have in mind a new exhibit, to be entirely Mexican, and every print made since the last show of a year ago. Something must be done to stimulate "business," for alas, finances are very low again.

October 4. Tina sat to me yesterday morning. We had long planned that I should do her as I have often seen her, quoting poetry — to attempt the registration of her remarkably mobile face in action. There was nothing forced in this attempt, she was soon in a mood which discounted me and my camera — or did she subconsciously feel my presence and respond to it? Within twenty minutes I had made three dozen Graflex negatives and caught her sensitive face with its every subtle change.

Monday October 6. We have been like a couple of happy excited children, Tina and I, over the results of our recent sitting — but also sad with disappointment, for though the series of heads are the most significant I have ever made, though my vision on the ground glass and my recognition of the critical moment for release were in absolute accord with her emotional crises, I failed technically through underexposure, just the slight undertiming which destroys chemical continuity in a set of negatives made under a strong over-head light.

But why should I of all persons fail on exposure? I had figured to a nicety, $1/_{10}$ sec., $f/11$, Panchro film, Graflex, knowing though that I was on the borderland of underexposure. I had placed Tina in a light calculated not to destroy expression in her eyes, and then to augment it cast reflected light down from above with an aluminum screen — an unusual procedure for me — to be using light accessories. But the sun moves in its orbit, and I, working in a state of oblivion, did not note that my reflector no longer reflected! I feel the weakness of my excuse, my intellect should not have been overwhelmed by my emotions, at least not in my work!

With a stand camera, my hand on the bulb, watching my subject, there is a coordination between my hand and brain: I *feel* my exposure and almost unconsciously compensate for any change of light. But looking into a Graflex hood with the shutter set at an automatic exposure, a fixed speed, is for me quite different. I dislike to figure out time, and find my exposures more accurate when only *felt*.

Then came another disaster in the darkroom — pure carelessness and quite mortifying. Ready to develop, I turned white light onto a dozen exposed films, ruining half of them. So Tina and I tearfully contemplate what might have been! But there are several that I simply must try to pull a print from; they are too fine to relegate to oblivion.

October 7. 4:30 A. M. and all's not well! Confound all Mexican Saints and Virgins for giving the people excuse to make noise, awakening me from a hard-earned sleep with their firecrackers. Such a night! Preparatory, I had sprinkled my sheets with flea-powder and lit three sticks of incense, which act was neither cabalistic ritual nor aesthetic indulgence, but merely self-defense against hungry hordes of mosquitos. My precautions proved futile; the fleas came and playfully leapt admist the powder, the mosquitos joyfully sang as they sailed through the smoke which nearly smothered me — not them, and it seemed I had only gained sleep when the volley of bangs in praise of the Virgin started me out of bed. "Another revolution," I thought. "Or—our neighbor, the histrionic zapatero— shoemaker—after too much pulque, has decided to exterminate his enemies." But no; once awake, the answer was simple — just a prayerful exuberance was being expressed, that was all!

Mist-like rain is falling. This irregularity forecasts the Season's end — now sun and cloudless days for many months — and next Sunday the first big fight in El Toreo.

My exhibit is to open the 15th; hard work ahead, though if necessary I could open tomorrow. Reporters came last night, and their enthusiasm indicates much acclaim. But business is what I need — not praise!

Yes, my work is far in advance of last year; the striving, the sweat — though expended — is not so obvious in the prints.

October 8. Tentative discussion under way with Flora over the possibility of my returning New Year's for a visit. I favor the plan, for I cannot remain away much longer from the boys.

I am utterly exhausted tonight after a whole day in the darkroom, making eight contact negatives from the enlarged positives.

At dusk, clouds over the moon's face were pink fading into grey against a sky ground of pastel blue.

During lunch hour we were interrupted by an Indian who beseeched and besieged us to buy carbon because his poor burro was too tired to carry it further!

October 11. Have been quite sick — fever and incipient sore throat. Lay all day on my bed in a half stupor, unable to work; fasted and sweat myself and am practically well again. I am ever thankful that doctors play no part in my life — that is, doctors with pills and knives — nor Christian Scientists, nor their like. A day lost.

With the opening day of my exhibit near, it is too bad — for we have endless detail ahead.

Too bad also that I should have blamed the Virgin, or some Virgin, for the recent cannonading: it was the celebration of the Eucharist taking place. A great conclave is now here. The city is bedecked in a ridiculous fashion —Independence Day in comparison becomes a minor event. Catholicism has yet a tremendous hold on the people, despite the government and constitution. The priests must have much inward satisfaction and security these days. Everywhere are more or less pretentious signs announcing, "Viva Cristo Rey" — even over a dirty pulquería named "La Gran Turca" — The Great Drunk! My mistake in blaming the Virgin for all this noise — my biblical knowledge is lacking!

Sunday, October 20. Wednesday the exhibit opened. I have had — as last year — applause; real homage — yes, even more than last year — and as before, the men far outnumber the women in attendance and interest. I am pleased, not satisfied, with my prints as they display themselves to me on the wall. No question but that I have gone ahead. And then comes the question, what next? An exhibit is always a climax to a certain period: once shown, a print becomes definitely a part of one's past; if not actually discarded, it is relegated to a portfolio of old loves, to be referred to at times with perhaps no more than tender memories.

Three prints sold the second day — all nudes — and to the same person, for ninety pesos. One was of Tina, one of Marguerite Agniel — "Dancer's Legs," and an old one of Ruth Wilton.

The most talked of photographs in the exhibit are the heads of Galván, Lupe and Nahui Olín, and several of Tina. The clouds excite much interest, praise and comment; also the new work done with my Mexican toys. Nahui is a bit "enojado" – annoyed – that I should display such a revealing portrait of her, though I had her permission before hanging... Now she wishes me to do nudes of her — and I shall. Several sittings seem assured as the result of my show, so for awhile yet we eat and pay rent.

Amazing news: for the first time in Mexico, a letter from Johan, and quite characteristically Johan. "What shall I say — I have so much to say — how can I say it — but why — why shall I say it here — in a medium so inadequate — when I can choose a better one — and have chosen! I shall come to see you in Mexico — visit and talk with you to my own heart's desire: Yes, I shall come — I must — and if fate is not against me — not so very long from now. I shall get things in readiness here for my going — perhaps in a month or so. Edward — I am happy — the joy — the thrill to see you again — to be together once more and in Mexico at that — until I see you! Au revoir! Johan."

Well, this is astounding! Unbelievable. Yet I am perplexed. If I return for New Year's to see the boys, should I encourage Johan to come now? If he waited we could return here together. But the question is always flitting through my mind,

will I ever return to Mexico again? What a joy indeed to have Johan here — for us to see Mexico together!

And another letter came which brought memories, it was signed "your own J." She is in California; perhaps we are to meet again!

And yet another letter, a screamingly funny one from Brett. "I weigh 113 pounds of meat — blood — bones — fat — grease and especially brains and muscle. I am 5 ft. $3^1/_2$ inches tall — Have you (still) got a cute little mustache? I sure did like those pictures you sent of Chandler — He still has that big nose and fat chin and dirty mouth and sticking-out ears and yellow cat eyes. I could take on about $13^1/_2$ just like him and maybe more, but of course that has nothing to do with my *good looks*. I am just about the craziest writer in the whole school and everybody knows it too. I'm sorry I can't write you a half way decent looking letter. Just before we went to the beach I had my head shaved clear off. Hot soup — Brett." Dear old Brett Boy! I'll appreciate you even more after this long separation.

October 31. Diego and Lupe came to the exhibit yesterday — he large and lumbering as ever, she big with child. Diego showed his usual enthusiasm over photography, and immediately became involved in an argument with some other painter on the subject. "I would 40,000 times rather have a good photograph than a realistic painting," he stated, and dismissed his opponent with a wave of his hand. He liked my "Circus Tent" best of all, also the new still lifes of fishes and horses and birds immensely.

Dr. Atl has visited too, and registered in the guest-book as finding even greater interest than last year. Viewing my "Colonia Condesa," he said, "This means nothing, yet it means everything." Dr. Atl is a unique personality, and far more valuable as such than as a painter. Maria Appendini wrote in my guest book, "Un Nuevo Tormento—a New Torment."

The general attendance has been good — greater than last year: many promised purchases, but so far no money! With the evening hour arrive familiar faces who drift in to talk and smoke: Charlot, the Salas, the Quintanillas, Felipe, Roberto. Felipe, by the way, is to open a puesto in "El Volador"! With books and antiques, it will be called "El Murciélago—the Bat—" and decorated in *Chauve-Souris* style. What a unique adventure!

A few lines from B.: "You are ever a definite part of me — people's lives are like threads — some of them cross our own and remain forever part of the pattern – the Attic days of ridiculous and delicious humour, of daring and romance — I shall ever bless you for that fall — Saw Jack Taylor — he is well and happy in New York — Be well and be near to me always for I love you —."

October 22. Came Herr Goldschmidt, with his hearty embrace — more like a bear-hug — his tickling of the ribs, his infectious laugh. ¡Qué hombre más simpático! He insisted again that I must exhibit in Berlin.

98

How tiresome it becomes to be polite to all those who come — yet the pleasure from genuine appreciation is compensating; and the Mexicans can be so intense, so excited, so passionate in their felicitations as to buoy one up into a like state of exaltation and belief in one's work!

Of course, I hear that I must have a marvellous lens or extraordinary camera — instead of a lens with shutter and all for 20 pesos, and a camera quite gone to ruin! Not many realize that good photographs — like anything else — are made with one's brains.

Charlot said, "I am going to work out the geometrical plan from some of your photographs which are so exact as to appear calculated." No, Jean, to stop and calculate would be to lose most of them.

Diego, Tina tells me, also expressed delight over my "Fruta de Barro"—Clay Fruit—and "Caballito de Cuarenta Centavos"—Forty-cent Horse. When Galván saw the title to this picture of my little horse, he said, "You're Gringo all right; you paid too much."

But it is not my little horse any more; Charlot's desire for it was so great that I could not be comfortably selfish any longer, and sent the caballito to fresh pastures. Charlot's pleasure was expressed concretely — he wandered in last night with a water-color sketch under his arm. "To Edward, my first Boss — Horsie." It was a humorous thing, and I told Charlot that either he had fed horsie too well on beef-steak or else "he" had become a wee bit pregnant! The painting was signed "Fot. Silva", which starts another tale.

That mad Mexican photographer came yesterday, tells Tina, and after raving and waving and tearing his hair went up to a certain "Torso", exclaiming, "Ah, this is mine — it was made for me — I could —" and with that he clawed the print from top to bottom with his nails, utterly ruining it. Tina was horrified and furious, but it was too late. "I will talk to Sr. Weston," said Silva. "The print is mine, I must have it!" Tina was called away and later found that the mount had been signed — "Propiedad de Silva". I don't know whether Silva is really mad or only staging pretended temperament; if the latter, I could quite graciously murder him. Either way the print is ruined.

October 25. Dr. Peter, who has been my best patron in Mexico, bought from the wall "Pirámide del Sol" for 30.00. Mr. Fred Davis, in whose Cuernavaca garden I photographed the great Palm, purchased a copy for the same amount, and Mr. McGuire was so in love with the head of Neil that I sold him an extra print for half-price, knowing that he could not afford to pay the full. A lawyer who purchased three nudes has failed to return with the money, so this is the rather discouraging way sales stand at present. I have assured sittings ahead, so something has been accomplished besides glory; but the glory has been sweet and I shall ever be grateful to the Mexicans for their fine attitude and appreciation.

Lupe has her baby, a girl. Diego says it looks like a tadpole and that he could put it in his pocket!

Sunday evening, October 26. On returning from "El Toreo" — Matadores Valencia I y Valencia II — and bad bulls. My ideal of a toreador is Valencia el primero ...he fights with such dare-devil audacity, such smilling nonchalance, such dazzling nerve, and he maintains such mastery over the bull, controlling its every move with his elusive flourish of the cape and fearless posture...

With poor matadors, nothing is so tiresome or so disgusting as a prolonged attempt to deliver the estocada; it reeks of the slaughter-house. With certain toreadors, no matter how brave, one feels their imminent danger, awaits in a tense and uncomfortable excitement their inevitable fate; with others — and they are the real artists — one loses all sense of their personal danger, watching the pageant in all its elegance, entirely oblivious to possible death. So does the great artist, by ease and command of execution, dissemble the means to his end.

Roi Partridge writes me, after receiving the forwarded prints: "I am always most agreeably surprised by your technique. Sir, aside from what you may or may not be as an artist, you are a damned good craftsman — none better."

October 28. Rain fell in my dream last night; this morning the streets are dry. I have a desire to work after this long spell of inaction: day after day at the exhibit, seemingly a waste of time, though between visitors I have some moments for writing, also much opportunity for contemplation, a chance to size up my work and more especially myself.

The most important visitor recently has been El Señor José Vasconcelos, ex Ministro de Educacion Publica. He was deeply interested, particularly in the clouds, and requested seven prints for publication in his magazine *La Antorcha* – The Torch.

A much bejewelled and super-haughty French dame came, who, asking my prices, drew up in feigned surprise or misunderstanding. How I despise that trick of pretending not to hear correctly! "What? Three for ninety pesos!" "Yes, Madame, really quite *cheap*, eh?" I overlooked her pretenses and she was properly squelched. She could not resist telling me that Zuloaga had painted her. Then I scored, for she made a date for a sitting!

October 31. Jean Charlot wandered into the exhibit at evening, rather woebegone and discouraged: that is Mexico, it either raises one to ecstacy or dumps one into depths. We took him out to dine, Tina and I, prosaically filling him with hotcakes. Nahui Olín joined us, we met her on the way; then all four of us went to Nahui's house. Jean, who knows her well, defined Nahui as genius opposed to talent. At times brilliant in the extreme both in writing and painting, she is again commonplace, without discrimination, discounting her own best work,

100

insisting on her worst. We spent two hours listening to her poems and prose and satires written in both French and Spanish.

November 1. The exhibit is over. The naked balcony walls presented a sad and stripped void as we glanced back to be assured no print was forgotten; but no time for tears, for already a new exhibit is on! Tina and I for the first time are showing together; indeed, it is her first public showing, and I am proud of my dear "apprentice." We went directly from the "Aztec Land" and under the auspices of the Secretaría de Educación Pública hung ten prints each in the Palacio de Minería. It is a big affair: Rafael, Charlot, Felipe among our friends are also showing.

November 2. El Día de los Muertos. Like mushrooms magically appearing over night, los puestos — in celebration of the Day of the Dead — once more are with us. More numerous, more varied than ever, they line both sides of two blocks and the street centres as well, I wondered and searched untiringly for my occasional concrete reward; this time I found more "Mexican porcelains" — animales de barro – clay animals — a magenta-colored dog mouthing a green basket, excellent in form, and, at the same booth, a wildcat biting into a green snake...

Returning late from the puestos, company awaited. Bert and Ella Wolf had brought to see us Scott Nearing, American Socialist. From one hour's contact I would say that he was a typical labor-leader, a preacher, pedagogic and pedantic — but then, that is his mission! And, after all, he may have another side on closer acquaintance. Few of us give ourselves freely on first contact.

Yesterday, with the band's salute, President Obregón formally opened the exhibit at the Palacio de Minería. Our photographs are simply and well displayed. Tina's lose nothing by comparison with mine — they are her own expression.

Sunday Evening. D. H. Lawrence, English author and poet, in with Louis Quintanilla. My first impression was a most agreeable one. He will sit for me Tuesday.

Monday. After experiencing the ever-recurrent condition of being "broke", I have sold two prints: "Palma Cuernavaca", and a nude; besides, I have four definite dates for sittings. Such prosperity is overwhelming!

Tomorrow I dine at a luncheon in honor of the United States Ambassador to Mexico. God knows his name — I don't — but duty calls. In preparation I trimmed the fringe from my trousers and borrowed a hat from Rafael. Now to buy a collar and I shall be ready for the fray.

Tuesday Evening. The sitting of D. H. Lawrence this morning. A tall, slender, rather reserved individual with a brick-red beard. He was amiable enough and we parted in a friendly way, but the contact was too brief for either of us to penetrate more than superficially the other: no way to make a sitting. Perhaps I

should not have attempted it; now I actually lack sufficient interest to develop my plates.

The dinner to "our" ambassador! How "United States," how childlike! "Our country right or wrong," "moral example to the world," "business — business — business —."

Wednesday. The D. H. Lawrence negatives were not technically up to standard — damn the ambassador's banquet for my hurry! Now it amounts to this: unless I pull a technically fine print from a technically fine negative, the emotional or intellectual value of the photograph is for me almost negated, no matter how fine the original feeling and impulse.

Thursday, 6. I dread these two months to come before Christmas, despite the foreseen influx of pesos. Many sittings are in prospect, meaning a period of concentrated hard work. One might as well be in Java or London or anywhere else during this work which closes one in the dark-room or hides one under a focusing cloth.

My "life" in Mexico is already over, for I am returning to Los Angeles after Christmas. There can be from now on but little time for excursions or work that I want to do. I have a quite definite feeling that once I leave Mexico I shall never return, at least not for many years; once with the children again, I know how difficult it will be to part with any of them, and I cannot have them all. Also Tina and I must surely separate forever.

November 10. Saturday night with Charlot to Teatro Hidalgo, where was given the annual performance of an old traditional Spanish play, *Don Juan Tenorio*, the hero being that same gallant knave whose name we use when alluding to one who is a devil among women as a Don Juan. He was surely a hero to the audience, who watched wide-eyed and listened breathlessly while he conquered innumerable women and killed his rivals. All the time we were constrained to silent laughter at the naïveté of the performance, at the quite ingenuous presentation, the obvious hocus-pocus, and stage clap-trap; indeed, we enjoyed the show so much that when the curtain went down upon the last scene — Don Juan and the beautiful nun on their heavenly throne surrounded by a bevy of pink-clad girls, both fat and lean, dancing to Mendelssohn's Spring Song — we too joined in the applause, though from quite a different reason.

Tina and Pepe also came, joining us. Between acts Pepe and I went out to smoke; we wandered up and down, arms about each other's waists, each thinking his own thoughts — but speaking of the weather!

November 11. Madame Charlot served Jean and me one of her delectable suppers — "Mexican," she called the meal, but methinks it had a marked French accent!

102

Jean is a prolific worker. "I am never happy unless I am working," he said; he is a tireless, never satisfied experimentalist. I note a tremendous growth in his work since the year ago I met him. He renders the quintessence of Mexico...

For me he is the most important artist — aside from Diego and Pintao — whose work I have known in Mexico, and I somehow sense that someday he will be the greatest of the three.

We talked last night of a joint exhibit — his paintings, my photographs of Mexico — to be given some day in New York. The idea appeals to me indeed.

Mr. Fred Davis of the "Sonora News Co." is, as Brett might say, a "good scout," for when I boldly suggested, in desperation over my ragged clothes, that I would exchange photographs for clothing from his store, he fell in with the plan at once. "Get what you wish," he said. "The more you take the better I shall like it." I came away with new pyjamas, shoes, hat, suit, neckties, amounting to 200 pesos.

Well, dawn is upon me. I go to prepare, and, despite the foreseen enrichment, rather reluctantly, for the ten o'clock sitting.

Chandler wears his first pair of long trousers — my old suit with but little alterations!

The next morning. Through my window a pink and blue symphony: the background sky-blue, the pattern geranium-pink. I awakened to it from profound slumber, almost startled. Where was I? Why, yes, Mexico, of course! And last night Tina and I had talked and talked for hours, trying once more to reconcile and adjust our lives to each other.

The conversation centered on the future, should I return here or not. "You must not decide now, Edward, wait until you reach California, then you will have more perspective. As for me, my mind is clearly focused, I want to go on with you, to be your 'apprentice' and work in photography —"

Questions and answers back and forth, a quite deep and tender and hopeful final understanding — clearer and closer than ever before. Now some five weeks of hard work; then, California!

November 15. Printed the profile of D. H. Lawrence; he, at least, is very well pleased. Jean and I visited Diego's new murals on the walls of the Secretaría stairway — quite the finest of his work. Luxuriant, tropical, complex, yet in the last analysis a conception simple and powerful: a great piece of work.

Jean and I, plus a bottle of Vermouth, took a camión for my home. We set the table and poured a glass for the unknown guest as well as ourselves; the unknown one came — it was Tina!

November 19. Tinita and I visited Diego and Lupe last eve to pay our respects to the new baby. We drank its health with a bottle of port — old Spanish, which

proved to be unduly potent! We found ourselves frankly borracho and unable to conceal the fact as we swayed arm in arm down the street toward the Zócalo. "We must seem to have come straight from a pulquería, Tina!" In a laughing, rollicking mood we leaned, to collect our wits and exchange a kiss or two, against the great door to some Zaguán – entrance hall; it swung open and the astonished porter almost received us in his arms!

"Roma — Mérida — Sonora —" cried the camionero. The camión was empty and remained empty the way home, which was fortunate since our conduct and posture was a bit undignified. "Durango" was near to being passed unnoticed, but we tumbled off, handing the surprised camionero an extra diez centavos in sympathy for his poor business...

November 21. To Frontón — Juego de Pelota — with Pepe, Chandler and Tina. "You may find it more thrilling than 'los toros'," said Pepe. I did not, though it was exciting, to be sure — a game to make, by contrast, our tennis and baseball appear quite tame. The Latins evolve sports that are spectacular, sensational, dangerous, and always elegant. Every second of the play was scintillating; one fairly gasped as the pelota shot through the air like a bullet while the players executed most miraculous passes, involving dramatically tense and beautiful postures.

Preceding our departure for Frontón, a surprise was afforded us by the arrival of Charlot, Nahui Olín, Federico, Anita and several bottles of wine. They had come to celebrate! And this is why — at the recent exhibit in the Palacio de Minería, I was awarded first prize for photographs (one hundred and fifty pesos)! Quite unbelievable. I shall await undue enthusiasm until the money is collected. The honor of winning amounts to nothing: we had no real competition. Diego Rivera was on the jury, who else I know not.

November 24. Sunday in the "Secretaría" patio I made two dozen Graflex negatives of Diego Rivera. As yet they remain undeveloped. Also started an undertaking which I have already given up, that of copying his work for reproduction in a book to be published about him in Germany. It looms as too great a task without ample renumeration, which is uncertain.

There are some who feel that Diego's work is too calculated, too entirely a product of his brain. For me it is emotional as well as intellectual. For a man to paint murals twelve hours a day — sometimes even sixteen hours at a stretch — and day after day working quite as a day-laborer might, not awaiting "mood" or "inspiration", it is amazing to me how much feeling he attains in his work. Only a man of great physical strength, possessed of a brilliant mind and a big heart as well, could have done what Diego has.

Yesterday I felt, as I have before, the preoccupation of his work. Direct questions were often entirely unheard, his eyes would be utterly oblivious to surroundings

— then suddenly he would start out of himself, break into a broad, genial smile, and for a few moments Diego the dreamer was gone.

November 25. I said to Tina, having noted several interesting items in a downtown bookstore, "Let us go on a book-hunting expedition, I am hungry for a new thrill." We were successful in acquiring a number of additions to our library, mostly books reproducing the work of contemporary painters. Ferat, Grosz, Dérain, and a volume on African sculpture — what splendid things! — and how fine is Dérain!

Now my orders are printed and the stage set for more sittings. It will take many orders to pay the expenses of our return trip.

I am so lonesome to hear a word from Ramiel — why is it he does not write!

November 29. Diego, refering to my head of Galván, said, "Es un retrato — portrait — de México."

I cannot work in such feverish haste as I do with my Graflex and register quite the critical definition desired. F/11 is the smallest stop possible to use without undertiming when making portrait heads in the sun, — setting the shutter at $1/_{10}$ second and using panchromatic films, — thus when depth is required my difficulties are increased. Diego's ample belly as he sat on a packing box in the Secretaría patio, swelled forward quite like a woman pregnant, presenting much difficulty.

Jean thinks they are the most interesting set of proofs from a sitting that I have done in Mexico. Well — I do like some of them, yes, a number of them, yet I could wish, especially with Diego, that I had made something to be very enthusiastic over. In each proof I find a fault, granted a minor one, and I had hoped for a quite perfect negative from this sitting, not just because Diego is a big artist, rather because he is especially interested in my work.

Last evening we went to a "studio tea" at Fred Davis's home: a genial host, delicious food and drink, many beautiful things, mixed to be sure with an overwhelming number of bad ones. But I am impatient, I cannot enjoy social gatherings; the meeting with a few friends, one or two at a time, is the only form of contact that appeals to me.

I face the fact that I find myself really happy only when I am lost behind my camera or locked in my dark-room. So today I became happy for a while: I photographed more of my "juguetes Mexicanos", this time the "pajaritos" — little birds — in blue, — exquisite things in line. I combined two of them on my ground glass. Perhaps three negatives will be considered worth printing.

Martial music, – soldiers pass below, — a bedraggled lot but with brave front: not to be denied, dogs of sorry mien march with the procession somewhat lowering its essayed dignity. Tonight Chapultepec Castle is a blaze of light. — All this is preparation, for tomorrow is Calles inauguration.

Surely here in Mexico we live in another world for Thanksgiving Day was passed quite unremembered!—perhaps it should have been—

Sunday. Technically dissatisfied with what should have been my best photograph of "los pajaritos", I spent another several hours attempting to duplicate it: impossible to place even inanimate objects exactly as seen before. I still think my failure the best seen negative though the actual difference is ever so slight.

December 2. In the same way that I ruined part of my last sitting of Tina done two months ago, I fogged today's by turning on the white light during the development. It almost seems that fate has decreed against my doing what I wish to do in the way of portraying Tina. But one of the negatives made this morning pleases me: the glare of light on the azotea destroyed all the delicate modulations in Tina's face. It was flat and uninteresting,—too, the eyes were filled with unpleasant catch lights. I must call the sitting a failure. We shall try again tomorrow —

After ordering prints on our exchange, amounting to 230 pesos, Mr. Fred Davis intimated that he would like at least four or five more prints, so I shall have clothing to the value of some 380 pesos. Good luck indeed!

Tomorrow a big day: in the morning Tina again, in the afternoon Jean Charlot. Diego was pleased with his proofs. They are, I will say, well seen. His choice was one in which his huge bulk was exaggerated, and his face expressed a cynical sadness.

December 4. I have approached Galván for passes. "Not on a basis of friendship, my dear friend,—only if you think the work I have been doing in Mexico has value to the country so well loved by you."

...from these last two sittings of her [Tina] I surely have recorded something worth while. I know how difficult it will be to please myself after our first attempt in which both of us were attuned to the moment, and failure was only through my faulty technique. The faces from that group of negatives will always haunt me: they were without a doubt supreme registrations—that was my moment— and I failed.

Rafael gave me a new name for my list of Pulquerías: "Mírame Bien"—Look At Me Well.

December 5—night. It is a lonely walk to the Salas, but I take it often,—they are such altogether agreeable and "simpatico" people. I usually arrive in time for cafe con leche and then to their amusement, take an after dinner nap, curled up with "Peggy" and "Xóchitl" [the dogs].

Chilly tonight walking the deserted streets home. Mexican streets are always deserted at night.

106

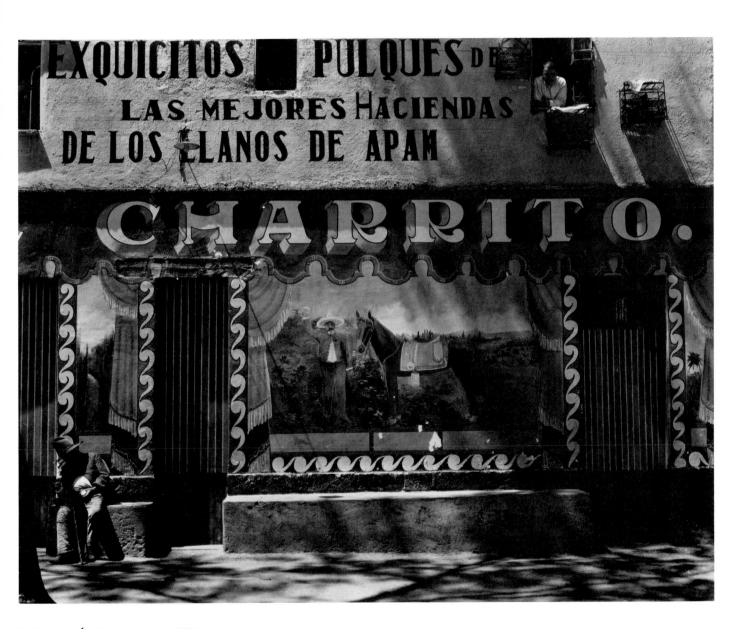

17. Pulquería, Mexico, D. F., 1926

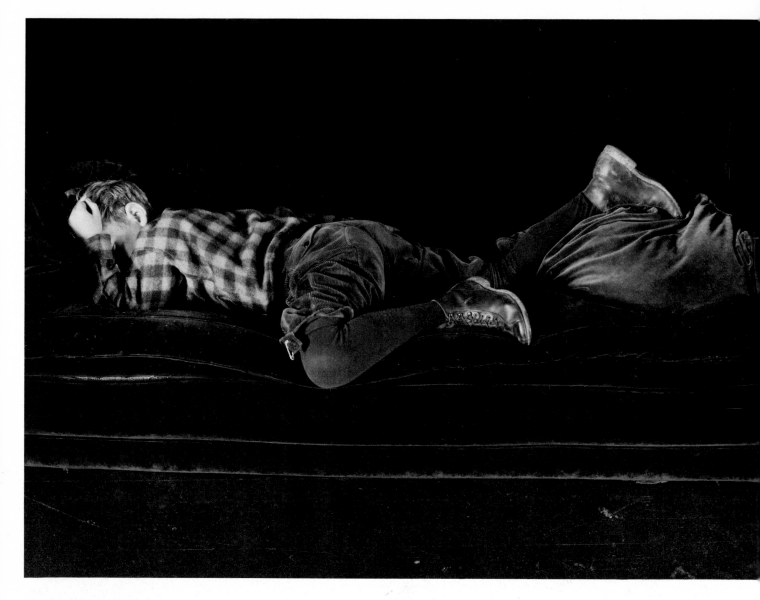

18. Neil asleep, 1925

19. JOHAN HAGEMEYER, 1925

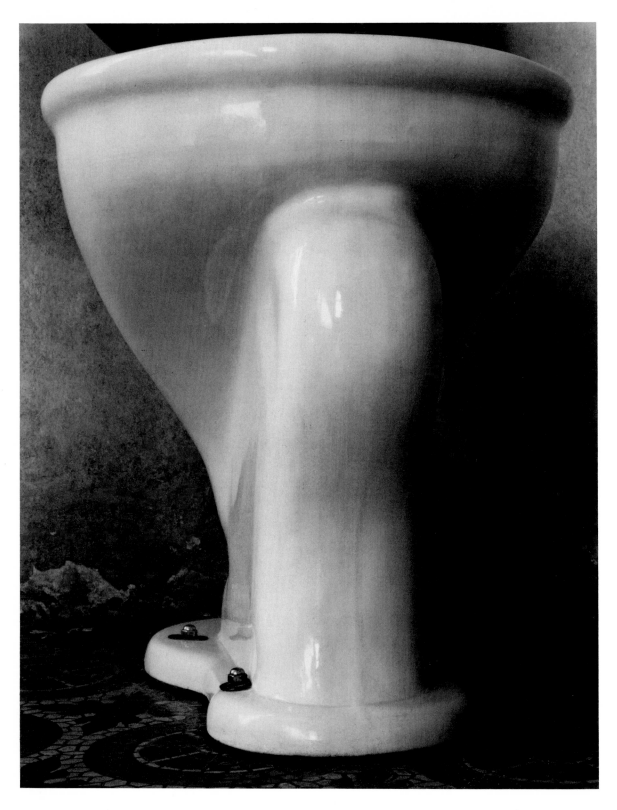

22. EXCUSADO, 1925

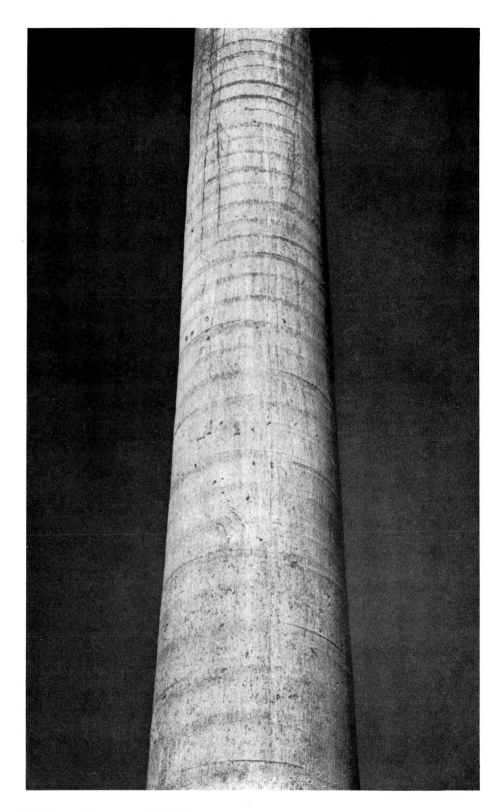

23. PALMA CUERNAVACA, II, 1925

24. Palma Santa, 1926

December 8. After a beautiful day in the mountains with Galván, Pepe, (Galván's Pepe) and the Salas, we went to the latters' home for cafe con leche. There happened a near tragedy, for Pepe, playing with Chandler, fell onto the pike of an iron gate and seriously tore his leg. We rushed him to the "White Cross" for first aid. What a terrible place!—dirty, inefficient,—and what sights I saw! Two men, victims of auto accidents,—heaps of raw bloody meat.

The brilliant driving of the Mexicans cannot save them from their recklessness. We noted a half dozen wrecks on the road to Ajusco,—and we passed these wrecks going a hundred kilometers an hour over a none too smooth road. A rut,—and Monna, Tina and I struck the auto's top. Tina was hurt, painfully hurt, and lay almost senseless in my arms.

Early breakfast in Las Tres Marías,—then a morning tramping the hills around Mt. Ajusco. Lunch was delicious: Chicharrones, cheese, mescal, and solid food it was for hungry people. Four generous drinks of fiery mescal did not phase me, yet at times a glass of wine will turn my head. I worked some with my Graflex, interesting cloud forms, surprising at this time of year. The landscape fine too. As to results I am in doubt,—the festivity of our party prevented concentration.

December 10. Rain! A rumble of thunder, then a gentle downpour. Preceding the shower, clouds assembled on the horizon. One strange serpent-like form I captured from the azotea with my Graflex: it borders on freakishness, exciting interest through strangeness of shape. But I feel it has enough value to include in my cloud series—in fact my only hesitation is over its bizarre quality.

Night time after the rain — clouds — white like sweeps of drifted snow, moonlit, dazzling. I watched them from the azotea.

To Fred Davis yesterday with a portfolio of photographs for a last exchange. He took 190 pesos worth. I returned with clothing for Chandler to the value of 70 pesos, and there is now a tidy sum left for Tina and myself. Chandler and I will return to California looking quite prosperous. Alas, "business" is quite slack again.

Fred Davis thinks he has a wonderful collection of my work,—he has not. His sellections were from my unimportant prints. He invariably passed by unconsidered my best things. I shall have to reprint but a few from out the entire exchange of 420 pesos worth of photos. I am sad and glad!

Considering my recent photographs:—a landscape done near Ajusco I shall finish; it is simple, quite dependent on a delicate sky of horizontal clouds, almost ruled lines across the nagetives. Then there are the latest cloud forms done from our azotea,—all are well worth finishing, surely one of them I shall do. It is a sensational thing, like some strange monster, but it is also technically good and fills the plate well.

Jean by the way is enthusiastic over my "Pajaritos", and so is Tina.

Sunday. With Felipe to "la Merced." Again that most charming little church in pink, again the overwhelming array of tropical fruit, the scent from heaps of pineapples. But the day's most interesting sight was a meat-market. I must say that the proprietor was a good business man. We were attracted from afar by the strains of a danzón: it was played by an orchestra seated in the street fronting the market. As is customary, great sides of beef hung from the ceiling,—ice in cool dry Mexico being superfluous. But the beef here was in gala attire,—artificial flowers, large, brilliant tropical blooms patterned in profusion the raw and bloody meat.

Felipe and I were enchanted and watched with admiration the rushing trade of this enterprising market... Speaking of carnecerías – meat markets – their names are even more amusing than those of the pulquerías – at least more incongruous, for one rather expects a poetic title or an imaginative one over the door of a house of dreams: but to name a butcher shop "La Lluvia de Oro", The Rain of Gold, or "El Paseo de las Ninas", which one might translate as the Promenade of the Flappers, is quite a delightful absurdity. Another pulquería title recently noted,—"El Misterio del Comercio"—The Mystery of Commerce —I well understand and sympathize with!

December 14 – Sunday in El Toreo. "I want to go with you", said Tina. I was surprised. Tina had not shown my interest and enthusiasm in los toros. I understood her though,—it was a gesture to please me rather than herself.

Three vivid impressions I shall record, though surely I can never forget them. So then – there was Ixtaccihuatl, "The White Woman," suddenly revealed to us through parting clouds: raised high above the topmost seats of the arena, her snow covered figure glittered in the setting sun.

Now, eyes down into the Arena's pit, sunless but for one long ray which streaked in through an open gate. The last bull was being fought, one of its victims lay stretched in the sand,—a horse, once white now crimson: and there it lay, light from the sun ray like a halo resting on its head.

The third impression was Valencia's fight with the first bull, as dramatic as I have yet seen. Valencia appeared in royal purple trimmed with black jet, his bull was a perfect one, a super animal, valorous to the core. The fight was beautiful, the enthusiasm supreme, the arena rocked with applause; but in an attempt to cap the climax Valencia hurled himself into the kill too recklessly. The steel entered to its hilt,—Valencia lost his balance, literally fell onto the bull's horns, was tossed and dropped heavily to the ground. He lay face down an instant, then in a last effort raised to his knees, arms outstretched as though in supplication, and fainted into the sand. He was carried out unconscious, but a moment later ran back to attack once more the mortally wounded but still standing bull. There was no need, the bull was really dead, but Valencia, in half crazed bravado tried to finish him with a short dirk from in front. He did, and

then was retired to the hospital for repairs! To my disappointment he was not able to appear again in the afternoon. The last bulls were worthless, and so ended what I feel sure to be my last viewing of a bull fight, unless I return to Mexico.

December 12. Notes on this year's festival at Guadalupe, with Tina and Charlot. We lost Jean in the terrific crowd pressing into the Church, and so spent the morning alone.

The church was quite as impressive as last year: the strange Indians from far away as interesting,—they were gypsy-like in attire with beads and bracelets and brilliant colors. Tina coveted their fajas of unusual fineness. After much persuasion and bargaining and difficulty too—for the Indians, many of them, spoke no Spanish,—we possessed three fajas—quite a triumph, for last year Lupe and Monna had each tried in vain to convince the owners that they should part with the sashes that held up their very skirts! We purchased too a weird flower, like a witch's claw, blood stained: flor de manitas. We ate food typical of the day, bizcochos called gorditas de la Virgen or little fat ones of the Virgin!

A few side lights of the day: A blind man with a flute played "It Ain't Gonna Rain No Moh", and an aeroplane whirred overhead,—modern touches to costumes and customs of centuries past. As we entered the church a leaflet was handed us: on one side a picture of Nuestra Señora de Guadalupe and a prayer to her, on the other a patent medicine advertisement for the cure of sexual debility, urinary disorders and diarrhea!

A dream I had of the night just passed: someone, and to my regret I cannot recall whom, perhaps Tina or Chandler—came running to me and called, "Come quick.—There are the most wonderful cloud forms for you to photograph." I hurried, regulating my Graflex as I went. But once out of doors I was terrified, for black ominous clouds bore down on me, enveloping me: I seemed about to be overwhelmed, I dropped my head into my arms to protect myself from the sweeping forms and slammed the door to keep them from me.

December 22. Charlot has reserved several prints from which to choose two, in exchange for one of his paintings. The selection interests me so I will record it. First of all, and with no further question, he chose "Bomba en Tacubaya"; the others are "Lupe Marín"—"Two Bodies"—"Caballito de Cuarenta Centavos" —"Circus Tent"—"Hands against Kimono".

Last evening I tried to select one of his paintings. It was difficult! Hardly one that I could not have been happy with, yet he had several in reserve which I wanted and probably might have chosen from. Finally I took the hand of an Indian girl holding a bouquet of flowers. He handed me a number of ink sketches of "Luziana", maybe thirty or more for my choice. It narrowed down to four. "Now I shall see how our taste agrees," said Jean. I chose the one he would have indicated!

Sunday afternoon. Nudes of Tina, indoors this time. I used my new anastigmat, it has fine quality. My sitting pleases me.

December 23. No word of the passes—greatly distress—edworry over vaccination and income tax—what a difficult world we live in! and it seems as though it should be so simple. Several last moment sittings have added to the confusion. I don't know if I should even attempt to make an appointment with General Calles—(I had a letter of introduction)—better not than fail.

Two of the last series of nudes of Tina ready to print, elegant things in line, fine technically.

The Christmas puestos are like last year, – colorful, indeed the ensemble even more picturesque, but little of real value to purchase. The craft work is becoming greatly corrupted,—crude, formulated, commercialized, and a flood of cheap German and Japanese toys has crowded out the delightful native espression.

December 26. No passes to date! Packing now — in go those damn day-books! Adiós a México—

December 28—On the train. We faced each other speechless at the parting—a hand clasp—tear filled eyes—a last kiss—

Jean came to the station though I had warned him not to. Of course Elisa we brought with us, dear Elisa, pathetic little figure in black, and she cried too, indeed has wept by spells for two weeks past.

I lay in a half stupor all day—emotional exhaustion, the shock of parting, worry and work. Awakening once, I saw a sky as magnificent as any I have seen in Mexico. Twilight came on and a superb sunset, long streaks of scarlet clouds over black hills: they changed and were black against a lemon sky: above all hung the first delicate half circle of the new moon. I think at every station a blind man on his harp has played, the last one at Irapuato.

I seemed to realize that I was leaving not only Tina but dear friends and the land of my adoption too.

Of course I must record a new pulquería—"Después Te Digo"—I'll Tell You Later.

One was besieged at each new town or stop by vendors of every thing imaginable: food stuff, fruit, dulces, sarapes, baskets. One Indian insisted that I should buy a basket for my Señorita. "But you have a novia,—fiancée"—he retorted with mischievious eyes. "Tampoco—neither one," I finished the argument, and we both laughed.

I got no passes,—it was a financial blow, the spending of 200 pesos for tickets. Our train is trailed by an armored car with soldiers ready for action.

Finally, I did not "do" Calles,—the opportunity came too late. But this chance for fame and business awaits my return. I sense my return, but for a while I shall no longer hear "Zócalo por Tacuba!"

110

PART III.

California, January—August, 1925

1. "I Felt Myself a Foreigner"

January 3rd, 1925. Los Angeles. Sitting here at my old desk, my much loved desk where I have worked and written, where I have shared morning coffee with Tina, Margrethe, Betty, Ramiel, Johan and how many others! But the desk is now in the "ranch," the home place where I am living. Flora has moved to the house of her parents, which was empty.

Joyous greetings with the boys!

The little ones, though taller, have not changed—are still babies. But Brett has, a big strapping fellow with amazing energy and a rebel! To leave him in these surroundings would mean his landing in a reform school; he must return to Mexico with me. Yes, I must return; I have already announced my intention.

I walked the streets of Los Angeles and found myself a stranger,—more, I felt myself a foreigner. Who were all these drab grey people!—not my kind! It was not merely that they were Anglo Saxons, for in New York I am sure the reaction would have been different. No, what I saw was a parade of Christian Scientists, Angeles Templeites, Movie Stars, Arty People and Iowa Farmers. To be sure there are in Mexico just as vulgar a class,—but there is also something besides!

Flora?—the same—she tries to be nice, I try to be decent, but underneath a thin skin is irreconcilable antipathy. Margrethe?—the same—almost submerged in mystery and intrigue.

Peter Krasnow saw my work, the first of all my friends—"our" work, I should have said, for his response to Tina's several prints was keen. Now I must see Ramiel at once!

January 7th. It is surely cold here in winter. I literally shake in my shoes after a night walk, and hover over the stove mornings. As for a cold bath, the very thought terrifies. On the other hand the days are hot and uncomfortable. Comparisons to la ciudad de México are unfavorable to Los Angeles.

Yesterday with Margrethe to Redondo beach and Ramiel. Who would have thought that we three outcasts from respectable society would ever be together again by the old sea-side! It was not the meeting I wished with Ramiel, and another must be arranged alone. I hardly need comment on his fine response to my new photographs, his appreciation war a forgone conclusion. We talked all day until my jaws ached and my throat was raw!

January 9th or thereabouts. I lose track of time,—and Christ how cold! Evenings usually with the little boys, reading *Robinson Crusoe* and telling tales of Mexico. Last night with Millard Rosenberg whose kindly face recalled our meeting in Mexico. Betty and Miriam have been out and I see Peter often, but other than these I have seen no one, nor want to.

From Tina letters. The parting has brought us closer together. Last evening a joint letter of New Year greetings from Tina, Monna, Nahui, Felipe, and Rafael, written from the latter's home, and another from Johan. "God! I want to see you!" I echo the thought, Johan!

I have sold two lenses and am bending every effort towards acquiring money for the return. Whether to attempt an exhibit in San Francisco I am undecided. The glory means nothing for I can show my work to the few whose praise and pleasure I would enjoy, but it might result in added income. My cameras are being over-hauled, a new bellows for the 8 × 10 and new lenses fitted. Altogether I am a busy person!

EDITORIAL NOTE: Entries in the 1925 Daybook stop here, and do not begin again until August 21, when Weston was once more sailing to Mexico.

Back in Mexico City, on December 17, 1925, he writes: "I have been reliving the past— that period recently spent in California—from reading letters sent to Tina. So—to save a few notes, but in no particular order, for it would take hours to arrange consecutively this fumble of letters—" he begins copying into the Daybook what he considers significant passages. These entries occur intermittently from December 17, 1925 to January 23, 1926.

I have arranged these as far as possible by date or internal evidence into what seems to me a reasonably coherent sequence. N. N.

2. *Letters to Tina*

Undated, from El Paso: "Well it's all over, the border crossed and we are in the U.S.A. I confess no thrill upon reaching my native land, in fact a certain reserve came over me as I noted foreign faces — people with whom I could never have one common thought. A typical middle-west family is across the aisle, a drab worn-out mother, a flapper daughter, a gawky boy. Chandler remarks, "I hope all Americans are not like these." On the American side a detective accosted me, — he had noted my "foreign accent." I convinced him at last that I was 100% American!

"It is quite cold — praise be: the desert exquisite, fantastic, enticing. I have always been fascinated by barren wastes, — even the mid-west prairies, especially in winter. One tries in vain to pierce the distance, the white silent level unrelieved by even a mound. The sky is white, there is no horizon, all is a shroud of white."

Glendale — the old home — January 3, 1925. "Too bad for me to have returned to this! — this worn out spot, surrounded by my dead past, the once-blossoming fruit trees I cared for so tenderly, sapless, brittle, naked, the plow and garden tools rusty, scattered, — the house with shattered window panes and sagging sides doomed to tumble soon unless new life and love comes to save it. But who is to bring that love? Not I! For I am only a camper, using this ruin for temporary shelter. Almost as a stranger, I speculate, philosophize, try to pierce the past of this abandoned place, to revision it peopled, ringing with children's voices, fragrant from roses and honeysuckle, alive with desire, intention, potentialities. This is not sentimentalizing on my part, — my tears are unshed, — I am merely reminiscent.

"The Mexican juguetes with which I have tried to decorate the place seem strangely out of keeping. I rather pity them. — The tropical tiger, the bright blue heron, the scarlet jicara shiver with me, and as for my comrade 'Panchito,' that tough rough-neck, with a faded flower in his horse's bridle, I am afraid any moment that he will turn and shoot up his best friend for bringing him to this land of grey sky, bootleg, and singing evangelists.

"My little studio presents even a sadder, sorrier aspect, surrounded on all sides by brick blocks, business-like and efficient, which scorn the falling shack and seem to say, 'Soon, soon we shall crush you, crowd you out, tear up your garden, cut down your trees, clean out this eye-sore to a wholesome, right-thinking commun-

ity.' The sign *Margarethe Mather* is falling too, in a week it will be gone forever. I go on. Is it my will, am I stronger, or do I have better luck? Even the faces and voices of my old friends come to me as in a dream. Yes, I used to know these people, but now who are they, and what have I to do with them? But I knew it would be this way, I had no illusions —"

Los Angeles — January 17. — "This morning I dressed in the dark — it was early. Just as I was tip-toeing out, bound for the ranch and coffee, a little roguish face peeked out from under the covers, greeting me with, 'I want to go with you, Daddy.' So here he is, to interrupt me as I write. He sings and chatters and is altogether delightful." (Cole)

Los Angeles January 27. — "Last night, as I kissed Cole good night he said, 'I wipe off other people's kisses but I don't yours daddy!' Surely it will be a sad and difficult thing to leave them again...

"The reading of *Robinson Crusoe* to Neil and Cole has been a very precious thing, to be looked back upon as more important than a supposedly exciting adventure. Neil's fair hair, his grey eyes, his finely pointed chin: Cole's determined little jaw, mischievous eyes, saucy nose, — they are two delightful boys."

Carmel. — "Johan and I! You know what that means to me? — of course you do! In his attic, — the rain falling through the pines outside, conversation intense and vital inside: my craving to show him my work satisfied, his response, arguments on technique, approach, our quarrel on 'definition'."

January 29 — Carmel. — "We leave tomorrow for San Francisco. I am glad, you know how restless I become. Besides I am being pursued by a 'poetess' and feel quite uncomfortable, even embarrassed, the wooing is so open! I'm sure it's much easier for a woman to say 'no' than for a man, one feels like being polite, or accommodating."

February 6. — "I have treated this exquisite spot rudely, glanced over it hurriedly, exclaimed and turned away my head, almost afraid to be seduced by its charm. The pursuing poetess I treated likewise. I said to her, 'I shall return — and then —' but I knew that I would not. She handed me a poem that 'you have written' — and faded into the sea-fog."

San Francisco. "Neil is beside me, chattering his head off in great excitement. We arrived last night. I arose at 5:30 thinking to be alone and write awhile — but no — he was wide awake in a moment, eager to have his first view of the bay and boats."

February 11. — "At last the end has come for Margarethe, and my old studio passes into alien and vulgar hands. A letter from her, 'Today — my last Sunday in the Studio — raining softly — like tears — for you and for me — and for the willowed river we never walked to — a terrific nostalgia envelops me.'"

116

Exhibit at "Gumps" [store specializing in art goods]. "The opening days have brought many enthusiastic people. There is something vital about photography — *not* art photography — that draws and holds people from all walks of life. A significant note is the interest taken by the store's employees who return again and again. Miss Starr, in charge of the room said: 'They are fed up on 'art' and never come to see the exhibits of paintings.' Though men come too, it is of course the women who form the majority. Some very intelligent ones, but most of them I despise: club-women — just curiosity seekers who come to 'rubber' and bore one with insane comments on art. And do you suppose they ever ask the price of a print? No it's a free show in which they idle away a leisure moment of the shopping hour, a moment stolen from their more important business of buying fripperies."

San Francisco. — "A brisk tattoo of rain on my roof of glass awakened me at four. Always the first impulse is to gaze out over the bay. It is white capped and sullen, — one tiny tug, a black speck trailing smoke and foam, buffets the waves. One pink cloud, a rift in the grey, a rising sun. I am endeared to this studio, to this spot, to San Francisco, and yes to several fine new friends: Jean Roy, Lester, Consuela [Kanaga, photographer], Dan."

"Do you remember the name or work of Sidney Joseph? — Knowing that his pet aversion was photography and photographers, Mrs. Celrion arranged a meeting between us. Innocently unaware of the trap — before my portfolio was opened, there was a long discussion over the evening's subject, with Joseph emphatic, definite, unswerving in his opinion. 'Photography could never be a personal expression, it had spoiled public taste, had hurt the painter by making him see nature wrongly.' I was stimulated, I had a worthy foe with a good mind.

"Finally, deadlocked in our differences, I opened the portfolio to prove a point. The first two prints were enough, he retracted everything, he capitulated absolutely. His admiration was deep, enthusiastic, sincere: he proved one of the keenest critics I have met lately, thanking me for having changed his attitude. Once he said, 'Anyone seeing that line and recording it could have done great things in any art!'

I liked his remarks on art: that it is being taken too seriously, reduced to mathematical problems, lacking in the sheer joy of creating, the thing from the heart, the fun. I don't know Joseph's work — but I like the man."

San Francisco. — "This is the morning after the night before — such a night! of course with your [the Modotti] family! Easy enough to say one had a good time. This was a glorious time! I do not — could not exaggerate. Of course we got beautifully borrachito — no — I should not have added the diminutive — at least in regard to the condition of Johan, Benvenuto [Tina's brother] and myself

117

— and if Mamacita was not, she didn't need to be, for she was quite the gayest person in the room. I made love to her and then to Mercedes [Tina's sister] with intense fervor and shocking indiscrimination. O she is lovely! Tina mia! I am quite crazy over her. With a few drinks, Johan is always a scream. Last night was no exception. Benvenuto was superb — gave us Grand Opera in the kitchen and acted all over the place. We jazzed — sang — did mock bull-fights. My sides really ache this morning from last night's laughter. I have had little sleep — yet I have no 'head' and am still exhilarated. So much for good wine and a good time. And the dinner! — what a feast — with little pigeons so tender one ate bones and all — fresh mushrooms too — and then for emphasis I repeat — the wine! — the Wine!"

San Francisco. — "Blake said, 'The eye sees more than the heart knows.' And I say, 'The camera sees more than the eye, so why not make use of it!'"

"Neil goes to play every day at Carter's with their little girl, four; when he starts to leave she threatens with tears. Rather young to pull this feminine stuff. I shall have to warn my sons early."

March 4. "The fog sweeps by like smoke. The sirens shriek dismally. I am alone in this great room — no, you are with me, but only your counterpart on the wall, forming a kiss I never got. I read a bit, walk the floor, smoke nervously, try to write but cannot. I question which of my friends who have begged me to call I shall telephone. The answer comes—none, so I shall open a can of Campbell's Soup and try to find solace in eating.

"Later: the soup was not inspiring. I don't stand inaction — that's *my* trouble. I must keep going towards something—if it be but a blind alley or a locked door. Intermissions of relaxation, yes, but not this uncertain waiting and wondering. I shall go out and walk in the fog."

"Consuela got me a sitting for next Wednesday. She has been so anious to help and so upset because she could not swing things faster for me. Imagine another photographer — in business in the same city, so helping a stranger, — and she struggling too. Well—they are the kind who do such things.

"Slept ten hours again last night. Exhausted nerves I realize. Thank God I sleep when overstrained. Johan does not, he lies awake to think and go crazy. I protect myself by giving up at night."

San Francisco. — "May left for Los Angeles an hour ago, taking Neil with her. It was a sad good-bye, marking the end of another period, never to be repeated. He clung to me at the end, sensing perhaps the same in his child-like way: he has been a trial, but he has brought me much beauty."

Weston comments in the Daybook, December 19, Mexico, D.F.: Besides Neil's companionship mentioned in the above note he afforded me a visual beauty which I recorded

in a series of Graflex negatives of considerable value. He was anxious to pose for me, but it was never a "pose," he was absolutely natural and unconscious in front of the camera. When I return he may be spoiled, if not bodily changed, in mental attitude. Last spring in San Francisco at eight years, he was in the flower of unawakened days before adolescence: tall for his years, delicately moulded, with reed-like flow of unbroken line: rare grey eyes, ingenuous, dreaming, and a crown of silken blond hair. He is a lovely child!

March, 1925. — San Francisco. "I have been here almost three months, almost four months since leaving Mexico. I had expected to be in San Francisco not longer than a month, had hoped indeed to be in Mexico ere this. Yet the end of my stay is not in view, — even more indefinite.

"Rain has fallen all day. Not for one second has the beating on my skylight ceased. It seems to fall directly on my brain, while I, tied hand and foot, writhe and twist and turn in hopeless effort to escape the seeming symbolism of this incessant downpour.

"I am tired of thinking, my mind is a vortex of negated plans and desires, my thoughts find no rest in coordinate intentness of purpose. Whatever the cost — a fusion of apparently incompatible wishes must come, or else some vagrant hope will be buried forever. But to finally dismiss a hope is as sorrowful an act as to inter a beloved friend — I hesitate — and so returns the unanswerable question.

"One does not necessarily act for the best, nor even nobly, in destroying personal aspiration for the sake of others. The greatest if less apparent gain, even for those others, must come from the fulfilling of one's predilection rather than in sentimental sacrifice. Yet I realize that I face sacrifice, no matter what the decision, thus involving the whole situation and complicating any plan or proposal. So all questions remain unanswered today as they have for days past."

Thursday, April 9 — San Francisco. "It is the hour before dawn, a time I love, so very still. The whole world sleeps—for aught I know I may be the only living person. For the moment this thought pleases me yet if it were true I imagine one would commit suicide, for—craving aloneness—yet some human contact is necessary to rebound from or identify with. Anyhow at this hour I seem Lord over my dominion and preside in mighty isolation.

"My remark at Jean Carter's that, 'The artist needed an audience,' started an argument. I should not have used the word audience, for it pictured perhaps a group of from a hundred to ten thousand applauding people, when I meant not necessarily more than half a dozen, or even one. Neither did I mean the artist creates to *please* his audience—not primarily—but the feeling of having given is as important an item in art as it is in sex. Misanthropic as we may be or become, we are basically a social group and only grow anti—from bitterness, disgust, weariness. Arguments are so futile, the loser in his own eyes is never defeated, he

119

starts with an a priori premise, his attitude remains stolidly incontrovertible, debating becomes absurd."

Undated. "There's too much 'swooning' in Lawrence—too much 'sweat' and 'surging' — overemphasis on 'vibrations' and 'anticipations'—repetitions of 'white fury' — 'voluptuous ecstasy' — 'sardonic look' — 'demonical soul' — 'fine hate' — 'convulsed moment' — 'drugged eyelids' — the writer of *Nick Carter's Weekly* never rose to such melodramatic heights. His characters are over-drawn—for instance, 'Hermione'—he's too anxious to make plain their pathology. Better to write a book of facts and statistics on sex psychology. Lawrence is unrelieved by a single laugh, which might, by contrast, strengthen his drama.

"He is keen indeed—has much to say on 'love.' He sees, he feels, he knows: his baring of impulses, his revealment of the cause, the why and wherefor is profound. But in the *telling*, in the *words*, he loses by repetition and obvious statement of fact.

"But *I* do not attempt to criticism of Lawrence! I am indulging in passing thoughts. To me he is [a] head higher than contemporary novelists that I happen to know. But my reading is limited, so after all I don't know much!"

San Francisco. "It is not best, this reading of one book after another in such quick succession, as I, in this insatiable spell, am doing. Moore lessened my pleasure in Lawrence, and now after Rosenfeld's verbosity, his sky rocket of words, I find relief in the mature direct elegance of Havelock Ellis. You remember how Rosen-feld loves to 'toss the glass balls' before a bewildered audience. He must write with a well-worn book of synomyms by his side, cigarette stubs scattered around him and certainly one feels that a typewriter nervously clicked as he wrote. In Ellis one senses the repose and dignity of a goose-quill which I am sure he used."

San Francisco — April 12th. "Morning, with fog so dense that vision penetrates scarce half a block. Sounds of fog-horns are muffled, the wail of a siren on Alcatraz is faint and chokes abruptly. The sailors on the anchored battle fleet must gaze out into nothingness.

"Sailors I like, but do the strutting soldiers that infest San Francisco never realize their humorous pomposity? And why does the sailor offend less? — is it merely a difference in uniform, or has the sailor from long night watch or day-dream over the sea, acquired a deep self-questioning? In answer he *wears* his uniform, he never flaunts it."

San Francisco — April 15th. "After an overcast muggy day — earthquake weather, I heard whispered — this morning came clear. The bay is blue — blue — every detail of the other shore revealed. 8:30 is late for my coffee, but I went last night to a 'movie'. Unusual form of dissipation for me, but I would go more often could such films as last night's be seen. Fine acting — fine photography and real

120

life. No sub-titles were used to insult one's intelligence—nor needed to make shift for poor directing or acting. The added 'happy ending' was unfortunate. It was evidently an after thought to please the American audience who so dislike to face the truth. The film is German — titled *The Last Laugh*."

May 18th—San Francisco. "I have had another rotten contact with a newspaper man, the general-manager, the big cheese of *The Chronicle*. Really I boil when I think of him and what he represents. Realizing that this man caters to, and knows the taste of, several hundred thousand readers, and that these readers average like millions of others all over the country—one becomes appalled, hopeless.

"His remarks: 'Well — what are these pictures — what do they all *mean*? I can't get any *idea*, they may be very fine technically, but they have no *art* value' — and so on! He finally selected begrudgingly a dozen for one page, saying — 'If you had to buy this it would cost you a thousand dollars.' It took him five minutes to look over fifty prints. I did not return."

June 3rd "Is one after all ever *influenced* by anything? Is it not an abused word? Would not a better word be awakened or stimulated? I feel one is *influenced* only because one already has inherent qualities — maybe dormant or unused or misused or misdirected.

"Your individualistic attitude towards life is not selfish, at least not unnatural, in fact it is most natural, a law of nature touching everyone, everything. Are not your thoughts a reconsideration of 'the survival of the fittest'? — to consider oneself first is in the last analysis the least selfish attitude. My eternal question over my children is between my emotional, personal love for them, my selfish love! — and the impersonal consideration, realization, that to do the best thing for them — unselfishly — I must think of Edward Weston first.'

"George Stojana last night. We met at arm's length, we kissed on parting. I cannot hold a grudge against such a person,—anyhow the parting gesture was was his. There were no explanations. A trifle worn was George, and older, much of his past work destroyed,—he would show me but five wood carvings in relief, fine things..."

June 16th. "Someday I shall tell you of the beauty and drama of my leaving S. F. —how Jean Roy, breathless, reached the train to wave farewell just as it pulled out: it was a perfect gesture."

Exhibit in Los Angeles given before a Japanese Club on East First Street. August, 1925. "The exhibit is over. Though weary, I am happy. In the three days I sold prints to the amount of $140. — American Club Women bought in two weeks $00.00 — Japanese men in three days bought $140.00! One laundry worker purchased prints amounting to $52.00—and he borrowed the money to buy with! It has

been outside of Mexico my most interesting exhibit. I was continually reminded of Mexico, for it was a man's show. What a relief to show before a group of intelligent men! If Los Angeles society wishes to see my work after this, they must come to the Japanese quarter and rub elbows with their peers — or no — I should say their superiors! I owe the idea for this show to Ramiel — and his help made it a success."

Venice, California, no date. "So this is 'Venice!' I live on the Grand Canal — isn't that grand! I am a nurse girl, policeman or something quite objectionable. I wasn't made for the job. The boys fight and bicker all day: my last memory of them will be wails, whines, and scoldings.

"It is tawdry as ever here but I am amused and amazed watching humanity enjoy itself. They come for the week end, get burned fiery red and raw, buy salve and return home to suffer. The thrill-producing rides exceed one's wildest imaginings. Is it sex repression? Skirts are worn well above the knee, — the question is are they more provocative or *less*!

"A man just returned with a catch of fresh fish. His red-faced slovenly wife called out, 'Eat a lot of 'em, 'Sam, they're good for your brains!'

"Well the boys are awake and the first fight has started. I don't stand confusion, I want to run — run away — my fingers in my ears."

PART IV.

Mexico, August, 1925 — November, 1926

1. *"Life through My Camera"*

August 21, 1925. On board S. S. Oaxaca. *Brett and E. W.* Sailing! Once more bound for Mexico, returning to my unfinished period of work and life. There were farewells yesterday. Sad acknowledgments of the pang of separation. Partings with friends and loves, old and new. Leaving the children, the most painful. But it had to be, this going away again.

I have enjoyed my new cape—its ample encircling folds, the swish and flap of it in the stiff breeze—long coveted, I now possess a cape. So, warmly wrapped, my pipe glowing with good tobacco from Miriam and with many a thought of her, I dreamed away the hours before bedtime.

Today the sea is rough. Our little ship rides mountainous waves. I enjoy its careening but Brett "feels rotten." He cannot eat the good cooking and Brett unable to eat is an anomaly.

The boat is clean in contrast to the *Colima* of two years ago. We are the only passengers, it seems quite like our private yacht. Cabins and decks are deserted and silent but for the engines' rhythm and the lament from a love-lorn Mexican youth singing to the waves.

August 22. The morning is cool and calm. The *Oaxaca* steams ahead with scarce a roll. Brett is more himself and in his irresistible way, making friends with all the crew.

Eight months have passed since I left Mexico, unable after eighteen months' separation to be longer parted from my boys. Leaving, I no more than half expected to return, and why I return, questioning myself, is not so simple to answer. Pages of reactions to people and places might be indulged in without conclusive reason. There might be more than one answer from more than one self. I simply packed my trunk and left before becoming once more too deeply involved in a mire of routine or imagined responsibilities.

But I am sure if my studio were not awaiting me intact and ready for work and if Tina were not in Mexico I would have hesitated longer or never have considered the return at all. At least I have some idea of what to expect of conditions and surroundings. I am not blindly venturing unchartered seas. I am not ready for another adventurous change.

To the cackling overheard from busybodies I can say that Tina's presence in Mexico is not the magnet supposed, since she has expressed a willingness to leave for any place of mutual desire.

The moon set early. Only a spectral lantern sways from the masthead. We plow on through the black night noiselessly, except for the plunging piston and plaintive cries from sea fowl overhead. A sudden jarring impact and we have struck a whale,—then on again. The chief engineer, rotund and waggish, kids Brett. "Tomorrow is Sunday. We no work. I stop the engine and fish for sharks." Brett, wide-eyed, ingenuous, half believes him or wants to.

August 23. I am disinclined to exertion, mental as well as physical. Better had I used animal instinct, were that possible, instead of exhausting myself in an attempt to reason out the why of everything. The best thing to do, though it may well be that my instinct has played a part in finding me this August day southward bound.

August 24. I have written thirteen letters today. Really I should call them notes of farewell. What a volume the history of these several persons would make if detailed episodes of their part in my life were to be recorded. I did record much from day to day, even as I now am doing, but one brave moment in San Francisco, three years of writing went into the flames. No doubt this period will meet the same fate, but write I must, no matter to what end. It is the safety valve I need in this day when pistols and poisons are taboo.

August 25. We are anchored in the very beautiful Puerta Vallarta having arrived here from Mazatlán yesterday morning. I did not expect to lose a day here. However I deserve reproof for calling time spent here loss. Green mountains, palm-covered, meet the waters of this small gulf. Only a narrow strip of sand gives room for the pueblito of white tile-roofed houses and thatched huts, set against steep green inclines.

Tobacco is being loaded, canoes the means of transportation. The water is a thousand fathoms deep, even close to shore. So we are near enough to make this primitive way of loading practical if slow.

Our day at ever-remembered Mazatlán was spent with El Capitán Arenas of the *Colima*, and a fine reception he gave us. Many incidents recalled my first visit of two years ago, especially when Brett and I took a coach over the same winding road which follows the coast. We have been ashore twice in this Puerta Vallarta, Brett casi loco over the flitting myriads of tropical butterflies which he ineffectually tried to catch with my newly blocked panama, quite ruining it, but in a good cause. Finally, hot and exhausted, we stopped under cool arches and protecting trees to be served coconut milk; with a two foot machete an Indian hacked off the coco's end, inserting a soda pop straw!

September 14. — Mexico D.F. I have been sitting on the "hypo" barrel in the dim green light of my dark-room, reflecting upon the past, pondering over the future… However, I willed myself in Mexico again—and here I am!

September 22. Musing over events en route from Manzanillo to Mexico, I shudder with aversion remembering the landing,—the confusion, heat, officials,—but after all it could have been so much worse, and certainly the Mexican officials were courteous and lenient. Only my deep rooted antipathy to all "red tape," to all uniforms demanding a dreary consistency of acquiescence, of submission to formulae, brings this always disagreeable revulsion.

At last we were accepted as proper people to land on Mexican shores, my letter to President Calles having had due and immediate effect in the consideration, and weary but relieved we relaxed in the train for Colima.

Towards evening, approaching Colima—a sudden lurch—a grinding of wheels —and we went off the track, destined to a six hour delay before reaching the hotel. To bed at one, up at five,—then Guadalajara in the afternoon. There they were! Tina and Elisa excitedly waving from the station platform.

The ten day stay in Guadalajara excepting for a few bright hours, was a boresome period. The proposed exhibit took place in the State Museum. Every day we went, waiting for sales which never happened, every day we grew more irritable and despondent, the governor's purchase of six prints for the museum bringing quite inadequate reward for the effort expended. But hail to Sr. Zuno for being such an appreciative patron!

The bright hours were Sunday dinner with the Marín family, the venerable parents and seven children, including Lupe, with them for a short visit. Almost without exception the children were individuals in every sense of the word, but Victoria to me was an outstanding figure even amongst this unusual group.

Another happy evening was the mask party at Carlos Orozco's. Tina and I exchanged clothing as once before in Mexico. That our make up and acting was well done may be judged from the effect we had upon the Orozcos, who were frankly disappointed that we had merely masked! — until gradually they perceived that "Tina" was not Tina, nor "Edward," Edward! Brett appeared as a California Bathing Beauty: in his blue bathing suit crowned by a wig of golden curls—a wig such as is worn by the adenoidal "movie queens" of Hollywood— with flapper lips rouged to a cupid's bow, his blonde eyebrows delicately penciled, he startled even us with his girlishness.

After the exhibit, we made two excursions of interest,—one a descent into "La Barranca de los Oblatos,"—Valley of Forgotten Men—a famous gorge near the city. Diego had said, "It is the strongest landscape in Mexico," so, visualizing great mountains of bare and precipitous rock, forbidding black abysms, etc., I prepared enthusiastically to do my first photographic work of the new adventure into Mexico. We hired an Indian to carry the weighty 8 × 10 camera, and Brett of course made ready to capture the butterflies which flit through his dreams even as photographic images are preexposed in mine.

All day long we explored, making but two exposures, one of a sunset cloud, another a detail of the rocky trail beneath my feet. The expected barren landscape was completely covered by luxuriant tropical growth, gorgeous to the eye, impossible photographically. Diego afterwards complained we had been directed down the wrong descent. Nevertheless I do not believe that the tropics can ever show the austere grandeur of a northern landscape, wild, insidious, intense as it [the tropic landscape] is in other ways. But I am expressing disappointment from only one angle, for the day was rich in experience.

The descent of 2000 ft. was leisurely made, except by Brett, who surely covered twice the distance we did in his chase for butterflies: prepared this time with net and box he captured many.

The bottom of the gorge was under cultivation, all tropical fruits flourished in the humidity and heat engendered there. The ascent was even more leisurely made, but not from carefree indifference! An overhead sun dispelling all shade, the heat became intense: water, which was not to be had until near the summit, became our preoccupation,—so when at last a spring gushed from the rocks we literally threw ourselves into the spreading pool beneath.

With twilight and the end of our ascent we rested in the open country above. A storm was gathering,—great clouds afire in the sunset, flashed lightning, rumbled, roared, and massed together to an approaching deluge.

One other remembered day at Tonalá, amongst the potters. On the way, Indian women passed, balancing great water jars upon their heads, though "balancing", which seems to indicate effort,—is that the word? For the jar and figure were a synthesis, moving with exceeding elegance.

We found at last the adobe home of Amado Galván, most famous of potters. He squatted on the earthern floor,—delicately moulding his clay.

That afternoon we left Guadalajara for good. I shall recall it as a city, clean and gay, with sparkling skies and balmy air, with beautiful and, more surprising, smartly dressed women. I noted but little poverty, less begging than elsewhere, yet if there is any over-indulgence in, or worry over, work or business in Guadalajara my observations failed! Incomprehensible to the Anglo-Saxon, life sailed serenely on! In none of the 1001 proudly progressive, despairingly new California Cities, with red, white, and blue Standard Oil Stations, and "Cash is King" grocery stores, have I seen such a blaze of street lights. Night became day even unto dawn, for not until then did the extravagant display end.

The press notices concerning the exhibit brought us screams of laughter. I was announced in head lines as "Weston the Emperor of Photography, who, notwithstanding his birth in North America, has a Latin Soul." This was the usual style, but Alfaro Siqueiros, painter, writer, radical, wrote a most intelligent, brilliant article which though directly concerned with the work exposed, might

be read as a exceptionally understanding treatise on photography. I quote one paragraph:

"In Weston's photographs, the texture, the physical quality, of things is rendered with the utmost exactness: the rough is rough, the smooth is smooth, flesh is alive, stone is hard.

"The things have a definite proportion and weight, and are placed at a clearly defined distance one from the other. In one word, the beauty which these photographs of Weston's possess is Photographic Beauty!"

Tina insisted on riding second class the journey to Mexico. Brett and I had our first class tickets straight through from L. A., so I bought a berth for Brett,—too cruel to make such a sleepy head sit up all night, I thought, and I spent the night alternating between a watch over my cameras in first class and Tina in second, in the dim light among the Indians, sprawled over each other on the hard seats, dozing or drunken or garrulous.

September 29, 1925. I have been very sick since arriving, a terrific cold, chills, and fever,—perhaps malaria? Today, my old self has emerged, weak and gaunt but on the mend. The weather has aggravated my condition, a continued dreary drizzle or downpour, till I who love rain have prayed for a moment's sunshine to warm my shivering bones. It is still cloudy,—most un-Mexican weather.

I have met many old friends,—Monna, Rafael, Felipe, and Jean Charlot,—also Diego, Carleton Beals, Frances and Pepe. I have seen the new work of Jean and Diego,—they have not stood still, nor, considering my own new negatives from California, have I.

Prolific I have not been these past months in the States. I have seldom been aroused or had opportunity to work, yet from each brief period with my camera, some sensitive recording has been achieved. The majestic old boats at anchor in an estuary across from San Francisco, [Neil] who, naked, seemed most himself, the full bloom of Miriam's body, responsive and stimulating, the gripping depths of Johan's neurasthenia,—the all-over pattern of huddled houses beneath my studio window on Union Street—in these varied approaches [I] have lately seen life through my camera.

October 2. And the first day I have printed palladiotype since returning. The rocky trail and storm cloud from La Barranca, several of the new industrial scenes from Los Angeles and two heads of Diego.

Diego has painted a self-portrait into one of his murals in the Secretaría, copied quite exactly from one of my photographs of him, one which I could not use because of poor definition, though it was my favorite as well as his.

I am now in a fine mood having printed once more after so many months, despite a very bad night previous. We loaned our house for a "wild" party,— some have the idea that "wild" is to hold hands in a dark corner. Fortified with

129

cognac, I did not become bored for quite awhile, even played at being wild myself, but alas, ready to retire, I found my room occupied by spooning couples, and I an outsider! When the party finally dispersed, F. was left behind, down and out: with difficulty I steered her to my room, got her shoes off, tumbled her into bed and found a corner for myself in the studio,—rather cold and rather uncomfortable.

October 3. Rereading letters before burning. Love like art returns in measure the emotion one carries to it,—one finds what one seeks—

Well, already I have been compensated for my loss, and surely this is the strangest love of my life. A little brown Indian girl came to live with us, to help. At first it was a timid, distant admiration, then she would softly caress my hair, then stroke my hand or cheek, until one day, seeing too well her passion, and feeling deeply, I took her to me and kissed her lips; since then our embraces have been often and impassioned, no less genuine from me than from her. There is indeed something exquisite yet sad in this love between such extremes of age and tradition,—for what can ever come of it!

My little room is once more assuming character, a corner to hide in, enjoying my retreat the while. A new "trastero"—whatnot—which, stained brilliant yellow, stamps the room at once as Mexican: of course by "Mexican" I mean the indigenous race, for no sophisticated Mexican, always excepting the artist, would have a trastero in his room. So—starting with a trastero, a petate, a sarape, the room irresistibly becomes fixed in character: no additional properties could find place near such direct, vigorous, primitive expression. On the trastero I have placed my new juguetes—toys, a crimson spotted dog, a leopard, a couple of viejitos, and pigs with bursting bellies.

I never tire of the juguetes, they are invariably spontaneous and genuine, done without striving, fancied in fun. One imagines the Indians laughing and joking as they model and paint. My old flower-bedecked chest, a new orange and black sarape, a drawing by Diego, and a small canvas by Jean complete my exposed treasures.

Charlot seeing my delight in his new oil, said, "Take it, you have many photographs I want to choose from." It is simple, this painting,—two terra cotta [arches?] over a base of Mexican pink, surmounted by a mountain-top and sky of deep blue-grey,—a subtle thing in color and construction,—aesthetically satisfying.

October 10. After all, life is not so difficult for me,—I slip a new disc into my musicbox of emotions, grind the crank and out squeaks another tune. To be sure it may be a more or less familiar melody, but one can always change the tempo and use imagination!

October 12. Brett and I were guests of new American acquaintances yesterday. First the bull fight in which the bulls were victorious, matadores being carried

to the hospital for repairs after their first encounter. Complete demoralization of the lesser lights followed and the fight continued on in confusion—a sorry spectacle. Later we picked up Tina and Jean and were treated to a good supper with wine.

Wednesday, October 14. Brett at thirteen years, wanted a cane! Last night I got him one, incidently a new one for myself, of ebony,—another trade with Mr. Davis. A great event this first stick!—the selection an occasion for prolonged and profound deliberation, though I should confess that my own consideration of shape, size, surface was quite as extended!—then off we went down Madero, swinging our respective "bastones." Brett handled his well, albeit with some self-consciousness. "Dad, you don't carry a cane for show do you?—you just like to swing it?" So—I assured him! Now we are both happy!

October 15. With Brett to a nearby "movie," perhaps a little worse than the usual average of mediocrity. Yet why is it that I can be emotionally moved at the most vapid climax, the while I intellectually deride the whole false and mushy mess? It is of course but the awakening of memories by some act or gesture related to the past,—some unrealized hope is returned, a lost thread is for the moment woven into reality. However, the absurdity of my Jekyll and Hyde situation, with my mouth in a grin and my throat choked, and this from viewing some quite preposterous melodrama, ridiculously conceived, acted by imbeciles, presented for bovine clodhoppers, brings the question am I infantile? senile? maudlin? or also beef-witted? With a superlative stretch of the neck I answer these questions, "No!"—yet feeling uneasy over the sureness of my self-estimation. Better to wink at my weakness than to discover it a truth!

October 17. It was a rare joy, my first view of the paintings of Carlos Mérida. We had been told that Mérida was one of the first three painters of Mexico,—the others, of course, Diego and Jean, but one learns to expect nothing, so the visit was an unlooked-for treat. He may be amongst the first three, though more than that I shall not put down, knowing the hazard of first enthusiasms—my own, I should add—for I am so liable.

Mérida himself is a finely organized type, more that of Jean than Diego.

From Mérida's work and glowing with a fine heat of aroused ecstasy, we went to call on Pintao. Almost too much for one day, the painting of Merida and the carving of Pintao! It was a foregone conclusion that Pintao would again bring us full satisfaction: he did!

We sat on his funny brass bed,—he offered us the same crooked cigars and his night-pot for spittoon: then he talked while we watched his remarkable eyes and prescient gestures.

In New York following the showing of a wood-carving by Pintao, a "critic,"

quite with usual stupidity, wrote that Pintao is one of the "moderns" who played at being naïve. Pintao! who is naïveté itself!

October 21. "Form follows function." Who said this I don't know, but the writer spoke well!

I have been photographing our toilet, that glossy enameled receptacle of extraordinary beauty. It might be suspicioned that I am in a cynical mood to approach such subject matter when I might be doing beautiful women or "God's out-of-doors," — or even considered that my mind holds lecherous images arising from restraint of appetite.

But no! My excitement was absolute aesthetic response to form. For long I have considered photographing this useful and elegant accessory to modern hygienic life, but not until I actually contemplated its image on my ground glass did I realize the possibilities before me. I was thrilled! – here was every sensuous curve of the "human form divine" but minus imperfections.

Never did the Greeks reach a more significant consummation to their culture, and it somehow reminded me, in the glory of its chaste convolutions and in its swelling, sweeping, forward movement of finely progressing contours, of the Victory of Samothrace.

Yet the blind will turn longingly back to "classic days" for art! Now I eagerly await the development of my exposed film.

October 22. I awakened this morning to the song of a bird. Yes, this is rare enough to comment upon! There seems to be almost no bird life upon the plateau: city, parks, country alike are lacking, and why, I cannot conjecture nor ascertain.

But we have music,—forsaken by birds there are compensating melodies. Early amongst the street songs comes the cry, "Tierra negra para las macetas—black earth for the flower-pots!" and an Indian, sack on back, passes. Or he may sing— and it is a real song—"Tierra de ocha para las macetas—earth of leaves, etc.—!" Follows the woman with "Los tamales! los tamales!"—and soon the scissor-grinder, always from Spain—blowing his plaintive tremulous notes on a Panlike pipe, carrying one away from today, perhaps to ancient Greece,—a whistle traditional, archaic. Later, the organitos serenade beneath one's window, delighting with wheezy melodies, from well loved popular airs to jazz.

These are a few from the many songs of the street,—and with night, safely tucked in bed, one shivers a bit, listening to the eery shrill of the police whistle and the faint far-away answer from another shrouded figure. Or perhaps a sharp clatter of hoofs startles one from half-slumber and peering out, a half-dozen black-cloaked, lantern-lit mounted police spur on their horses into the drizzling night.

October 23. The portrait of our privy could not have been finer but for a piece of carelessness on my part: during exposure I shoved a sheet of cardboard within

range of the lens. So today I am working again with my new enthusiasm. It is not an easy thing to do, requiring exquisite care in focusssing — and of course in placing — though the latter I am trying to repeat. Elisa had only this morning polished up the bowl, though hardly in anticipation, so it shines with new glory.

The household in general make saracastic remarks re my efforts, — Brett offering to sit upon it during exposure, Mercedes suggesting red roses in the bowl, while both criadas believe me quite crazy. I showed the first negative to Felipe who unhesitatingly offered congratulations, — and Felipe is one of the first persons among my friends whose opinion is invariably sought for and well considered.

Evening of the 23rd. A good negative—technically at least—of the W. C. is washing, together with several enlarged negatives from my evening's work. My head is sublimely swimming from plenty of excellent Vermouth. Best of all I'm alone! Brett asleep and the rest — even the servants — out. How precious to be alone!

October 24—evening. Already the W. C. negative is printed! — a beautiful print too. Charlot and Paul have seen it and agree that it is one of my most sensitively observed photographs. Now that it is printed the tile floor does not distract, in fact quite takes its place as a satisfactory base—suggestive yet unobstrusive. What absolute joy to be working again.

October 26. Several days full to crowded with work, and more unusual, divertisement. Saturday night, supper with Rafael, the occasion his saint day. There we encountered Dr. Atl already accoutred for the ascent of "his" mountain "El Popo," — and he was to walk there besides! He gave me a new spelling for that glorious mountain, "Itztatzihutl," and a new meaning which appeals most of all—"The Ice Woman."

Also, there was Dr. Gruening, one time editor of the *Nation*; he knew Stieglitz and his "group," admired his work but thought him a poseur, at least to the public, ridiculed too, the exaggerated worship of his followers, and the bunk mysticism read into his photographs.

Rafael's supper of fish—Catalonian style—and fried mushrooms was delicious, but as usual the wine befuddled my brain and I slept erect in my chair.

Sunday afternoon, the bull-fight, with Brett and Mercedes, — her first. The furor, in which I joined, created by "Chicuelo" and the magic fifth bull: "there is no bad fifth bull," a traditional superstition.

Tea with Diego and Lupe, — the three of us, Tina, Brett and I. Of course I must carry my portfolio of new work to show Diego, saving for the climax the "Excusado." After his first exclamation, — "In all my life I have not seen such a beautiful photograph," Diego sat silently considering the print for many moments. This was more significant to me than any praise. I gave Diego two portraits of himself and left with two drawings chosen from his collection.

October 28. No use to "kid" myself longer, I am not absolutely happy with the toilet photograph. My original conception on the ground glass allowed more space on the left side, hardly a quarter inch more, but enough to now distress me in the lack of it. Not my fault either, excepting I should have allowed for the play of holder in the camera back. I finally trimmed the right side to balance and though I admit a satisfying compromise, yet I am unhappy, for what I saw on the ground glass, I have not,—the bowl had more space around it.

I spent hours yesterday contemplating the print, trying to say it would do, but I am too stubborn and refused to say. This morning I am no wiser which may mean that I should do it over. Yet if I restrain my impulse and put away the print for a week, I may become perfectly satisfied, not acquiesing to something badly done but accepting a different conception quite as good. And I am anxious to work more!

October 29. Mariposas—mariposas! Brett's net swishing through the air, butterflies captive in its meshes or sailing away to his chagrin. This was our day together in Tlalpan, a happy day for both, though my joy was most in seeing his!

The evening, Frances took us,—which meant Carleton Beals and the Weston-Modotti household — to Teatro Lírico. Too much "carne"—though I am not moralizing. I was finally bored by all the wiggling arses and wobbling tits. We wound up the party at Monotes where food is good and the crowd congenial. But to bed at 2:30 has never been my way, less than ever now! Seldom that I do not regret the time lost and energy spent.

October 30. Trying variations of the W. C., different viewpoints, another lens. From certain angles it appeared quite obscene: so does presentation change emotional response.

Only one more negative so far, which I might have liked, not having done the first one. However I am not through, the lines seen from almost floor level are quite elegant, but to work so low I must rig up some sort of camera-stand other than my tripod.

November 1. It was more simple than I had thought: by placing my camera on the floor without tripod I found exactly what I wanted and made four negatives with no change of viewpoint except that which came from substituting my short focus R. R. Unhesitatingly I respond to my new negatives, and shall choose one to print from.

November 4. Questioned—I could hardly answer which of my loves, the old or the new privy I like best: perhaps the first, yet the second, or rather the last which is such a different conception as to be hardly comparable, is quite as elegant in line and as dignified as the other. Taken from floor level the opening circle to the receptacle does not enter into the composition, hence to nice people it may be

134

more acceptable, less suggestive; however, "to the pure"—etc. I like best the negative made with my R. R. lens of much shorter focus, for by getting closer and underneath the bowl I attained finer proportions.

But I have one sorrow, all due to my haste, carelessness, stupidity, and I kick myself with pleasure. The wooden cover shows at the top, only a quarter inch, but distracting enough. Of course I noted this on my ground glass, but thought I must make the best of it; such a simple act as unscrewing the cover did not occur to me. I have only one excuse for myself, that I have done all these negatives under great stress, fearing every moment that someone being called by nature would wish to use the toilet for other purposes than mine.

Now shall I retouch the cover away—difficult to do—being black, or go to the effort and expense of doing my "sitting" over? I dislike to touch a pencil to this beautiful negative—yet it is in the unimportant background—and to do the thing over means a half day's work and confusion plus expensive panchromatic films. I shall start to retouch and see how I react!

Afternoon—Now that I am "nicely" stewed from beer imbibed at Mercedes' birthday dinner, for which we bought a keg, I see with more clarity.

To take off the toilet's cover, either by unscrewing or retouching, would make it less a toilet, and I should want it more a toilet rather than less. Photography is realism!—why make excuses?

November 5. Following the custom of this season, *Don Juan Tenorio* is being played at almost every theatre in town.

We went, a half dozen of us, with great expectations, remembering last year, and were not disappointed.

The same handsome devil played *Don Juan*: he had taken on a few extra curves, especially noted fore and aft of his umbilical region, presenting a most voluptuous silhouette. Unfortunately, the *Doña Inés*, fat and "cursi"—vulgar—of last year, had been replaced by a quite beautiful woman: nevertheless when *Don Juan* grappled to carry her away, she needs must jump up a bit to aid him in the abduction—but why not grant this often true to life!

The last scene—*Don Juan* and *Doña Inés* were in heaven. Heaven was presented like the "Venice Amusement Pier" or "Coney Island." Back of the throne on which sat the lovers, now awakened to life immortal, were great windmills of swiftly revolving colored lights; more lights of every gorgeous hue played from the wings and front, while to the strains of soft music, a chorus of fat angels in pastel pink tights cavorted, wriggled, floundered to regale the deceased. The hero and heroine in heaven, in quite unheavenly embrace, — while the colored wheels went round and round!

November 12. I have sometimes said or written, that "I am in a fine creative mood—period." This is misleading, it seems to indicate some hour, day or week

when I happened to be in an especially exalted state of mind, or raised to emotional heights. This of course is the way of all artists as portrayed in novels, "best sellers," and is indeed a pretty picture to palpitate the hearts of kindly spinsters, male or female, in need of someone or thing to mother; a dog or cat would do as well!

But fact is not indicated in such sweet fiction: peace of mind and an hour's time, given these, one creates. Emotional heights are easily attained, peace and time are not. Yesterday I "created" the finest series of nudes I have ever done, and in no exalted state of mind.

I was shaving when A. came, hardly expecting her on such a gloomy, drizzling day. I made excuses, having no desire, no "inspiration" to work. I dragged out my shaving, hinting that the light was poor, that she would shiver in the unheated room: but she took no hints, undressing while I reluctantly prepared my camera.

And then appeared to me the most exquisite lines, forms, volumes—and I accepted,—working easily, rapidly, surely.

Today, reviewing yesterday—with my new negatives at hand—comes the emotion which did not arouse my "creative mood."

Afternoon—The "peace of mind" aforementioned I would indicate as that state of being, in which one is reasonably free from petty worries of a material sort: the heart-ache of tragedy is not so devastating as the belly-ache of poverty. A broken heart is more easily cured than a shrivelled stomach.

November 13. I made fifteen negatives of A. Eight I may finish, six most surely. My first enthusiasm has not abated, I was not unduly excited. Under cool reconsideration, they retain their importance as my finest set of nudes,—that is, in their approach to aesthetically stimulating form. Most of the series are entirely impersonal, lacking in any human interest which might call attention to a living, palpitating body.

Not that I am prepared to say this is a finer use of photography than the rendering of realism, the frank statement of fact, the capturing of fleeting moments from life, as I have done, and never better than with Tina,—in fact I have always held the latter approach more important, since no other medium can possibly picture life so well: but one must satisfy all desires and at present my tendency seems entirely towards the abstract. If this is not so fine a use of my medium, it may indicate a more introspective state of being, a deeper intellectual consideration of subject matter. But I am not prepared to argue these debatable issues: enough, if I work, produce, and let the moment direct my activities.

November 14. It is—well, most fortunate that I took advantage of A.'s presence the other day. She was badly hurt in an automobile accident the night following the sitting and is now in a hospital with various cuts, contusions and a broken

136

ankle. Poor girl! I shall send her a set of proofs to cheer her. The reckless driving of automobiles in Mexico is appalling!

November 14. This afternoon billions of diamonds fell from the sky. The sun shone upon a terrific hail storm backed by leaden thunder clouds. Arched high over all, framing the downpour of brilliants were two complete rainbows. We were printing in the little dark-room on the azotea. Hail stones attacked our paper-roof like fire from machine-guns: work became impossible from actual confusion of senses.

November 17. I am flirting with the idea of giving up cigarettes. There is no morality connected with this proposed restraint of appetite—but wait!—it gave me an immediate reaction to write down "there is no morality"—am I indeed afraid of becoming moral!—for then I am as weak as one who fears to be immoral! No, I have no wish to attain any height of morality nor immorality, but I am impatient with my lack of poise in smoking: it has become a nervous habit which half the time I neither need nor enjoy. Yet there must be a need or else why do I forsake my pipe, in which there is such serene enjoyment? Well, I do know why I desire to limit my cigarettes: they may be lowering my vitality—and I need it all, every ounce, for my work.

Friday the 20th. Day follows day of gloomy weather. Without a watch, noon might be twilight. The sun seems in permanent eclipse, and only with sun, is Mexico—Mexico. O for a crackling, roaring grate fire these days! But it is colder and sadder indoors than out.

Yesterday we drove to Chapingo, Carleton Beals having procured a government auto. The attraction other than viewing new country and the National School of Agriculture was Diego's new murals in the school. The ceiling and top panels were almost complete. Two tremendous nudes dominated the room—to the right a prone figure from a drawing of Tina—to the left a semi-erect figure from Lupe—both majestic, monumental paintings. The ceiling with figures in exaggerated perspective was intellectually provocative, stimulating, but effort and calculation were more evident,—while the first mentioned nudes were presented with such grand manner as to bring no questioning. The are worthy of anyone's pilgrimage and homage.

At Chapingo we met Khan Koji, most lovable friend of last year. Dinner with him,—then a hurried drive home to escape the menacing storm.

The sun is at last unveiled. I feel more like working and happily it shall be work for myself. I have found a retoucher who can prettify all the obese and wrinkled hags who expect full value for keeping me in salt. I have been tortured by such work for weeks.

Ten minutes, no more, the sun shone. Then I donned my bathrobe over a wool shirt. Even the glow after my morning inquisition, the cold bath, does not stop

my shivering for long, and the ceremony of morning coffee warms but briefly. Everyone wears a long face offering no compensation. To spend the day in bed with a congenial... [fragment missing].

November 21. ...but I only sneer to hide a hurt, my sarcasm is a defense against my emotional self. I know this even while I ridicule and scoff and grin. The hurt may come from my own false gestures or the guile of another—either way I acknowledge disappointment with contempt. Better if I could start with a premise admitting possible incompatibility and hold a philosophical attitude throughout. But no, my fault or not, the protecting grimace comes.

From Paris yesterday arrived a most beautiful, tender letter from Miriam. Here is a letter I may turn to, not only for its contents, but also for the memories it recalls, when I find myself indulging in that perennial weakness of mine—unwarranted cynicism. Diverse reasons returned me to the States last winter: if nothing else had been attained but the new love and friendship of Miriam I have reason to be ever grateful.

She had always attracted me. For the last several years she had appeared and reappeared to me in person and in thought,—but the right time delayed. Then came the night on her hill-top. The Rabbi's good wine—God bless him!—the first kiss—the assent—the affirmation. But from the vagrant episode which might have died that night, grew rare affection which has never lessened. Each fresh contact brought me finer appreciation, fuller understanding and ever increasing ardour. To be with Miriam was a fulfillment. She is in Paris, I am in Mexico—a few thousand miles away. Three months ago we parted, today I retain impressions as of yesterday of all our times together. I find myself climbing once more to her hill-top, or racing with her over the white sand of Carmel, or listening to Stravinsky, or pointing my camera towards her naked body.

Sunday—November 22. The weather condition unchanged,—cloudy, cold. I cannot print and am most impatient to do so. The nudes of A. have caused more comment than any work I have done. All the group of friends,—Diego, Jean, Rafael, Monna, Felipe showing much enthusiasm. I visited A. in the hospital, finding her happy with the proofs. She has a broken ankle and is quite badly bruised and cut.

For me too, her accident was unfortunate. I should like to have continued on working with her in the same frame of mind and direction, correcting my mistakes,—the worst of them being in the use of a distracting background. I knew it to be bad at the time, but in my fear of losing lines and postures never to be repeated, grabbed the first thing at hand. Now I pay penance: I shall repent for my haste when I attempt to simplify a messy background in the printing.

Tuesday the 24th. I am told that when Clemente Orozco—a Mexican painter—and considered one of the best, went into the States via New York, his drawings

138

of nudes, a life's work, were destroyed by the U. S. custom-house officials: he was not allowed even the alternative of sending them back!

November 25. Cuernavaca—guests of Fred Davis. From the chill, dark gloom of Mexico, to the frosty pine-covered heights of Las Tres Marias, then down, down to tierra caliente, into paradise—the Valley of Morelos.

Today, staring out upon the drab sky and sad city street, yesterday returns as a tantalizing mirage, a favored moment in some Eden.

I was incited to work, the stately palm in Davis' garden... [page missing].

...than that of last year,—though so different in intent, as to be perhaps, not comparable.

Brett echoed my thoughts—"I don't like Mexico City any better than Los Angeles, Glendale or any other city." But I might add, if it is to be a city, let it be a real city, New York or San Francisco.

December 2. Diego Rivera received first prize, 3000 pesos, in the Los Angeles "Pan-American" exhibit. All we "Mexicans" are happy, though for my part I wish Jean might have won, if for no other reason than his actual financial need. I think Jean is quite in distress, his demeanor indicates worry. And Felipe is another whose condition is revealed in his bearing.

Tuesday—In Mercedes' honor, we gave a party. It was so much like the old reunions at Lucerna 12, that I quite expected Chandler to appear. Galván came with guitar and song; Jean, Carleton, Frances, Diego, Lupe, Pepe Quintanilla, the Salas recreated the past, and A. bandaged but gay, was carried to her first fiesta since the accident.

The weather having favored me at last with printing days, I had ready to show a print of the new palm. Why should a few yards of white tree trunk, exactly centered, cutting across an empty sky, cause such real response? And why did I spend my hours doing it? One question is simply answered—I had to!

December 6. "While the cat's away the mice will play"—only I should not indicate Tina as a "cat"—not in the shrewish usage of the word. Nevertheless the "fiesta" of yesterday would not have been possible had she not been away posing for Diego.

Brett and X. and I sat down to the table for dinner together. There was a half keg of beer which we tapped—with unforseen consequences, for not always from a few glasses of beer does one attain such hilarity. But it was a day forecast for inebriety, Bacchus in the ascendancy, and we honoured him well! First X.'s eyes began to roll heavenward, then Brett suddenly turned his beer upon the bread and with a gesture quite as bombastic as a matador tossing his velvet hat, let fly the empty glass over his shoulder.

There was no work that afternoon, but singing, dancing, grandiloquent words

139

and nonsense. Brett was a burlesque worth a price of admission: we wept from laughter.

Yet how I would be criticized, berated for allowing my son to so shame himself —even taking part in his downfall!

But I know Brett! So full to overflowing with life! I did not scold him when an "obscene" drawing from his pen was turned over to me by his teacher; I put it in the waste-basket with a chuckle. He could be ruined by a tight rein or a long face. He needs to explode naturally. He is bound to adventure much, to experience much. He is open-faced, laughter-loving, amenable to suggestion. I hope to help him when he stumbles or give him a gentle kick in the right direction —if I am able to decide which is right, at the time!

I was forced to make a hasty decision when we first arrived. An obvious homosexual made pressing overtures to Brett. And what was I to do, with a personal distaste, but no moral objections? If a woman of the right kind had desired him, I would have aided the affair, but to have Brett at thirteen thrown into a perverse relation, unformed in tendencies as he is, perhaps to be physically drained by this very sophisticated older man, I could not give in to. So the person suddenly disappeared from his life. With my attitude towards so-called perversions, which is certainly understanding and tolerant, I retained some feeling of guilt over what I had done, for the man was infatuated, and wealthy, would have done for him in ways that I cannot. Well, in three years, I shall not stand in the way of any experience which opportunity may afford him.

December 6. A letter from Johan—always an event: and a letter from Alfred Stieglitz, postmarked Lake George, N. Y. He has been very sick—but, "For the past four weeks I have been able to work like one possessed," and, "I want O'Keeffe to stand on her own feet through her work. She is developing greatly. And is taking root if taking root is possible for any real artist in our country."

December 9. Following a telegram with advice of her mother's precarious condition, Tina left for San Francisco this morning! The house is so strangely empty.

December 10. In writing of the street songs of Mexico City, I did not put down that one most often heard, the song of the Indians in conversation. No matter what chance the Indians are given to regain their lost dignity as a race, which seems the present political tendency—though I must guess from reasons not wholly altruistic,—ulterior motives such as brought prohibition in the States— how can they fit into a material world, this present commercial age?

The Indian needs a new shirt,—does he buy it?—not if first he sees a fancied bunch of flowers! When hungry does he consider calories for maximum nourishment?—no—he eats and drinks for pleasure, most likely wandering to the nearest pulquería. Or he may prefer to starve all week, tightening his belt in

anticipation of the Sunday bull-fight. So one questions—what hope is there for such uncalculating lovers of life?

December 13. Days of professional printing, tiresome indeed, but the weather not permitting work with platinum, I did not rebel.

Well, I have been rebellious enough in another way and do not know just how to handle the situation. Since Tina's departure, X. and Elisa too, have hovered over me and pestered me till I am half crazy, never knowing a sure half-hour to myself. They imagine that Tina's absence means one long fiesta of play and love-making. If the North American is too much concerned with business, the Mexican is over-steeped in love. Granted it is a more colorful life, one becomes nauseated with "amor" and it becomes quite as boresome as business. The two races might well mix to advantage, attaining an agreeable balance. So I am paying a price for my conquest.

December 15. The catalogue and papers at hand reproducing canvases from "Pan American Exhibit"—L. A., reveal scarcely a stimulating achievement. I am not surprised. This is an age of "scratch my back and I'll scratch yours."

I am guilty too. Afraid to offend with my true opinions for fear of ten centavos loss. I should like to test myself someday with just enough money ahead to allow of snapping my fingers at public opinion.

The Anglo-Saxon is eminently equivocal. He goes beyond hypocrisy in self-deceit, actually believing in his formulated buncombe, so warped in judgment, and blinded by "should" and "should not", that his real self no longer responds to uncoloured "likes" and "dislikes."

The water stops, maybe for an hour or maybe for a day or two. Fortunately, I have had no catastrophe from [safe] light failure during development. I have that to expect.

December 17. I went to Jean's for chocolate at 7:00, taking reproductions of the Pan American exhibit. "Really though," he said, "I am so angry with painters and 97% of paintings, I get to hate them," and turning over the newspaper, "Now look at this, it is something fine"—a news photo of a football player in action!

One can always expect to find a fresh new attitude in Jean's work, or rather he has no "attitude," is continually experimenting, changing. I spent three hours going over his new drawings and paintings with the greatest interest and pleasure. He is growing into an important figure, while Diego, unless he gets out of his rut, has reached his limit; he is going around in circles, repeating successes, but cold and calculated in their formulization. Charlot has no mannerisms, not in colour, brush-work, arrangement, subject nor medium.

I saw at Jean's a drawing by a young Mexican, Pacheco, it was excellent!

December 18. Destroying old negatives, saving others for possible sale, reconsidering some for printing.

Today dawned clear and cold. After a hard rain the hills much lower than Ajusco are topped with snow, and the Ice Woman is resplendent, dazzling in her fresh white shroud. At last! I can print palladio, and God help visitors who bother me.

Besides a number of 8 × 10 negatives I have decided to print contacts in palladiotype from a series of 3 × 4 Graflex. Aesthetically they will be quite as satisfying, and the time used in enlarging two dozen or more small negatives, I might better spend in doing new work.

December 21. I had a curious experience last night which well proved that my habit of going to sleep evenings no matter where, is not disinterest in my surroundings nor lack of mental stimulation. I fell asleep viewing *The Gold Rush* — Charlie Chaplin, — dozed off while those around me were shrieking with laughter and I too had been just a moment before. I felt it coming on, my brain fought desperately but hopelessly for mastery over my physical self, so I missed some choice bits. Charlie is as great a tragedian as comedian, and he makes use of those less obvious, little ironies of life, more poignant than standardized sorrows. An article I recently read by "Sadakichi" [Hartmann] contra Chaplin, sounds like the wail of a misanthrope embittered over failure and envious of success. For though Charlie may be spoiled and overrate himself—he stands alone in Filmdom!

Carlos Mérida back from N. Y., having successfully arranged for an exhibit: the dealers fighting for the privilege. Latin American art will yet be the rage.

December 22. X. can never understand how one would at times rather work than make love. I was actually driven from the house the other night by her persistency and spent some preferable hours alone wandering the streets and sitting in the Alameda.

Brett and I to "El Toreo" yesterday. If I were not blasé over bull-fighting I might write pages of enthusiasm about Sánchez Mejías. His marvellous and daring work with the banderillas, his perfect control, mastery of the bull. I have seen no one fight so close, nor with such seeming risk. He fights not merely with bravura and elegance but with brains. Brett is quite as much interested in "the bulls" as I am and always anxious to go.

I have been offered a government position, to teach photography in a technical school for girls. Two hours daily, five days in the week and pay during vacations, the salary 120 pesos a month. Small but sure income.

December 23. I'm acquiring a fine complex over the weather question. How quick I would take the next train for Cuernavaca, Guadalajara, or any place of genial

warmth if I dared spend the money. But no sittings lately and none ahead. I shall yet have to accept the "professorship."

The Principal of the Gabriela Mistral school is short and fat, two watery blue eyes fade into the alcoholic patina of her face streaked with hasty dabs of powder. She sits sideways, braced as though fearing a toboggan slide to the floor, her plump hands discreetly folded amidships over what once was a stomach, now seen as an unbroken swell progressing from the chin. Her eyes roll unctuously, her head nods knowingly, while Rafael explains that I would rather accept 90 pesos a month as professor than prostitute my art by commercialism!

Yesterday I worked with the 8 × 10. A mask against petate: a pig-tailed "Pancha" of woven reeds against an equipal. But it was too cold to develop; I went to bed to keep warm.

One so easily gets into a rut. Why I have not used the white stock palladio before can only be answered by admitting myself addicted to buff from years of professional usage. And to use a tinted stock is a form of affectation near to "artiness." The white stock is clean, direct, unpretentious: it presents unveiled all the negative has to give. It reveals the best of a good negative and exposes the worst of a bad. There is no hiding behind a smudge of chemical color. Now I am troubled, for I would reprint most of my past work that still satisfies, but have neither time nor money. From the new negatives, the print on white stock which most pleases me, is a nude, a torso of Neil. It is a simple, artless conception and one of my best.

December 24. I have rolled with laughter, reading Brett's day-book entry of December 23. He writes delightfully, impulsive and natural as his way of speaking. Also his photography has been well seen,—done with constructive instinct.

December 25. Christmas day. It is raining, the city presents a forlorn aspect, especially the puestos which should be so gay. This year they hold more junk than ever, cheap tin toys, German and Japanese,—hardly a thing worth buying, except the piñatas which are gay in color, fantastic or funny in conception. It is remarkable that such plastic beauty can be achieved from the use of tissue paper.

La Noche Buena was spent with the Salas, Carleton and friends. Gayety forced with habanero and vino rioja, an immense guajalote—turkey, dancing and games until 4:00. Up at 9:00 to keep a date with Anita. Luziana cooked a tasty meal—real Mexican. ¡Qué bravo la chile! I sweat while eating. Conchita in her inevitable pink bonnet was the important guest. She was handed in turn to each, down the table's length, always bright and cooing. Charlot swears she said "¡Ay Mama!" at two months.

December 26. "Two things are necessary for the poet and artist. He must rise

above literal reality, yet he must nevertheless remain within the sensuous. When both these exigencies are fulfilled equally there is aesthetic art." Schiller

"Life proceeds not by burnishing up the existent ideals, but by the discovery of new and more vital ones, thanks to the imagination, which reaches out into the unknown whither the intelligence is able to follow only by a long second."

Van Wyck Brooks

December 27. ¡Qué mala suerte!—what bad luck—to be serenaded in Mexico for the first time and sleep through it all! Xmas night it was, but who honored me I do not yet know. The story came from our roomer with Brett's confirmation. "There were wild songs ended by the persistent cries of ¡Viva Weston!' They tried all the windows in turn and in vain. I came to your door and called, but no answer so thought you out." Well how, how sad. I missed a chance to respond with flowery speech. And think of the poor serenaders singing to deaf ears!

I have forgotten what the sun looks like! The streets are drenched this morning and fine rain is still falling. The fleas have decided summer is here and attacked with after-hibernation appetites. Elisa is cooking pozole de pollo for a dinner to Sr. Darday Abriani, a young Hungarian whom we met on the boat. I liked him at once. Jean and his mamma are also coming and I have provided plenty of vino rioja.

Yesterday, worked with juguetes again: three negatives with possibilities.

That professorship? No! the "salary" is not worth the distraction and effort —

December 28. 4:30 a.m. Rain! I'm a bit "nutty" on the subject. Warmer though, —that's something. But the warmth has brought mosquitos with the rain. They are a nuisance but don't like my flavor as do the fleas. It is rather a pleasure to scratch flea bites, if one did not feel them crawling on the job!

Elisa cooked a marvellous pozole, and received felicitations from all guests, — Jean and mamma, Sr. Darday, and Miss Goldstein my new roomer.

The best of the still-lifes is one of a rag-doll and sombrerito against my black and grey striped sarape from Texcoco. I satisfy my desire to make calculated arrangements by still-life: it used to be an attempt to introduce life into a preconceived placing of Studio properties,—pictures, pots, what not,—always forced, though I was better than my co-workers in creating these artificialities. Now I am content to take life as I find it.

December 29. 4:00 a.m. again.—I made five negatives all told of the juguetes and shall print from five: not all masterpieces to be sure, but each with some interest. I seldom make an exposure now that it is not printed from, for I never make a random shot. I am not speaking of portraits, when I battle to bring out or find an elusive expression, nor do I mean that I am always certain with my Graflex

144

used without tripod, but the 8 × 10 view-box firmly screwed to a sturdy base usually yields results. As for exposure and development, their correctness is a foregone conclusion, which should be so with my experience.

I was working on one of the nudes of M. when a letter came from her, from Paris. "O Edward, I wish I could give over to you the feeling of complete immersion in love and affection your recent letters have given me. I can truthfully say they have been the one satisfyingly personal thing to me since my arrival here." And she writes further, "I am intensely interested in your writing. Betty and I discussed it."

I only wish I had this confidence in my writing. I seem to read between my lines something quite different from what I wrote, yet I try to be genuine, and imagine myself so at the moment. But when I glance back over myself speaking on such and such a day, I either snicker with amusement, or get a belly-ache, or "see red." If I could write in the "style" of Brett, with all his boyish uncalculated enthusiasm, then I would be content! But write on I shall, I need to, I derive personal pleasure, it is my way of exploding, my way of self-indulgence, self-communing—so quite enough. I even regret destroying my day book prior to Mexico: if badly written, it recorded a vital period, all my life with M. M., the first important person in my life, and perhaps even now, though personal contact has gone, the most important. Can I ever write in retrospect? Or will there be someday a renewed contact? It was a mad but beautiful life and love!

December 30. The only possible way to stay warm these days other than sitting on the oil-stove, and our stove is quite temperamental, refusing to function properly in crises, is to soak in a boiling bath or stay in bed: but these are temporary alleviations, and one soon proceeds to shiver.

A.'s body as the camera sees it, is mottled and blotched. The nudes I did of her, required a skin quality of exceeding smoothness, otherwise,—and this happened, the eye is disconcerted from full pleasure in the enjoyment to their fundamental offering,—form.

In fresh gingham of checkered pink, a contrast to her brown skin,—I admit almost unwillingly, quite agreeable, X. appears on duty after a hot scrub. I say "admit unwillingly" to emphasize a point, for consciously, I am willing at any time to change an opinion or alter a view. But nature protects from too sudden change which might unbalance, by making unlearning more difficult than learning. We cling to old ideals, we are easily shocked, we disagree with opposing conceptions of a foreign port and find fault according to our most cherished presumptions with politics or food, with morals or color combinations. Until suddenly or by degree, it is revealed,—unless we are impervious 100% Japanese or American, that what once was assumed as right in "Centerville" is not right in "Tlaxcala," or perhaps not right at all. And this is rebirth! Then how delicious

taste maguey worms, how natural becomes the Indian who buys a flower with his last centavo, and how charming is the pink and brown dissonance of X!

January 1, 1926. ¡Feliz Año! I saw the old year out asleep in bed!—invitations did not tempt me, nothing but oblivion. I start the new year holding no new resolutions and forseeing no financial security. I do believe, granted leisure and frijoles, the coming year will be my best in photography.

Came a Mrs. Swift from San Francisco with introduction from Imogen. I spent all day "showing off" Mexico, she being so thrilled that I received many a second hand emotion. Considering her first day I withheld from acquainting her with mole de guajalote y pulque—too sudden a break from ham and eggs, I thought—and took her to Sanborn's. I have before rebelled against the desecration of this architectural gem by the hideous modern murals, now I have a new reaction. The mural by Orozco on the stairway, granting its intrinsic value, has no more place in the building than the aforementioned paintings. It is to me, simply another desecration! But it is a powerful conception and I must know Orozco better.

January 4. The artist is considered the most impractical of mortals. Quite contrary, I would say, perhaps in personal defence, he is the most practical. Because he will not recognize as important much of the complicated machinery and useless superfluities of average life, the artist is damned as a visionary—which is true enough. He attempts to travel a straight line to his goal, cutting all possible corners, instead of deviating in tortuous spirals. For his contempt of custom as ordained by his peers, the ventured goal may end in gaol, it being incorrect, even naughty, to overlook "Keep Off The Grass," though the grass be withered or dead.

January 6. The sun hot and brilliant after his weeks of seclusion. Printing of course! Printing exhausts me. If I am ever temperamental as story book artists are, it is while printing. The reason is based on economics. The first print must be perfect, which is of course expecting the impossible. If it comes almost right—my purse says—"Good enough." But the craftsman answers—"Good enough is not enough." By nightfall the quarrel between "common sense" and "extravagance" has torn me asunder. If there was someone to pay for the ideals of craftmanship! One nude of Neil is "almost right." Should I reprint? Or is it "good enough?"

January 7. Printing of yesterday yielded five more prints, the most pleasing, another nude of Neil, though I must say that I am not happy with the rendering of deep black in the white stock, which seems to solarize more easily than the buff. The deepest blacks are not clean—they have a chemical quality—yet Neil's whitest of white bodies should be printed on white.

January 10. Diego came Thursday eve. I had fine contact with him. Being alone, I was forced to enter directly into the Spanish conversation and allow no thought

146

to escape. He stimulated me greatly because of his remarks on photography, and on divers topics,—what actually amounted to his feeling for life. He speaks well, and I envy one who can so clearly express in words his thoughts. My own, clamoring for release, too often stick in my throat. If they did not, I might write instead of photograph, and that would be too bad, for there are few good photographers!

Diego is a profound admirer of photography. "I want to write about your work sometime," he said. And—"The exhibit you mention of machinery and modern paintings must reveal the painter's weakness. The best brains of our day, the strength, has gone into the machine. All the modernists are sentimental. Picasso is, except in his cubism. I like the work of Marcel Duchamp, but I like your photographs better."

I showed him Johan's work. "This man has a feeling for composition but not for the aesthetic value of his medium. Seeing his work I think at once of where it was made or of whom. Your work leaves me indifferent to subject matter. There is no attempted interpretation of a mood. Now this print of his would be excellent but for the indecision of presentation."

Then many topics were touched upon. "Europe does not interest me now. I dislike Paris. I am a typical American. What difference if the U. S. makes conquest of Mexico? The sooner the two races mingle to produce a greater race, the better."

Later, in came that sociable "social uplifter," a Russian Jewess rooming with us. She moaned, "I am so musical and there is no Grand Opera here." She always irritates me to exaggeration. I said, "The organitos serenading our windows are preferable to Opera, and an Indian's voice from out a pulquería I choose before all Carusos bellowing." Diego laughed and nodded in approval.

Another admirer of photography lunched with me yesterday—Jean. I repeated Diego's conversation, he often agreeing. "I too like the painting of Duchamp, but your photographs mean more."

January 15. Photography is, or can be, a most intellectual pursuit. In painting or sculpture or what not, the sensitive human hand aids the brain in affirming beauty. The camera has no such assistance, unless of course, the process after exposure has been interfered with, and hence ruined, by manipulation, manual dexterity.

My technique is never quite equal to my vision, but this is preferable to the reverse. The last few days, besides printing new work, I have reprinted several old negatives, especially of clouds. The results are far ahead of my printing of a year ago. Perhaps it is not so much a finer technique as it is a surer feeling for that which I wish to say aesthetically.

Reviewing the new prints, I am seldom so happy as I am with the pear-like nude of A. I turn to it again and again. I could hug the print in sheer joy. It is one

of my most perfect photographs. If (the saddest of words) if I had not needed to remove the spots in that patterned background, so carelessly used, I might be almost satisfied.

January 16. The weather, turning cloudy again, halted my printing debauch. But I shall register no complaint. I have worked steadily, intensely, and gotten myself into a state of nerves demanding a change, so I turned to my camera. Long eyed and considered as a desirable victim, I subpoenaed into service the armless, legless torso of a wooden church Cherubin. I found it all and more than I had hoped for, exposing seven negatives during the morning.

January 16. Evening. The letters of most importance come from the little boys — illegible scrawls—mostly the same refrain, "Dear Daddy, when are you coming home?"

January 18. Outside, yesterday was a dull dead day indeed; but inside with a keg of beer, hot pozole and pleasant company, the hours sped swiftly enough. Came the Salas and Eric Fisher, to whom I have taken a great fancy. Eric presented me with a most exquisite cigar-holder of carved amber he got in Vienna. It is to be counted as one of my treasures...

One does more in Mexico because one dreams; more time for dreams. You can't hurry because no one hurries. No one runs for a camión, they back up a half block,—you leisurely swing your bastón, puff your pipe, and they wait.

"Mi querida" "Mi morena"—my darling, my dark-haired beauty—they can love—these brown skinned Inditas. Thank God they don't talk "art." Mexico hasn't a group of "arty" people, mouthing boresome nothings, sitting around at studio teas. Too much talk—not enough work. Life—the passion of love—the passion of work—these count—these and nothing more...

Elisa sat near, planning pozole for our fiesta. I patted her cheek, saying, "Qué simpática Elisa."

She put her arms around my head. "I don't want you to leave for the States—ever, Don Eduardo." (It sounded nicer in Spanish)

"But Elisa, I may have to go."

"What is there to do there—vámanos todos a Guadalajara—let's all go to Guadalajara."

"But I can't earn a living there."

"We don't need money, we shall have a ranchito, raise chickens and pigs, and you can photograph the chickens and pigs all day long!"

January 19. 4:00 a. m. This is my hour—a time when I am most alive—eager— clear headed. This is the hour Johan and I always split over, he, most likely going to bed or at least going to sleep, as I arose! If we did happen to arise together we had another difference, he would have his tea and I would have my

148

coffee. I wonder if I would so write down these thoughts if it were not for my hour with morning coffee,—my early hour alone.

Every morning when X. dusts the studio-room, she puts out of balance two candlesticks placed formally under a framed print. I as regularly replace them and explain, while she shakes her head despairingly. She does not see, she has no sense of proportion. This irritates me more than the gaudy calendars collected from butcher shops and baker shops with which she plasters her room.

January 23. Even knowing Jean is to be vastly benefitted by his change, it was sad to view the breaking up of "Independencia 50," so long his home. He leaves today for Yucatán and I question if I shall ever see him again.

I wish Brett knew how my heart was warmed by a request of his last night. "Dad." "Yes." And then hesitantly as though asking a great deal, "I should like to have a couple of your photographs for my own."

No request from my most sophisticated admirer could have pleased and complimented me more. And his first choice was interesting to note, Johan stretched out on the couch at Union St.,—the long table above strewn with cigars—tea-cups—milk bottles—laundry—canned soup and what not from our bachelor days.

Sights I have seen in Mexico: A barefoot Indian wearing a wrist-watch; a charcoal vendor, face black from unwashed days of grimy toil, twirling his moustache with gestures elegant as a dandy; an Indian seated on a curb of the fashionable shopping district, trimming his great sombrero with a peacock feather; the owner of a street stand for tobacco, creating a doll,—yes—creating! for he smiled at it as he worked, oblivious to surroundings, and held it off for better perspective, head cocked as a painter might to view his canvas.

The "sights seen" to be continued.

I worked well that day in the Los Angeles industrial district. So far six negatives from the series have been printed. Now it has been clouds again. Brett called me to see them. One with fish-like form, quite exciting—and I have it.

Yesterday I felt the time could no longer be postponed to attempt finding beauty in our ugliest room, the "Louis XV" dining salon! It is festooned with wreaths of roses, embellished with fruited cornucopias, bedizened with scrolls and gewgaws, all panelled and stuccoed in most elegant rococo style. I took Monna's straight-laced rag-doll with "feminist" face, placing her against one fragment of floridity. She appears delightfully indignant, forced into surroundings so compromising to her starched reserve...

February 4. At last I have met again and photographed Victoria Marín—here visiting Lupe and Diego. I still hold the opinion that she is an outstanding personality. But she does not belong here in the city with conventional hat and clothing. She does not belong to this day of "flappers"—"pelonas."

Juguetes have continued to hold my interest. I did three fishes on a silver paper sea,—quite fine in form and in technique—and I did an amusing group of the little figures woven from rushes: two buglers announcing the arrival of Panchito Villa—two women gossiping oblivious to that important event: and I placed in front of a flowered petate, a parrot and a pile of painted fruit. All these I like very well indeed.

February 8. I have made the juguetes, by well considered contiguity, come to life, or I have more clearly revealed their livingness. I can now express either reality, or the abstract, with greater facility than heretofore.

But should we use "abstract" in describing a photograph? Better "elemental form" or "simplified form." But again, should one use "abstract" in connection with painting or sculpture? The most abstract line or form, of necessity is based on actuality—derived from nature, even as God is pictured a glorified man. If "abstract form" was used to indicate form abstracted from nature, then I have no quarrel. But no, its usage has come to mean, and I speak in connection with "art," something apart, something metaphysical, something done by the artist whose feet are where his head should be, whose head is muddled in the mire. These nebulous persons believe themselves soaring, but like those who indulge in a clatter of cryptic words they really grope for the very spirituality which they lack. To keep one's feet firmly planted on terra firma is to keep the head poised and receptive. To leap with wildly kicking legs towards the unattainable is but to giddy the brain, to miss the attainable. The higher the leap—the harder the consequent crash.

February 20. The coldest morning I have experienced in Mexico. If not the lowest in temperature—the most penetrating. In my dark-room at 7:00 the thermometer registered 38⁰, but outside I noted ice on the side-walk. I sit here with a bathrobe over my wool blazer, none too warm, though the oil stove is close to my shins. But a brilliant sun forecasts a quick change, and if the cold will only kill off the spring crop of fleas and mosquitos, already noted, I will gladly shiver on.

These are exciting days in Mexico! The government has closed all catholic schools in the republic—1000 catholic priests have been deported without even personal property or money. In Brett's school, fortunately exempt from this drastic measure, every indication of Catholic tendencies was quickly obliterated, crucifixes hidden beneath mattresses and morning masses discontinued. The result will be worth noting. A lid is not suddenly and peremptorily clamped over a still seething kettle without a resultant explosion—a reaction, as witness prohibition in the States. Calles has played a dangerous card which may undo him. Was he attempting to forestall another revolution? And will he cause one instead?

150

February 21. "Carnaval" week just passed. I "stepped out" but once. If Eric had not shown desire to go, I would have gone to bed and so missed a funfull evening at the Mendizabels'. Lacking enthusiasm I planned no costume until almost time to leave. But one idea came at that late hour, to look at Tina's left-behind clothing—dress as I have before—become a girl. So "Miss Weston" took the arm of "her" gentleman friend and walked down Avenida Chapultepec!

Gendarmes eyed us suspiciously—or was it my imagination?—but we wavered not! Once there, my mood changed. Helped by countless drinks of habanero, I became a shameless hussy! Monna, you were a beautiful boy! Frau Goldschmidt, you, balancing on your snub nose a painted, perfumed rose—you were the burgess personified—as always. Herr Blank, you in monkey costume, were a dull monkey. But the antipático elements left early—and we danced and sang till dawn.

I recall chasing a pretty criada—my specialty—around corners, through doors. She escaped! I recall lying beneath the piano, groaning and shaking with ill-suppressed laughter at the Grand Opera bellowing of some ponderous male.

I remember our genial host placing a revolver at Eric's head, a subtle suggestion to cease embracing his wife. Eric murmured "Don't kill me yet," and waved away the menace. Of course there were seductive señoritas, and coloured snow falls of confetti, and tangles of ribbons which wound around and bound us, a laughing, swirling, dizzy whirlwind of "borrachito" fun.

February 22. This contact with Brett in Mexico has given me a clearer understanding of the boy. The swagger he affects, the loud, bold words of self-estimation, his posture of a braggadocio, hide an over-sensitive personality. This I have noted in divers situations. He is physically clumsy, forever hurting himself or breaking something. But this aspect will pass. Mentally for a boy of barely fourteen he is well integrated—indeed beyond his years. His reactions to people and conditions are violently colored. He is able to formulate his opinions with fine perception of salient points. That someday he will write—or can if he so wishes, I am sure. And because he enjoys writing, I am sure that he will write.
[fragment missing]
. . .horse-man, a sombrero and a straw-rain-coat to make an all grass symphony. And I tried, in various combinations, three black clay ollas de Oaxaca. These latter have been especially fascinating to work with.

February 27. Dr. Mayorga does not pose as an "intellectual," yet I always enjoy showing him my work. His response delights me, his enthusiasm warms me. He explodes with rhapsodic speech—not the calculated club-woman style—which is the more charming when he intersperses broken English with flowery Spanish. "Tell me where I can buy anteojos (spectacles) to see as you do," or "I want a pair of scissors such as you use for cutting prints."

When I showed him my series of Mexican toys, he exclaimed, "You are a god—for you make these dead things come to life!"

February 28. They came to cut off our lights for non-payment. Next it will be the telephone—that instrument of torture with which undesirables can invade one's privacy at any hour of the day or night. The telephone is the special joy of all the busy-bodies, live-wires, Rotarians, who lacking brains, want action. "Speed up life," cry these people of pep,—"hustle, bustle, meddle, push, we'll make this world efficient, we stand for Service, we'll bestir the dreamer, and put a red, white and blue oil-station at the very foot of the Pyramid." And phones and Fords will help them.

But I want to simplify life—my life. Christ! what a lot of excess baggage and blah we civilized moderns carry. We pay a pretty price for these extras, sweating to support supposed necessities which are superfluities.

If one could have slaves as did our ancestors—but alas, "all men are born free and equal"—something like that—there are no more slaves—or better—we are now all slaves.

March 4. Weak—from an attack of influenza. I tried to fight it off, but finally took to bed. Nevertheless, here I sit at my desk, dressed and writing, before 4:00 a.m. Tina arrived Sunday night—which was a big event, though not for X. who is bathed in tears. And I am genuinely sorry for the child.

March 7. Tina met many old mutual friends in San Francisco and Los Angeles, and several new ones: Jean Roy and Lester, Consuela, Dan, Cristal.

I have a feeling that I will see much of Cristal in Los Angeles, or even here in Mexico. She writes of the possibility of coming, and I would welcome her! A fine, sensitive girl, Cristal. From that chance meeting—or was it chance?—at my Japanese exhibit, a deep attachment has developed, stronger now than when we parted.

Ramiel tried to keep us apart,—that was not possible. I can understand him. He thought, "God—another female!" But the inevitable happened.

March 12. Today for the first time since my sickness, I feel again my real self. But matters have not been at a stand. A new exhibit is under consideration, as a move to stimulate business. This time prominent persons of the city, politicians, generals, artists and bull-fighters will be exposed to awe the buying public. To give added "class," the show will be presented under the auspices of the "League of Writers of America," Dr. Atl having offered the assistance of this distinguished group of pen-pushers.

What an irresistible combination, "The Emperor of Photography"—the "bellisima Tina Modotti"—"the League," with flowery phrases and flowing ties—generals, bristling with pistols and moustaches—toreadors, brave and bespangled

152

—a liberal dose of titillating señoritas—and nudes, plenty of them! My poor juguetes will be overlooked in such dazzling company!

But the juguetes have had their day of glory recently. Diego saw them and later Carlos Mérida. They both were so delighted as to augment my own certainty that I had seen them well.

Brett to my great satisfaction has been working in photography and has done several things which I would be pleased to sign as my own.

March 16. After reading Bernard Shaw's *Saint Joan*, I exclaim why have I not read Shaw before! What clear unfrosted thinking, what biting arraignment of the credulities of today which are quite as fantastic as those of Joan's day.

Vaccination!! Are we indeed more civilized, more intelligent, who poison our blood with pus from diseased cows, than they who burned witches? A century or so from now our system of inoculation will be referred to in wonder and horror. But then—the enlightened race to follow will substitute their own imbecilities, quite equally stupid, brutal, insane.

March 17. Having gone to bed early, I awakened early. The stars were just paling in the dawn, when I dreamily peered into the murky morning-light of my shuttered room. Nice to laze awhile in half-sleep, I thought, to evoke the imagery so delicious in the langor of awakening hours.

And then—is this fantasy or reality?—this spectral white bird poised upon my flowered chest?—this most elegant form—from where? Either it is an exquisite sculpture by Brancusi, or a creation granted me by Morpheus. With a rub of my eyes, it became neither—*only* a juguete, fashioned by some unnamed Indian.

Paul sent it for me to work with. I shall today!

Open season for fleas is now on. I have made several small catches. I should perhaps let them live and feast undisturbed, remembering the passionate pleasure from scratching their bites, but to feel them crawling excites me to murder.

I now have a pupil in photography. A well-to-do Mexican who will pay me $4.50 an hour, and I hope to teach him six hours a week. Finances being low I welcome this drudgery ahead.

March 19. Eric entertained last night,—not in the common usage of the word, with tea and marmalade, nor chocolate y bizcochos, but with his ever brilliant conversation. Excepting Paul Jordan, I have known no other whose conversation is so thoroughly diverting. He has achieved a style, not to indicate by style a formula. The most insignificant yarn he turns with wit, mimicry, and riot of racy, piquant words, into a finely woven fabrication which holds one charmed throughout—and leaves a memory.

As an artist recreates from the commonplace, so does Eric, reaching the climax with an ease of execution attesting his command of words. This he has—and besides, a lovable personality.

March 23. The white heron Paul loaned me, has been all that I could ask for to work with. Every turn of the body tempts an exposure, though so far, I have done no more than slight variations of the back.

The best recent negative is of three ollas, of black clay, grouped on the azotea — well seen and technically fine.

March 24. 5:00 a.m.—and my birthday morning. *And* 40! Sounds quite ancient! Estoy triste—but not over my age. I wish for the children around me!

X. and Elisa came, bringing coffee. They sat beside me singing birthday songs. X. told of the beautiful bed-spread she was to buy me. I heard her horrified! I protested, that she should so spend her money—"A little potted plant as greeting if you wish, but nothing more." My protest brought a scene—"One should sacrifice to give pleasure to a loved one"—she almost wept.

The Xmas gift of a ghastly Tlaquepaque water-bottle was bad enough—but imagine me with a lace bed-spread! I must prevent this catastrophe!

March 25. Celebrated my birthday by putting in hellish hours of hard work. First my student—a session of pretended profundity. Then a sitting, members of a wealthy Mexican family,—mother, child and dogs: the mother alone, the daughter alone, the dogs alone, the mother and daughter together, the dogs and daughter together, until my brain was a muddle of mother, daughter and dogs, wriggling and posturing, barking and smirking.

I was given a fiesta in the evening, with Pepe, Carleton, Felipe, the Salas, Eric and Dr. Atl as guests.

More pulquerías: "Acuérdate de Mí"—Remember Me; "Vamos de Nuevo"— Let's Go Again; "El Corazón de Maguey" – The Heart of the Maguey; "Horas de Consuelo y de Olivido"—Hours of Consolation and Forgetfullness; "La Reforma de la Providencia"—The Reform of Providence; "Me Estoy Riendo" —I Am Laughing.

March 26. 3:30 a.m. Black morning—star sprinkled—empty streets. We started for Mixcalco 12, Diego's home, planning to be in Santa Anita by sunrise for the annual fiesta.

"Yes"—they would be ready by 4:00 was the promise. They were not! Gringos are usually on time,—most Mexicans never.

Not a light, nor sign of life,—so we called to the window above, "Diego!— Lupe!" Diego sleepily answered. He had not heard the ring of his alarm. We walked the streets—waiting. It seemed they would never come down. Lupe leaned from the balcony—"Diego can't get his shoes on"—she chuckled. Another long wait. Lupe again, "Diego is sitting on the toilet." Derisive laughter, and a longer wait.

It was break of dawn before we left.

154

25. Pulquería, Mexico, D. F., 1926

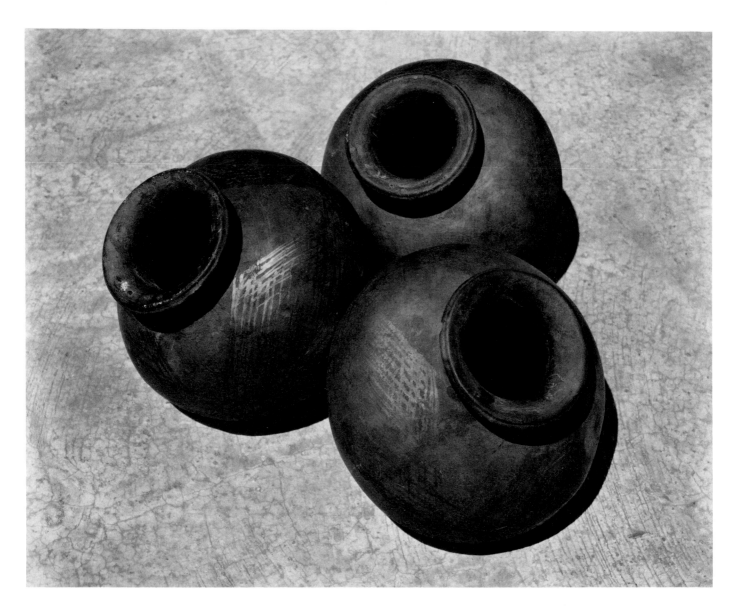

26. TRES OLLAS DE OAXACA, 1926

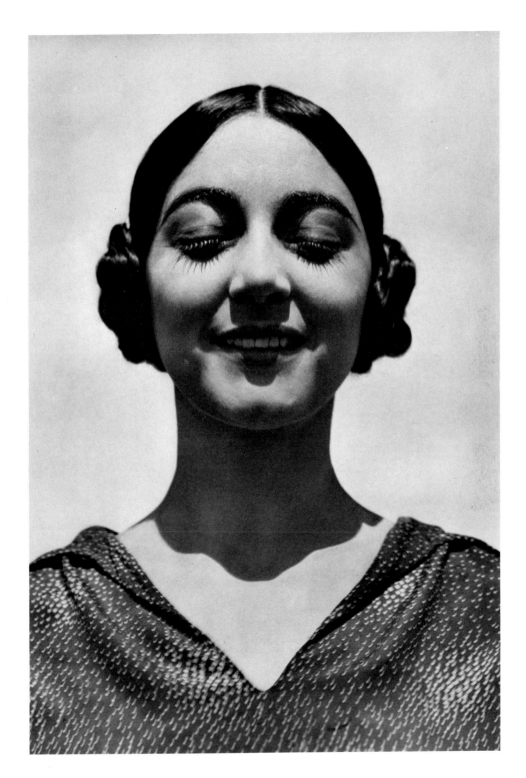

27. Rose Covarrubias, 1926

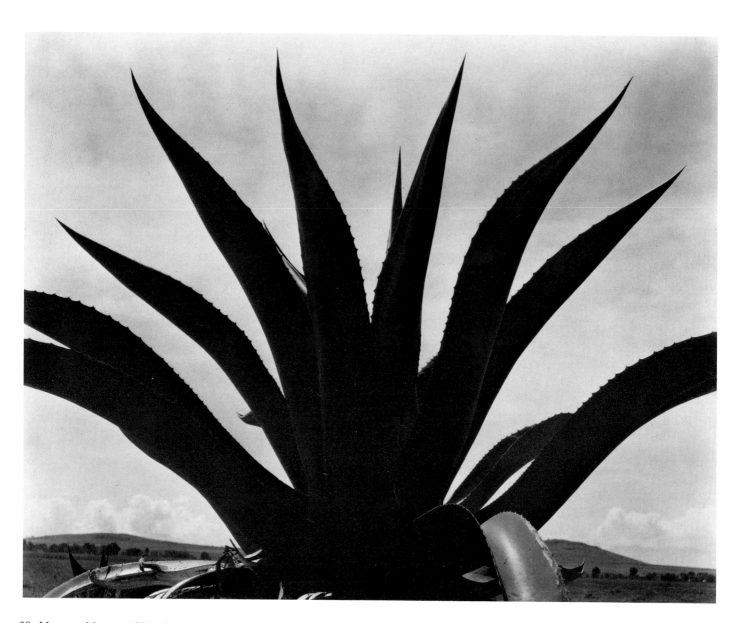

28. MAGUEY, MEXICO, 1926

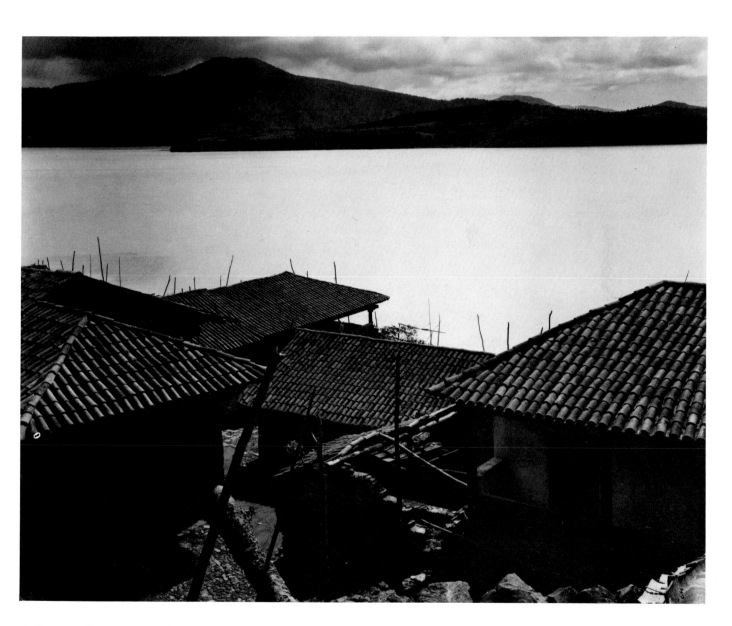

29. JANITZIO, PATZCUARO, 1926

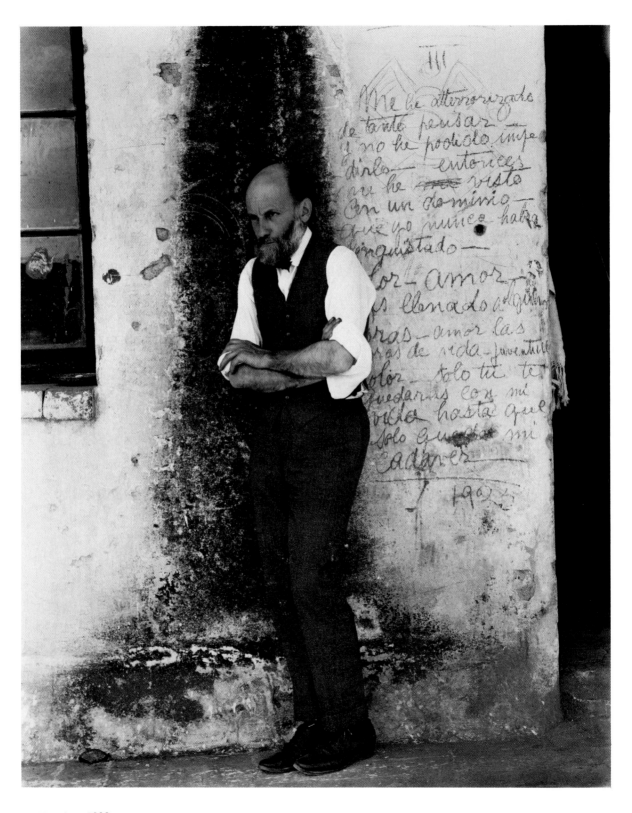

30. DR. ATL, 1926

31. Casa de Vecindad, 1926

32. ARCHES, LA MERCED, 1926

Arriving at sunrise, Santa Anita was already alive. A surge of people, mostly Indians, swarmed along the Viga Canal, jostling, singing, calling their wares, which were flower wreaths, fresh vegetables, wax canoes,—moulded facsimiles of the colourful boats crowding the canal: and, besides other symbols of the day, pale reeds were woven into diverse and ingenious designs, of which each of us bought several.

The canal was overhung with fronds of brilliant tissue, and the water below, agitated by gliding, colliding canoes, blended the colours into a vibrating kaleidoscope. Diego remarked, "Good material for the impressionistic painters!"

Finally we too were floating down the water amongst the singing, bantering, vacillating throng, perhaps out of place in our civilized costumes. Yet, one of us, rebozo-wrapped and flower-crowned belonged there. It was Victoria.

March 30. The woven palm-leaves from Santa Anita—which I had called woven reeds until corrected by Rafael—proved tempting material to work with. I have made several negatives, one especially significant in form, exquisite in texture, and symbolic of Mexico. Then I have a queer fish or an animal, or bird, but the likes of which was never seen on land nor sea. It is quite a creature of the imagination—perhaps a penguin with webbed feet and scales. Diego loaned me this amphibian of papier-maché. I have two negatives—jolly records of this humorous beast.

With what aversion I await the arrival of my new student!

Last night I literally ran away from the house—to be alone. After a long walk I found myself in a "movie," more to sit awhile than see the show. I had not even read the program before entering.

The Passion Play, photographed at Oberammergau was showing, which was of interest, since I had not much idea of the production. But of much more interest to me were the inconsistencies in the program as presented by the theatre management.

Before the Passion Play, a Buster Brown Comedy was shown, and after, a Wild West film by Tom Mix. While Christ was healing the blind and raising the dead, an orchestra rendered the Anvil Chorus from *Il Trovatore*. While Nuestro Señor was being nailed to the cross, a sensuous danzón was played, and his descent was enlivened by a blare of jazz!

April 4. Came Dr. Peter, the best patron of my work I have had in Mexico, or anywhere else. He purchased as usual. It was a print from the boat series—San Francisco, price thirty pesos.

Have printed the black ollas, Diego's queer fish-bird, and the Palma Santa—the palm decoration from Santa Anita. The latter I foresee is destined to be well liked by those whose opinion I value.

I have a new and charming friend—this is also a forecast—for I have met Mr. Pat O'Hea but once,—the day he sat to me. Yes, he is Irish, quite Irish!

April 9. Another pupil! I should welcome this good fortune—this opportunity to earn an honest living. But I am instead quite depressed. I have no time for myself now, and my juguetes stare down from the trastero reproachfully.

April 14. Ten new platinum prints,—result of two day's vacation. My student away, the sun favorable,—I worked!

In trying to analyze my present work, as compared to that of several years ago, or even less, I can best summarize by indicating that once my aim was interpretation, now it is presentation. Also I could now, with opportunity, produce one or more significant photographs a day, 365 days a year. Any creative work should function as easily and naturally as breathing or evacuating.

April 16. These days bring no moment of loneness—not even with morning coffee. X. comes early, if I tell her I am busy, tears follow. Then Eric, who stays overnight quite often, may knock, and much as I enjoy him, I resent morning intrusion, one is not always ready for conversation. Then Brett follows; unable to use his badly strained eyes for study or work, he is more sociable than ever. Finally Elisa arrives with her never failing question, "How much milk shall I buy today?" which receives my never failing answer, "The same as usual!"

Tina alone hesitates before knocking.

April 17. Even as I wrote down the above description I was interrupted! However there has been no item of much importance to record lately. Yesterday Galván purchased two prints; in the evening Miss Moore, my new pupil, brought a "gringo" to see my work—another sale, and she too purchased; which, with the print Dr. Peter bought, brings my total this month to over 100 pesos, an unusual amount from an unexpected source of income.

Manuel (Galván) is now president of the Mexican Senate.

There is a possibility that our lives will be full of adventure and new scenes. A proposition from Anita may take us to Michoacán, Jalisco, Oaxaca and other points. I live in this hope, for I hate this city life and would gladly leave for anywhere, even the States.

Frances just returned from Tehauntepec, telling tales to arouse one's desire for like experience. But these are for her to relate. May our itinerary include Tehauntepec!

Just one joke I must remember—a true story. Frances went to a "movie"—they have them even there. A melodramatic Italian film was showing. The heroine, chained, was unable to escape from a mass of descending rock, the hero could not release her, their last moments were spent in agonizing embrace. The

situation was too much for an Indian in the audience who frantically screamed "¿Por qué no se chingan, cabrones?" or "Why don't you_____, you fools?"

April 23—4:30 a.m. Rather early even for me! I sleep soundly, while it lasts, but awaken with a start, my brain active in planning the next move. If the contract is signed for my proposed tour, I shall, at the end of four months, leave Mexico. If the tour does not materialize I shall take Brett somewhere, perhaps Tehauntepec, and then leave. In any event, I hope, expect, and plan to leave.

April 24. In Mexico most everyone has suffered, so they don't bother over another's affairs. One need not pose. It follows then, that there is less hypocrisy here, for actions succeed feelings. But the Anglo-Saxon lives on self-deceit or wears his mask and becomes a neurasthenic or a hypocrite. What one can't feel, one can't be. To play a part too long is death to instinct with consequent introspection.

However the Mexican has formulated politeness. It is quite pleasant to be thanked by the conductor for paying a car-fare, or flattering to a lady when she is greeted with "I kiss your feet." But—in a camión a pretty girl is offered a seat while a tottering old hag stands; in public places, banks, ticket offices, post offices, there is more crowding, pushing rudeness, than I have seen in the more brusque "States." And the unreliability of the Mexican in keeping promises and appointments discloses their want of courtesy, their ill-breeding. Naturally one generalizes. Just now I am bitter over our treatment by Dr. Atl, who with fine face made elaborate promises to aid us in presenting an exhibit, and we were naïve enough to actually believe him! . . .

These black clay toys and pottery from Oaxaca, I like extremely well. Some toys are in the tradition of the ancient idols,—direct descendants indeed. I also worked with a great bellied cat—or bat—I know not which: the creature's arms or wings, terminate in little bats, yes assuredly bats, for they are winged. Then Paul brought a most laughable startle-eyed bull, whose tail is the mouth-piece of a whistle. In fact all these juguetes are whistles. Interested in my present tendency, friends bring all sorts of toys for me to use. My trastero is strewn with them, awaiting their turn,—an inexhaustible source of pleasure.

April 30. Having sold, in the morning, another print to a visiting gringo, I hied myself to town, and purchased a f/4.5 Zeiss Tessar lens of 21 cm focus, for 80 pesos. Longingly I had viewed this lens from the street, in the window of an antique shop. I wanted it for my Graflex, having worked too long with a lens not suited to my needs. Anyhow I made the reason for purchase easy by many plausible arguments—and then bought.

Afternoon—"C. R. O. M."—the "yellows" as the real bristling "reds" call them, marched the city streets today in their annual labor manifestation. The parade lasted hours: we watched from Paul's roof. Every imaginable group was organized

from vaqueros to opera-singers. In the latter group was a bloke in derby hat and loud checked suit. He might easily have been a character drawn from a novel. He raked up the past of some last century melodramatic stage.

I wonder why there was no parade of prostitutes? They should organize for a six hour night and double pay for day work.

80,000 marched—80,000 hoping—

May 3 [?]. From a recent sitting, a six hundred peso order! One print each from seventeen negatives! But O! the memory of that sitting! The maddest jumble of grandmother—grandsons—granddaughters—great grandchildren—sons—and daughters—in every conceivable combination. I made four dozen negatives in one hour, thanks to my Graflex, without which I would not have earned six hundred pesos. This sitting I made on an empty stomach the third day of a fast!

May 4. Sunday, Anita and I went to Coyoacán for a visit with Orozco the painter. I had hardly known his work before, which I found fine and strong. His cartoons—splendid drawings, in which he spared no one, neither capitalist nor revolutionary leader—were scathing satires, quite as helpful in destroying a "cause," heroes and villains alike, as a machine gun. I would place Orozco among the first four or five painters in Mexico, perhaps higher. Monday eve he came to see my work. I have no complaint over his response.

I wish I had known him sooner,—now it is almost too late.

May 5. Frank Tannenbaum called recently—though, I am sure, not to see me. A superficial observation, quite superficial I admit, would be that he has all the petty dogmatisms of the average labor leader. One remark he made which at once gave the clue to his intelligence was in regard to Havelock Ellis' *The Dance of Life*. He "could not read it!"

May 6. I am not going to have the signing of this contract dragged out Mexican style. I have given the officials until Saturday to sign if they wish my services.

I carried X. from her bed into the cheerful studio—into the sunlight; she cried out in agony, "¡ Me voy a morir!—I shall die!" But she will take no advice. She should have water, air, sunshine. The doctor gives her injections and pills.

May 7. Moonlight and morning light combined to awaken me at 4:30, after a night of fitful sleep. I am overstraining my nerves to finish the 600 peso order while a spell of sunshine lasts. I want the money in my pocket, then I can leave here if the contract is not signed. My decision is quite definite, I only lack money.

May 8. Dr. Morley, chief of Carnegie expedition in Yucatán, came with letter of introduction from Charlot. He said that Jean was the "find" of the year for them.

After seeing my work, he asked what amount I would consider for my services next season.

How quickly would I accept any reasonable offer but for my family. Almost a year now, since I have been with my boys.

May 10. Monday—Rafael, lucky fellow, leaves today for the south, into the tropics, with an expedition which will hunt the breeding ground of the "langosta,"—the locust, so devastating to Mexico. My "expedition" is still uncertain, and uncertainly is demoralizing to me. The big order is finished—if not paid for, I will have enough cash to leave, but just enough, — and that is not enough. I want to return via Guadalajara. I want to live there awhile, but how could I earn a living?

May 11. Not only was the order paid, but a re-order received for 400 pesos more—a total of 1000 pesos—the largest amount, from one family, I have had in Mexico. Hardly comparable to the W. A. Clarke order of 2400 dollars which I had some six years ago in Los Angeles. In those days, orders for 500 dollars, while not common, were not unknown.

During a brief breathing spell, I printed my "changos negros de Oaxaca" and my black cat too. Both please me, except perhaps in minor details.

I used to wonder why the ollas from Oaxaca were made with rounded bases. They would not "sit up" in proper fashion, always rolling around on my floor. The Indians place them on the earth, give them a turn or two and there they sit secure. The soil conforms, the olla takes root, the union is complete.

May 13. Just as the light dimmed to prevent further work, I placed the last touch of chinese ink on unacceptable wrinkles, and finished the 1000 peso order. The tension, working against time and weather has been severe. To relax I should like to drink a bottle of Vermouth with someone. But with whom?

May 14. Let no one say to me that Mexico City is fogless. I watched the sky grey over and veil the city in a soft, wet mist. But it is rare.

After an apparent deadlock over terms, the expedition seems assured. With the signing of our contract, we leave for Puebla and Oaxaca next week. This is the opportunity I have awaited three years.

May 15. "The morning after"—a bit "crudo"—though I was more drunk from laughter than from tequila. I laughed at Eric, we all did, indeed we roared, for Eric drunk is a three ring circus. I needed just this hilarious evening. Of late my only laughter has been like D. H. L.'s, sardonic. Now, after the churning around of my liver, I am quite buoyant.

May 20. Martial music brought me to the window—it always does. Much as I despise the military, a drum and bugle thrills. But even more, the fife and drum of our Civil War veterans actually causes my hair to creep.

With dragging out of negotiations by the University, I am mentally prepared to leave this very week for the States. I am starting to pack.

Diego often said he would write an article on photography. He did, and Frances [Toor] published it in the current *Mexican Folkways*. The title is "Edward Weston and Tina Modotti." Though personalities enter in, it is really a lucid commentary on the art of today—and photography. "Few are the modern plastic expressions that have given me purer and more intense joy than the masterpieces that are frequently produced in the work of Edward Weston, and I confess that I prefer the productions of this great artist to the majority of contemporary, significant paintings." I should be pleased—and am—by such words.

Monday the 24th. I have had a definite offer from Morley to join the Chichén-Itzá project next season in Yucatán. The salary small—250 pesos a month—but all expenses paid and R. R. fare. I asked however for fare from the States, for I surely will be there. Jean will join the expedition again, and to be in Yucatán with Jean would be jolly indeed.

Tuesday. Did more work for the family of the 1000 peso order. I photographed the young señora in exactly the position she was painted by Zuloaga,—then copied the painting for her. They are taking the enormous canvas way back to Paris, so that Zuloaga may put a black mantón over her shoulders! What a waste of money and energy! There were half a dozen of Zuloaga's hanging around. Yet they overlook the far greater painters of their own country.

Saturday next I am *supposed* to receive the first 500 pesos on the contract for our expedition. If it is not forthcoming I am through waiting. This I swear!

May 26. Tina told a delightful story which quite demonstrates the Indian's indifference to time. Passing the tower on Bucareli in a camión she could not see the clock so asked an Indian sitting by "¿Qué hora es?—What time is it?" "Las tres en punto, señorita—exactly three, Miss," he answered. But Tina knew it was much later and told him so. "Entonces, señorita, son las cuatro—then, Miss, it is four!"

May 29. Brett with his butterfly net, I with my camera, went a-walking way out on the plain beyond Ixtapalapa. Mountains, which at dusk, might have been man-made pyramids, cut the horizon with geometric precision. The sun burned deliciously, the great plain, once the site of a pre-Spanish city, quivered in the heat, slender dust columns spiraled into the air, while we, so far as eye could see were the only human beings: until Abe came down a hillside, his fire-red pate flaming in the sun. Strange, for we of the genus "pale-face" to meet in such a place.

Today is the day—the question,—money or no money?

May 30. A check for 500 pesos in my pocket—letters for civil and military authorities—a program outlined—the expedition assured!

160

June 1. I was surrounded immediately by a rabble of gaping, gesticulating men and boys, mostly ragged Indians. Perhaps many had never seen such a big camera, not in action, certainly not pointed at their special haunt the "pulquería." They pressed close, interfering, but not intentionally, though I feared they would not understand the spirit in which I worked and cause me trouble.

We went to some eight or ten carefully chosen pulquerías,—Frances, Diego and I, to make records for an article Diego had written for the *Folkways*.

I have enthused before over the pulquería,—my feeling has been sustained. The aspiring young painters of Mexico should study the unaspiring paintings—popular themes—popular art—which adorn the humble and often—most often—filthy pulquería. This he should do, instead of going to the degraded impotent art of the self-glorified academician.

I photographed brave matadores at the kill—white veiled ladies, pensive beside moonlit waters—an exquistitely tender group of Indians,—Diego himself could not have done better—and all the pictured thoughts, nearest and dearest to the heart of the people.

June 3. We leave today!

2. "Mexico Breaks One's Heart"

July 4. Mexico again after a month in Puebla and Oaxaca. If I had not so much finishing to do, from over a hundred negatives exposed on the trip, I would be depressed indeed to be here. Mexico City is not Mexico at all.

Oaxaca, city raised from rock,—a mellow, yellow-green rock. After the rain which swept the country afternoons, the glistening rock turned to jade,—one walked on flagstones of jade.

The train trip to Oaxaca, a twelve hour ride, was varied in aspect and climate. Miles of waste-land interspersed with little oases brilliantly green,—hills dry, and prickly with organ cacti, followed by ravines where fields of sugar cane galloped in the wind.

Contrasting to the drab railroad stations in the States, each little stop had some interest,—a new food to try, new costumes to note, new types to discuss. We gorged on mangoes at three for five cents and on aguacates even cheaper. We chanced tamales which proved savory, steaming hot, and burning with chile.

A "bad man" impressed us all. He outrivaled a movie make-up in acting and in costume. He lounged wickedly on the station platform, clad in black shirt and scarlet neckerchief,—sizing up the crowd from furtive eyes,—fumbling his six shooter true to all tradition.

Travelling in Mexico has not the comfort we spoiled Americans expect. On a narrow gauge track the antiquated cars swayed and bumped along appallingly. Everyone carried at least ten bundles, and we, three cameras, tripods and suitcases. As usual cargadores mobbed us at the station.

When one arrives in a new city after dark, dawn holds out such eagerly awaited horizons,—to spring from bed and view for the first time a new land! And Oaxaca,—rain bathed, sweet and fresh in the morning sun, musical with bird song,—with water playing over cobbled streets, encircled by green mountains, topped by lingering clouds—fulfilled all expectations.

The architecture, dignified and massive, appealed to me more than the tiled walls of Puebla,—often exquisite but disquieting to live with. In Puebla one wearied of seeing daily the same portraits, allegories, flowers in tile. In Oaxaca the green walls,—plain or carved with simple elegance, achieved a satisfying visual harmony. And the people of Oaxaca are more agreeable, more open than those of Puebla.

The church dominates Puebla. Bleeding Christs beckon,—veiled Virgins implore,—the bells from sixty churches clangor arrogantly, demanding penitence

162

and servility from funereal puppets who scurry by with averted eyes,—who cross themselves or doff their hats when passing a church portal. I noted one man, speeding by in an auto, remove his hat!

Being cheaper and quicker than train, we took a bus to Puebla. The road, newly constructed, was in fine shape,—the trip comfortable. Dusk,—when we stopped in front of the "Gran Hotel,"—every other hotel in Mexico is "Gran." A hurried wash—then out for a stroll. Fine luck—a fiesta was on in the plaza,—this was surely planned in our honor!—but, it so happened that we were passed unnoticed in the surge of people strolling by the puestos, around the band stand,—and around again. Well, here were new juguetes,—something different. Gayly coloured images of papier maché,—cartoons they were—of fat men—but really fat—burstingly fat,—and ladies of haughty contour, dressed in the bustles, the railing gowns, and peaked bonnets of long, long ago. These Indians caricature with exquisite sarcasm,—keen observation. The fat men had faces of surprised, baby innocence, revelant to the obese. The ladies swept by with high held chins, quite on their dignity. Of course we bought.

My note book shows June 3rd as dating the first negatives done. I worked in a private home,—a collection of antiques belonging to Sr. Bello. Rather uninteresting work but many exposures made to count in the necessary total. The four hundred negatives to be done appear at present as a herculean task—for each one must be exceptional in interest, technically fine, and must be finished within a few months, in my own interest as well as Anita's.

While developing the first night, Ray Boynton, here from San Francisco knocked at the door. We thought to have missed him, so were happily surprised.

Developing was a real labor,—funny only in retrospect. My manga de hule—sleeveless rain coat—proved its impermeability used as a hypo tray! And after, to conserve the hypo only the night-pot was large enough. That there should be no mistake as to its content swe placarded the pot—"Don't empty!" And always there was a commandeering of coats, blankets,—anything to keep out stray gleams of light. It seemed like a return to my amateur days of long ago.

Our first excursion was to Cholula. How insolent the Spaniards to crown the great pagan pyramid with their flimsy Christian temple! However, they chose a magnificent site, and from a distance the ensemble was perfect. Climbing the pyramid was worth while only for the view afforded,—the church itself had suffered from abominable restoration.

The Indian women wore elaborately embroidered camisas—blouses—but they were not for sale,—and I would have one. Finally one Indita, wearing an especially fine example, made known through an interpreter,—for she spoke but little Spanish—that in her village we might buy them. She was on the way,—we could follow, it was only a few miles away. We *followed*! I emphasize "followed." She started with that space-covering walk of the Indians, which is almost a run.

It was a hot, hot day,—we sweated and panted after her. An hour passed and Tina questioned—how much farther to go? "No es lejos, Señorita—it is not far, Miss." Another hour passed and we pantingly questioned again,—a like answer! This was now too indefinite—this hag ahead was laughing up her sleeve, we knew. A passing Indian was hailed: "How far to so and so?"—"About two hours away," he assured! We called "Adios," to the Indian woman now far ahead. She did not so much as look around! However, I had my camisa after all, bought it literally from the back of an Indita,—but only after much persuasion, while an amused bantering crowd gathered around us.

On the return to Cholula we stopped to investigate a little church,—no one was around, so we entered the forsaken weed-grown yard. Ray and I climbed a tumbling wall to better view and photograph details of the tower.

Just then appeared several excited Indians, one of whom in peremptory manner ordered us down. "What right had we there?—would we enter another's yard without permission?"—and so on. "Well, the House of God is for all," was Tina's retort, which seemed to rather stagger them,—and before they had time to retaliate we produced letters which might or might not have had any effect,—but fortunately did, more I think because the "jefe"—head man, mayor—took great pride in being able to read off the letter with much hesitating pomposity. A tense moment passed,—we shook hands all around,—and gladly parted!

There was great joy in finding important things in unexpected places,—for instance the stone angel in Hotel Jardín,—a squat heavy-set angel which only an Indian could have done. The bell-hop insisted it was no angel—that it was pagan. Evidence enough that our instinct was right—for it was an angel in every detail,—only the execution proved that the Spanish had but changed the names of the Indian Gods. Another instance was a ponderous stone cross. Christian symbols done with pagan mind,—and stronger for the pagan interpretation!

Everyone goes to San Francisco Ecatepec—the guide books insist. It does astound, this gem in vari-coloured tile,—even to me, blasé from seeing much, it brought emotion. The encargado—agent—would bring the keys,—"Vengo pronto—I return soon." "Here, leave us your sarape,"—otherwise he would never have returned!

Despite the elegance, the complete beauty of San Francisco Ecatepec, it was a nearby church which is outstanding in my memory. It was Catholic in name only,—it was completely Indian, and having been newly painted in crude colour, it held a barbaric splendour. The Indians were excited by the strange invasion but they were friendly and willing to help. I wished to photograph a bloody Christ with weird angular arms. His loin cloth was missing,—maybe in the wash, they chuckled, and grinned over his predicament while Tina scolded them for being sacrilegious. They teased us by speaking "Mexican" and roared at our bewilderment. Altogether a pleasant episode.

164

I am sure there are as many churches in Puebla as in a great city like Chicago, —the least of them more beautiful than Chicago's best. All, except a Methodist Church,—a crude, cold invasion from the north. The Catholic mind demands beauty.

No alarm clock was needed in Puebla,—the din from sixty church bells could awaken the deaf,—and out the window, black veiled women scurried to early mass. Here for contrast I record a pulqueria title—"Me Voy Fuerte—I Go Forth Strong." A little competition for the churches.

Hunting "retablos"—the votive offerings to this or that virgin who has miraculously cured or saved the donor—has been one of our joys. They range in execution from the crudest expression of simple minds to exquisite and sophisticated paintings. Almost our first thought on entering a church was—are there retablos? Not less interesting are the dedications. For instance, a child fell head first into a pot of hot soup, but through the intervention of so and so escaped serious injury. Another,—a woman in the throes of childbirth feared the deliverance of twins. She implored divine help and as a result but one child was born!

Pottery, Mexico's most important craft, had too brief mention in the guide. The splendid loza of Oaxaca receives not a word, though Terry deals at length with the sadly commercialized sarape. He could not overlook the famous Talavera ware of Puebla, but this loza is far removed from the truly indigenous pottery of Oaxaca—the Puebla ware has Chinese influence, and Spanish of course, though I am told and was shown, that it is far superior to the machine-made Spanish article of today.

We watched the making of tile and dishes and vases,—it seemed sheer magic to see the clay blossom into form from the potter's wheel. More magic at the glass blowers—molten glass forming like great soap bubbles. This cheap green glass of Mexico has great vogue now in California,—selling as something quite exclusive to the wealthy gringo for twenty times the price in Mexico.

But my thoughts of Oaxaca blot out those of Puebla,—and my first thought is always of the market,—and the market meant first of all loza—crockery!

I bought and bought—dishes, jars, juguetes,—of the dull black or grey-black ware, and of the deep green glazed ware. It was all so pure, strong,—really Indian. There were great hills of piled up loza,—the black round ollas, flanked by baskets heaped with juguetes,—bulls, horses, monkeys, birds,—every animal the Indians know, and some entirely imagined! And there was Cortés the conqueror, stiff in armour, draped in his cape. Very well do these people reproduce, make use of the essential quality of a material, — splendidly do they observe and utilize to advantage the very essence of a form. A race of born sculptors!

With my meagre collection of Oaxaca juguetes I envy no one's collection of "modern" sculpture. The little bells of clay which tinkle so sweetly, are ex-

quisitely elegant,—a great flare of skirt forms the base, which narrows to a swaying waist and to up-stretched arms for the handle.

From the dull black hills of ollas, one came to pyramids of glazed dishes, gaily splashed with color, sparkling in the sun. And then to puestos of giant baskets, or little bird-cages, or fresh petates, or coils of rope.

Besides this visual feast, the nostrils were gratified by the scent of pungent herbs, of spicy fruits, or the bouquet of flowers,—fresh clean smells,—none of the filth of La Merced in Mexico. Nor was the sense of hearing neglected, a busy hum rose to complete a sensory feast,—the buzz of conversation,—gay repartee,—sing-song of vendors.

Market day—"dia de la plaza"—was a climax of activity. Hordes of visiting Indians came from far away. It was sarape day. We were besieged to buy even at the hotel door. Gringos pay well for sarapes which an Indian would not be seen with. Sarapes made to sell, with a great calender-stone woven in the center. But I found the Germans and French buy just such disgusting sarapes. Well, the poor Inditos had no luck with us. Instead we bought such sarapes as they with good taste wear,—black with a flaring red center, a few stylized flowers or whimsically fierce tigers. One questions how long they will keep their fine colour, for aniline dyes are universally used,—another sad result of commerce.

Bargaining with a group of Indians in the market, we talked on varied subjects. Thinking that like Tina, Brett and I were also Italian, they gave us a rather distressing idea of their attitude toward Americans. "The gringos?—we kill them and eat them!" It is unpleasant to feel this antagonism,—I admit justified on their part.

One is always the pivot for all eyes, and I would rather be the onlooker. Yet in the States I managed to be conspicuous, wearing my "knickers" long years before movie stars adopted the convenience of knee breeches.

But the Indians—the Zapoteca—were friendly,—so agreeable that I find in my note-book—"A misanthrope would change with contact of the Indians near Oaxaca." They are clean, have an air of well-being, and I noted few beggars. The women wear valuable gold jewelry,—earrings and necklaces,—and refuse to sell. They have fine carriage and noble breasts. Skirts are worn to the ankle with ample flare. Their dignity makes modern woman of the knee skirt—all too revealing, disillusioning,—look cheap,—awkward. The men dress in white with wide fajas of red or black tied in front and reaching to the knees. Sometimes a kerchief of like colour in worn,—and usually finely embroidered sombreros. They go barefoot or wear huaraches of excellent weave.

Two notes on huaraches,—Brett saw an Indito sitting in the plaza having his shined!—and in the market we noted many for sale with buttons!—a climax of corruption but very funny!

166

These Indians continually suggested a remote Chinese ancestry. The slant of the eyes, the drooping moustache, the sound of their language,—they say "Chan!" for greeting!

Besides the pottery purchased in the market, I bought an animal water-bottle from an antique dealer—though the bottle was modern—which is quite as fine an expression as any prehispanic piece I have seen. It is of red clay. Water is poured into the body, which forms the container, and pours out from the open mouth. The neck of this bottle, which is the animal's neck, rears up stiff to meet the handle, curved over the body. Braced legs perfectly conform with the reared up neck and form a solid convincing base. This is major art. The same dealer sold me a fish,—a painted gourd, the like of which I have never seen. Nature attended to the form, but some Indian, noting her incomplete effort, decided to "gild the lily." Nature never created such a funny fish, with great, round, surprised eyes, a tiny, silly nose stuck on to a jolly fat body. A most perfectly logical tail helps him to buffet the waves. He is scaled all over, excepting his red checkered belly. Minor art—excellently conceived.

We lived well in Oaxaca. Hotel Francia I recommend with all augmenting adjectives. First item: it was clean,—then it lacked the usual hotel aspect,—then it was reasonable in rates,—and finally the charming French lady was a perfect hostess. The meals we still speak of with gusto,—a six-course dinner for a peso. But that does not tell the tale, for the food was abundant and well cooked,—more, cooked with artistry. Our room opened,—each side,—on to a patio, and there at night we would sit on the edge of a little stone fountain, the air fragrant from jasmine,—no—not indulging in romance—but washing developed films.

Yet when it rains into a patio,—that patio in Oaxaca,—one becomes perforce romantic.

Ushered in with full ceremony of celestial pyrotechnics, a few great drops spat, spat onto the flag-stone court, then the heavens open, the stone water-spouts piss from bursting bladders, the patio becomes a lake, the tropical foliage droops heavily,—then suddenly all is quiet,—all but a soft drip, drip, and the scarce audible, half-imagined rustle of night.

We haunted the market, hunting for loza, juguetes, sarapes, or merely for the pleasure of being there,—to watch the whirl of activity. We became familiar figures. "Ahí vienen!—they are coming!" we heard an Indita call out one morning as we approached.

I worked there with my camera,—the big 8 × 10 box drawing a crowd of curious spectators. I did a "close up" of the heaped black ollas and of the little glazed dishes arranged in pyramids.

The Mexican always displays his wares,—fruit or pottery or what not—with an instinctive sense of proportion. No matter how meagre the stock, it is arranged,

167

—and I do not exaggerate in writing that a stock may consist of three bananas, two oranges and a handful of peanuts!

Curiously thumbing the hotel register, I noted the signature of D. H. Lawrence. We decided to call on Padre Ricardo,—an English Padre, with whom Lawrence spent some time. We found him gone,—arrested and deported to Mexico the night before by the military. The neighbors spoke in hushed voices but with flashing eyes,—the criada we found in tears. He had been well loved. This was a hint to us of that which followed in the religious war.

The first excursion out of Oaxaca was ahorse to Cuilapam. There was a splendid Dominican church of the 15th century, built on a magnificent site, overlooking such a sweep of valley, hills, mountains, as to bring desire to return the horses and stay there with a fig for the future. I found some work to do,—strong hieroglyphs imbedded in the wall,—and a painting on another wall, standing alone amidst fallen arches, to do which I cut my way through dense tropical growth.

The next trip was to the ruins of Mitla. No camiones were going direct, so we took one to Tlacolula, a several-hour ride. There we waited with no luck for a connecting camión,—they went irregularly on account of the rains. Impatient, we hired horses and started on a long, hot pilgrimage, burdened with cameras, suit cases, tripods, butterfly nets, and rain coats. We furnished, I'm sure, a curious spectacle to the passing stream of Indians bound for Oaxaca,—the usual cavalcade on their way to market that one encounters on any highway in Mexico, —with a very beautiful addition—that of oxcarts, great creaking carts with solid wooden wheels, arched by a sun-shading canopy of petate. And the oxen, majestic, sculptural forms,—their heads held immobile, grappled together, bridged by a massive wooden yoke. The ox manifests power in every heavy move. He cannot be hurried beyond his deliberate measured pace. He submits to the yoke, but in his own way,—he obeys, but holds out a rigid plodding resistance.

Weary, hot, dry adventurers at last reached San Pablo Mitla to find a not half bad hotel. We went immediately, after dining and a brief siesta, to the ruins,— not in tourist style, to quickly satisfy insatiable curiosity, but to plan work for next morning.

Lacking time and money for roaming the country at leisure, we have had to carefully calculate our itinerary,—attempt to plan activities ahead, sometimes too suggestive of a forced march. But if we cannot travel as might a carefree globe-trotter, the very nature of our work has made us keenly observant, open to impression.

Our guide, *Mr. Terry's Guide*, was impressed by the dramatic desolation of the ruins and surroundings. I was not, not after deserts I have known in Western

168

U. S. But one's impression depends much on the day,—and ours was balmy, with rain clouds forming.

I am not one who can view ruins no matter how magnificent, and these were, with the same thrill of pleasure that comes from discovering a fine contemporary creation, though it be only a five-cent piece of pottery.

But I was fascinated by the stone mosaics of Mitla, for besides a variation on the Greek fret, there was a unique pattern,—oblique lines of dynamic force,—flashes of stone lightning, which remain my strongest memory of Mitla.

Adjacent to the ruins was a church. The Spaniards had robbed the ruins of ready cut stone for their far inferior construction. Here Tina made an important discovery. A stone angel bearing a cross, which made such an impression that every curve and cut I recall without reference to my negative. It was modern, we were told,—done last year by an "albañil"—a brick layer who recently died. The world lost an artist! I count this real discovery,—not the digging up of primordial ruins. Here was something done in the grand manner,—with tenderness and love and power,—done by someone who felt stone and cut it with decisive command.

The excusado in our hotel was like a throne. One ascended several steps and felt quite regal sitting there. And there was no way to shut out others who aspired to like heights,—one could not sit and silently brood without possible invasion. But the excusados in Tlacolula—can I call that terrible place we stayed one horrible night a hotel?—were even more amusing: just a large room with some six openings, where a group of sociable people might sit together and discuss the weather...

What a night in Tlacolula! We had to stop there on the return, for work planned in the church. The bed made one itch to see it. Better to sit in the plaza awhile before going to our room! The Indians wore striped sarapes, wrapped close, full length. One leaned against a lamp-lighted wall,—like a tiger in the night. For twenty minutes he leaned motionless, maybe longer, for so we left him.

We were not without reason for misgivings. They began at once their invasion,—the bed-bugs, and midnight found us sitting bolt upright, wild-eyed,—questioning what next?

Breakfast was offered us in a bed-room just vacated after the night! We took coffee from the store-counter,—flies were preferable to fusty, bed-room air.

Work in the church was delayed,—a fiesta was on,—Mass would not be over till nine. We waited in the church yard. Midway of the Mass came the tatoo of a war-like drum—prodigous cannon crackers burst—burros brayed—startled dogs howled – and the low rumbling bellow of oxen mingled with distant anthems from the church.

All memories of Tlacolula are disagreeable. One *waits* in Mexico for camión or train,—but there we waited—waited—desperate—for three hours. Here I might

169

hint to any young lady in a delicate condition that sure relief would result from a camión ride—Tlacolula to Oaxaca—in the rainy season! We went through roads which were rivers bedded with mud. Oaxaca and our nice hotel seemed like paradise!

Etla followed,—a short trip but not without excitement. We had walked to a tiny settlement adjacent,—not to say Etla is large, and in the church found a Virgin,—black robed,—quite exquisite in taste, so simple and unadorned, so unusual in this respect. Permission to photograph her was easily obtained from a gracious sacristan. She was however in poor light,—so the three of us, with ceremony and reverence, out of deference to a few onlookers, moved the effigy, dusted her, arranged her robe and made her portrait.

We had just packed and were leaving the church yard when a sharp command halted our exit. The jefe of the village and all his cabinet had arrived to demand with what right had we entered and taken such liberties in their church. Our official letters had no effect,—neither [did] the permission from the sacristán. It was evident the "mayor" felt his dignified and illustrious position as chief of the town had been slighted. He scolded the poor sacristan and argued pedantic-ally with us. After twenty minutes of palaver in which he duly impressed us with the seriousness of our offence,—the barred window of the town calaboose was just across from the church!—the jefe ran out of official lingo and bowed us out of town. He had a wonderful opportunity to show his official power while we melted in a broiling sun.

A group of small uncovered pirámides near Etla kept us hunting idols for an hour, with no luck. But Tina bought from an Indian a prehispanic whistle, done quite in the spirit of those sold in Oaxaca today. One other recollection of Etla,— not an unusual one in Mexico, is the hours, long wait for a return train.

I wanted to stay on and on in Oaxaca,—and today, given leisure and money, I would return. But many other states ahead indicated the end of work and play in Oaxaca.

Little incidents often remain with one more vividly than apparently important ones. A drizzly night I took Tina's shoes to the Plaza for a shine. One little bare-foot urchin donned them, and assuming lofty airs, lit a cigarette while the other, on his knees, shined.

It was in Oaxaca also that I saw underneath a shrine to the Virgin, all draped with red plush, gold embroidered, a table cover of blue-and-white scalloped oilcloth!

Another note—though I have seen like exhibits elsewhere—a coffin swinging on a bracket over the sidewalk to advertise a trade. Once I saw coffins painted bright blue and decorated, which seems a sensible variation.

Torrents of rain had fallen for days before our departure from Oaxaca,—flooding the country, washing out tracks. There was some doubt as to whether we could

170

make the trip, but we found an antiquated engine waiting to take us to the worst washout where we transferred ourselves and luggage to the regular train, a quarter mile away. The cars lurched along as though at any moment they might leave the track. Finally they did,—with a shocking crash, grinding and plunging over the ties, amidst crashing glass and screaming voices. A moment of panic,—then we faced each other on terra firma with white faces and knocking knees. The engine had not jumped the track and with some manuevering the cars were shunted back in place. Proceeding cautiously,—the cars now creaking and groaning in protest,—a few miles later, around a curve, the engine struck rock. The cow-catcher doubled up, but on we went. Any pretext to feel one's feet on solid ground; so the toilsome pilgrimage over a washout was a relief.

Puebla at midnight—well worn out.

No less memorable was the trip from Puebla to Mexico. The bus left at 7:00,—one half hour later it was stuck up to the hubs in mud near Cholula. Once free and on a fine road, our driver made up lost time. On the straight-away the Cadillac went 100 kilometres an hour; over dangerous mountain roads, around curves even, so fast as 90. Only one who knows the fool-hardiness of Mexican drivers will appreciate this episode. When sign boards indicated danger ahead we speeded up a bit! I vowed to dedicate a retablo (ex voto) to any or all of the Virgins if saved from what seemed inevitable death.

When we stepped within our long vacant house it seemed but a cardboard toy after the stone strength of Oaxaca.

Through Michoacán, Jalisco, Guanajuato, Querétaro — Two weeks of developing and printing,—then off again,—Acámbaro the destination. From the train,—purple hillsides,—lupin purple,—or corn fields far as eye could see. One seemed to hear the pat-pat, pat-pat of tortillas in the making. The city, Acámbaro, lacked interest, but the country side was fair indeed, and continued so the trip to Morelia. Green, rain-drenched hills and valleys,—instead of lupin, purple water-lilies. Lakes, lily covered,—meadows of orange wild flowers,—orange shading to yellow, splashed with purple.

We were ready to leave Morelia after working in the Museum. The Indians lacked the character, as did their crafts, of those in Oaxaca. The church interiors had been stripped of all interest. But the city was clean,—had much fine architecture, and again the surrounding country was alluring.

In this day of the pedestrian's decadence—when even those who would walk, find no place,—we chanced upon a promenade, a flagstone walk, wide and long, lined with stone benches, shaded by elms. Here one might rest and dream, or leisurely stroll, unmolested by the insolence of automobiles.

Of course it was built 200 years ago when legs were still in use!

On July 22nd we waited two hours for the train to Pátzcuaro. Rain—rain—

171

water flowing over tracks,—spectral mountains opening cuts, red and raw, for the train's passage,—then Pátzcuaro—Michoacán.

Whenever we did not have advance information,—providing of course there was more than one hotel in a town, the question was always which to chance. Sometimes one look would suffice to turn us away, convinced of bed-bugs,—or the room would lack privacy—or be poorly ventilated. Hotel Concordia was unhesitatingly adopted. Rooms with floors of red flagstones—waxed,—ceilings of uncovered beams. And who could have resisted Pedro's infectious smile, his open face, his willing service. He tended our rooms and confided to us his woes. He wanted to return to his "tierra," but he never could save enough from his wages. He had hoarded two pesos, only to have his room robbed. He was sad, for he did not like this "metropolitan life" and his sweetheart was far away. I am certain no guest in that hotel had ever asked Pedro to sit down and have a smoke as we did.

Our arrival was well timed,—the next day was to be "dia de la plaza"—market day. The street below swarmed and buzzed with Indians cooking over improvised fires. One wondered where they slept,—so many vendors and buyers from far away,—certainly not in the hotels!

With us in Pátzcuaro was "Count" René d'Harnoncourt. He had [the] right to use "count,"—but did not take his title too seriously, except when with that species of democratic American eager to hobnob with royalty,—then his title proved a financial asset.

When René joined our little party we were a bit distressed. Conspicuous enough as new arrivals are in a small city, we were now destined to be heralded far and wide like a circus come to town. For René was just six foot seven, wore checkered knickers and white spats. The small-statured Indians looked up, stretching their necks as though René might be a New York skyscraper,—first amazed, then convulsed. But René was so charming a companion that we forgave him this undesired publicity. Evenings in the improvised hotel-dark-room, he regaled us with stories of court life in pre-war days, and sang to us the folk songs of Austria. Brett still recalls René's version of the *Marseillaise*, which he thundered forth to what must have been the amazement of all the natives within a city block.

That night we overslept, and René beat us to the market, returning in triumph with a water bottle,—a fat, round little duck,—a gem in red clay. Leaving coffee half finished, I scurried to the plaza and bought one,—the last, for myself. Later I purchased a bird,—a transfigured gourd: now I no longer envy Paul for his.

Again to write down admiration for the Indian in his sense of balance, knowledge of anatomy,—for in painting and amplifying upon the gourd, they actually recreate. The perfect placing of the legs upon the round gourd's body,—slightly straighter or more sharply angled, and the fine continuity of line would not have

172

been achieved. As it stands I cannot imagine a great sculptor creating more sensitively.

Market day in Pátzcuaro was next to Oaxaca in beauty and interest. The arranged produce [was] an incentive to buy: neat little pyramids of green chiles, bouquets of lily-white onions, a half block spread of sombreros. The sombreros served not only as head protection,—they logically enough became a convenient "catchall," a receptacle in lieu of bag or pocket. Glancing down at the sombrero of one squatting figure, it held—chiles, cigarettes, matches and a handful of tiny silvery fishes.

The costumes, even for "picturesque" Mexico, had unusual distinction. The women wore pleated skirts of scarlet or black,—pleated anew each day, for at night they unfolded to become bed covers,—and fajas, sashes of exquisite craftsmanship, and silver earrings. The old sarapes, even when in rags, held brilliant color,—were simple and dignified; the new ones often hideous. Red was a favorite color, and also black. Their wrapped figures became a scarlet flame against the grey sky which hung that week over Pátzcuaro, or loomed black in the drizzle.

One man with a rare old sarape, continually crossed our path, until Tina approached him to buy. Yes, he had worn it about eight years,—he would sell for three pesos. For once Tina did not bargain! Later that day we saw the same Indian proudly strutting through the plaza wearing a brand new sarape,—an ugly modern one. He surely thought, what a stupid gringa to buy that dirty old rag from me!

Good as hotel cooking may be, one tires,—so we were happy through Señor Solchaga to discover Buenos Aires and Panchita. "Buenos Aires" was made up of out-of-doors lunch counters. Panchita was owner, cook, waitress and dishwasher in one. She performed her fourfold obligations quite miraculously over a single charcoal fire. Panchita cooked for us better meals than the hotel served, at one third the cost, and, best of all, whatever we wished, if in the morning she was forewarned what to buy. This might be the dinner "menu": caldo (soup), arroz, (rice) aquacates well seasoned with onion and chile, jokoke (sour cream) served with tortillas, and of course frijoles.

"Buenos Aires" nestled at the foot of the "Santuario de Nuestra Señora de Guadalupe." *Mr. Terry's Guide*, with characteristic lack of appreciation, dismisses this sanctuary with the words, "It is uninteresting." On the contrary it has such great interest that we often walked out of our way just to be "inspired" (apologies to Terry) by the four great sculptured figures which crown the campanario. They were grandly conceived, executed by a master,—attributed to Tresguerras, but now supposed by some who have documents in proof to be the work of one Casas. The controversy seems immaterial,—sufficient these superb sculptures which have the strength and fineness of archaic Greek. Casas, or Tresguerras, (three wars)—the latter name conjures up a more vivid imagery—

is called the Michelangelo of Mexico, to indicate his importance rather than any similarity to the maestro.

Impossible to photograph these figures from the ground; I climbed the campanario,—even then only a profile was possible with the 8 × 10. So I crept out onto a narrow ledge, hugging close to the wall, not daring to look down,—and with the Graflex obtained a $^3/_4$ view. The slight jar of the Graflex shutter seemed enough to overbalance and drop me down into the charcoal fires of "Buenos Aires."

Unconnected notes—Offered for sale a lacquered screen from Uruapan of marvellous technique, but of deplorable taste, of picture post-card realism.

Encountered a store in which coffins and bread were sold from the same counter. The staff of life and the symbol of death,—take your choice,—on Monday buy bread, on Tuesday a coffin.

Have I yet mentioned how often one sees, both in painting and sculpture, black Christs? Or how unusual it is to find a Christ, gashed and gory, but wearing in place of a breech cloth, a lace petticoat and pantalettes!

Encountered the coldest weather in Pátzcuaro since leaving sunny Southern California. San Francisco papers will copy.

Delicious candies we overindulged in,—sold in the plaza, but surely not made by the Indians. It was hinted to us they were made by ladies of the old aristocracy, now in poverty, who turned to this covert way of earning pennies,—yet remaining ladies.

I had been wondering if our stay in Pátzcuaro was to be prolonged because of a threatened strike on the Railroad. It did not happen. Calles ordered all engineers who would not start their trains to be shot and replaced at once! Direct action in Mexico.

Analysts get busy—an entry of July 20th in Morelia—dreamed Cole was dead—awakened weeping and crying out "O my baby!"

I was possessed by a great uneasiness while in Pátzcuaro, in view of the government order to officially end Mass in the Catholic Church. One felt the tenseness of the situation affecting the whole community. The severity of the ruling might result in civil war. I recall one morning,—4:30 it was and pitch dark. I was awakened by a delirious clangor of bells,—more than protest, I thought,—an insinuated rebellion. Then came Sunday, August 1st—when no bells rang—a heavy silence, more alarming than the foreboding bells, threatened the city.

No longer did Tina, for favors, have to kiss the greasy hands of lecherous priests —but I insisted more seriously than heretofore that Brett join me in doffing my hat to every church door,—for now the attitude towards strangers,—possible government spies, or at least unsympathetic aliens,—made our situation precarious. We were marked. If we entered a church some fanatical old hag would

174

follow, or a crowd of sullen faces would eye our activities. A source of importance to our work, the sacristy, was closed, locked and sealed by the government. With the going of the padres, permission to work in a church was not easy to obtain, for no one cared to—or would not—assume responsibility,—so often we went around in maddening circles.

As I review our travel and adventure from the vantage ground of my comfortable desk I think this: that if a woman had not been in our party, especially Tina, with her tact and sympathy for the Indians, a woman which made the group seem less aggressive, Brett and I would never have finished the work.

Pátzcuaro, built on the slope of hills which flank an exquisite lake, is "picturesque." In the hands of American business men it would soon be a world-famous all-year resort. But the hillsides and shores are so far free; bill-boards have not yet conquered Pátzcuaro. Instead, green hills with scarlet skirts of women and scarlet sarapes of men scattered here and there like exotic tropical blossoms.

In La Iglesia del Calvario we found work to do,—several important paintings —though Mr. Terry again played the blind man. To reach the church one must climb a rocky road to Calvary, and the camera became my cross which I shirked when an Indian would bear it for a peso a day. The way up was stationed with little shrines painted as a child might see. Near the church, a hilltop commanded a great sweep of the valley, lakes and hills.

Idling an hour, we watched the Indian dugouts gliding from island to island or across to the far away shore.

The daily storm, approaching, alternated sunshine and gloom,—burnished the lake or turned it leaden. There was the islet of Xanicho [or Janitzio], and on the horizon Tzintzuntzan,—both places we were soon to see,—to retain vivid and not altogether pleasant memories.

The name Sr. Salvador Solchaga, to whom I had a letter of introduction from Anita, will always be linked with Pátzcuaro. With him we spent much time, and to him we are indebted for his courtesy as host and guide.

The night before,—to be sure of no delay, a Ford had been engaged to carry us to the launch, which also had been hired for the morning, with Tzintzuntzan the destination. That the Ford would not be punctual was expected from past experience,—that it would be an hour late exceeded our worst fears. ¡Qué gente tan informal!

The gasoline launch was out of place,—a modern trespasser upon this lake which once held the royal canoes of Tarascan emperors,—canoes we may imagine all brilliant in lacquer. Even today the slow-plying dugouts rule by right of affinity, —the motor's "put-put" and the stench of gasoline seemed sheer impudence.

In Tzintzuntzan "the centre of attraction" for guide book tourists is the famous Titian (or Titianesque) painting. It was supposed that we went as most do, for

no other reason. Out of courtesy we had to glance at it. Not a single line do I recall! But, under the arches of the patio, well-remembered frescoes. In abandoned corners the stink from bat dung nauseated. Several women swept the church. They would sweep a few moments, then kneel in prayer. Up and down they bobbed, most of the time down. I wearied of the droning mumble from prayerful señoras, whose religious emotion, from over-indulgence, had become a formula.

But I was often awed by the fervor, the agony, of the Indian man as he knelt with outstretched arms before his God.

News of our arrival spread, and vendors came even into the church. Mostly prehispanic fragments were offered,—the usual clay heads, but I made one purchase of exceptional value,—a pipe, probably not less than 400 years old, most likely much older. The bowl was smoke black.

A more notable day was that in Tupátaro,—a long ride ahorse from Pátzcuaro. "Venado"—the deer—carried the cameras, coats, and numerous incidentals to a strenuous trip. Venado, a little grey burro, deserved his name,—not once did he allow the horses to nose him from the lead.

Few had seen this church of Tupátaro, far from tourist tracks. The Indians told us that only a "gringa" whom we knew was Anita, had visited their village before. She had insisted that we include Tupátaro, in our itinerary as being of great importance to her book, which it certainly was. The ceiling was entirely lacquered, even the beams,—a notable achievement in colour, design and craftmanship. Already ruined in portion from the seepage of rain water, another few years of neglect will allow irreparable damage to this fine monument.

Here in Tupátaro the villagers were more than hospitable, and excited as children when I asked permission to photograph their Santiago. Santiago was a childlike expression. They must feel more than mere reverence for a saint, he must be like them,—one of them. So Santiago was. He could have been displayed in any American department store amongst the toys,—a super toy. All details had received careful, tender attention. He was booted and spurred, over his neck hung a little sarape, around the waist a real faja, and his spirited hobby horse had been branded! Because of a recent fiesta the horse was still wreathed with roses. "Should we remove the wreath?" "No, no, please no!"

That was a hard day of work, so much to do that must be done before the afternoon storm. Exposures were prolonged to even [fifteen?] minutes with additional flash light, the while I must remain quite still upon a rickety balcony for fear of jarring the camera, which was real torture with more fleas biting and crawling than I ever knew could jump from a few square feet of space. Fresh gringo meat was evidently a rare and toothsome treat.

The cordial villagers vied to have the honor of serving the "extranjeros" dinner.

176

And who could have thought that in such a tiny, smoky hut, we could eat so well!

"Venado" led the return procession, going sure-footed while the horses slipped and stumbled. The storm behind promised a soaking, but never caught up, though it grumbled and spat rain on our backs, blowing us ahead fullspeed to Sr. Solchaga's ranch,—the night's destination.

Tired,—exhausted I was, yet the sunset over the valley,—two white clouds racing in the dark sky above darker hills—brought me to my feet and my camera out in a hurry.

"Would we care to dig for idols in the morning?" "We would!" and did. I made the first find—a tiny clay torso lying in the furrowed ground. The rest were envious for it was a perfect piece, but nothing more was found except fragments of no value, though Brett dug deep with pick and shovel. The Tarascans threw away all pottery and images every two years, creating anew,—they liked things fresh and bright. Being real artists, no tremendous effort was required to replace their pots and Gods with new ones equally good. So the earth of Michoácan is strewn with broken bits.

The Mexican government has become very strict concerning what "art" is taken from the country. This is an admirable stand, yet there comes a question,—is it not better for a nation to be rid of its past,—even more so if that past were a mighty one?

Better for the present generation not to live in the reflected light of great ancestors, imagining the glory their own.

Xanicho [Janitzio] of disagreeable afterthoughts! We were eager to go,—more eager to leave. It was a small rocky island of fisher-folk, who received us with hostility, which made me bristle in turn. Upon our approach the church was locked and remained so despite our letters and entreaties.

Maybe our visit was an intrusion,—one felt so wandering through the narrow streets,—like private property, like invading someone's back yard, it was that intimate,—personal. Before landing we heard music,—distant orchestra,—song and laughter. What a gay place! A wedding feast was on and we were the uninvited guests. This was the second day of celebration,—half the villagers were drunk. A reeling Indian greeted us, swearing uproariously. My inclination was to knock down the filthy beast, but not wishing to commit suicide I half embraced him instead; surprised, he staggered off still swearing.

Upon a cliff by the church, fishermen mended nets,—yards of mesh stretched on poles to dry, sunlit and sparkling. To gain our end we affected great sympathy, denouncing the government for ending Mass. But they were taciturn, aloof, answering with laconic sarcasm. One offered to take us where there were prehispanic idols. He asked five pesos, which so incensed Tina that she berated

them for greediness. "Well, when we go to the capital," he retorted scornfully, "we are cheated and know it, but we pay for our fun without question."

Hopeless now,—sure that the church would not be opened, I turned my camera toward the huts and lake below: the tiled roofs a jagged foreground,—the lake a sheet of silver,—the hills of Pátzcuaro beyond, murky under storm clouds.

And as I focussed the wedding procession approached. Up the rocky lane they wound, stumbling, staggering, led by a drunken hag whirling round and round, wildly gesticulating with a pair of steer horns, lunging at the bridal couple, retreating, crazily screaming,—while the orchestra blared forth barbaric music. The others waved flags or empty bottles, drowning the music with hoots and shrieks.

"We had better leave," I suggested, "before meeting that mob. They might decide on a funeral march for variety. Let us hunt for old lacquer from Uruapan in the village below." We went down, — the wedding up. Then happened a near tragedy, for to my horror the old horn-waving witch charged my camera, left standing on the cliff's edge in charge of our cargador. What he did or said to dissuade her I don't know, but the boy had an extra peso in his pocket that night . . .

Brett and I acquired new names in Pátzcuaro. Brett—"El León"—the lion, and I—"El Señor de los Milagros"—the miracle man, because they said I worked miracles with my camera!

Uruapan was not included in our itinerary, but the temptation to go down into "tierra caliente" was so strong that August 2nd found us on the train headed for the land of lacquer.

Suddenly Tina gave a horrified "O!"—then she was speechless,—and following the direction of her staring eyes, I in turn became mute,—stricken with grief. A newspaper headline announced the burial of Señor Manuel Hernández Galván! No room for doubt—it was our own fine and beloved friend. But how? Details were not given. He could not have died a natural death,—not Manuel. He was marked,—he knew this, and we had half-jokingly told him that "he would get his" sooner or later. Surely he was killed from ambush, no one dared face him on equal terms. How often have I seen him draw his pistola and dent a peso the first try at thirty paces!

Only a few days before we left for Acámbaro he had dropped in. "Phone me when you are near Guanajuato," he said, "I'll plan a real fiesta with barbecue and song and dance." Now he has gone—dear Manuel! A Don Juan of today, a brave cavalier, handsome, charming, generous, the wit and life of any gathering. Many will mourn his going.

From every important stop, a varied assortment of purchases,—loza, fajas, juguetes, had to be expressed back to Mexico City. A large, strong basket, lined

178

with grasses, sewed over with petate, was invariably chosen for container. Not one piece of pottery was ever broken en route. I doubt if a box would have been easily found had we desired one,—not in the smaller cities,—for shipping in baskets is quite universal, and the idea is beautiful. The sweet-smelling grasses, the sturdy basket, the flexible cover of petate, all from the handicrafts,—an intimate, living ensemble.

Our guide book would probably read, "The landscape between Pátzcuaro and Uruapan is inspiring." It is. But what is the matter with words! Have the poets so abused them that they have become anaemic, dulled,—robbed of all suggestion?

The track formed an unbroken curve over which the train creaked distressfully. My thoughts would revert to the horror of Galván's death. Rain fell to make the day more dreary. I recall a valley, rain-filled from mountain top to mountain top.

"The best hotel in Uruapan" was pointed out. It had running water in each room, but every vacant room opened onto the street, and all had wooden floors. This would never do,—wooden floors in Mexico! We searched and found a hotel with flagstones.

I half imagined the streets of Uruapan would be paved with lacquered bateas, —trays—and it was almost so. The industry, though flourishing, has become corrupted to such a degree that one can only hope for its ultimate death. It is dead in feeling,—only the technique remains. We watched Cruz Hernández, super craftsman, wasting his time and skill over piddling knickknacks to clutter the rooms of the fat-minded burgess. Truly it was sad!

Others had preceded us in the search for old lacquer,—Uruapan was stripped. But an unexpected joy was the discovery of the green loza from Patambán. I would rather have one piece of this pottery than all the Talavera ware of Puebla. Like that of Oaxaca this loza has retained its indigenous character. It is never shipped to the Capital, hence there has been no concession to hybrid taste. The output must be small, barely supplying nearby villages, for even in Uruapan none was to be had on Market day and our few purchases were all from private homes.

Sr. Solchaga had first shown us this pottery,—then, seeing my delight, presented me with an exquisite dish. The pattern is almost always a vivid green on a brown-black ground,—sometimes a touch of ivory is introduced. The better dishes are painted underneath,—green and ivory patterns over the natural red-brown clay. If it came to parting with all my pottery but one piece, this green dish from Sr. Solchaga would be under consideration as my favorite. For in it all the Indians' imagination, their lyrical spirit, their plastic reconstruction of nature is manifest in essence. Chained to the outer edge of the plate, a little animal, maybe a deer, balances on leaf sprays. No deer could stand on such

delicate stems, but what cares the Indian for humdrum truth? Another dish presents a gambolling deer, so elongated, that without legs he would be a snake. On another a bird hovers, about to alight, drawn with one sweep of a brush.

A jar I have from Patambán is crisscrossed with a mesh of lines, forming diamond shapes or squares quite like a Scotch plaid. It is round as a ball, a big one, with a small base and a generous mouth. It is a jolly jar,—and has a story. We first spied it on a counter in the market filled with milk,—that was its use, to bring milk to market every morning on the head of a nice Indita. Would she sell it? No, she needed it for her milk. But she could get another and we could not. No, they were only brought to market after the rainy season. Finally she remembered having another. If we would come to her home that afternoon she would sell it.

She lived far in the outskirts,—but what a memorable walk into an extravaganza of surprises! The way led through lanes carpeted with moss, under a canopy of trees,—mulberry, banana, coffee, chirimoya,—and flowers,—scarlets, pinks, whites,—and lush ferns.

Arriving at our destination, a cordial welcome was extended, but not a word about the reason for our visit,—the green jarro of Patambán. After courtesies, I had to question. She had changed her mind! The other jar had a round base, it would not balance alone on her head, she would have to hold it there the several miles to market, and that was too much effort. Besides she really liked the jug and might not find another quite the same. Raising her original price 25 cents each time I reached an offer of two pesos, and since she had paid less than a peso for it and yet allowed us to walk away without capitulating, I'm sure this Indita had real love for her jarro. I am equally sure that she finally sold it, not for gain, but because she was kindly, and saw how we loved it too.

It was misleading to write that "the technique remains", in speaking of the bateas. Some few workers use the old technique in which the pattern is cut out of the ground and the paint inlaid, whereas the modern facile method is to stencil. The old tradition never approached realism. The leaves and flowers were stylized,—presented as flat geometric forms. But now all dimensions are in mode, and being dexterous and imitative the Indians copy nature perfectly, with results which delight the burgess and outrage the artist. Even when adhering to the old tradition the craft lacks interest because of a universal crystalization of idea in design. The bateas are with but slight variation alike,—seeing one is to see them all.

In contrast the little candy boxes from Paracho are gayly imaginative and the furniture, cheap in construction but finely carved, was far from being commercialized. A chair brought to market many miles on burro back could be had for 50 cents. Maybe the candy boxes influenced the painting of coffins, decorated with similar flower designs. Rather a tender idea!

180

In the States, a grocery store in California and one in Illinois are prosaically alike. Each with its shelves of standardized foods. Rows of "Quaker Oats," "Campbell's Soup," "Heinz 57,"—canned conveniences allowing our feminists time to hunt culture and invade man's last retreat—the barber shop. This is digression, the point is that from coast to coast the stores are depressingly monotonous. Not so in Mexico. Each market place has a new note in display, besides peculiarities of costume and variety in food. The Inditos of Uruapan for instance, offered their fruits on long green fronds of the banana tree.

While in Pátzcuaro René loaned us Lawrence's new book on Mexico, *The Plumed Serpent*,—such boresome reading that we could not force a finish there, but, curious to find out Lawrence's reactions to Mexico, we brought the book along. Despite its entire lack of humor, we were at times convulsed with laughter. His chapter on the bull fight in which he belly-aches, weeps and ridicules, is full of absurdities. Lawrence tries, it is evident, to bolster up his symbolism by indicating the customs of one locality. I never found a market where the Indians "never asked you to buy,"—they are usually clamorously insistent. Nor do the women hold their water jars as he points out, to show their lack of poise. More often, they walk free handed, with regal bearing. Throughout the book apparently trivial inaccuracies persist, and form a wrong or one-sided impression of Mexico. Lawrence was bewildered by Mexico, he was frightened, but he over-dramatized his fear. There are fine descriptive passages, intelligent analyses, accurate prophecy, but such a padding of tiresome allegory about Quetzalcóatl that excellent material has been used to create a volume of unconvincing mysticism.

There was no excuse of work to let us dally in Uruapan,—so August 5th found the "expedition" Guadalajara bound, over a branch line which led to Penjamo, the night's destination.

The more I travel through Mexico, the more I am impressed with the tremendous wealth of its natural resources. An Italian newspaper headed an article, "Poor Mexico, she is too rich!"

We passed neglected orchards in which cacti had regained their lost dominions.

After an unexpected dearth of food, unusual on Mexican railroads where every station affords fruit at least, we bought gorditas at a siding—maize cakes filled with a savory medley of meat, potatoes and chile.

Except that awful night in Tlacolula, the hotels had been clean, airy, comfortable and reasonable,—but I had a premonition about the night to come —

We arrived in a driving rain, slipping and stumbling a block to the "Hotel." My premonitions, I swore, were about to be fulfilled. So, preparing for the worst, I wet my face with melisa for mosquitos and powdered the bed for fleas. The room had no windows,—there are few fresh air fiends in Mexico,—to leave the door open would have been financial suicide. I erected a barricade of table and

chairs, coyly viewed my bed, crossed myself,—and—awakened next morning remembering a sanguine, night-long battle with fleas,—batallions of them. The dead lay strewn between the spiteful little hillocks of my mattress, between which I had found no vale of rest.

Hot baking powder biscuits and good coffee cheered us at 4:00 a.m.—a Chinese Restaurant in Panjamo station! On the stone floor of the waiting-room, Indians had slept all night. They lay there like so many animals, sprawled or huddled together for warmth. Over them we gingerly stepped to morning coffee. Waiting for the half hour late train, the grey smoke from a standing engine turned golden in the sunrise.

Ugh! The entry into that fetid train,—the bleary faces! Two men having beer with breakfast! I smoked to kill the stench.

Terrific rains had wasted the land. Acres of drowned corn rotted in new made lakes. And still it rained, while the train wavered over shifting tracks. Alongside were water hyacinths,—lavender lagoons under a rose dawn sky.

An Indita offered tortillas with chicken, chile and onions. No sale. Disgusted, she flung a sarcastic, "What *gentlemen* in first class, so delicate they cannot eat my food—" Of course I bought!

For the third time we are in Guadalajara. This had to be a cheaper visit. No one questions morals in Mexico. Not even in the Casa de Asistencia kept by the highly respectable Morales Hermanas,—the only concern is board-and-room bills. So we lived as we often had before, three in a room, to save a few pesos. Morality is a personal issue in Mexico. A large corner room was ours for 2.75 a day, with dinners for .85. Imagine living so well and yet so cheap in a hotel!

It took a straight ten hours sleep to recover from Panjamo,—no, not quite uninterrupted, for the slats clattered out of Tina's bed in the night, and three chinches aroused me in time for breakfast. The weak bed was repaired, the inhabited one removed, and there were no more misadventures.

We were not strangers in, nor to Guadalajara. The Marín family would have us live with them,—no?—then eat with them—no?—then "our" home was open for any time we could spare. Such unbounded hospitality.

They told of Galván's death. Shot by political opponents, as I had guessed. The murder took place in "The Royalty," where three years ago Llewellyn and I used to sit over hot rum punches. He had no chance,—fell dead across his table, shooting as he fell, but shooting with eyes already dead. I suppose one might say he died as should a man of action,—but it was a monstrous tragedy.

The electrical storms of Guadalajara were noteworthy. Our solid stone building would tremble from crash after crash. The streets became impassible rivers. Ragged little urchins made good on such nights, building plank bridges over-which they demanded toll of "un centavo".

182

More negatives were done in Guadalajara than in any other place. Work was concentrated. The museum furnished many. The new home of Governor Zuno also. This "colonial" house represented a fortune. With splendid details,—as a whole it was not convincing. Governor Zuno—he who had bought my work—and later Tina's—for the museum where it now hangs,—almost to my sorrow, being work of my past,—sat to me in charro costumes, of which he had the most extravagant collection. Then in the University were the frescoes of Amado de la Cueva and Siqueiros to be done. I thought them a splendid accomplishment, a synthesis of color and idea,—realism geometrically expressed.

Admitting all the charms of Guadalajara,—perfect climate, cleanliness, beautiful and chic señoritas, progressive spirit,—I would choose to live in Oaxaca in preference. I felt a pretentiousness in Guadalajara,—consequently a superficiality. The new "colonia" of vulgarly ostentatious houses irritates me, — indeed the very commendable progressive spirit was not acceptable. As yet it seemed but a weak graft upon dissenting roots.

Guadalajara was not gay. What city could be during this crisis! Black prevailed,— the Catholics in mourning. A boycott of all luxuries, all pleasures, emptied the streets and stores. Street fighting between soldiers and Catholics,—the majority women, armed with bricks, clubs, machetes,—resulted in bloodshed and death.

To work in such a belligerent atmosphere was embarrasing. Every movement out of the ordinary was noted. Setting up my camera in front of a church was next to training a gun upon it. I wished that instead of puttees and leather breeches, I had the most conventional suit.

Two Mexican engineers—(suspected of being Government spies)—had been lynched in Acámbaro shortly after our visit...

This recalls a story from Aguas Calientes. A General said he would have no black-dressed women mourning for the church in his town. He arrested a number, had them stripped and sent home in their underwear.

In Guadalajara for the first time we did not need to turn our hotel room into a dark-room. A most hospitable photographer allowed me the freedom of his. However it was the fine old colonial building he had turned into a "studio" which I must mention,—or more explicitly the stairway leading up to his rooms. I think it furnished a striking example of a difference between that period and this. There was no economy of space,—the stairs were built for a leisure-loving people. Broad, low steps compelled a slow and dignified ascent,—one could not climb jerkily,—hastily. The rise was so gradual one walked as on a level promenade.

Victoria cooked us wonderful meals,—real banquets. Caldo with aquacate sliced in, chiles rellenos, pipiano de pollo,—a sauce of pumpkin seeds over chicken, fruit salad of guayava,—delicate and refreshing. And then another well remembered meal,—supper at Valentina's in the outskirts of town. Valentina was a famous

183

cook, a magnet for all classes. Food was the thing. Formalities she would not be bothered with. We asked for knives and forks,—she had none—only food!—and we had hands!

Except the farewell to the Maríns, there was no sadness as the train pulled out from Guadalajara. I was glad to leave there,—it would have been the same elsewhere,—just to be leaving, to be through, was the desire.

Mexico breaks one's heart. Mixed with the love I had felt was a growing bitterness,—a hatred I tried to resist. I have seen faces, the most sensitive, tender faces the Gods could possibly create, and I have seen faces to freeze one's blood, so cruel, so savage, so capable of any crime.

The first station-meal at Yurecuaro. Fresh cream in earthenware jars, gorditas fat with goodness, and a sort of pudding,—a work of art,—I guessed it was milk, cheese and burnt sugar. "Chango!" the vendors cried.

A hard day with two changes to reach Guanajuato. We arrived in the night. Our train had no headlight,—but lightning flashed to reveal a mountainous landscape, and the train puffed and wheezed up a heavy grade.

I stepped out on the balcony of our hotel room to view the city,—and—Galván faced me like a ghost. No Manuel to greet us but a great poster across the street, done from my photograph, announcing his candidacy for re-election. It was printed in a ghastly green,—rain-streaked and sodden. On every corner in corner in Guanajuato we met that portrait!

The first day at dinner a disagreeable and tense episode happened. A party of men took an adjacent table,—and casually noting them, I recognized General G.—who had been with us on those first excursions during the revolution, when Galván had driven to El Desierto and Las Tres Marías. We had been gay friends together. Then General G. had turned traitor, had become Manuel's bitter enemy, had plotted against him. He recognized us, I'm certain. I turned away as casually as I had looked, but pent with emotion.

Apart from the mines and the mummies the only great interest in Guanajuato was the situation of the city. "Picturesque" it was, Mr. Terry says so, but saved from this damning label by its ruggedness. The house of the poor grew from solid rock,—out of the hillsides, but the pretentious homes were the most vulgar we had yet encountered,—frivolous, unrelated excrescences imposed upon an austere landscape. The climax of bad taste was the "Teatro Juárez", described in our guide as "the pride of the city." I could no longer tease Tina about Italian Art, for the bronze allegorical figures "crowning" the edifice were by an American! Yet the building had its value,—it was amusing! And so was another,—a pulquería named "A Ver Si Acaso—Let's See If By Chance."

I had looked forward to finding much fine pottery in Guanajuato,—but no—the industry was in decadence. The younger generation had not learned the craft,

184

few workers were available, and those few unreliable from drink. From door to door we went in search of such fine loza as Guanajuato had once been famous for, —a heavy, durable loza, broadly painted in bright yellows, blues, greens on a light ivory ground. And we found it, quite unexpectedly in a grocery store. The little old lady did not wish to sell. The dishes had been in the family for years,— they were for festive occasions,—but—"What would we offer?" It was evident she was poverty-stricken and forced to grasp this opportunity and I felt guilty in tempting her. But if we did not buy, another surely would, so without too much bargaining, excellent examples were ours.

All the activities of Guanajuato, all energy, all life is directed into the subterranean. It impressed me deeply, the idea of this great underworld army of men burrowing, tunneling day after day for silver and gold for someone else. We heard the story of one mine, "El Tiro de Rayas,"—The Gunshot—of 1000 men working 1500 feet down,—then—through the courtesy of the manager, Mr. Harold Mapes, we were taken there.

To the uninitiate the first look down that shaft must be awful. 1500 feet deep, from 40 to 60 feet wide,—a dark, dank bottomless pit,—the depths of which the sun reached but two days a year. My ears popped from pressure as the lift went down, and looking up to daylight, the steel cables were but threads too trifling for a safe trip. "The miners sing hymns as they descend to work," remarked the guide,—"and one slipped off the other day. He made a nasty mess." At the bottomless pit's bottom was a little shrine, tenderly decorated with pretty rock crystals.

Another subterranean visit was quite as awful as that down the mine shaft. In the underground vaults of the Panteón (cemetery), we paid our respects to the dead. Circling the entire room, they stood there naked—not a sheet, not even a breech cloth to soften the ghastly sight. A gruesome, grinning crew whose tanned, taut hides had warped them into monstrous grotesques. They held an appalling beauty. But not all were naked. Two old men still wore their evening finery. Skulls and skeleton hands thrust out from tattered glad rags. One woman had been buried alive, her mummy writhed in horror and agony. Another had died in childbirth, she clasped the foetus to her breast—and grimaced. I repeat,— they had a fearful, shocking beauty. I wanted to photograph them, do details of contorted hands, of shrivelled breasts and gaping mouths,—it would have been a monumental theme. But the caretaker would not move the bodies, and the vault was too narrow for work, also the fusty air of the locked room almost overcame me,—so I have no records, but I have ineradicable memories.

My camera was not removed from its case while in Guanajuato, though we wandered looking for material through, or rather up and down the narrow streets, which sometimes changed to steps, and again to bridges.

The same story was repeated in Guanajuato. Every time a church was entered a

spy would follow us,—usually a woman. She would drop to her knees simulating prayer but watching our every move. I became nauseated by churches...

Rain fell every day of our stay in Guanajuato. I recall mines, mummies and a dismal, reeking landscape. My frame of mind accentuated my view-point. I wearied of insults. I vowed to practise shooting and throwing a knife,—to learn every curse in the Mexican tongue. My love for Mexico turned to something near to hate. It was forced on me though I tried to repress my feeling.

The worst day of all was that spent in the station of Guanajuato and the subsequent journey to Querétaro. My God, *what* a day!

Torrential rains had fallen. The train was chalked up four hours late. We gasped. But that four hours was nothing. Six hours passed,—eight, ten! No one dared leave, more than to pace the platform in turn. Romantic Mexico! Twelve hours after we had *hurried* to the station, at dawn, we left, or rather,—thought we had left! The train carried the extra weight of "La Burra" as the Indians had facetiously named the dead engine,—and "El Burro," straining and snorting, could not make the grade just outside the station. Four times dauntless "El Burro" dashed for the summit, four times it slid back to the station. "La Burra" was cut off,—then the second class was cut, and a steaming, reeking crowd was jammed in with us. The air became poisonous, it was a cattle-car,—no one could move,—hardly stretch. And we had two changes ahead before our destination, Querétaro!

Silao at 10:30—waiting again. The extra basket of loza from Guanajuato was almost the last straw. Other passengers eyed us disapprovingly as we crowded in upon them. The train barely crept along, while uneasy travelers leaned out over dangerous crossings. A sigh of relief at Irapuato,—the last change. And when it was announced that the connecting train from Guadalajara was two hours late I only shrugged my shoulders. There was no spirit left for temperament,—just a dull acceptance. Even bad station coffee at outrageous prices did not bring a protest. Querétaro might be reached at dawn,—my watch read 3:00 a. m. At Celaya, a barefoot blind man stood ankle deep in mud, shivering, and fiddling a water soaked violin. He played a well-remembered tune of Manuel's, and earned the few centavos that I tossed him.

Twenty-four hours after arising in Guanajuato we went to bed in Querétaro! Two hours sleep had to suffice, or miss the early hours of market day. Besides we did not want to be charged for a night, after arriving at sunrise. Beds were carefully smoothed out, and, braced with coffee, Querétaro, the last city of the grand tour, awaited our conquest.

Here was greater activity, and the sun shone cheerfully! I began to feel almost enthusiatic again.

Tresguerras, or Casas, whichever you will, had worked in Querétaro. The "Palacio Federal" had noteworthy figures, and the flying buttresses of the church

186

"Santa Rosa" were a powerful expression. The base, perhaps, was too weak a support for the great inverted arches,—but I only say "perhaps." How sad to compare the sculpture of today in Mexico to that of the glorious past! But it is not even Mexican. Porfirio Díaz, that tyrant of bad taste, imported Italian "art," —portrait busts, fountains, monuments, the "Teatro Nacional." Enough said! With his vulgar mind he of course had no understanding of the more intelligent, finer Indian. He should have been dethroned for aesthetic reasons, not political. In such a revolution I could joyfully take part!

Seven o'clock that night found us unanimously ready for bed. Not the band playing in the plaza below, not the long, snaky, bumpy pillow kept me awake five minutes. No less than twelve hours dreamless sleep sufficed to revive us from that twenty-four-hour harrowing train trip from Guanajuato.

Thanks to Tresguerras much work was found in Querétaro,—church interiors as well as exteriors,—sumptuously carved doors and confessionals,—altars splendid in gold leaf,—wrought iron. The sacristy of Santa Clara was sealed and locked by the government. We never discovered what treasures were hidden there.

After learning to take the cue from Mr. Terry we found him an excellent guide. When he said a sculpture or painting was strange, queer, bizarre, we hurried to it and were usually rewarded with a find. When he praised unduly we avoided going out of the way. He is a good guide for historical dates, natural history, geology, climate and—bad art.

At last we were through with Querétaro, which meant the end of travelling, except to nearby towns. Over a month had passed since leaving Mexico City and all were travel worn and weather beaten.

Blond, blue-eyed Brett,—ingenuous, 200 percent gringo, was the marked one in the party; he could not escape. Loafers sneered as he passed, and he it was who received the last parting curse from a fat old bitch on the steps of Santa Clara. Tina could pass as Mexican or at least what she is, I could pass as European, but Brett was always definitely damned as Yankee.

The train from Laredo was jammed, our extra basket of loza was again cursed, and hunger made us irritable until, Mexican style, we bought chicken from the window which challenged the cooking of any famous chef. And farther on, cheese, which Brett exclaimed was the best he had ever eaten,—and tostadas as big as a big sombrero, thin as a wafer, crisp and toothsome.

3. *"The Beginning of a New Art"*

August 26. Distrito Federal again, surrounded by the beautiful new loza from Patambán and Guanajuato which came through safely, — the Guadalajara shipment to arrive this morning, — that from Pátzcuaro mysteriously missing, causing me considerable concern.

The first visit was of course to the Salas — dear, dear people. Shocked to see Rafael so very sick — the torrid zone was too much for him. He brought me a coat with collar and cuffs of monkey fur, from Chiapas. It seems anything but Mexican in character, rather as coming from the arctic regions.

Hearing that we were at the Salas, Eric, Frances, Mary came later. Much talk of the tragedy of Galván's murder. Everyone is dazed. The man who killed him walks the streets free! Mexican law allows a "diputado" to go free no matter what the crime, until his term expires. Then, or by then he will be gone. What a convenient law! How fantastic!

Mexican Folkways published, with my photographs of the pulquerías illustrating Diego's article.

Professor John Dewey, here to lecture before the University Summer course, called yesterday to see my work. A quiet, dignified gentleman, but how can I comment after a short hour's contact? He left to pack for his return to the States.

August 29. Came Frances, Mary, and René—René had not yet seen my work— He burst into superlatives, excited gesticulations. " The modern painters are all off. They have chosen the wrong medium to express their ideas — but they would not dare admit so if they saw these photographs. This print (Three Ollas of Oaxaca) is the beginning of a new art."

August 30. I called on Jean. I always go to see him with expectations. I am never disappointed. His new work from Yucatán in contrast to the sombre, heavy painting done here, sparkled with delicate, but brilliant, jewellike color. I loved his old work and I love the new equally, if differently. He showed me also a delicious caricature of Mrs. Nuttal of Coyoacan.

All the loza has arrived — but alas! My favorite dish, an elegant old piece found in Tonalá, was broken. I have cemented it, or rather Rafael did, but it can never be the same to me, though it appears quite well, — for I buy not in the spirit of an antiquarian but to have beautiful things for actual use. I am much happier when I find a modern piece of value than I would be to discover the most

188

precious antiquity. And it is sad to note that the pottery done in Tonalá today is either indifferent, bad or actually ghastly!

I am told that Dr. Atl is responsible for the present corruption and formulization. If so, may he suffer in hell for his sin. He told the Indians, "Your ancestors used the greca [Greek fret], you inherit the greca, make grecas." So they stopped painting their spontaneous rhythms of birds, flowers, animals, and, one and all, do "grecas."

We went from door to door in Tonalá in hope of finding something different; we always turned away disgusted, — except in just one hut — where, on the wall was sketched a delightful landscape. "Why don't you paint your dishes so!" we exclaimed. "I would like to, but we can sell only grecas. I must live," he said. Then I discovered in a corner a little dish, done in the same spirit, a gem! The theme was a tiger hunt. A ferociously funny tiger, two white clad hunters holding guns in impossible [positions], treed in trees whose dainty elegance presaged slight safety from the wild beast. In a corner two deers gambolled oblivious to the pending tragedy, prodigious butterflies fluttered, birds sailed in long lines, and a scared little rabbit jumped over stylized grasses in the foreground. I must have shown my delight and desire too plainly. It was not for sale! Only after waiting and pleading for half an hour did the dish become mine for a peso, which amount, large compared to prevailing prices, I did not begrudge.

The other fine dish, broken in transit, I discovered, dust covered, discarded, and bought without much bargaining for fifty centavos. It is more elegant, less realistic, more sophisticated. On a cream ground the figures are painted in warm browns and black browns. A flowered border surrounds a fern and bird harmony. In the center are three long-legged, long-billed herons circled by twining leaves. Ferns sweep over them and two larger birds, birds which in life would be actually much smaller, complete an outer circle with a flourish of plumed tails. But the black brown herons in the center are nothing less than a poem in line. The three in silhouette, all alike, with just a slightly varying tilt of their elongated necks and extra long bills to save from monotony, are a tour de force in repetitive form.

That day in Tonalá we had stopped first to see Amado Galván — he of more than local fame. I bought a signed vase, and Victoria bought for me a plate. When an artist begins to sign his work it is indicative of a certain self-esteem, self-consciousness. And Galván, finding himself recognized, has felt his importance. It shows in his work, he repeats, — only the very great do not repeat their successes. One must admit its beauty, yet it is a bit cold, — calculated, while amongst the cheap botellones—bottles, demijohns—one finds many a gem. I have one which cost me forty centavos. I would rather own it than the vase or plate of Galván. Whoever painted it did not take himself seriously, he had no formula, he just dashed off the first thing that came to his head, and he must

189

have been in a jolly fine mood that day. The painting pulses with life, — swirls with energy. A full throated black bird bursts into song — two flaring magueys top a pink hill — leaves and grasses, dots and lines cut hither and thither — done with carefree surety.

They are painted alfresco, these botellones, — the colors are dull, but never dead, — the ground is always the natural color of clay as it comes from the oven. There are hundreds of them to choose from and one might choose blind-folded and be happy.

Another ware almost always good is a cheap, friable pottery, brilliantly glazed red brown. The patterns or figures are cream with accentuating lines of green or black. Again one might choose at random and make no mistake. It is very personal, this pottery, indigenous, done with no desire to please an alien public. It is obviously cheap ware, the burgess would never display it, so there is never a concession to burgess taste. It is gay, irresponsible, imaginative; it could not be placed in a room with silk lamp shades, lace curtains and pompous furniture. Tonalá is a city of potters, yet not one potter's wheel did I see. "Hand made" can be applied to their work without reservation.

There were seven of us wandered this day in Tonalá — Chavala, Pancho, Carmen, Victoria, Tina, Brett and Edward.

September 4. A copy of Spring *Little Review* at hand. It is "old fashioned" — *The Saturday Evening Post* is far more exciting. I used to eagerly await it — to devour it. Now I find myself impatient, irritated or indifferent to most of the contents. I feel but an attempt to force attention by bizarrerie, or a fierce, puerile effort at being intellectual. Either I am becoming conservative or else I am more discriminate, more aware, less deceived by affectation of knowledge. Naturally I place myself in the latter class, — yet, to be fair, or to build a defense — I claim no intellectual apirations, — I even confess a lazy mind. So my reactions may be an admission of weakness.

The photographs by Zwaska are trivial mannerisms, the centre one least offensive. I would quite as soon have a dark smudge by Genthe. The "N. Y." done by Charles Sheeler, had a genuine grandeur, — nobility — these photographs by Zwaska are an effort to be smart. Neither do I contact with the photography by Moholy-Nagy — it only brings a question — why?

I would not change one piece of my green loza from Patambán for any thing in the *Little Review* and this may explain my attitude.

These several years in Mexico have influenced my thought and life. Not so much the contact with my artist friends as the less direct proximity of a primitive race. Before Mexico I had been surrounded by the usual mass of American burgess — sprinkled with a few sophisticated friends. Of simple peasant people I knew nothing. And I have been refreshed by their elemental expression, — I have felt the soil.

190

September 6. No, — I should not say I have "a lazy mind" — rather, I do not have a studious mind. That which seems to concern me, I go to eagerly and dive deep, but I cannot memorize, or ponder over problems of irrelevant interest. Though they may appear important, my intuition says no, and that is the end of them.

At Rafael's I glanced over a German magazine — it had an article about the photographs of Man Ray. I suppose it was a laudatory review, but not being able to read the German I was spared. This photographer has been much praised and why, I wonder? The photographs reproduced show nothing beyond the usual, — even the best of them — and the worst are what one might expect from anyone of a hundred commercial photographers in New York, — theatrical postures and soft focus "effects" — Picasso done in a blurr — well, well, how funny!

In another magazine reproductions of buildings constructed for recent Paris exposition — again the sweat of effort to do something striking, different. No dignity — no reason for existence.

September 4. Roberto is grinding his camera for a movie to illustrate the popular song *La Casita*. It is to be done in a style especially suited to the Chautauqua course, and will serve to show these serious students the sweet romance of life in Mexico. An influx of enthusiastic Chautauquans bent on a realization of their dreams will follow. But not if they first read D. H. Lawrence' teeth-chattering, hair-raising nickel-novel, titled *The Plumed Serpent* or a timorous tale of dreadful days in demonic Mexico.

September 7. X. has gone to visit her mother in Guadalajara. I walked to the camión crossing with her, — we kissed good-bye and I slipped her ten pesos I could ill afford to spare. I feel that she has gone forever and though she irritated me sorely at times, with child-like lack of consideration, — yet she was tender and sweet.

September 13. They are artful, these Indians, — good liars — clever to a certain point at least. They can sit on a pin and claim comfort. X. did not go to Guadalajara, she was seen near Now I wonder what is up?

Brett has been ill — his condition worries me, and I am not one who becomes excited over sickness — I must get him away from here soon — and myself too.

September 14. Brett still sick. I cannot work with this worry. He must have an intestinal infection. My heart aches to see him so gaunt and sad. I fear my own judgment, the assumption of authority — but I fear the pill and knife doctors more. Have delivered to Anita 450 prints from 150 negatives all done on this last western trip. Adding those from Puebla and Oaxaca I have yet to finish some 140 negatives. And now I am very anxious to be done.

September 15. Brett better. I am still his doctor. Made eight more negatives of things around the house.

September 23. Pintao came. He will not allow his work copied for Anita's book. We — Anita, Tina, and I — have failed to persuade him, he remains obstinate, — not firm, not holding to some principle, but just cussedly obstinate. He is at outs with "Art" — "It does not pay — better to sit in a cool patio and thrum a guitar,' which is only the surface Pintao speaking in a crossgrained mood. He is one who could never do "Art" for money — he creates because he has to.

Later Covarrubias and Rose Roland came to see their proofs. Of Rose, I have one at least for myself. Miguel I should like to do again, but they leave for New York tomorrow. They are both very agreeable, jolly persons — I like them.

Well, X. returned. So much for my premonition. Yet I was not far off perhaps, for after two days of tears and kisses — and the consequences — she left again. Her brother came to take her home. I confess being sad — the house is lonesome. She was a nice little plaything to love. I did not need to waste energy making love, she brought it to me with outstretched arms and upturned face. She was charmingly wanting in brains, — and that was nice.

September 24. "In Union there is strength" — Yes — commercial strength — mob strength — fine motto for labor-unions, — for politicians — but for the individual who would create — no.

In the early morning, when all the rest are snoringly asleep, then one feels strong — untouched — released from the drag of personalities, for one pays a price for beloved friends — granting of course that they pay too!

With the first sounds of life, the bugle to awaken soggy soldiers, the first careening camión, the snarling of dogs, — then my enthusiasm wanes, then I feel the imposition of social service.

September 26. Surely this is a strange turn of life. X. and her mother and brother and sister are now on the way to Los Angeles and in a month I will be there!

September 30. A representative of the Berlin *Tageblatt* wants to reproduce a number of my photographs, but how to spare time for making prints, I question. I am so "fed up" on this work I am doing. I go to bed thinking negatives, prints, failures, successes, how many done, how many to do — and awaken with the same thoughts.

I received the most unique love-letter of my life — an almost illegible scrawl from X. She was full of sadness, going so far away. But she will blossom forth as a real flapper in Los Angeles, and soon forget Mexico in all the excitement of a big American city, where everything is offered to distract one from self-communion. Life is offered predigested. Not that X. could ever be introspective!

October 1. "Diez a Guadalupe — ¡Carrera! — Guadalupe — ¡Carrera!" "Ten cents to Guadalupe — Racing!" I have gone faster, but it was fast enough, —

and five cents cheaper than street-car. I took a day off from this work, — deserved, I swear.

Though market day, the town was empty compared to the two feast days of December 12 I have seen, when the streets were an almost solid suffocating mass of Indians.

Market day, — yet I was disappointed, for I found few things to purchase. Fortunate for my pocket-book, — or no — the price of most things in Mexico, the things I love, is so low that even a scanty purse is scarcely lightened. It is my trunk space I always consider — even now the overflow is appalling and I dread to consign my treasures to freight. But purchase I did — of course loza! A lion of tremendous mane, and I hardly need add of elegant form. I call him a lion though he has five horns. His legs are ridiculously small, yet considered as an integrity there is no disproportion. He is a pulque bottle, glazed brilliant metallic black. A real beauty!

A large gathering in the church conducting their own songs and service indicated a Catholicism revivified by suppression. A large marble figure of some venerable prelate kneeling before the main altar was having his face scrubbed with soapy maguey fibre.

Returning, I noted from the camión a pulquería, named "Risas y Llantos," best translated "Laughter and Tears!"

October 4. Sunday, — Jean, Brett and I went pulquería photographing for Anita's book. I dreaded the day, — even the day before. The pulquerías are always in crowded sections; closed Sundays, yet in their shadow the habitués linger perhaps because some small side door may be ajar, or perhaps from habit.

It seemed difficult to find just the right ones to illustrate the point. One week a fine example is noted, the next week it is gone, — repainted or painted out, or covered with posters. These fine examples of popular art are treated with scant respect. Too, many new paintings are in bad taste! The "art of pulquería painting" is in decadence.

Nothing untoward happened for a time, but just as I heaved a sigh of relief that we were out of the crowded, tough districts, and set up in a quite respectable, quiet street, an unpleasant incident took place. A Mexican of the middle class really quite a fifi, accosted us. He was boiling with hardly suppressed anger. We were to use such pictures to ridicule Mexico, to show her worst side to the North Americans, – and so on. Words with such people are futile, but Jean argued, then became sarcastic. "You think the Teatro Nacional is a finer expression?" — which naturally he did! I thought he would use personal violence, but he hurried half running away, — "to get a gendarme," so I hastened the exposure and we were off. But such people form the mass, the world over — except, in Mexico, they seem a bit more touchy.

Our search took us even to Guadalupe. There I found not a pulquería, but more loza! I am becoming ashamed of my repeated adjectives, fine, elegant, naïve, — but what is one to do? For I bought a siren, to which I might apply these and more. She is of the same ware as my lion, black brilliant glaze, but gorgeously decorated, painted and gilded with flowers and leaves. She too is a pulque bottle, her tail the container, her head and waist the neck. On her shoulders are two great gilt roses and she lures the mariners to destruction with an orange and black guitar.

René came in the evening. He is painting parchment lamp shades adorned with coats-of-arms for democratic American women with a hankering for royalty, — wishing to cut a figure with armorial bearings acquired in the good old days before all men were born free and equal. So Count René is purveyor to their inhibitions. René also gives lessons on "art," — tells these culture-hungry people which is the greatest picture ever painted, which one sold for the most money, when Velásquez died. To one eager lady, René showed a painting in gouache. One day she brought her husband, and all in a flutter to to exploit her attainments, exclaimed, "Look, dear, at this pretty picture painted by Gouache!" So René finds his discounted title soaring above par in the American colony.

October 6. Not 4:00 a.m. yet. Rising at such an unseemly hour accounted for by retiring before 8:30. Yesterday a full, tiring day of printing. I have cut the number of negatives down to 45. They want me to return to Querétaro. I balk. I have worked hard enough for the money. Working here I could finish in two weeks, print a few platinums for myself, — then leave. Sporadic rebellions everywhere, — talk of another real revolution. Better to leave soon. No place this, to work in a peaceful frame of mind.

Monday — I smashed my camera to the tune of thirty pesos. Brett thought I had hold — I thought he had. It fell from tripod height to the cement floor of Museo Nacional. I just stood and looked at it.

A sitting ahead today — must try to find some half-decent clothes to don. Funny people who think a good photographer, or a good anything, must have money!

Sunday 10. Thirty more negatives to make! I work at high tension to be done and go. But these last few negatives seem — or are — more difficult to assemble than the hundred preceeding ones. With so many illustrations already settled, the choice of subject matter has been narrowed with consequent slowing down of my work. Two weeks more?

October 13. Mr. McL. called on me last evening. I had not had the pleasure of meeting him before. He furnished me an evening of intellectual stimulus amounting to inspiration. He came to me on a quest for nude photographs.

194

"We are furnishing a bachelor apartment, you see. We want a nude study about 2 ft. × 1 ft. to hang above an inverted red light. Of course I'll cover it with black chiffon, — more discreet, you know. I don't want anything esoteric either — a tall, slender model with long hair." Quite a bill for me to fill — I despaired while my pocket book itched. My prints were either the wrong size or perhaps too "esoteric". "Well, we might hang these two to fill the space, but can't you bring your pictures to our apartment? I want my partner to help choose — he's the artist."

So, with some thirty nudes, we mounted his waiting limousine. Money, evidently! "F. and I have been together twenty-five years, — learned ship carpentering. When the war broke out we started two ship yards — built a lot of ships for the government." Ah, I see, from one suspender to spats!

At the door we met a short, stout baldheaded lackey, an ex-bartender turned butler, I thought. "Meet my pal and partner, Mr. F.," said Mr. Mac. Caramba! — how deceiving is appearance!

"María, bring cocktails for three. Shall I play a Caruso record or a blackface dialogue?"

House and Garden had helped them a lot in furnishing and decorating their home. But — "I don't like this round table in this square room, Tom — what do you think, Mr. Weston?" "A fine time to doubt, Jack, after I have just spent five hundred pesos for a blue satin cover — and besides — I saw a picture of Henry Ford's living room with a round table." I felt safe in agreeing with Henry Ford's good taste!

In blue-and-yellow-striped satin panels, gorgeously framed, hung life-size heads, "hand-colored" photographs — fried photographs — by the famous Mexican artist-photographer, Silva. "But we are going to change these for steel engravings, — one of Washington and one of Hidalgo. These two closets are to be turned into niches for statuary, draped with blue velvet, — this lampshade Tom designed and I am having miniatures painted of our friends to hang around the border. — Over these spaces we want two painted pictures — good color, you know — of Xochimilco and Popocatépetl."

They turned my nudes every which way to find the right way, with no success, they were too esoteric!

"Will you come to dinner? Tom is the cook, our girl makes fine native dishes, but we'll give you a real American meal — do you like roast beef? — but we can't find turnips — good American turnips, — big yellow rutabagas." By this time six cocktails had been finished and I felt relieved when the car was ordered to take me home.

"None of these nudes are quite right, Mr. Weston — don't fit the space — but I want my portrait done in platinum. Sorry we did not meet sooner — we go in

195

the same crowd you know — read the same magazines — *The Dial, The Little Review.*" "But," I feebly protested, "I only read *The Saturday Evening Post* and *The Ladies Home Journal.*"

October 17. Since writing the above the Messrs. McL. and F. have become bosom friends to me!

The famous dinner party took place with M., Frances, Tina and Edward, the invited guests, and Ann Gorlick brought along half-protesting, from a chance encounter on the street.

I have every reason to be grateful to our hosts, for in their home I first discovered M.'s lips, and they were sweet indeed, and her Irish blue eyes were bluer than ever in contrast to her flushed cheeks. We danced and danced and loved and loved — but she would not leave the party — "because of Tina!" How ironical!

I protested and explained — but no! Now this is a sad situation, for M. is a girl I could care for deeply. I must have another talk with M.

October 18. M. and Frances came the day after to gossip a bit about the party. I found urgent need to develop some plates and took M. with me. More kisses and embraces in the dark-room. "But this must end, Edward. We have all believed in the legend of Edward and Tina, you are leaving now, and I want to still believe. It was a beautiful picture." "But I insist, M. darling, that I have no one else, not by the farthest stretch of imagination!" M. would not surrender her fabulous picture. "I shall not be a persistent suitor, I never am — it is seldom worth while — but you are unusually worth while." So I wrote M. after we parted. Now if she does not change, then I forget M. and indulge in derisive laughter at the irony of my position, an unwilling participant in an imaginary idyl!

October 15. Packing trunks now — leaving soon. Yesterday a crate came, ordered for my Spanish chest. It was a poor job, roughly thrown together. The lumber cost at the most a peso, I could have done the job in an hour, I was charged seven pesos. This was the price agreed on, but I had expected a strong, neat box. "Labor" is all powerful these days! But I am becoming a reactionary. Too much sentimentality over the proletariat. Too much deification of the Indian. Labor thinks itself underpaid — the fact is, that it is usually paid too damned much. What incentive is there to excel as craftsmen with uniform wage scales and set hours? Injustice is a stronger way. The weaklings are weeded out, the fit survive. But I am only talking and without statistics. Yet statistics can always prove things either way.

October 20. Just five more negatives to do! My herculean task nearing the end. The trip to Acolman and Texcoco netted seven negatives. To make the two towns possible in one day I hired a Ford. Ten hours and a half, — sixteen pesos.

196

The road to San Agustín Acolman led out towards Guadalupe. In the chill early morning we passed processions of barefoot Indians and women of the wealthier class, also barefoot, flower laden, bound for the shrine of Guadalupe. No men of the better class, barefoot; it is the women who remain religious fanatics.

Then we passed a typical Mexican landscape,—a Ford wrapped around an iron lamppost. Later another head first in a ditch. Acolman — that strong, fine temple — there I copied many frescoes — which seemed however to have but little Indian influence. I recalled the happy day of two years ago when we and the Salas, with ample lunch baskets and good red wine, dined and whiled away the hours in the church yard. But this time it was work — and hurried work — for we had yet to make Texcoco. The road to reach the highway for Texcoco was a mere clearing through a cornfield, — I give credit to a Ford for accomplishing almost what a burro might!

I had always wanted to work with that most magnificient plant, the maguey — here on the highway was my chance. I took it. But I hurried, — each hour was costing pesos. Always the preoccupation of money!

Bulls and cows and calves wreathed with marigold! We passed them near Texcoco.

This chapel in Texcoco is said to be the oldest on the American continent. It is strongly Mexican. Angels, which are delightfully unangelic, flitting over the portal, and on the church facade were sculptured Indians with plumed head dresses. The old padres may have watched the work with dismay and surely contempt — but they were wise to let them have their way. The return ride to the city is surely one of the most beautiful out of Mexico.

October 22. Well, here I am until the 1st of November, at least — and through no fault of mine. Sr. Pallares cannot pay me the balance due of seven hundred fifty pesos before this date. I was furious — having more than fulfilled my end of the bargain — and to stay on here means extra rent—expenses I had not counted on. But it may be the fates are kind to me for M. seems to have changed her attitude, and when she returns from Guerrero, Tuesday, I am to see her.

What probably are the last negatives I shall make for the book I did Wednesday in a "casa de vecindad" — neighborhood house — in Colonia Soreto — la S. Antonio Tomotlan 10.

This was a community home, a sort of tenement house. A fine old convent, converted to this more utilitarian purpose, admirably served to house the obscure.

We met Goitia, a Mexican painter, in the patio of this place the night before. He had promised to show us a typical casa de vecindad. "I will have an organito there to play *La Golondrina* — so the *light* will be perfect," he said! We found him sketching the patio, though he could not possibly have seen it through the wall of

washing hung from a cobweb of ropes. The organ grinder did not come but the "light" was made perfect by the collective noise of cats and dogs, children laughing and crying, women gabbling and vendors calling. A great opportunity to do something for myself, — this maze of ropes and festooned washing, the zigzag of the cement community wash tubs — but the life? — how could I render that and retain definition, minute detail of objects near and far, all fascinating and necessary?

The next morning I went early. I must "stop down" — the exposure would be at least a second — it was a gamble. I waited for a moment of arrested motion — I tried at least eight times. I think from out the lot, one or two may join my collection.

Brett too has been working with the camera and I give the boy great credit for fine vision, — accurate observation. A sureness that I did not have six years ago. So much for contact in life. He has lost a year and a half of school stupidities. But he has gained.

October 23. Cold frosty mornings — cloudless days — the rain is over; the season in El Toreo is on — tomorrow Chicuelo fights — I must see one more corrida! Bless Frank and Bob my *House and Garden* friends for that evening with M. Tuesday seems many days away.

Rafael's condition no better — Monna near to collapse with worry and work. I want so much to return by boat — Soon I shall see those little rascals — and the big one — once more — Cole — Neil — Ted [Chandler].

October 25. El Toreo — yesterday for the first time in many weeks, and for the last time in Mexico, I am sure. A perfect day — cloudless — hot. A great crowd, expectant and enthusiastic, for it was the season's first appearance of Chicuelo, last year's idol. The music! The suspense! The great empty arena, like a blank sheet of paper ready for the recording of comedy or tragedy, beauty or ugliness, life or death! The bugle! Chicuelo — Barajas — Rayito! Chicuelo acclaimed with a roar of applause and a rain of hats, canes, flowers. The bugle! The first bull! A magnificent brute. But Chicuelo killed in bad form and was hooted and hissed. The bugle! Another superb bull. Barajas — an unknown quantity. A whirl-wind fight — a perfect kill — a new hero. Twenty thousand white handkerchiefs, a swirling snowstorm of acknowledgment — a thunderstorm of voices. Each bull was a fighting bull — tremendous animals.

There are those who see a bull fight — for example, D. H. Lawrence — and all they see with with their unseeing eyes and all they feel in their unfeeling stolidity is a fight between a man and a bull with a few gored horses to groan over. Sentimental? an abused word — flung around too easily by modern "intellectuals." Bourgeosie? also lovingly mouthed by those who read *The Dial* — what then? Apathy to the aesthetic quality of the fight — granting its undeniable

198

sordidness—bars such persons from feeling and understanding its symbolic pagentry. Perhaps they are more humane, if less human, but they miss in life those fearful forbidden heights from which some see beauty masked and arrayed in alien guise. Refinement of aesthetic response or shocking sensuality; one may seek and find, each in his own fashion, in El Toreo.

October 28. Printing palladio! near to six months since I have indulged in this rare pleasure — also yesterday I made the last two outside negatives to be done — the arches of that fine patio in the ex-convento de la Merced, and a new prehispanic discovery — a large model of a temple, a sculptured stone, found while remodelling the Palacio Nacional. One more negative only, a painting by Goitia to be copied, then I am free! I am quite gay and carefree to be through. Now for a few happy days with M. and I'll sail away forever!

Brett worked with my Graflex from the roof of la Merced, and made negatives technically fine and equally as well seen. The boy has a great future, and I believe he realizes it. For a boy of fourteen he is remarkable well balanced and free from "spooks".

Lupe had phoned to come for tamales and atole at six. A crowd was there — too late to back out — Anyhow I might never see them again. Lupe with her racy tongue convulsed us all as usual. Her topic, which allowed of caustic and flippant garrulity, concerned two girls, friends, who had published a manifesto against men in general. A warning to long suffering women to awaken. They published even to intimate details their relations with men and also the names of their betrayers! Then personally distributed the propaganda to prove their courage.

This morning I awakened with tears from a half dream in which Diego said, "No te vayas, Edward," as we embraced farewell. It was reacting our parting of last night! I suppose in the dream Diego was a symbol for all that I shall be sad to leave in Mexico.

The "tamalada" was a success — couldn't have been otherwise with la Señora Marin supervising.

October 31. Tomorrow I am to receive my last payment — or I should say I am supposed to!

We have decided to return by boat via Manzanillo — stopping over a day or so in Colima, — the few glimpses of that city leaving impressions which tempt me to further exploration, and Brett knows that there must be an unexcelled hunting ground for butterflies.

But best of all must be a week upon the water — enforced idleness — that sort of idleness which allows the brain to function clearly – unharrased by daily duties.

November 1. M. came — and M. went!

She came early. For a birthday present I had asked her to select one of my

photographs. She chose my Three Ollas de Oaxaca — of all my work maybe my present favorite.

Then we went out Guadalupe way. Another religious pilgrimage was on. Singing and crying "Viva," hordes of people marched into the church. To have entered would have meant suffocation, so we climbed high above the fanatical mob and watched the sunset over a truly noble landscape. "El Popo," whose white blanket changed to rose then faded to grey — black geometric forms in the foreground hills — lightning over Lake Texcoco.

I had asked M. more than once to go away with me — but always evasion of this culmination to our episode — "To Oaxaca — to Colima — anywhere, darling —" But always evasion — even to my "Why not?" — except a vague "After, come so many pains, so much sadness."

We descended to the plaza and sat for awhile in the dusk — very close together — yet very far apart — little flashes of recognition — a touch of finger tips and exchange of the eyes — her head on my shoulder — and then, when I might become insistent, a barrier of casual remarks — behind which sat M. with who knows what thoughts — yet she cares, I can see in her eyes.

November 2. And no money yet — Pallares promised yesterday. I cannot make boat reservations with no surety of my pay. What a ghastly day it was — too cloudy for printing — all other work finished — M. away — Brett haunting my heels. I don't blame him — he has not enough outlet here — he is sociable but has no friends — I have to be father — friend — teacher. I want to be — am glad to feel I can be — but not every moment of the day.

The puestos are open for "El Dia de los Muertos". For the last time we walked the alameda. Kewpie dolls, tin toys, Japanese screens, horrible abortions from Tlaquepaque, — such rubbish was offered and sold from two thirds of the puestos. Yet it was colorful despite the corruption of taste. Massed gewgaws may be visually delightful — but taken separately become abominations.

The indifferent familiarity of the Mexican to death — the macabre viewpoint is indicated in the puestos on this day of the dead. "Death for sale" is the vendor's cry — Death from every realistic and fantastic angle is sought and sold. Great candy skulls, tin trolley car hearses, tombstones, puppet skeletons who fiddle and dance, gruesome death masks — while a jolly crowd banters and buys.

November 4. At last my money — all but forty pesos. The boat four days late, — I should leave the 13th. A party has been planned at Frances' to bid me farewell. I don't want it. Just sitting around, talking, tea sipping, joking. A dancing party at Frank's and Bob's, yes, for there I could lose myself with M. There a party would mean dances, drinks, embraces, kisses with M. — and the rest go hang! My last gesture in Mexico with M. — that is my wish — She comes in half an hour for her portraits — this early morning — 7:00 a.m.

200

November 5. No M. came — She must go, as guide with a group of labor delegates from Europe. These laborites have played havoc with my love affair. I must in revenge become more conservative than ever.

Before the clouds came — I pulled a brilliant print of my palm, better than the one Diego has. In the afternoon Jean sat to me. He has given me a number of drawings to dispose of in Los Angeles—they are so fine that I almost hope they do not sell!

With the greatest satisfaction I note Brett's interest in photography. He is doing better work at fourteen that I did at thirty. To have some one close to me, working so excellently, with an assured future, is a happiness hardly expected.

Both Jean and Diego, who came late, like a new negative done in Xochimilco of cactus and rock. It yields a hard contrasting print, — in spots where the sun reflected from cactus or sand the value is represented by almost clear paper, but how else could such eye-blinding portions be registered? The same with a lake reflecting the sun, seen above a foreground of Indian huts heavily shadowed, which I recorded from Xanicho [Janitzio]. The lake is a blank, — quite without detail. I know just the people who will criticize these prints. But I know that I saw correctly.

November 7. My boat delayed again — now it does not leave till the 17th. I do not feel so badly — for it will give me more time to print palladio, but Brett is quite cross, and all for leaving by train, which can't be done, for all my papers, passes, idols, chest, photographs are for the officials at Manzanillo.

Brett hasn't a friend of his own age in Mexico, and I feel sorry for him, but I'm afraid when he returns, his old friends will not satisfy him either, for he has gone beyond them; they will no longer speak the same language.

I did not say that the delay will also give me more days with M. For what is the use? I have given up hope that she will "run away" with me. Yesterday she sat to me, and there came moments when we forgot the purpose of her visit, but always her answer to my "Why not?" was "Because." Could ever a word be more exasperating!

November 8. Two Tarahumare Indians ran from Pachuca to the Mexico Stadium yesterday, a distance of 100 Kilometres or 62.5 miles in 9 hours and 37 minutes, close to seven miles an hour for nine hours!

Frances, Peter, Claire, M. and I hired a car and met them about twenty miles out. They were running strong, these huarache-clad interlopers in modern athletic games. I was told that several had once been sent to the Olympic games in Paris, expecting to clean up the world in long distance, but had failed because they tried to run in modern running shoes and bandaged ankles. So they wore huaraches yesterday, an amusing contrast to the usual track uniform, with the colors of Mexico on their breasts. But the huaraches were not the only note which

showed them out of place, for each wore a string of bells, which jingled merrily as they ran, and peaked straw sombreros.

The finish took place in the Stadium, where as a reward for their performance, officials tied around their necks silk handkerchiefs of gaudy red.

M. and I ditched the crowd for the bull fight, in which "El Chato" fought gloriously.

I saw her but once again, alone for a moment, but with nothing more to say. We met at Frank's — a farewell party for me. Successes can not be repeated — it was a sad and tiresome affair.

Tuesday—9th. Rather sleepy — not having slept off the wine which Madame Charlot served with a little farewell supper for me. Just the three of us, Madame, Jean and I, were the party. I took Jean a print, the new "Maguey", and he gave me an oil, which I hardly need say delights me. Jean was happy with the proofs, especially one head against a brick wall, a perfectly fine negative and a strong likeness.

Pulled some fine palladio prints yesterday and want to continue printing today with such perfect weather. But I have very bad news. — The boat we were supposed to take does not stop in Los Angeles. A nice time for the stupid agents to discover this! Now all my letters of introduction must be changed from Manzanilló to Juárez. And we must take that miserable train trip, — hot, dusty, and quite uninteresting.

As usual I have last moment sittings. A bride! — and Sra. Llamosa who says I cannot leave Mexico without once more making her portrait. Also I have sold a print. Dr. Boehme, professor in the German School, purchased my petate horseman — the second German who has chosen this print. With Dr. Boehme came the wife of the German Ambassador to Mexico, who made a fine impression on all of us, as a strong, intelligent woman.

On the train. The leaving of Mexico will be remembered for the leaving of Tina. The barrier between us was for the moment broken. Not till we were on the Paseo in a taxi rushing for the train did I allow myself to see her eyes. But when I did and saw what they had to say, I took her to me, — our lips met in an endless kiss, only stopped by a gendarme's whistle. Our driver tactfully hinted that public demonstrations were taboo, — for shame! Mexico is surely becoming United Statesized.

Dear friends came to the train, — Felipe — Pepe — Roberto — Frances — and M., — others sent messages and love.

Vamanos! — last embraces all around — Tina with tear filled eyes. This time, Mexico, it must be adiós forever. And you, Tina? I feel it must be farewell forever too.

Glossary of Mexican Words and Phrases

aguacate – avocado, alligator pear

atole – non-alcoholic cornflour drink

azotea – flat roof

bastón – walking cane

batea – painted tray

bizcocho – biscuit

bomba – pump

borrachito – slightly drunk, exhilarated

camión – bus

cargador – porter

chango – monkey

charro – cowboy with special skills, as against *vaquero* – a cowhand

chirimoya – cherimoya, a tropical fruit

criada – servant girl

crudo – hangover

diana – fanfare

encargado – agent, attorney

enchilada – pancake of maize with chile

equipal – Weston's mishearing of *episcapodo* or *episcopal*? – a bishop's chair

faja – sash

frijoles – small kidney beans

habanero – a rum drink

huarache – Mexican sandal woven of strips of leather

jefe – chief, head man, mayor of a village

jicara – small jug

juguetes – toys

loza – pottery

mariposa – butterfly

mole de guajalote – turkey with a chile and chocolate sauce

naranja – orange

negro – black

olla – pot

petate – straw mat

piñatas – papier maché figures made to be filled with gifts or candies and then broken in a blindfold attack

pollo – chicken

pozole – hominy, usually cooked with a hog's head, sometimes with chicken

puestos – booths, stalls at a market or fair

pulque – fermented juice of the maguey cactus

pulque curado – pulque prepared with pineapple or orange and sugar

pulquería – bar where pulque is served

rebozo – shawl or scarf, worn by women

serape – blanket, worn by men

tamale – crushed maize, minced meat and chile, dipped in oil and then steamed or boiled

tequila – distilled liquor made from the roasted stems of the century plant, *tequila*

tierra caliente – hot country

tortilla – pancake

tostada – toasted bread

trastero – whatnot

vaquero – cowhand; see *charro*

viejitos – little old ones; Los Viejitos is a famous folkdance caricaturing elderly white men

vino rioja – red wine from La Rioya, Spain

zaguán – entrance hall, foyer

Edward Weston's Technique

Edward Weston brought to Mexico an 8 × 10 view camera and a $3\frac{1}{4}$ × $4\frac{1}{4}$ Graflex. His battery of lenses included an "expensive anastigmat" of unspecified make and several soft focus, or diffused focus lenses, among them a Wollensak Verito and a Graf Variable. These lenses had the characteristic that the degree of diffusion (i.e. spherical aberration) could be altered at will.

The Variable was basically an anastigmat, fully corrected for its maximum aperture, f/3.8. By changing the distance between the front and the rear elements of this double lens, varying amounts of spherical aberration could be induced. Theoretically it thus produced either a needle sharp image or one so diffused that it hardly seemed to be produced by a lens.

The f/4 Verito was described by its manufacturer as "a specially designed double lens... which, while it gives the desired diffused or soft optical effect, shows no distortion, double lines, or other optical imperfections, and being rectilinear gives an even diffusion over the whole plate... Will not make sharp negatives with wiry definition unless stopped down to f:8."

When Weston wrote, on Easter, 1924, "Sharper and sharper I stopped down my lens; the limit of my diaphragm, f/32, was not enough, so I cut a smaller hole from black paper," he was referring to this characteristic of the Verito as well as to the fact that great depth of field is given with small lens openings.

He had trouble with the Variable. Although he stopped it down to the smallest aperture, he found troublesome flares. An optometrist deduced that this was caused by the large glass surface of the f/3.8 lens. On June 24, 1924, he purchased for 25 pesos a second-hand Rapid Rectilinear lens. This type of lens had long been considered obsolete, if not archaic. Years later he gave this lens to his son Brett, who has most generously presented it to the George Eastman House. It bears no maker's name. On the barrel is inscribed: "8 × 10 THREE FOCUS," and the scratched dedication, "To Brett — Dad, 1937." Examination on an optical bench proves it to be an unsymmetrical form of Rapid Rectilinear of $11\frac{1}{4}$ inch focal length, well made and well centered. It has no shutter — Weston used a behind-the-lens Packard shutter — but an iris diaphram marked "R. O. C. and C. CO." (Rochester Optical and Camera Co.") The smallest opening is marked "256." Measurement proves this to be the long-obsolete "Uniform System," the equivalent of f/64.

Weston used panchromatic sheet film. This material, capable of recording all visible wavelengths — in contrast to orthochromatic emulsion, which is relatively

insensitive to red and overly sensitive to blue — was an innovation in film form: it was first marketed in America by the Eastman Kodak Company only two years before Weston sailed to Mexico. Notations of exposures in the Mexican Daybook indicate that the speed of this "panchro" film would be rated today at 16 by the American Standards Association system. A portrait in full sunlight required $^1/_{10}$ sec. at f/11; an open landscape was stopped down to f/32 for an exposure of $^1/_{10}$ sec. with a K-1 filter. He had no meter to calculate the exposure. Experience guided him: "I dislike to figure out time, and find my exposures more accurate when only *felt*."

On August 24, 1924, Weston noted: "I have returned, after several years use of Metol-Hydroquinone open-tank developer, to a three-solution Pyro developer, and I develop one at a time in a tray, instead of a dozen in a tank!" This technique he used for the rest of his life. It is classic; he undoubtedly learned of it at the "photographic college" he briefly attended. The 1908 instruction manual of a similar institution — the American School of Art and Photography — recommends it as the standard developer. Weston used it with less than the usual amount of sodium carbonate. (Interestingly, the Wollensak Optical Co. advised: "Negatives made with the Verito should be fully timed, and slightly underdeveloped, using any standard developer with a minimum amount of carbonate of soda...")

He printed on several kinds of paper. In his early years in Mexico he was especially fond of the platinum and palladium paper made by Willis & Clement, which he imported from England. This paper, which became obsolete in the 1930s, was sensitized with the salts of iron and platinum (or palladium), rather than silver. It gave soft, rich effects quite unlike any other kind of paper, and was cherished by pictorial photographers. Prints were exposed in sunlight for minutes, developed in potassium oxalate and fixed in hydrochloric acid. The addition of potassium bichromate to the developer gave an increased brilliance in the whites; this technique Weston used in his struggle to get prints of the dramatic white clouds which so moved him. The paper had a tendency, especially if damp, to solarize, i.e. partially reverse in the highlights, giving a dark edge instead of a light one. Printing was slow work. To make fourteen prints from as many negatives in one day, as he did on September 30, 1924, was unusual.

On this day he noted with surprise that proof prints, made on Azo paper, gave him as much satisfaction as platinotypes. This material, which is still produced by the Eastman Kodak Company, was a typical gelatino-chloride developing-out paper exposed to artificial light. Weston always referred to it as "gaslight paper," a name given to it in the 1890s, but which was retained decades after electricity became universal.

Although Weston preferred an 8 × 10 camera (he rejoiced in "the precision of a view box planted firmly on a sturdy tripod") he made increasing use while in

Mexico of his $3\frac{1}{4} \times 4\frac{1}{4}$ Graflex – hand held even at exposures as long as $^1/_{10}$ second. To enlarge these negatives on platinum or palladium paper was tedious. An enlarged negative had to be made. First an 8×10 inch glass positive was made from the small negative. From this, in turn, he made a new negative, which he then printed by contact. Apparently he never printed by projection –although it was entirely practical to do so with gelatino-bromide papers which were then readily available. On his return to California he abandoned platinum and palladio papers, and settled on glossy chloro-bromide papers — which he invariably printed by contact.

This simple technique Weston used throughout his life. It was a direct outgrowth of his formative Mexican days.

<div align="right">B. N.</div>

Selected Bibliography

1. BY EDWARD WESTON

Letter describing portrait technique. *Photo Miniature*, XIV, No. 165 (Sept., 1917), 354–56.

Statement in catalogue of exhibition: Edward Weston – Brett Weston, Los Angeles Museum, 1927.

"From My Day Book," *Creative Art*, III (Aug., 1928), 29–36.

"Amerika und Fotografie," in Catalogue of exhibition "Film und Foto," held by Deutsche Werkbund, Stuttgart, 1929.

"Photography – Not Pictorial," *Camera Craft*, XXXVII (July, 1930), 313–20.

Photography. Pasadaena: Esto Publishing Co., 1934. Pamphlet.

"What is a Purist?" *Camera Craft*, XLVI (1939), 3–9.

"Photographing California," *ibid*. 56–64, 99–105.

"Light vs. Lighting," *ibid.*, 197–205.

"What Is Photographic Beauty?" *ibid.*, 247–55.

"Thirty-five Years of Portraiture," *ibid.*, 399–408, 449–60.

California and the West, New York: Duell, Sloan & Pearce, 1940. (With Charis Wilson Weston.)

"Photographic Art," *Encyclopaedia Britannica*, 1941 and following editions. Revised in 1954 by Beaumont Newhall.

"Portrait Photography," *The Complete Photographer*, VIII (Dec., 1942), 2935–40.

"Seeing Photographically," *ibid.*, IX (Jan., 1943), 3200–206.

"From My Day Book," in *Stieglitz Memorial Portfolio*, edited by Dorothy Norman (New York: Twice a Year Press, 1947), pp. 25–26.

The Cats of Wildcat Hill. New York: Duell, Sloan & Pearce, 1947. (With Charis Wilson Weston.)

My Camera on Point Lobos. Yosemite National Park: Virginia Adams; Boston: Houghton Mifflin Co., 1950.

"Color as Form," *Modern Photography*, XVII (Dec., 1953), 54.

Studies of Human Form by Two Masters: John Rawlings and Edward Weston. New York: Maco Magazine Corporation, 1957.

"From the Day Book of Edward Weston," *Art in America*, XLVI, No. 2 (Summer, 1958), 49–53.

207

2. ABOUT EDWARD WESTON

Adams, Ansel. "Photography," *The Fortnightly* (San Francisco), Dec. 18, 1931, pp. 21–22. Review of Edward Weston exhibition at De Young Museum, San Francisco.

Aragon Leiva, Agustín. "La Fotografía y la fotografía en México," *El Nacional* (Mexico), Dec. 5, 1933.

Armitage, Merle, *ed. Edward Weston*. New York: E. Weyhe, 1932.

——. *Fifty Photographs: Edward Weston*. New York: Duell, Sloan & Pearce, 1947.

The Aztec Land, Mexico. *Edward Weston – Exposicion de sus Fotografías*. 1924.

Brenner, Anita. "Edward Weston nos muesta nuevas modalidades de su talento," *Revista de Revistas* (Mexico), Oct. 4, 1925.

Charlot, Jean. "Edward Weston, " *Calif. Arts & Architecture*, LVII (Apr., 1940), 20.

"Fotografías de Weston," *Forma* (Mexico) II (1928), 15–18.

Newhall, Beaumont. "Edward Weston in Retrospect," *Popular Photography*, XVIII (Mar., 1946), 42–46, 142, 144, 146.

Newhall, Beaumont and Newhall, Nancy. *Masters of Photography*. New York: George Braziller, Inc., 1958.

Newhall, Nancy. *The Photographs of Edward Weston*. New York: The Museum of Modern Art, 1946.

Newhall, Nancy, *ed*. Special Weston issue. *Aperture*, VI, No. 1 (1958), 1–50.

Parella, Lew, *ed*. Special Weston issue. *Camera* (Lucerne), XXXVII (April, 1958), 147–81.

"Photography," *Mexican Life*, II, No. 4 (June, 1926), 16.

Reyher, Ferdinand, *ed*. "Stieglitz-Weston Correspondence," *Photo-Notes*, Spring, 1949, p. 11–15.

Rivera, Diego. "Edward Weston y Tina Modotti," *Mexican Folkways*, II (Apr. – May, 1926), 17, 19, 27–28.

Siqueiros, David Alfero. "Una transcendental labor fotografíca," *El Informador* (Guadaljara), Sept. 4, 1925.

3. ILLUSTRATED BY EDWARD WESTON.

Brenner, Anita. *Idols Behind Altars*. New York: Payson and Clarke, 1939.

Whitman, Walt. *Leaves of Grass*. New York: Limited Editions Club, 1941.

Index